2D: visual basics for designers

robin landa, rose gonnella,
& steven brower

THOMSON
™
DELMAR LEARNING Australia Canada Mexico Singapore Spain United Kingdom United States

2D: visual basics for designers
robin landa, rose gonnella, and steven brower

Vice President, Technology and Trades ABU
Dave Garza

Editorial Director
Sandy Clark

Senior Acquisitions Editor
James Gish

Product Manager
Jaimie Weiss

Marketing Director
Deborah Yarnell

Marketing Manager
Penelope Crosby

Production Director
Patty Stephan

Editorial Assistant
Niamh Matthews

Senior Production Manager
Larry Main

Senior Content Project Manager
Thomas Stover

Content Project Manager
Nicole Stagg

Cover Design
Steven Brower

Interior Design
Steven Brower and Dawnmarie McDermid

This book was typeset in Melior, a serif typeface designed by Hermann Zapf in 1952, originally commissioned by Stempel, and Gill Sans, a sans-serif typeface designed by Eric Gill in 1928, for Monotype. The cover design features Profile, a nineteenth-century Egyptian or square serif lead type, and Trade Gothic, a sans-serif typeface, designed by Jackson Burke in 1948, for Linotype. It was printed on an offset lithography web fed press.

COPYRIGHT 2007 by Robin Landa, Rose Gonnella, and Steven Brower

Printed in the United States
1 2 3 4 5 CK 09 08 07 06

For more information contact
Thomson Delmar Learning
Executive Woods
5 Maxwell Drive, PO Box 8007,
Clifton Park, NY 12065-8007
Or find us on the World Wide Web
at *www.delmarlearning.com*

Library of Congress
Cataloging-in-Publication Data:
ISBN: 1-4180-1160-6

NOTICE TO THE READER
Publisher does not warrant or guarantee any of the products described herein or perform any independent analysis in connection with any of the product information contained herein. Publisher does not assume, and expressly disclaims, any obligation to obtain and include information other than that provided to it by the manufacturer.

The reader is expressly warned to consider and adopt all safety precautions that might be indicated by the activities herein and to avoid all potential hazards. By following the instructions contained herein, the reader willingly assumes all risks in connection with such instructions.

The publisher makes no representation or warranties of any kind, including but not limited to, the warranties of fitness for particular purpose or merchantability, nor are any such representations implied with respect to the material set forth herein, and the publisher takes no responsibility with respect to such material. The publisher shall not be liable for any special, consequential, or exemplary damages resulting, in whole or part, from the readers' use of, or reliance upon, this material.

Table of Contents

2D: Visual Basics for Designers
Robin Landa, Rose Gonnella,
and Steven Brower

2D: Visual Basics for Designers

Foreword by John Gall

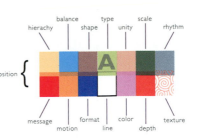

As a book cover designer, I am continually amazed at how the same basic rectangular format can be reinvented over and over again. I mean, it doesn't seem so hard, right? Take a rectangle, add a title, an author's name, maybe an image, and bingo, you've got a book cover. Well, in some ways, it really isn't that hard (title at the top, author name at the bottom, image in the middle usually works), yet in other ways it can seem a nearly impossible task.

Having had my hands in over two thousand covers during the course of my career, every so often I reach a point where I think I've exhausted every possible combination of the cover elements. "Well, we haven't done the upside down cow with type coming out of the udders in a couple weeks—maybe no one will remember." Then I'll spend days or weeks, pushing type around the page trying to make some "magic" happen. Then, when all seems lost—usually at a point when that inspirational force known as the deadline approaches— some new and surprising relationship will reveal itself, opening new avenues for future exploration.

So, what is this magical combination of elements that makes designers go "aah" and clients go "hmm"? It can be seen in the examples presented in this book. Even if devoid of their concept, these designs retain a beauty that engages our eyes and our minds.

How can we identify it? Does it even exist?

Advancements in computer technology during the past ten years have put the instruments of the graphic designer into the hands of anyone with access to a computer. There are no more mysterious tools and intimidating methodology to keep the public at bay. No more haber rules or character counting; no dirty Photostat machine chemicals; no layers of amberlith or rubytlith to cut; no more secret coded communications to typesetters; and somewhat less frequent trips to the emergency room due to X-acto blade mishap. The tools have changed, as they tend to, yet the foundations have not.

Communication by visual means dates back to the days of early mankind, yet as a serious creative profession, it is about one hundred years old—and it's only been during the last fifty years that graphic design has been treated with the seriousness and scholarship that it deserves. There are heady dialogues and criticism, dedicated periodicals, master's programs, and countless designer monographs; additions to the canon of books like *2D: Visual Basics for Designers* builds an even stronger foundation on which graphic design education for future generations can be built. The texts that accompanied my design education, a mere twenty years ago, were a stack of dusty old

Art Directors Club annuals found tucked away in the school library and a copy of Philip Meggs's *A History of Graphic Design.* Fine books indeed, yet not at all a comprehensive approach for the education of a graphic designer. *2D: Visual Basics for Designers* goes a long way toward achieving that goal.

This is also a very interesting and challenging time to be a graphic designer. More and more students are graduating with design degrees and entering the job market—many wonderfully talented students, I might add. Competition for jobs is fierce. This competition for work comes not only from other designers; we are also seeing the rise of "stock design templates" that offer predesigned page layouts and "logo mills" that crank out personalized logos for next to nothing. The bar is being raised. It is now fairly easy to make acceptable design. But to go beyond what is merely acceptable, to discover something unique and surprising is what designers should be after. What separates those with the tools of a profession from those who know how to use them is an understanding not only of how to hold the tools, but also how to apply them effectively and creatively, to provoke and surprise, to challenge one's expectations.

Which brings us to the importance of a book like *2D: Visual Basics for Designers.* What the authors have assembled in these pages is a much needed, clearly written and concise foundation in two-dimensional design—a primer for students, an outline for teachers, and, dare I say, a refresher course for professionals. Although this book presents itself as a visual basics study program on two-dimensional design, it is much, much more. All the basics are covered, things like line, shape, color, texture, balance, perspective—all the biggies. And don't let the two-dimensional title fool you, since nearly all graphic design is based on the principles of manipulating two-dimensional space. These applications cover all aspects of graphic design, from book covers (which are, in fact, more three-dimensional objects than two-dimensional surfaces) to CD packaging to posters, logos, and web sites, etc.

This book covers the basic ideas of design, then connects them with outstanding examples of graphic design from the past and present. From A. M. Cassandre's beautifully lithographed posters to April Greiman's early embrace of the computer to Stefan Sagmeister's wonderfully crude line work—each of whom have a readily identifiable style, but also a complete understanding of the underlying elements that allowed them to "push the envelope" of their time and inspire legions of future designers.

When I approach a design project, one of things I am trying to do is to create space—trying to create the impression that there is more (or sometimes less) space than is actually available within a given format. Whether it's creating the illusion of three-dimensional space, negating the illusion of space, arranging a harmonic balance of elements, or creating organized chaos, for me, it is one of the most rewarding and satisfying aspects of the design process.

Scientists now believe there may be as many as eleven dimensions making up our physical world. That's seven or eight more than I can even remotely comprehend and nine more than I really need.

John Gall is the art director for Vintage/Anchor Books. His award-winning cover designs for Alfred A. Knopf and Grove Press and CD packages for Nonesuch Records have been recognized by the AIGA, Art Directors Club, *Print, Graphis,* and *ID* magazine and are featured in the books *Next: The New Generation of Graphic Design; Less Is More;* and *By Its Cover: Modern American Book Cover Design.*

He has also written about graphic design, covering an array of topics from the history of Grove Press to contemporary skateboard graphics. His first book *Sayonara Home Run! The Art of the Japanese Baseball Card* was published in 2006.

Preface

by Robin Landa

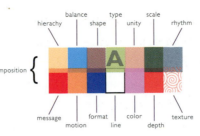

Background of This Text

We realized that the best possible course in *visual basics for designers* would focus on just that—visual communication—and *not* focus on how the elements and principles operate in painting or printmaking. Certainly, we want our students to study the history of fine art and design, and take fine art courses to enrich their creativity and their lives. However, it just seemed to make much more sense to concentrate a 2D course on the needs of aspiring designers and art directors. Deficiencies in understanding the principles of visual hierarchy, unity, and composition will, without a doubt, inhibit communication and creative expression in intermediate courses. Therefore, without a strong foundation in visual basics, a student would be at a loss in any application course.

Intended Audience

2D: Visual Basics for Designers is a comprehensive and comprehensible book on two-dimensional design principles for visual communication—graphic design and advertising. *2D: Visual Basics for Designers* was created in response to the many requirements of a student's design education and the need to start with a focused, in-depth study of visual basics. This book serves several purposes for students in visual communication programs and for aspiring designers.

2D: Visual Basics for Designers:

- Is a thorough guide to key two-dimensional design elements and principles of composition, for graphic design and advertising applications
- Examines typography in relation to two-dimensional design principles and composition
- Offers an overview of the nature of message and communication and how it depends upon visual basics for effective solutions

- Introduces the design process for solving visual communication problems
- Presents two-dimensional design elements and principles as the foundation to any design
- Teaches by cause and effect design approach
- Instructs with studio exercises at the end of each chapter
- Addresses both print and screen-based media

Emerging Trends

There are always emerging trends and, more importantly, design movements and theories.

On Teaching Fundamentals. From public service advertising to publication design, creative solutions become important contemporary visual communication vehicles. That said, every designer has a responsibility to himself or herself, his or her client, the audience, and society. Also, in order to successfully communicate visually, every designer must be adept at the creation and manipulation of graphic space, with all the tools that are available. Therefore, in this book, we cover formal elements and principles, always keeping in mind problem solving, message, communication, context, culture, client, and personal expression.

On Message and Communication. Designers and art directors solve visual/verbal communication problems. Although a portion of the work created is aesthetically compelling, expressive, and provocative, designers are not creating art as a pure matter of self-expression. Clients want their visual communication projects and problems solved, and they want creative professionals who understand the true nature of the discipline.

On Problem Solving. Emphasizing cause and effect visual communication encourages students to understand the importance of critical thinking to the creative process. For any student or novice, it is imperative to develop sophisticated problem-solving skills, to be grounded in liberal arts, to have excellent communication skills, and to be a good "information-gatherer" and a careful listener. These will serve a student best during a long career.

On Creative Expression. Visual communicators solve problems; they search for appropriate and meaningful solutions. We take great care to state that creative expression must serve the design problem. We foster creative thinking by asking the student designers to think, research, study, practice, and experiment. Jose Molla, creative director of La Commuidad in Miami, advises: "The difference between bad and good creatives is that they both come up with the same pedestrian solutions—the bad creative stops there, and the good creative keeps working toward a more unique and interesting solution."

On Preparing Future Designers. Teaching graphic design and advertising is very challenging. Students must become critical and creative thinkers very quickly, learning to visually and verbally express and represent their creative ideas. In order to thrive in a fast-paced marketplace, visual communication professionals must stay current with technology, design theory and movements, economic trends, and culture. Knowing and respecting the audience and client is crucial. Today, collaboration is becoming more and more a necessity. A designer must collaborate with clients, IT professionals, and many other creatives in order to best solve communication problems.

Textbook Organization

The major portion of this book covers the basics of essential two-dimensional design elements and principles as they relate to composition and meaning. In order to view two-dimensional design in practice, we have utilized graphic design and advertising solutions, both contemporary and historical.

Part I—Chapters 1 through 6—provides a thorough explanation of two-dimensional design elements as they relate to visual communication and composition, including an extremely extensive chapter on type, which we saw as essential to include in any basics study for designers. Part II—Chapters 7 through 10—focuses on principles of design as they relate to composition. Part III—Chapters 11 through 14—addresses composition, illusion, and screen-based media. Part IV—Chapter 15—deals with the fundamental issues that every visual communication professional must face: message and communication.

The chapters are easily used in any order that is appropriate for the reader or best suits the educator. For some curricula structures, there is far too much in this book to be covered in one semester.

What we have done is allow for at least four scenarios:
- Some instructors will teach principles first, and those educators can easily reverse the order of Parts I and II.
- Instructors may pick and choose what to teach, whether it is by chapters or various exercises.
- This book can be used in a two-dimensional design course (print or screen-based), as well as in a beginning graphic design course.
- Students and designers can use this book as a resource for a very long period of time due to the abundance of information, great examples by venerated designers, and good number of exercises.

Each chapter provides substantial background information about how an element or principle is used, with references to prior information. Certain information is repeated in various chapters; the purpose for this is to ensure that the correct connections will be made among the elements and principles in design. Also included in the chapters are figures, diagrams, and sidebars with additional information to further explain the text, and appropriate exercises to aid in learning. Some chapters are much longer than others, due to the role they play in most curricula.

We have written *2D: Visual Basics for Designers* to serve as a guide for our own teaching, and hopefully other educators will find it helpful, as well.

Looking at the Illustrations

Anyone can learn an enormous amount by analyzing graphic design solutions. Whether you dissect the work of peers in a classroom, examine the examples of work in this text, closely observe an instructor's demonstrations, or analyze professional work, you will enhance your learning by asking *how* and *why* others did what they did. The examples provided in this text are just that—examples. There are innumerable solutions to any project. The examples are here to give students an idea of what is possible and what is in the ballpark; neither are they meant to be imitated, nor are they by any means the only "correct" solutions. Creativity in any visual communication discipline is not measured in terms of right and wrong, but rather by the degree of success demonstrated in problem solving, communicating, applying visual skills, and expressing appropriate personal interpretations.

Every illustration in this book was chosen with great thought to providing the best possible examples of effective and creative work. The work and information in this book represents the best of what is being produced today, as well as iconic and historical examples. Throughout this book are many captions written by well-respected visual communication professionals, intended to add different voices and greater wisdom to the reader's education.

Features

The following list provides some of the salient features of the text:

- Examples of work from the most esteemed designers and art directors in the world
- State-of-the-profession view on message and communication
- Clear explanation of the major two-dimensional design elements and principles
- Composition discussion throughout
- Historical examples
- Numerous bulleted lists and sidebars that enable student comprehension
- Cutting-edge chapter on type
- Diagrams that aid comprehension
- Two-dimensional design aimed at *designers*
- "A friendly read"
- Supplement package providing instructors with key tools

E.Resource

This guide on CD was developed to assist instructors in planning and implementing their instructional programs. It includes sample syllabi for using this book in either an 11-week or 15-week semester. It also provides chapter review questions and answers, additional projects, PowerPoint slides highlighting the main topics, and additional instructor resources.

ISBN: 1-4180-1161-4

About the Authors

Now in his own design studio, most recently **Steven Brower** was the creative director for *Print* magazine. He has been an art director for *The New York Times, The Nation* magazine, and Citadel Press. He is the recipient of numerous national and international awards, and his work is in the permanent collection of the Cooper-Hewitt National Design Museum, Smithsonian Institute. He is on the faculty of the School of Visual Arts, New York, and Marywood University's Masters with the Masters program in Scranton, Pennsylvania, and Kean University.

Steven Brower's published works include *Woody Guthrie Artworks,* published by Rizzoli, which he edited and designed as well as co-wrote with Nora Guthrie; *The Education of a Typographer* and *Design History,* both from Allworth, edited by Steven Heller; and *Art in Public Places* from City and Co.

Steven resides in New Jersey with his wife and daughter and their six cats.

Rose Gonnella is an educator, artist, designer, and writer. She is a professor in the Visual Communications program and chairperson of the Department of Design at Kean University. She teaches courses in materials and techniques for graphic design, identity and information design, and senior design portfolio, and she also directs the computer technologies component of the design curriculum. In addition, she is a board member of the Art Directors Club of New Jersey and the coordinator of the Thinking Creatively Design Conference *(www.adcnj.org/conference.html)* co-sponsored by the ADCNJ and Kean University.

A practicing artist and designer, Rose Gonnella has exhibited her drawings both nationally and internationally for fifteen years. Her drawings are included in the permanent collections of the Smithsonian National Museum of American Art, Washington, D.C.; The Museum of Art and Archaeology, Columbia, Missouri; and other public and private collections.

Rose Gonnella's published writings include a co-authored set with Robin Landa and Denise M. Anderson: *Creative Jolt* and its companion, *Creative Jolt Inspirations* (North Light Publications), and *Visual Workout: A Creativity Workbook* (Thomson Delmar Learning). Other books include: *Sea Captains' Houses and Rose-Covered Cottages: The Architectural Heritage of Nantucket Island* (Rizzoli), co-authored with Margaret Booker and Patricia Butler, and *summer nantucket drawings* (Waterborn).

Rose resides in Rockland County, New York, and Nantucket County, Massachusetts.

Robin Landa is the author of eleven published books about art and design, including *Graphic Design Solutions,* 3rd edition (Thomson Delmar Learning), *Advertising by Design* (John Wiley & Sons), *Designing Brand Experiences* (Thomson Delmar Learning), *Thinking Creatively* (North Light Books), and *Visual Workout Creativity Workbook* (Thomson Delmar Learning), co-authored with Rose Gonnella, and *Creative Jolt* and *Creative Jolt Inspirations* (North Light Books), co-authored with Rose Gonnella and Denise M. Anderson. Robin Landa's article on ethics in design "No Exit for Designers" was featured in *Print* magazine's European Design Annual / Cold Eye column. Her articles have been featured in *HOW* magazine and *Icograda.*

Landa has won many awards for writing and design. She holds the title of Distinguished Professor in the Department of Design at Kean University. She is included among the teachers that the Carnegie Foundation for the Advancement of Teaching calls the "great teachers of our time."

Landa has lectured across the country, including lectures at the *HOW* International Design Conferences, the keynote speaker at the Graphic Artists Guild conference in Philadelphia, and a participant on a panel about graphic design education at the College Art Association conference in New York City, among many others. In addition, Landa is a branding consultant and creativity strategist with her own firm, robinlanda.com.

Robin resides in New York City with her husband and their daughter.

Acknowledgments

Our humble thanks to all the designers, art directors, illustrators, photographers, creative directors, and writers for their generous good will in contributing work.

Great thanks to the following people at Delmar whose hard work and intelligence made this book happen: Jim Gish, senior acquisitions editor, and Jaimie Weiss, product manager, at the helm of this project, Larry Main, production manager, Tom Stover, senior content project manager, Nicole Stagg, art and design coordinator, Niamh Matthews, editorial assistant, Mardelle Kunz, copyeditor, and Laura Molmud, permissions editor.

We respectfully acknowledge these kind and talented people who have helped us: John Gall, Martin Holloway, Harold Bruder, Steven Hopf, Michele Kalthoff, Nick Law, Dawnmarie McDermid, Juan Montenegro, Jennifer Sencion, Janine Toro, Milton Glaser, Seymour Chwast and Alan Robbins.

Thank you one and all.

Thomson Delmar Learning and the authors would also like to thank the following reviewers for their valuable suggestions and expertise:

Robert Clements
Visual Communication Department
International Academy of Art & Design
Pittsburgh, Pennsylvania

Alice Drueding
Graphics Art and Design Department
Tyler School of Art / Temple University
Elkins Park, Pennsylvania

Brenda Innocenti
Communication Design Department
Kutztown University of Pennsylvania
Kutztown, Pennsylvania

Matthew Jackson
Art Department
Citrus College
Glendora, California

Howard Katz
Art & Humanities Department
Art Institute of Fort Lauderdale
Fort Lauderdale, Florida

Erik Miller
Computer Graphics and Visual
Communication Department
The Community College of Baltimore County
Baltimore, Maryland

Questions and Feedback

Thomson Delmar Learning and the authors welcome your questions and feedback. If you have suggestions that you think others would benefit from, please let us know and we will try to include them in the next edition.

To send us your questions and/or feedback, you can contact the publisher at:

Thomson Delmar Learning
Executive Woods
5 Maxwell Drive
Clifton Park, NY 12065
Attn: Media Arts and Design Team
800-998-7498

Or the authors at:
robin@robinlanda.com
rgonnell@kean.edu
studio@stevenbrowerdesign.com

Dedication

For my students.
—Robin Landa

To my life basics, of course: my mother, Josie, and my father, Joseph, with much appreciation for creating so many opportunities for learning.
—Rose Gonnella

For Mom and Dad.
—Steven Brower

Introduction

by Rose Gonnella

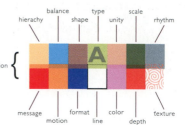

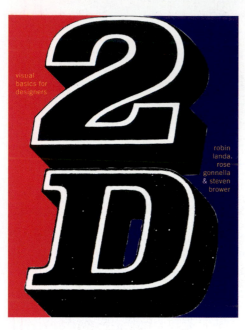

Figure I-1

Book cover: *2D: Visual Basics for Designers*

Studio: Steven Brower Design, New York, NY

Designer: Steven Brower

Client: Thomson Delmar Learning

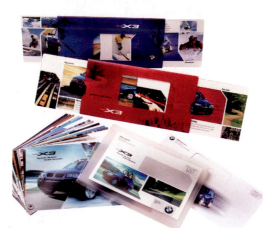

Figure I-2

Direct mail collateral: BMW X3 SAV

Studio: Ritta & Associates, Englewood, NJ

Creative director: Jonathan Hom

Designer: Cesar Rubin

Client: BMW, North America, LLC

The study of design basics brings with it the potential for a sophisticated understanding of the elements, including how to think about the organization of information on a complex format such as the one shown above.

What Are Design Basics?

Two-dimensional design at its most basic level is the conscious and thoughtful arrangement of graphic elements: lines, shapes, type, colors, textures, and patterns on a flat surface such as paper, cloth, and vinyl, or on TV, movie, and computer screens. Informed organization begins with an understanding of the principles of design: unity, balance, hierarchy, rhythm, and the manipulation of spatial illusions (Figures I-1 and I-2). The elements of a design are arranged for the purpose of visually communicating an idea and/or emotion, whether simple in statement or profound in its philosophical stance.

Why Study Design Basics?

Most students of college level who are embarking on a career in graphic design probably have previous experience creating images using traditional drawing and painting media; many may have tried the tools of image-making in Adobe Photoshop™ and Adobe Illustrator™ on their home computers or in the high school lab. Others may have purchased fonts and created posters for local events or party invitations. Some may also have "designed" their own web sites and screensavers or e-newsletters.

The desire to create and the production of creative work often precede the choice to study design in college. Therefore, a student may ask, why study the fundamentals when I have already been designing and creating? Or a student may say, I draw and design intuitively, why should I have to learn basic information that comes "naturally" to me? The answer is three-fold.

First, it could be supposed that creative intuition is primarily a manifestation of what has been previously, albeit unconsciously, absorbed by the mind. So, the intuitive person is not designing "naturally" as much as incorporating what was learned and felt, but not consciously realized as learning.

Second, conscious learning of the full scope of the discipline—starting with the gradual, step-by-step awareness and absorption of the basics—establishes a deep and more sophisticated understanding of design and a greater level of consistent control.

Third, studying design in a formal way, from the fundamentals to the most advanced stages (graduate school), also accelerates the learning process and carries the student into the realm of professional—beyond the hit-or-miss success of a hobbyist or purely intuitive designer (Figure I-3).

A comparison of the study of design basics can be made to the study of the rudiments of a sport—tennis, skiing, softball, or golf, for instance. A person may pick up a golf club for the first time and find that he or she can hit the ball and make it fly a hundred and fifty feet in a fairly straight path. The next ball at the tee is missed (the person "whiffed"), another is attempted and the player hits the ground rather than the ball (ouch—a "duff"), and the next ball is struck and flies a hundred feet. Striking the ball on two out of four swings is fair. If the new player continues to practice, it is likely that more balls will be struck—some straight to the cup, most into the bushes, but the game is played nonetheless. If the fledgling, but "naturally fair" new player learns the basics in a step-by-step procedure, his or her game will greatly improve because a conscious understanding will be developed of what makes a good swing and what makes the ball hook into the bushes. Awareness, then control, is gained and success accelerates. The comparison can extend beyond sports to other professions, such as law or accounting, and into the arts, such as sculpture or music. Think about it.

Figure I-3
Identity: Plastic Surgeon
Studio: Rizco Design, Manasquan, NJ
Designers: Keith Rizzi and Dawnmarie McDermid
Client: Physical Enhancement Center
Design is not a hit-or-miss proposition. Each and every design solution created must satisfy the client's marketing needs in a thoughtfully intelligent and originally creative way. Design is a significant factor in the success of a product in a competitive marketplace.

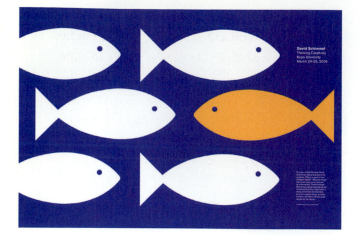

Figure I-4
Poster: Thinking Creatively Conference
Studio: And Partners, New York, NY
Art director/designer: David Schimmel
Client: Kean University
As visually stated in this poster design, to be a creative designer, you must "swim" in a unique way—at times against the pack. To be a good swimmer, you must first learn the basics well!

Design Work

"Why is it great to be a designer today?" David Schimmel, founder of And Partners, New York, asks and answers the question:

"Because design has never been more important or more valued. Fifteen years ago, it was feared that computer-aided design and desktop publishing would be the death of design in the creative sense. In fact, the opposite is happening. The Knowledge Economy is being replaced by the Creativity Economy. Right brain is rising. Fortune 500 manufacturers are sending executives to be trained in the creative process, now perceived as the wellspring of innovation and essential to competitive success. Companies need to reach out and touch their customer in new and very human, emotional ways, and design is a tool that helps them do that. Does that mean art has sold out to commerce? Not at all. It means art and the value of design are reaching more people, and that's a good thing."

Design implies action—planning, selecting, editing, sequencing (more editing), and composing to create a functional product, such as a newsletter, magazine, brochure, advertisement, web site, poster, or signage, just to list a few among the vast array of applications found in the broad public arena. Design is also a business and, as such, requires balancing the creative aspects with the practical issues—an obvious contradiction, but such is the life and challenge of being a designer (Figure I-4).

As a beginner, it is important to be keenly aware of the design fundamentals. Do not skip any part or piece of understanding and using the basics because neglecting any one element or principle will cause the whole composition to fragment—a design is a single body interdependent of its parts, which functions successfully only in unison. The elements, principles, and communication of a completed design are inseparable if the design is to be successful. However, this book does isolate, as much as possible, the individual elements and principles and approaches to design, in order to heighten awareness of each and fully explain the breadth and scope of the separate parts. When each part is understood and implemented fully, the composition can reach its full potential (Figure I-5).

EMPOWERING L
INKING MOTIV
ATION SYNERG
IZING KINDNES
S LEARNING GE
NEROSITY

ANNUAL REPORT
YEAR ENDING, JUNE 30, 2005

KEAN UNIVERSITY
FOUNDATION

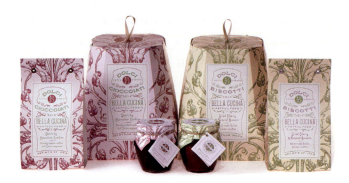

Figure I-6a
Packaging: Bella Cucina™ cookie series
Studio: Louise Fili Ltd, New York, NY
Designers: Louise Fili and Mary Jane Callister
Client: Bella Cucina

About Two-Dimensional Basics:
An Interview with LOUISE FILI, Louise Fili Ltd
by Steven Hopf, Kean University, Class of 2006

Q: Do you think about the individual basic elements
of design when you begin the composition process—
meaning how shape, line, and color will interact?

A: I would say that that is the basis of design, no?

Q: Do you design the 3D form of the packages—
say, for instance, Bella Cuchina biscotti (Figure I-6a)—
or is there an industrial designer involved? Do you
use standard templates, or are the packages your
original designs?

A: The biscotti box was based on a *panettone* box that the
client had liked. We use standard templates as well as
unique structures. The box company that we work with
is very good about constructing prototypes as needed.

Q: Which do you design first, the package or the label?
Or is it done as a whole?

A: It really needs to be addressed as a whole.

Q: It seems that many of your designs focus on line. Why
is this basic element of design something you return to
with frequency?

A: Probably because most of my clients have no illustration
budget, and I have to make the most of found engravings!

Q: Many of your books focus on Art Deco throughout many
countries. How have these movements influenced you
today? Why are you particularly drawn to Art Deco?

A: Typographically, it is the period that I find the most stylish,
exciting, and innovative.

Figure I-5
Annual report: Kean University Foundation
Studio: Cinquino + Co., West Patterson, NJ
Designer: Erin Smith
Client: Kean University Foundation
At the end of four years of studying design at Kean University,
Erin Smith had absorbed the vast variety of knowledge needed
to be a professional designer. This annual report design (her first
professional assignment) embodies all the knowledge she learned
regarding the basics—including a sophisticated selection of
elements and a refined understanding of the principles of design
on a single page and within a multiple-page format.

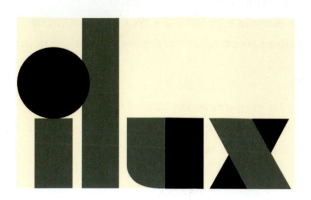

Figure I-6b
Logo: Ilux™
Studio: Louise Fili Ltd, New York, NY
Designer: Louise Fili
Client: Ilux

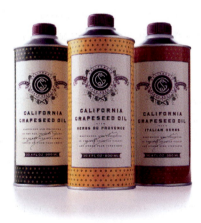

Figure I-6c
Packaging: Williams-Sonoma, grapeseed oils
Studio: Louise Fili Ltd, New York, NY
Designers: Louise Fili and Mary Jane Callister
Client: Williams-Sonoma

Q: I read an article on women graphic designers and it said: "Louise Fili literally changed the surface of mainstream publishing, rejecting the shiny finishes and garish foil-stamping packaging for mass-market books. Fili's designs for Pantheon used matte, laminated coatings to create mysteriously soft yet durable, highly plasticized surfaces." Through texture you "changed the surface of mainstream publishing,"—how did this come about? Was there resistance that you had to fight to convince otherwise? Where did your influence for this come from?

A: Since there were so many preexisting constraints in book publishing, I sought to implement changes by making the covers more tactile and intimate, like small-press or European editions. There was resistance at first, since this was "different," but I bargained with my production department in any way possible, for example, trading a fourth spot color for a textured paper stock, etc.

Q: Many of your logo designs on your web site enclosed the logo within a shape (Figures I-6b and I-6e). What is the reasoning here?

A: I believe that a logo should combine type and image as one unit, making it a stronger, more impactful design.

Q: How is your color choice determined when designing food packages (Figure I-6c)?

A: Very simply, the color needs to be appetizing. It is common knowledge in the food packaging world that blue is not a food color.

Q: I really like your use of pattern in your package design (Figure I-6d). Do you have any advice on using patterns?

A: Adapt them from historical sources—don't create them on the computer.

Q: Do you have any advice on the composition process for beginning design students?

A: Do sketches first. Ideas don't come from sitting in front of a computer.

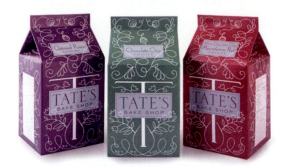

Figure I-6d
Packaging: Tate's Bake Shop™ cookies
Studio: Louise Fili Ltd, New York, NY
Designers: Louise Fili and Mary Jane Callister
Client: Tate's Bake Shop

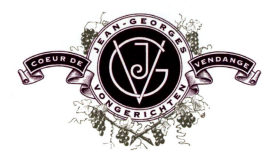

Figure I-6e
Logo: Jean-Georges Vongerichten
Studio: Louise Fili Ltd., New York, NY
Art director: Louise Fili
Designers: Louise Fili and Mary Jane Callister
Client: Jean-Georges Vongerichten

Solving the Design Exercises

The following general guide will familiarize you with the process of executing the design exercises in this book.

Step 1: Fully understand the assignment.

Create a list of clearly stated objectives. Ask as many questions as you need to be on track.

Step 2: Think by sketching.

For many designers, solutions happen when they are sketching. Creating original, interesting, and appropriate compositions is difficult. The process of sketching will allow you time to experiment for a creative and successful solution.

Thumbnail sketches are preliminary, small, quick, unrefined drawings of your ideas, in black and white or color. Create many. Thumbnail sketches allow you to think visually. The point of this phase is to generate as many different ideas as possible (Figure I-7). You can create thumbnail sketches by hand, usually with a fine-point marker on paper.

Step 3: Choose your best sketches and turn them into a finished composition.

The finished exercise should be clean, neat, and meet the objectives of the assignment—as would any full-scale, professional design. Get in the habit of making your presentations well crafted; an excellent presentation makes your work shine.

Critique Guidelines

A **critique** (or **crit**) is an assessment, an evaluation of your work. Assessing your solution forces you to evaluate how well you used the design medium, and to see if you fulfilled your objectives. Most design instructors hold a critique or critical analysis after students create solutions to a design exercise or project. Once you finish the design exercise, you can use these critique guidelines to make sure you are on the right path.

- Refer to your written objectives. Does your composition meet the objectives? (Be aware that sometimes it pays to let go of a composition that is not on target, even if you love it.)
- How well does your solution fulfill the stated objectives?
- Is your choice of color, paper, medium, size, and style right for the purpose or goal of the problem?
- Is your solution appropriately presented?

Assessing Your Process

- How many thumbnail sketches and roughs did you do before creating the composition?
- How much time did you spend thinking about the problem?
- Did you make any assumptions about what you could or could not do? Experimentation is very important; it can lead to exciting discoveries. Even mistakes can yield interesting results.
- Did you really become involved with the design process? Not everyone finds the same subject matter or exercise exciting. Remember, it is not whether the subject or the project is exciting or dull—it is how you solve it.
- Were you patient with the project and with yourself? Try to be as supportive of your own work as you would be of a friend's work.
- Where you creative in your approach? Did you take chances? Were your solutions fresh or pedestrian? When a critique is held in class, one way to test whether your solution is original is to notice how many others came up with similar solutions.
- Did you make good use of materials? Is your composition well crafted?

Note: Make a list of the formal elements and principles of design to ensure that each one has been tackled.

This critique guide is placed in the introduction so you can use it for all the exercises in this book. It will make a great deal more sense once you actually apply it to your compositions.

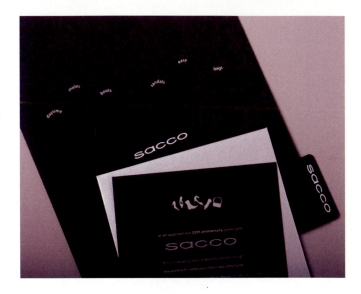

Figure I-7
Sacco Shoes Press Kit and 25th Anniversary Invitation
Studio: Rizco Design, Manasquan, NJ
Designers: Keith Rizzi and Dawnmarie McDermid
Client: Sacco Shoes
Many thumbnail sketches led to the design of this press kit and inviation to determine the most appropriate arrangement of shape, type, and color.

Elements of Composition

Format

Chapter 1:

Format

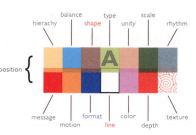

composition {

hierarchy balance shape type unity scale rhythm

A

message motion format line color depth texture

Objectives

- Define format
- Understand the role of the format in designing
- Realize format's size and shape constraints
- Comprehend design elements and format interaction
- Appreciate each type of format and its shape functions
- Recognize format as a creative consideration in any design
- Consider the impact of the quantity of images and text on a format
- Learn to include the format as a constituent voice in any two-dimensional design

8.5

Format Defined

All designs have to exist somewhere—on a physical surface, such as a piece of paper, or on a screen. That defined perimeter and the area it encloses, where a designer begins composing a design with his or her first mark, is what we refer to as the **format.** Whether the graphic design application is a printed page or viewed on a screen, the format is the outer perimeter that acts to frame and hold the design solution. There are many types of formats and, of course, there are variations within each format. For example, a standard variety of brochure formats can be found in various sizes and shapes, and each may open or unfold differently. Often a format is predetermined (by the client or budget constraints), and the designer needs to work within those constraints.

Shape and Sizes of Formats

Formats can be any number of shapes: square, rectangular, quadrilateral, and round. There are standard shapes and sizes of some formats for both print and screen-based media. CD covers, for example, are all the same size square. Paper utilized for posters is usually milled in standard sizes; however, you can

obtain a poster in almost any size, too. For most print graphic design applications (applications printed on paper as opposed to screen-based), any size format is available to the designer at varying costs. Shape, paper, size, and special printing techniques can greatly affect cost. (Paper is roughly half the cost of any printing job.) Shape and size are determined by the requirements of the project: function, media, appropriateness for the solution, and cost. It is advisable to use standard sizes and utilize a standards guide.

Context

Formats are seen in context. The distance from the graphic design application—from the object that is seen—is a consideration in working with a format. Some formats, such as outdoor boards, posters, and unconventional advertising murals or projections on a wall, are viewed from a distance. Others, such as CD cases, web banners, and magazine advertisements, are seen up close. There may also be other contextual issues concerned with where and how a design will be seen; for example, outdoor boards are seen while driving by, and posters are viewed while walking by. Knowing the **context**—*where* and *how* a format will be seen or used—is an important consideration.

Where

Often graphic designers and art directors will deal with a range of formats, from those that are huge—such as environmental digital displays and outdoor boards—all the way to much, much smaller applications—such as business cards and mobile phone or PDA digital screens. Large formats can have a grand effect, and small sizes beg intimacy.

How

In context—how the viewer takes in the piece at a glance *or* over a period of time—the size of the perimeter of the format is related to distance. When looking at a huge sign or outdoor board, we have to experience the entire work by standing at a distance from it or by passing in front of it. When a format is smaller—such as a book jacket—the viewer, in most cases, can see the entire design at once. Also, some for-

mats may be seen in multiple contexts. For example, a book jacket may be seen in a bookstore environment or online. A web site visitor can view a site using a mobile phone, a TV, a very old monitor, a new monitor, or a state-of-the-art twenty-eight-inch LCD screen. There are many factors that affect how visitors experience or view a web site.

Single Formats vs. Multiple Formats

Posters, magazine advertisements, outdoor boards, (most) business cards, letterheads, book covers and jackets, and CD and DVD disc covers are single formats. A designer composes a design on one *single page*. Often, a designer must work with a design application that has multiple pages. Books, magazines, web sites, and newspapers can have hundreds of pages. Booklets, annual reports, a variety of corporate communications, newsletters, brochures, and various promotional pieces can also have many pages, as well as different folds and bindings (Diagram 1-1).

4-PAGE **6-PAGE ACCORDIAN** **8-PAGE MAP FOLD** **16-PAGE BROADSIDE**

Diagram 1-1
Folding Styles

Folding Styles
- 4-page one fold
- 4-page French fold
- 5-page accordion
- 6-page two fold
- 6-page roll fold
- 6-page accordion
- 8-page saddle stitch

Binding Styles
- Case bound or sewn
- Perfect binding
- Saddle-wire stitched

A web site, which most often is a multiple-page format, is seen by scrolling or clicking through to another page. Many web sites operate as vertical scrolls. Yet, at any given moment, a web site can be a still image—and look like one still rectangle—viewed on a computer screen. Some multiple-page formats are seen as the viewer turns the pages or unfolds them, as in annual reports (Figure 1-1). Any brochure that unfolds must be addressed as a continuous field, keeping in mind the flow across the brochure format.

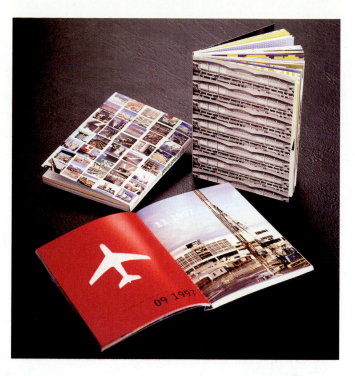

Figure 1-1

Annual report: San Francisco International Airport 2000

Design firm: Morla Design, Inc., San Francisco, CA

Art director: Jennifer Morla

Designers: Jennifer Morla and Hizam Haron

Photographers: Richard Barnes, Fred Cramer, Thomas Heinser, and Daniel Stachurski

Copywriter: SFIA

Client: San Francisco International Airport Commission

© 2005 Morla Design, Inc.

"The San Francisco International Airport 2000 Annual Report commemorates the opening of the new international terminal. Morla Design documented a visual history of airport construction milestones over the past eight years. The "pocketbook" size format (5 x 6 inches) is a compendium of site photos, art installations, icons, and graphs that highlight the building process and completion."—Morla Design, Inc.

Working within a Format

All elements, their direction, and placement interact with the particular shape of any given format. As mentioned earlier, a format can be any number of shapes: square, rectangular, quadrilateral, and round (Diagram 1-2). When you draw lines on a given format, they can run parallel to the edges of the format or move in an opposing direction. For example, if you draw a horizontal line on a rectangular screen-based page, it will be parallel to the horizontal edges of the screen. However, if you were to draw a diagonal line on the same screen, the line would move in opposition to the edges. In the poster shown in Figure 1-2, the radiating diagonal lines create visual tension within the rectangular format.

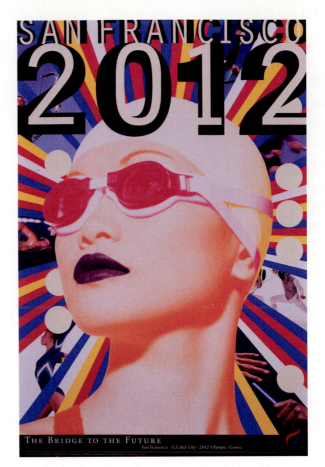

Figure 1-2

Poster: San Francisco 2012, U.S. Olympic Bid City Poster (Olympic Games Poster)

Design studio: Morla Design, Inc., San Francisco, CA

Art director: Jennifer Morla

Designers: Jennifer Morla and Hizam Haron

Photograpy: Jock McDonald (portrait) and Photodisc (Royalty Free)

Client: BASOC (Bay Area Sports Organizing Committee)

© 2005 Morla Design, Inc.

"Bay Area Sports Organizing Committee chose Morla Design to create a poster to publicize San Francisco as the U.S. bid city for the summer 2012 Olympic games. We created a contemporary version of the classic portrait poster, one that incorporated the optimism of the Olympics with a bold, iconic portrait of an Asian American swimmer. The radiating lines, bright color palette, and posterized dot screens are a modern take on San Francisco music posters from the 1960s. Photographs of summer Olympic events—gymnastics, archery, rowing, fencing, and track and field—peek thorough the background pattern and communicate the vitality of the events and the diversity of the Bay Area."—Morla Design, Inc.

Parallel vs. Opposition

When a line or mark parallels the given directions of a format's edges, the resulting composition feels and looks different to the viewer from when lines or marks juxtapose or run counter to the edges of a format. For example, within a standard size rectangle,

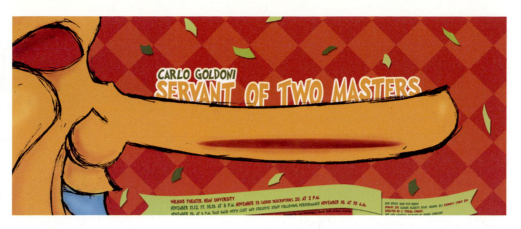

such as an 8 ½ x 11-inch page, horizontal and vertical lines might appear static, and diagonal and curving lines might appear more active, due to the way they oppose the format's borders. That visual opposition may result in a different visual effect, affecting the viewer in a different fashion. (Of course, everything is relative; however, this generalization is made to raise sensitivity to how elements react to the format.) For example, in Figure 1-3—a theater poster that is a horizontally extended format—the nose and green banner echo the long horizontal format to create graphic impact.

You must consider every judgment involved with distance, placement, length, and weight very carefully. Be aware of how any element reacts to a given format—do not view the format as a passive element. Always include the format as a constituent voice in any two-dimensional design.

Self-Contained Compositions

Not only do graphic designers have to work with a printed or screen-based page as a format—the defined perimeter—they also design logos, symbols, or pictograms, which must work within self-contained compositions. In Figure 1-4, the logo for Trio is a self-contained composition. In **self-contained compositions,** the format is the outer limits of the application, not the outer edges of a page or screen.

Figure 1-3

Theater poster: *Servant of Two Masters*

Playwright: Carlo Goldini

Studio: The Design Studio at Kean University, Union, NJ

Art director: Steven Brower

Designer: Juan Montenegro

Client: Theater department, Kean University of New Jersey

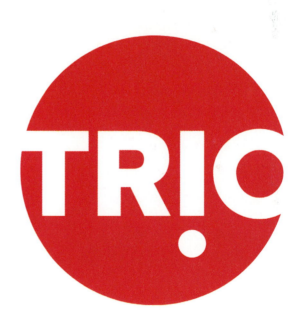

Figure 1-4

Logo: Trio Television Network

Design firm: Number 17

Art directors: Emily Oberman and Bonnie Siegler

Client: Trio

"This is a spotlight with the 'i' turned into an exclamation point for this pop culture TV channel."— Number 17

Let's examine how linear movements might respond to differently shaped formats. All lines are responsive to the original shape of a format.

Standard Rectangles and Squares

In relation to the edges of a standard size rectangle or square:

- Vertical and horizontal movements tend to appear static
- Diagonal movements tend to appear active (more forceful)
- Curving movements tend to appear more active

Vertical Extension (prolonged rectangle in a vertical direction)

In relation to the edges of a prolonged vertical (portrait) rectangle:

- Horizontal movements tend to appear static
- Vertical movements tend to appear energetic (more pronounced)
- Diagonal and curving movements tend to appear active

Horizontal Extension (prolonged rectangle in a horizontal direction)

In relation to the edges of a prolonged horizontal rectangle:

- Vertical movements tend to appear static
- Horizontal movements tend to appear more powerful
- Diagonal and curving movements tend to appear aggressive

Round (circular format, also called a **tondo** in fine art)

In relation to the edges of a round format:

- Vertical movements tend to appear more powerful
- Horizontal movements tend to appear more powerful
- Diagonal movements tend to appear more powerful
- Curving movements tend to appear static

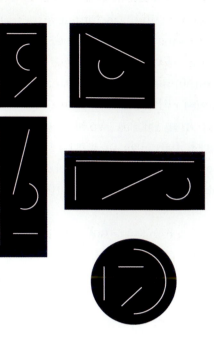

Sidebar Diagram 1-2
Rectangles, Square, and Circle

Although a logo can be constructed in other ways, a logo can be composed within one of the following frequently used format shapes: circle, ellipse, square, diamond, triangle, rectangle, or free-form shape (Diagram 1-3).

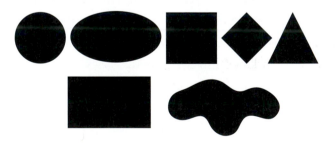

Diagram 1-3
Format Shapes

Boundary of Vision: Closed vs. Open

When composing, the format also acts as a boundary. The format is the boundary of the objects, shapes, and forms that the viewer sees within the composition and, thus, it becomes the boundary of vision. In *Principles of Art History,* Heinrich Wölfflin, German art historian, defines two basic categories of how the format is utilized as a boundary of vision: closed and open form. This distinction is not qualitative, but allows us to describe compositional structures.

This distinction—closed vs. open—explains very well how a designer can use the format to aid in communicating a message. It also can be used to affect the viewer in different ways, to offer different visual experiences. A deliberate use of the format's edges aids expression and communication. Ignoring the edges of the format does not make for an open composition, it makes for a poor composition. Choosing the compositional structure should be done with intent and attention to its expressive potential.

Closed Compositions

In closed compositions, the space on the page or screen would seem closed off by something at the edge of the format, as in the famous CBS logo, where the composition of the logo is closed (Figure 1-5), or in the poster design in Figure 1-6. In a **closed composition,** the limits of a composition are defined by the objects or marks within the format.

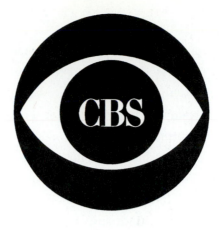

Figure 1-5
Logo: CBS®
The CBS and CBS Eye Design are registered trademarks of CBS Broadcasting Inc.
The CBS eye—an eye enclosed in a circular format—
has been an enduring mark for CBS for over a half-century.

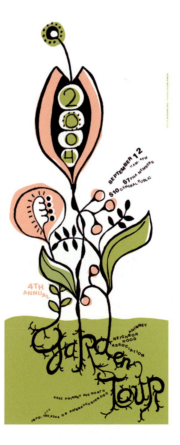

Figure 1-6
Poster
Design firm: Modern Dog Design Co., Seattle, WA
Client: Garden Tour
Both the typography and the image stay within the format; the solid green at the bottom of the poster reinforces the edges of the format.

Open Compositions

In **open compositions**, the compositional space appears or "seems" to stretch on beyond the limits of the format. Note how the space in the home page by R/GA for Aveda, seen in Figure 1-7 (top), seems to extend beyond the format's boundaries. Compare the home page to a product page in Figure 1-7 (bottom), and you can see how the vertical divisions within the long white horizontal area act to create a more closed composition. Compare both pages, and you will see a very different intentional use of boundaries.

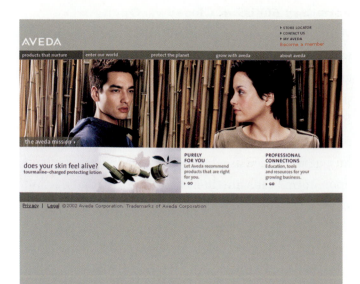

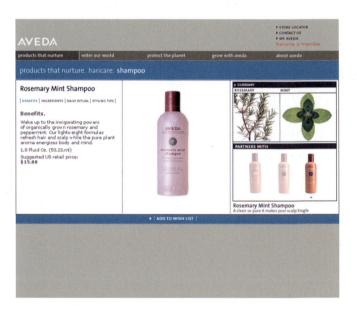

Figure 1-7

Web site design: home page (top) and product page (bottom)

Design firm: R/GA, New York, NY

Designers: Daniel Chen, Davie Eng, Nina Schlechtriem, and Winston Thomas

Interaction design: Chloe Gottlieb, Lori Moffet, Pat Stern, and Scott Weiland

Production: Afua Brown and Kip Voytek

Programming: Ed Bocchino, Jason Scherer, and Larry Edmondson

Client: Aveda

On the home page, the stress on elongated horizontal movements creates an open composition that gives the page a spacious, clean look and feel. Conversely, in order to best present the product, the composition for that page is closed.

Form and Function

Throughout the history of fine art, particular format shapes have prevailed in helping to express certain subjects or notions, often serving specific purposes. **Horizontal extensions,** including horizontally unfolding scrolls, have a commonly accepted use for the expression of time and conveying continuous movement with such subjects as parades, funerals, and battles, and folk tales, religious, or secular narratives, as well as in nonrepresentational works. **Vertical extensions** have been used to express movement up and down, for such subjects as ascensions, and views of heaven, earth, and hell. They have been also used to express divisions of landscape, such as sky, land, and water, as well as also in nonrepresentational works. These conventions are often employed in graphic design, as well.

Creative Considerations

Graphic design borrows from the fine art tradition of using specific shaped formats for expressive purposes. For a poster promoting a cross-country ski competition, for example, perhaps an extended horizontal format would allow the designer to create the illusion of movement across a field. Or a logo designed within a circle for a children's hospital might be well-suited in conveying the idea of caring for and embracing children. It's essential to remember that the format—like any other design element—can be an expressive element to aid communication and influence the emotional significance of a design. For the Garden Tour, the poster seen in Figure 1-8 uses a vertically extended format to express growth.

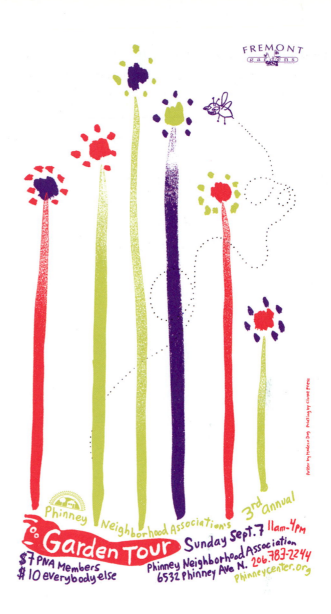

Figure 1-8

Poster

Design firm: Modern Dog Design Co., Seattle, WA

Client: Garden Tour

The vertical length of the flowers echoes the edges of the vertically extended format, communicating growth.

As mentioned earlier, the shape and size of a format (form) is often dictated by a variety of design objectives and constraints (function). However, when the form is at the discretion of the designer, then the choice should be based on functional objectives, as well as creative objectives. Designing within a particular shape format can aid in expression and communicating the spirit of the design piece, and ultimately have impact on the viewer. What is the design concept? Who is the audience? How will the audience relate to the format size and shape? The design concept, and to whom it is directed, should drive the format's size and shape.

If the design application is a poster, for example, then the format's size and shape can help to communicate the idea and information, as well as create impact. If the design application is a logo, then utilizing a self-contained format shape, such as a circle or square, will enhance or detract from the communication.

Practical Considerations

Since graphic design solves problems, there are always creative considerations *and* practical considerations. Since the format is the surface on which you build your design, you have to consider the practical quantity of images and text that will be utilized. Adjusting sizes and shapes is common to composing within any format. Along with "fitting" the text and images into the given format size and shape, the designer thoughtfully arranges the composition to enrich the viewer's experience and enable the viewer to glean information.

Predetermined Specifications

Very often, a designer works with constraints and hasn't much choice since the format is predetermined. Whether the format is a baseball cap or a single-page magazine advertisement, the specifications—shape and size—are already set. The jewel cases for DVDs and CDs are square; their packaging can be rectangular or square. The individual DVDs and CDs are always round; therefore, a designer has no choice but to design on a circular format. Consequently,

whether a designer is creating a design for a hip-hop recording artist or for income tax software, the round format must be utilized to communicate with the target audience.

There are times when a client sets constraints on type and images. For example, in a magazine article, a set number of words must be included, usually determined by the editor. Other times, the amount of information and images are choices made by the designer or creative team. Either way, the designer must compose the required text and images.

Each type of format—and its shape—has different possible functions, with advantages and limitations that must be considered when designing. Single pages and multiple-page formats (print or screen-based) all present different considerations. For example, a single-page print format could be an exaggerated, horizontal rectangle or a small square—its size and shape determined by the amount of information to be displayed and the message to be communicated (as discussed previously regarding the meaning of the shape of the format). Multiple-page formats, whether eight pages or hundreds of pages (as might be found in a web site), must be organized so that the viewer can easily navigate through the information presented. The shape of the multiple-page design should also be determined by its function and message. An intentionally playful web site, for example, may have multiple windows (subpages) spontaneously popping up as the viewer clicks through the main pages. Conversely, a serious corporate web site might be a strict and unchanging, vertically-oriented format with all information contained in limited and fixed rectangular shapes that would fit all size monitors.

Screen-Based (Web) Formats

Screen-based formats make the requirements of designing exponentially more challenging. When the format is a web site, the approach to design is different from that used for a print format. (Though, it should be noted that somewhat of an interactive or

motion experience can be simulated on paper, such as a flip book or pull-the-flap solution.) Most of us experience any web site screen by screen, as we scroll or click through. In a web site design, the boundaries may not be fixed; therefore, the viewer may not be able to see the entire composition, or the composition could be readjusting itself as the viewer clicks through. However, that is only part of the nature of nonlinear or interactive design. It is fascinating to consider how nonlinear formats—as opposed to linear formats—might reflect the human condition, the way we think, chaos, and many other vital issues. The complexities of designing for nonlinear formats should be studied in depth on its own. At this point, web site design will be studied on a basic level.

Web formats are measured in pixels. Most standard screen size formats are listed in the sidebar below; these specifications will be modified from time to time to keep pace with advancing technology and regulations. Also, in the United States, there are federal regulations concerning "Electronic and Information Technology Accessibility Standards (Section 508)" to accommodate people with disabilities:

"In 1998, Congress amended the Rehabilitation Act to require Federal agencies to make their electronic and information technology accessible to people with disabilities. Inaccessible technology interferes with an individual's ability to obtain and use information quickly and easily. Section 508 was enacted to eliminate barriers in information technology, to make available new opportunities for people with disabilities, and to encourage development of technologies that will help achieve these goals."—*www.section508.gov*

Standard Screen Resolutions in Pixels

- 640 × 480
- 800 × 600
- 1024 × 768
- 1280 × 1024

Paper Sizes

The cost of paper is a critical factor in determining format size—and in deciding what size paper to use (Diagram 1-4). A print run (the number of copies you intend to print) of good-quality paper can be very expensive. Often an application will require fitting several pages on a larger sheet of paper when printed. For example, a four-page, 5 x 7-inch booklet would be printed on a 32 x 44-inch sheet of paper. The number of booklets that can be printed on the sheet is eighteen, which would then be cut and folded. If you move up to a 5 1/2 x 7 1/2-inch size with the same number of pages, you must print on a 35 x 45-inch sheet, with sixteen as the number to be cut from this sheet.

Always consider the following factors when determining the size of the format:
- Waste
- Custom vs. standard size paper (possible surcharge for custom sizes)
- Web press vs. sheet-fed press use
- Multiple pages on a single sheet when printing

United States Paper Sizes		European Paper Sizes	
Executive	7.5 x 10	A8	2.07 x 2.91
Letter	8.5 x 11	A7	2.91 x 4.13
Legal	8.5 x 14	A6	4.13 x 5.83
Ledger	11 x 17	A5	5.83 x 8.27
Super A3	13 x 19	A4	8.27 x 11.69
C	17 x 22	A3	11.69 x 16.54
D	22 x 34	A2	16.54 x 23.39
E	34 x 44	A1	23.39 x 33.11
F	28 x 40	A0	33.11 x 46.81
G	11 x (22-90)	2A	46.81 x 66.22
H	28 x (44-143)		
J	34 x (55-176)		
K	40 x (55-143)		

Diagram 1-4

Standard Paper Sizes

Mailing Costs

The cost of mailing graphic design applications is an important consideration when selecting and designing a format. A client should have a determined mailing cost budget, and that information is necessary for the designer. Postage rates, in various countries, are based on trim size and weight. Some factors that contribute to weight are number of pages, quality/weight of paper, size of format, binding, and inserts. Paper is milled and available in standard weights: 70, 80, and 100-pound book weights and 65, 80, and 100-pound cover weights. Because the mailing cost is such an important consideration, it is sometimes necessary to weigh priorities; that is, how the quality of paper will take ink against the weight/thickness for mailing costs.

Basic design elements of line, color, shape, and texture activate the surface and can conjure up the illusion of three-dimensional space—whatever the designer's intent, design always starts with the format.

Summary

The defined perimeter and the area it encloses, where a designer begins composing a design with his or her first mark, is what we refer to as the format. Whether the graphic design application is a printed page or screen-based, your substrate is the format. There are many types of formats and, of course, there are variations within each format.

Since the format is the surface where you place elements to compose a design, it is easy to understand that the other design elements—line, shape, form, color, and texture—interact with the format. As soon as you make one mark on a page or screen, that mark reacts to the format's borders and begins to build a composition. Sometimes a format is predetermined and the designer has to work with constraints. Formats can be a single page or multiple pages, either print or screen-based.

All elements, their direction, and placement interact with the particular shape of any given format. Be aware of how any element reacts to a given format—do not view the format as a passive element. Always include the format as a constituent voice in any two-dimensional design. When composing, remember that the format also acts as a boundary.

Very often, a designer works with constraints and has practical considerations. A format can be predetermined by the assignment. Each type of format—and its shape—has different possible functions, with advantages and limitations that must be considered when designing. Since the format is the surface on which you build your design, you must consider the quantity of images and text that will be utilized. The cost of paper is a critical factor in determining format size, and the cost of mailing graphic design applications is an important consideration when designing.

EXERCISES

Warm-up

Novices tend to want to create configurations rather than allowing marks to relate to the format's edges, internal space, and to each other.
1. Rule ten evenly spaced lines.
2. Place a total of ten dots on the ten lines.
Goal: try not to line up the dots or create any kind of configuration.
This frustrating exercise demonstrates just how vital the format is when we make a mark on a page or screen.

Exercise 1-1: Leave the middle alone

When composing a design, novices often get "stuck in the middle," continually focusing on the center of the page. The edges of the page are often neglected or not considered at all.

Good compositions don't need to always focus on the center. Great designs engage the whole format, including the edges.

1. Create a composition where graphic elements, including type, touch all four sides of the page.
2. Leave the center area open.

With this exercise, you gain awareness of the power of edges.

Exercise 1-2: Unpredictable divisions

Some people build compositions starting from the top of the page, then progressively continue along to its bottom. Designers have different approaches to building a composition.

Stretch beyond the normal approach to composition.
1. Divide the page in half.
2. Make both independent sides work together as a unit.
3. Your aim is to search for the unusual. Be bold.
4. The composition must be unified and balanced.

This exercise pushes you to challenge your method of composing (or using the format) with unusual and unpredictable ways to divide the page.

Exercise 1-3: Logo formats

A logo can be composed within a closed format. Sometimes, a designer chooses to work within a circular format, square format, or some design within an oblique or polygonal format.
1. Choose a nonprofit organization.
2. Decide upon an appropriate visual symbol (representational, abstract, or nonrepresentational) for the organization.
3. Compose the same visual symbol within three differently shaped logo formats.
4. Evaluate how the visual symbol relates to each different format shape.

This exercise builds awareness of designing logos within closed formats.

Exercise 1-4: About time and space

Design starts with a rectangular paper or screen-based page. Its orientation immediately communicates a sensation. A vertical orientation has a strong feeling of movement from top to bottom, or bottom to top. It may give a sense of falling through or down to the viewer. A horizontal orientation may look like a landscape—a division of sky and earth. Extend the format into an elongated horizontal and you will have a dynamic left to right movement that could suggest the passage of time or a heroic panorama. With this knowledge, you can employ horizontal and vertical extensions for specific expressive effects.
1. Place small, simple shapes and lines in two different formats: an elongated horizontal format and an elongated vertical format.
2. Compose to emphasize (complement) the expressiveness of the format itself.

This project could easily be accomplished using cut paper or digitally within a simple drawing program. The point of this exercise is to become aware of the inherent properties of the shape of the page itself.

Exercise 1-5: Extended vertical

How do you go about organizing elements? Do you purposely position certain tones at certain points of a format? Does a format carry more visual weight at the top or bottom? Should all the shapes in a composition be clustered, spread out, or overlapped? Planning a composition involves decision making—critical thinking—as well as trusting your eyes as the final judge.

On a vertically extended rectangle (12 x 6 inches), arrange the following variety of shapes and tones to create the greatest possible sense of rising from bottom to top:

• One light gray rectangle, 10 x 1 inches
• One black rectangle, 6 x 1 inches
• One dark gray rectangle, 4 x $\frac{1}{4}$ inches
• One dark gray rectangle, 3 x $\frac{1}{2}$ inches
• One dark gray rectangle, 2 x $\frac{1}{2}$ inches
• One middle value gray rectangle, 3 x $\frac{1}{4}$ inches
• One middle value gray rectangle, 2 x $\frac{1}{4}$ inches
• One middle value gray two-inch circle
• One dark gray two-inch circle
• One light gray four-inch circle
• Four shapes of your choosing, not to exceed two inches in any direction

Note: Your goal is to move the viewer's eyes from the bottom of the format to the top. Think of all the various shapes and tones as pointers and directors to the top and to each other. They must relate to each other and work together effortlesly, as if they were in a play together. Each element is part of the greater composition. Did you find that if you moved one piece, you had to rethink or readjust the entire composition?

Exercise 1-6: Resource book
Create and keep a resource book of sample formats, bindings, and folding styles.

Chapter 2:

Line

Chapter 2:
Line

composition {
hierachy · balance · **shape** · type · unity · **scale** · rhythm
message · motion · **format** · **line** · color · depth · **texture**

Objectives

- Understand the categories of line and their functions
- Learn about the physical characteristics of line
- Become sensitive to line movement and direction
- Appreciate line as a visual organizer of information
- Become aware of employing line for drawing and design applications

Begin with a Dot

After becoming aware that the format is the first element of design, you can comfortably begin to activate its surface with dots, marks, fully realized lines, shapes, and colors, as seen in Figure 2-1.

A **dot** is the smallest unit of a line and one that is usually recognized as being circular. In a screen-based image or design, a dot is a visible, single **pixel** of light (with or without hue) that is square rather than circular, as seen in Diagram 2-1. In the digital realm of paint software, all elements are comprised of pixels. The pixels have a distinct visual character that give this type of computer-generated image "jagged" or "pixelated" edges.

 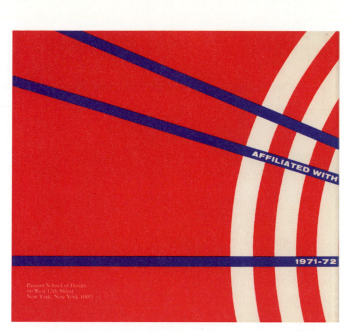

Figure 2-1
Catalog covers (front and back):
Parsons School of Design, 1971–1972
Designer: Cipe Pineles (1923–1991)
The Anna-Maria and Stephen Kellen Archives Center for the
Parsons School of Design.
Bold concentric lines and thin, sharply pointed lines are composed in simple but striking contrast to create a dynamic and
compelling design for this Parsons School catalog cover.

Cipe Pineles (pronounced SEE pee, pi NELL iss) was among
the first women designers in the United States to receive
national recognition for her work. She was respected in her
time and an important contributor to the historic record in the
field of graphic design. Pineles was the first woman to be asked
to join the all-male New York Art Directors Club and later the
ADCNY Hall of Fame.

Diagram 2-1
A dot and lines created with the point of a pencil.
A pixel (enlarged from actual size) and lines generated by
Adobe Photoshop software.

In the *Fiber* magazine pages (Figure 2-2), the pixels are exaggerated and "celebrated" in the illustrations and the composition. Such large pixels are not actual size, but purposely enlarged in a simulation—to emphasize the contemporary, screen-based context of the imagery.

In printing processes, **continuous-tone** photographs and illustrations—images that contain smooth modulations (tones) of color—are comprised of varying densities of thousands of dots of ink, as seen in Diagram 2-2. Non-tonal graphics are created by printing solid areas of ink. Printers usually refer to all non-tonal graphics as **line art.** Continuous-tone and line art are terms that distinguish the two types of images in regard to commercial printing processes, but not in regard to the element of line in design.

Figure 2-2

Magazine pages: *Fiber* Issue 2 – Pixel Power

Studio: Context Creative, Toronto, Canada

Creative director: Lionel Gadoury

Designer: Vanja Rais

Writer: Andy Strote

Illustrator: Eboy

Client: Fiber Partners

© *Fiber* 2004

"*Fiber* brings together photographers, illustrators, and typesetters from around the world to celebrate creativity and the printed page," states Lionel Gadoury, the *Fiber* magazine creative director. "Each issue features the work of one chosen artist. *Fiber* is a joint production conceived, designed, and written by Context Creative."

Diagram 2-2

Enlargement of the dots used in printing a continuous-tone image.

Photo by: Michele Kalthoff

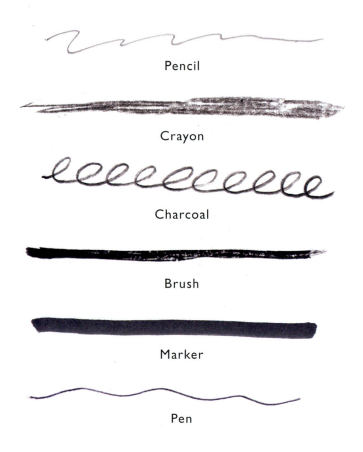

Pencil

Crayon

Charcoal

Brush

Marker

Pen

Diagram 2-3

Lines created with a variety of media and tools.

The Element of Line

Line art is a term used by the printing industry to describe a production technique, but a line is an element of design. A **line** is an elongated dot or defined area created on a substrate with a visualizing tool such as a pencil, marker, pen, computer graphics software, charcoal, pastel, a brush and paint, or perhaps even a twig or a fork dipped in ink (Diagram 2-3). The tool that creates a line can be flexible or rigid, flat, round, or pointed. Line is included among the elements of design because it has many roles to play in composition and communication. Although line may at first appear simplistic, with a better understanding of its full scope, the complexity of the element of line is soon revealed.

For instance, lines can have a rigid structure or be freely wielded. You are reading lines of type. Potentially, lines can carry a great variety of meaning. Lines can feel angry or elegantly lyrical. Lines can communicate on many levels, as seen in the logo designs in Figures 2-3 and 2-4.

Recognizing Marks and Line

A **mark** is a truncated, free-form fragment of a line (Diagram 2-4). When does a mark become a line? A line is primarily recognized by length rather than width, being that it is *essentially longer than wide (or thick).*

When does a line become something other than itself? The transition from mark to line to shape (a discussion of shape follows in the next chapter) is relative to the perception of the viewer and all elements employed in the design, particularly the size of the format and the scale of line within it.

Figure 2-3

Logo: Anacomp

Studio: Mires Design for Brands, San Diego, CA

Client: Anacomp

Designers rely on the element of line for creating letters and establishing a mood, feeling, and/or idea, as seen in the sturdy diagonal strokes and elegant curving cross-bar of the letter "A" —a logo for the Anacomp corporation. The horizontal, elongated figure-eight of the traditional mathematical symbol for "infinity" was cleverly incorporated into the design as the cross-bar. Infinity is also represented in the circle format (without beginning or end) surrounding the letter. As stated by the designers: "If you are archiving information, you want serious assurance that it's going to last forever. Hence, a timeless mark."

Figure 2-4

Logo: Specchio[SM]

Studio: Louise Fili Ltd., New York, NY

Art director and designer: Louise Fili

Client: The Borgata

Lines are not only mechanically smooth and straight, lines can be rough or textured in other ways. The quality of the line is created for expressive purposes. The curly lines of Fili's logo design may be evocative of a garden trellis, a European garden gate, or a fanciful wire sculpture. Using the curly line to create the letters projects a sense of delight and a bit of whimsy for Specchio, a small regional-style Italian restaurant located in the grand Borgata Hotel in Atlantic City, New Jersey.

Diagram 2-4
Marks created with a variety of media and tools.

Measuring Line Height and Length

In page composition software such as QuarkXPress™ or Adobe InDesign™, line width or thickness is stated in point sizes such as .05, hairline, .75, and 2-pt. (Diagram 2-5). The term **point size** in this case refers to the measurement system established in the twentieth century to define the vertical size, or *height,* of letters and line.

Line *length* can be defined in inches, centimeters, or picas (a type measurement system used for defining lengths).

Borrowing a definition from geometry and mathematics, line can be defined as a graphic path connecting two **points** (referring to a position on a format only, without color). In math, a line is without width; however, in graphic design, as stated previously, line has measurable widths or thickness.

.50 point

———————————————

1 point

———————————————

2 points

———————————————

2.5 points

———————————————

4 points

———————————————

Diagram 2-5
Five lines with their thickness measured in fractions of points and whole points.

The Adobe Illustrator drawing software clearly exhibits the way a line is created by connecting points (Diagram 2-6). In the vector-graphic software of Adobe Illustrator, the length and width of lines are calculated by the computer and drawn between two points that were designated by the designer; lines can then be curved or bent in angles by designating additional points.

Types of Lines

Familiar to us in our physical visual environment and found in a myriad of places—such as the branches of a leafless tree, lines of type on a page or screen, the cracks of dried mud in a desert, the grid of a window frame, the veins of a leaf, the roof line of a building, a mountain ridge, a Tartan plaid, the edge of ocean and sky, a zebra's stripes, a drawing by the artists Pablo Picasso or Henri Matisse, or corporate logos—lines are often in our vision (Figure 2-5).

Graphic Line

Our discussion of the element of line thus far has focused on physically drawn or graphic lines on a printed page or a digital screen. A line is drawn with wet (paint, ink) or dry (pencil, crayon) media, or with computer software. The basic functions of graphic lines include:

- Delineate and define areas within a composition
- Define shapes and create images, letters, and patterns
- Assist in visually organizing a composition
- Express a feeling and/or communicate a message

Diagram 2-6
Screen images of lines drawn in Adobe Illustrator.

Figure 2-5
Logo: Financial Corporation
Studio: Red Flannel, Freehold, NJ
Creative director and designer: Jim Redzinak

Implied Line

When a line is "broken" into parts or fragmented in some way rather than being a *continuous*, solid graphic line, it is sometimes called an **implied line.** An implied line is drawn as a *series* of marks (dashes or dots, for instance) organized in a single row with space or small gaps between each mark. The individual marks of an implied line are accepted as a line because they are adjacent, in a row, and their length is significantly greater than their width. In addition, a row of marks is accepted as a line because the viewer makes a cognitive connection between them, mentally filling in the gaps to create a solid line. Think of the neat formations of geese flying in the sky or students waiting in a row at the registrar's office—these situations are usually called "lines." And so the perception applies to the drawing of a line. With implied lines, the viewer mentally fills in the gaps to create the perception of a solid line.

Implied lines are useful when a "lighter" or less dense or solid line is needed for the composition. Implied lines are often used when organizing type (discussed further along in this chapter). Or, implied lines can be seen as playful in Stefan Sagmeister's design for a brochure cover (Figure 2-6). Implied lines are so frequently employed, they can be simply called lines. The distinction was noted to bring attention to their graphic character and use.

Figure 2-6
Brochure: Hugo Boss Prize
Studio: Sagmeister Inc., New York, NY
Art direction: Stefan Sagmeister
Design: Sarah Noellenheidt and Matthias Ernstberger
Production: Lara Fieldbinder and Melissa Secundino
Client: The Guggenheim Museum, New York
Dots make wonderful lines. This brochure cover title is readable because the dots are connected in the mind of the viewer. The dots are cut out of the cover to reveal more dots on the title page of the brochure.

"A laser cut typographic cover for the preeminent art prize in New York. The artist pages were designed by the individual nominated artists themselves. This publication represents a number of stacked white boxes, the artists can determine how his/her work is displayed in these boxes. We designed the outside signage (cover) as well as some guiding signs (dividing pages)."—Matthias Ernstberger

Along with solid and implied lines, there are two additional and important categories of lines to consider: edges and line of vision (Diagram 2-7).

Various categories of lines include:

- Solid lines
- Implied lines
- Edges
- Line of vision

Edges

Not all lines are graphically rendered. There are lines created as a result of the meeting of two shapes, two colors or tones, or a shape and a void. The meeting point or boundary (line) between shapes and tones (shape and tones are discussed in later chapters) result in delineation called an **edge** (Diagram 2-8).

Edges function on several levels:

- Assist in creating shapes
- Delineate boundaries within the composition
- Assist in organizing the elements of a composition
- Assist in creating a line of vision

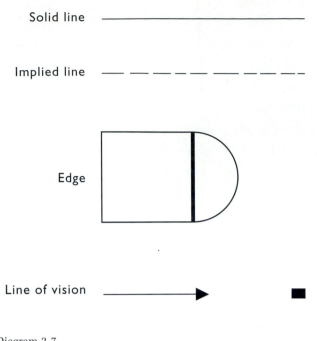

Solid line

Implied line

Edge

Line of vision

Diagram 2-7
Categories of Lines

 A line created where two shapes meet

 A line created where two tones meet

 A line created where shape meets void

Diagram 2-8
Edges that Create Lines

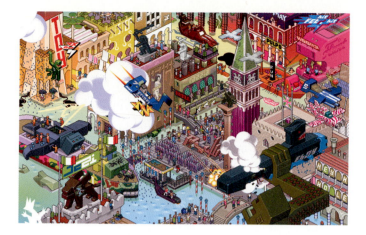

Think of an edge as the line created where a mountain ridge or the ocean meets the sky. Or, think of the white moon in the dark night sky. The edges of the mountain and the moon are clearly delineated. In a design, like the perception of an edge in nature, edges can be found where two contrasting colors or two shapes meet, as seen in the *Fiber* magazine page design in Figure 2-7 and the poster design in Figure 2-8.

Figure 2-7

Magazine page: *Fiber* Issue 2 – Pixel Power

Studio: Context Creative, Toronto, Canada

Creative director: Lionel Gadoury

Designer: Vanja Rais

Writer: Andy Strote

Illustrator: Eboy

Client: Fiber Partners

© *Fiber 2004*

A plethora of lines and edges can be seen in this illustration.

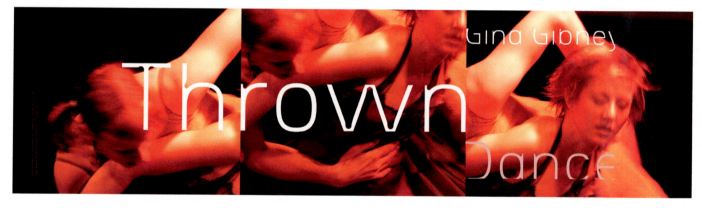

Figure 2-8

Poster: *Gina Gibney Dance*

Studio: O&J Design, Inc., New York, NY

Art directors: Barbara S. Olejniczak and Andrzej J. Olejniczak

Designers: Amy Hung, Andrzej J. Olejniczak, and Joanna Seitz

Photographer: Andrzej J. Olejniczak

Client: Gina Gibney Dance

There are many complex, interweaving edges in this poster that contribute to the organization of the composition, including the edges of the arms of the dancers, the edges of the type, and the lines of the type—all interconnected to lead the viewer through the design.

Figure 2-9

Magazine pages: *Fiber* Issue 2 – Pixel Power

Studio: Context Creative, Toronto, Canada

Creative director: Lionel Gadoury

Designer: Vanja Rais

Writer: Andy Strote

Illustrator: Eboy

Client: Fiber Partners

© Fiber 2004

There are many edges in this magazine spread that contribute to the success of the composition. The edges of images and type divide the page into neat sections that help organize the information presented and guide the viewer from place to place in the composition.

Line of Vision

A "line of vision" is not an edge or delineation or an actual line or a connection between a series of marks; a **line of vision** is the movement of a viewer's eye as it scans the composition. The viewer will follow the directional thrust of the various lines, edges, and shapes around and into the composition in a path created by the designer. The path is created in order to guide viewing and control the hierarchy (levels of visual importance) of the composition. A line of vision may also be called a line of movement, a directional line, or a psychic line (Figure 2-9). For further understanding, place a piece of tracing paper over Figure 2-9 and with a pencil or marker, delineate the line of vision in the composition. Begin at the place where your eye is first attracted and draw a continuous line, following the direction created by the lines, edges, and your own eye movement from place to place in the design.

Line is at the disposal of the designer to use for expressive and compositional organization. Not every composition will utilize all categories of line because the message or visual style does not call for it. However, in Figure 2-10, a brochure cover and inside page spread, the designers do use all four categories of line. The symbols are created with graphic lines. The stab binding (a traditional Asian technique) is a graphic line made of thread; the edges of the color boxes create strong horizontal and vertical lines. The diagonal lines of the percentage and multiplication symbols and the arrows move the viewer's eye in a line of vision. The circles of the percentage signs play connect the dots. On the spread, the letters creating the creases on the palm of the red hand are implied lines. Together, the four categories of lines make for an engaging design. Designs like this one also rely on the organizational principle of pattern to unify the whole composition (read more on pattern and the principle of unity in later chapters).

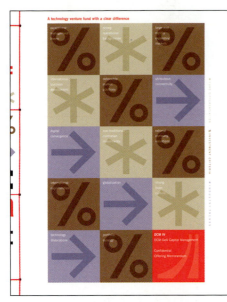

Figure 2-10

Brochure cover and spread: DCM IV

Studio: Gee + Chung Design, San Francisco, CA

Art director and illustrator: Earl Gee

Designers: Earl Gee and Fani Chung

Copywriter: David Chao (DCM)

Client: Doll Capitol Management

This brochure cover and spread illustrate all four

categories of lines.

Line Characteristics and Quality

Pick up a pencil or marker. Draw a line. Line has physical presence with recognizable characteristics and expressive emotional qualities. Producing a particular characteristic and overall quality of line is determined through the media selected and the drawing technique implemented by the designer.

Double-click on the Pen tool in Adobe Illustrator. The menu reveals a set of characteristics or "attributes" (size, shape, density) for the tool. The attributes have been prescribed by the software manufacturer based on consultation with designers and artists.

Whether using traditional media (pen, marker, brush and paint, pencil) and/or digital media (drawing and painting software), a designer's imagination can conjure infinite variations of line, including size (length), width (weight), shape (technique), color, and texture.

Size in Length

The length of a line is distinguished through comparisons—a line is long relative to the format on which it is drawn and to other lines or shapes in a composition. Line can also be precisely measured for a perfect fit in regard to the other elements on a given format. A continuous line drawn from edge to edge of the format ("bleeding" off the page) can create a feeling of infinity or continuity or stability. Truncated to a dot or dash or fragmented mark, lines become staccato in feeling and can create rhythmic sensation.

Width and Weight

The width of the line is also referred to as its weight. Thick lines are heavy; thin lines are light in weight. The visual weight of an element plays an important role in balance and compositional hierarchy, as discussed in Chapters 7 and 8.

Varying the weight of a single line within a composition can also create an illusion of depth or volume. Thin lines tend to recede when juxtaposed with thick lines. Short lines tend to feel distant in comparison to long heavy lines. The characteristic of width and weight will be explored again, further along in this chapter.

Shape and Technique

The hand of the designer has a significant impact on the appearance of a line. Line can be drawn lightly or with considerable pressure. In addition, the designer controls the shape of the line, rendering it as wavy, curvy, straight, broken, rigid, or jagged. Much expressiveness is contained in the way the line is drawn, as previously noted in Louise Fili's design for the Specchio logo, Figure 2-4, and also in the posters designed by Lanny Sommese, seen in Figures 2-11 and 2-12.

Figure 2-11
Poster: *Symbiosis*
Studio: Sommese Design, Port Matilda, PA
Art director and designer: Lanny Sommese
Technical assistance: Nate Bishop
Client: Penn State Institute for Arts and Humanities

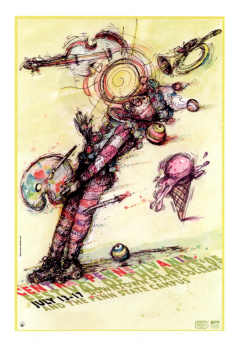

Figure 2-12
Poster: *Central Pennsylvania Arts 2005*
Studio: Sommese Design, Port Matilda, PA
Art director and designer: Lanny Sommese
Technical assistance: John Heinrich and Ryan Russel
Client: Central Pennsylvania Festival of the Arts

Color

A study in itself, color applied to line will certainly affect its emotional quality and impact. Imagine the Coca-Cola™ logo in cool blues—quiet and calm. In its normal bright white (type and line) on red background, the total effect of the color of the package is clean, bold, rich, and loud. Color's expressiveness and physical properties should be considered when composing with line—see the Red Bull™ web site design for an effective use of line color, Figure 2-13. To learn more about color, see Chapter 4.

Texture

Visualizing tools and the substrate contribute to the texture of a line (texture is discussed further in Chapter 5). Using a pencil, pen, brush, finger, or twig—and whether it is stiff, flexible, round, flat, pointed, or digitally created—will contribute to determining the textural character. Soft pencil on cardboard will create a rough line; a fine point marker on hot press paper will create a smooth line.

Figure 2-13

Web site: Red Bull

Studio: Odopod, San Francisco, CA

Art directors: Tim Barber, Jacquie Moss, and David Bliss

Designers: Chris Brown, Michelangelo Capraro, Gino Nave, Ryder S. Booth, and Andre Andreev

Illustrator: Alan Eldridge

Photographer: Bryan Medway

Executive producer: Kevin Townsend, Science Fiction

Producer: Gwinn Appleby

Client: Red Bull

The key to a successful web site is to move the viewer along in a quick and efficient manner. The use of a thick red line is essential in the design because it separates and organizes information in a distinct way, helping to make the web page clear, easy to read, and quick to navigate.

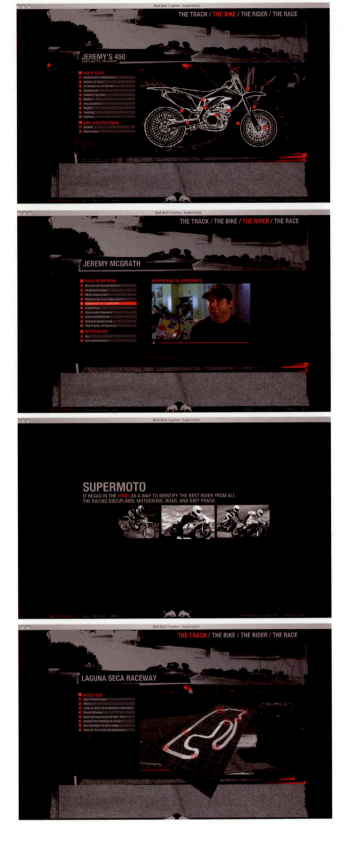

Linear Style

When using all lines, or primarily line, in drawing an object or within the composition, the design or style of the design is called **linear.** A composition or image that has a linear emphasis usually does so for the sake of simplicity, economy, and immediate impact. Lines can carry a complex message in a very quick read, as seen in the poster designs of Lanny Sommese, Figure 2-14.

Line Movement

Drawing is an action verb. Lines are drawn across the page or screen. Our handwriting is an act of drawing with continuous line. Lines seem to embody the movement of the designer's hand—looping at angles or straight. Line is significantly longer than it is wide, and because of this, line points the viewer in a specific direction. As noted previously, edges assist in creating a line of vision that guides and *moves* the viewer around the composition. The feeling of movement and implied direction can be said to be inherent characteristics of line.

Figure 2-14
Poster: *Share* (top)
Studio: Sommese Design, Port Matilda, PA
Art director and designer: Lanny Sommese
Client: Penn State Institute for Arts and Humanities

Poster: *Make a Wish* (middle)
Studio: Sommese Design, Port Matilda, PA
Art director and designer: Lanny Sommese
Technical assistance: John Heinrich
Client: State College, PA Make-A-Wish Chapter

Poster/Billboard: *Co-existence* (bottom)
Studio: Sommese Design, Port Matilda, PA
Art director and designer: Lanny Sommese
Client: Museum on the Seam, Jerusalem, Israel

Figure 2-15

Brochure spread: Cadillac

Studio: Chemistri / Leo Burnett, Detroit, MI

Creative director: Will Perry

Art director: Tom Kozak

Designer: Sarah Trent

Copywriter: Susan Zweig

Client: Cadillac, A Division of General Motors

© *Cadillac, A Division of General Motors*

This design has a strong horizontal line of type running across the two pages, and equally compelling diagonal edges. The diagonal edges of the photographic images are strong contrasting movements and direction that balances the extra-long horizontal line of type.

Figure 2-16

Woodcut: *Shono Station, Rainstorm in the Mountains.*

Artist: Ando Hiroshige (1797–1858)

Collection of The Newark Museum, John Cotton Dana Collection.

Inv. 29.2081, Tokaido Series, no. 46 (no date). 14" x 19"

The Newark Museum / Arts Resource, NY

This distinguished nineteenth-century illustration uses a lush layering of diagonal lines to simulate the movement of rain. Line and color stimulate the senses to create the mood of a rainy day.

Direction

The **line direction** guides the viewer from a starting dot on the page or screen to the line's terminus. Although physically static, horizontals *seem* to move in a left to right direction or right to left, as clearly illustrated in the Cadillac XLR™ brochure spread, Figure 2-15. Verticals seem to move from top to bottom or bottom to top. Horizontals and verticals move, but diagonal lines seem to contain the greatest sense of movement because there is an illusion of thrust, force, or action, as shown in Figure 2-16.

Seen previously in this chapter, the many horizontal, vertical, and diagonal edges in the *Fiber* magazine spreads, in Figures 2-7 and 2-9, illustrate the sense of movement and direction created by line.

When a line is animated, as seen in many web site designs, the movement and direction is *actual* and therefore strongly compelling—the viewers want to see where they are being led and what the result will be.

Speed and Quality of Movement

In general, the characteristics of a line affect the visual "speed" and quality of movement. A line can be quick and straight, or it can slowly meander like a long river through a valley floor. A smooth, solid, thin, straight line may zip the viewer along quickly. A rough, broken, and meandering line obviously moves slowly because the viewer needs more time to fol-

Figure 2-17

Woodcut: *The Whirlpools at Awa: Naruto Rapido*

Artist: Ando Hiroshige (1797–1858)

Collection of The Newark Museum, John Cotton Dana Collection.

Inv. 29.2081, Japanese 14" x 19"

The Newark Museum / Arts Resource, NY

Curving, curling, swirling lines graphically and masterfully depict the movement of water in this image by the celebrated artist Ando Hiroshige.

low its path. The viewer adds to the interpretation and can adjust speed, moving quickly or lingering, depending on their interest in the line and the design (Figure 2-17).

Actual Movement

When a line is animated on a web site or other screen-based medium, the speed is *actually* designated. The viewer loses the ability to make adjustments based on interest. With animated lines, a designer can turn a slow meander into a high-speed squiggle or the same meandering line can move slower than would usually be expected. The speed can be controlled for expressive purposes.

Line Movement and Direction in Nature

Movement does not only occur in a straight path or a meander. Look to nature for a variety of line movements, such as the looping twists of the helix found in a DNA strand (which is a double helix), the structure of a rose, or the tendril of a grapevine (think also: phone cord). Note the concentric lines created when a pebble breaks the surface of still water, or imagine the wind-born ripples across sand.

An Archimedes spiral (named for the ancient Greek mathematician who first described it) is found in a spider's web. This type of spiral is created with each successive twirl being the same width as the one before it. A snail's shell or a nautilus shell and the center of a daisy are also spirals, but as the shell or flower grows, it winds around so that each of its coils or florets is wider than the one before. This is known as an equiangular spiral (so named by the seventeenth-century French philosopher and mathematician René Descartes). Because of its concentric nature, the line of a spiral creates an inward/outward movement. A helix has a vertical/horizontal movement and direction. The horns of some animals combine both the helix and the spiral—an interesting opposable tension of linear movements.

Many designers frequently use these interesting shapes of line for logo designs. The Target retail corporation uses concentric lines in the obvious target image, but with a fresh, simplified, graphically bold look. For the Invitrogen™ logo, the designers appropriately adapted the helix (Figure 2-18).

Try a Google™ search for the words "spiral logo" and see what is listed for this popular natural shape.

Line and Spatial Dynamics

As seen in Chapter 1, line should be composed in relation to the format. The spatial dynamics of the format and the elements are reviewed here for the purpose of focusing specifically on the use of line.

The relationship of lines to the format (and to each other), determined by their placement and direction, can produce a dynamic illusion of spatial depth and/or visual tension.

Line dynamics are based on:
- Relative thickness of the lines
- Relative distance from one another
- Relationship to the format
- Whether the lines touch the edges of the format

Spatial dynamics are primarily set up through contrasts in line character and placement. Thick lines tend to push forward in space when placed next to thinner lines. Short, thin lines tend to appear to be set farther in the distance when compared to long, thick lines. Lines that touch or "bleed" off two edges of the format will most often look infinite in comparison to lines contained wholly within the format (Diagram 2-9).

Figure 2-18
Logo: Invitrogen
Studio: Mires Design for Brands, San Diego, CA
Art direction: Scott Mires
Client: Invitrogen
As stated by the designers, "In the double red helix, molecular biology researchers see an innovative partner in discovery."

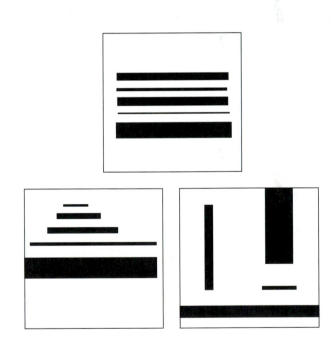

Diagram 2-9
Thick lines tend to push forward in comparison to thin lines within a square format.

Short lines compared with long lines tend to indicate an illusion of spatial depth.

Lines that "bleed" off the edges of the format tend to look infinite in comparison to lines that do not.

Because horizontal and vertical lines echo the edges of standard formats (rectangles), they can stabilize the composition by reinforcing the structure of the format, as seen in Figure 2-19.

In comparison to horizontal and verticals, diagonal lines tend to create tension because they oppose the format, as in the poster design in Figure 2-20. Diagonal lines can also create the illusion of depth because they appear to recede.

Of course, once lines are animated within a web site, the illusion of spatial depth compounds in strength. A line can appear to recede into the screen because it is *actually* shrinking in size, and the viewer follows the line into deep space (still an illusion). Or a line can actually enlarge on-screen and seem to come toward the viewer. Diagonals can actually spin and recede on-screen. Actual movement is forcefully compelling.

Employing Line

Employing line to draw an object on a screen or on paper, to sketch an idea, to write words, or to communicate symbolically seems to be among the primary human impulses. Because of the simplicity and ease of use, most designers have been drawing with lines since childhood, recording the environment and expressing their emotions. Some uses of line are:

- Sketching
- Outline and contour
- Creating tone
- Logo design
- Line created of letters
- Graphic organizers

Figure 2-19
Project: Graphics in the Environment
Studio: Tarek Atrissi Design, The Netherlands
Designer: Tarek Atrissi
This design is from a series of Tarek Atrissi's personal typographic experiments documenting the environmental graphics of the city of Beirut, Lebanon. This design shows that when lines echo the edges of the format, they can stabilize the composition by reinforcing the structure of the format.

Figure 2-20
Poster: *Chess, The Musical*
Studio: Tarek Atrissi Design, The Netherlands
Art direction: Gail Anderson
Designer: Tarek Atrissi
Client: Spot Design
The strong diagonal lines in this composition oppose the edges of the format and create a visual tension between the two.

Sketching

Still have a pencil or marker in your hand? Designers love to sketch. A sketch is a quick line drawing. Sketching is an excellent technique that allows a designer to rapidly visualize a variety of conceptual solutions for a given problem. The resulting renderings are sometimes called thumbnail sketches because the designer works very small in order to put a lot of ideas on paper quickly (Diagram 2-10). Linus Pauling, a Nobel prize-winning scientist and creative professional, said it well: "To get one great idea, you need to start with a lot of ideas."

Sketching helps designers give the seeds of their imagination a physical presence. Once the visualizing sketches are complete, the designer can select several and give extended time to develop compositions that will include all the elements of design.

Linear Drawing

Learning to draw usually starts with using line to describe the edges of simple shapes seen in our environment, such as a tree or house. A linear drawing of the outer edges of an object is called an **outline.** A linear drawing of the edges of an object (both the outer and inner edges) is called a **contour,** as seen in Diagram 2-11. In addition, an outline or contour can be either fully complete or "open"—that is, parts of the outline or contour will be purposely unfinished for visual interest. See the illustration in Figure 2-21 for an example of a representational outline in application.

Outlines and contour lines can be representational or object-oriented—describing a bird, toaster, car, building, or insect. Or, outlines and contours can be symbolic—describing a simple or complex idea or emotion, such as the feeling of love or religious belief.

Diagram 2-10
Thumbnail sketches facilitate ideation.

Diagram 2-11
Outline and Contour Drawings

Figure 2-21
Logo: Crawford Doyle Booksellers
Studio: Louise Fili Ltd., New York, NY
Art director and designer: Louise Fili
Illustrator: Anthony Russo
Client: Crawford Doyle Booksellers

Usually, outline or contour is a studied technique. The designer may first sketch an object or symbol, but then a careful outline or contour drawing is created to solidify the drawing and concept of the design. When a spontaneous and dynamic delineation is desired, lines can be employed to draw action. A free-form linear drawing that focuses on emotion and action, rather than exacting representation, is called a **gesture drawing.** See the poster designs of Lanny Sommese previously shown in this chapter for examples of gesture drawing.

Line Creates Tone

Bundling lines together, "hatching" or "crosshatching" lines, or massing gestural lines (black on a white substrate), produces a density of color that gives an appearance of gray tones. Loosely bundled, lines will appear light in tone. Packed closely, lines will appear dark, as seen in Figure 2-22 (top), or create tone as in Figure 2-22 (bottom). Tones are discussed in Chapter 3 on shape and in Chapter 4 as a characteristic of color. In addition, you will learn much more about outline, contour, gesture, crosshatching, and sketching with line in the study of drawing. It is important to combine your study of design and composition with that of drawing to better understand the scope and interconnectivity of the two areas.

Logo Design

Outline, contour, and gesture drawing techniques are often employed in the design of logos because these design applications seek to distill the elements to their simplest level in order to communicate an emotion or idea in the most efficient way. However, by no means is the distillation process easy to accomplish or simplistic in result. A logo is one of the most difficult design applications to create successfully simply because distilling a form into a few masterful strokes or lines takes great conceptualizing skill. Note any of the logo designs using outline or contour in this chapter or the book—each is a masterful distillation of line.

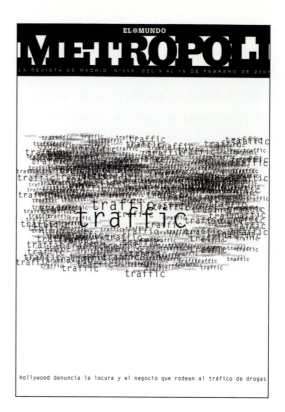

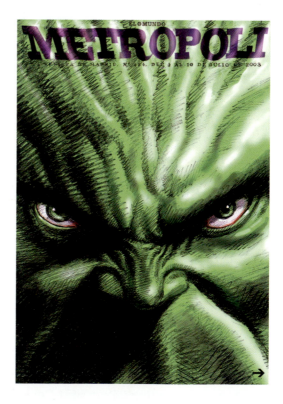

Figure 2-22

Magazine covers: *Metropoli*

Studio: Unidad Editorial S.A., Madrid, Spain

Art director and designer: Rodrigo Sanchez

Client: EL MUNDO

Lines Created with Type

Designers often use type to create a graphic line within a composition, as seen previously in the Cadillac brochure (Figure 2-15). In a body of type (many paragraphs), the lines created of type are primarily functional. A well-designed line of text type (small type) graphically renders language and makes reading a book or magazine easy. Or, a line of type can be for reading and have a visual design and *conceptual* purpose. When the role is strictly functional, a designer should create a situation where the reader is barely aware of the line—making reading comfortable and easily flowing. The reader wants to be engaged by and concentrate on the content rather than the design.

There are practical considerations in designing a well-functioning line of type, including optimum selection of typeface size and style, relative length of a line, column alignment (justified right or left), and word spacing. These will be discussed in Chapter 6. Considerations for designing with lines created of type closely follow the approaches previously discussed in this chapter. Be aware that a line of type also has shape, weight, texture, and color, as well as movement, directional pull, and spatial dynamics, as seen in Figure 2-23.

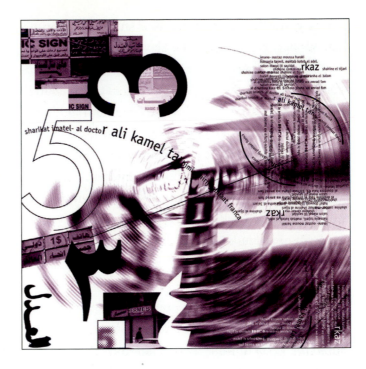

Figure 2-23
Project: Graphics in the Environment
Studio: Tarek Atrissi Design, The Netherlands
Designer: Tarek Atrissi
This design is also from a series of Tarek Atrissi's personal typographic experiments, documenting the environmental graphics of the city of Beirut, Lebanon. Using a variety of lines, including lines of type, Atrissi created a visually active (and a bit purposefully chaotic) composition in this design that is meant to capture the rush of graphics found in an urban environment.

A line of type can be used for descriptive outlines or contours. However, avoid any clichés such as using the line of type in the actual shape of the meaning of the words. The phrase "cats nap frequently" might look contrived if the words were curved into a representation of a sleeping cat. A sophisticated approach would be less obvious and more conceptual, thus provoking thought and not merely repeating content—refer back to Figure 2-10 (bottom), where the lines created with type represent the contour of the palm of a hand.

Graphic Organizers

In the nomenclature of typography, a line is called a **rule.** Rules are straight, horizontal, or vertical lines that separate and hierarchically organize bodies of type in a single-page or multiple-page format (print or digital). A rule can also act as a border or become an enclosing box—framing and containing bodies of type and keeping the page neat, as seen in Figure 2-24.

A rule will have a length determined by its function and relationship to the text in the page composition. Its thickness is measured in point sizes from .05 hairline to 12 or 14 points—any larger will probably cause the rule to look more like a flat shape. A rule has color and may have visual texture. For instance, a rule can be dotted or stacked double or triple. There are standard ways of stacking rules, such as a thin weight coupled with a thicker weight. This type of stacking is known as a Scotch-rule because it seems to look like a single unit of a Tartan (Scotch) plaid pattern.

Figure 2-24

Cover and page designs: *The Balthazar Cookbook*

Studio: Mucca Design, New York, NY

Art director and designer: Matteo Bologna

Client: Balthazar

Linear boxes, borders, and rules separate, decorate, and organize the various sections of information in this cookbook cover and page design.

Page composition software has a menu of styles for rules that includes basic solid, double, triple, thin-thick, thick-thin, all dots, dashes, and dashes combined with dots. In addition, you can create your own style of rule. Customized or decorative rules that contain a complex linear structure may be visually interesting, but should be used with restraint. Too many rules or a complexity of rules can be a distraction. Remember that the primary purpose of a rule is separation and organization of text in order to guide the viewer and make reading and comprehension easy.

Summary

For a simple graphic, line is anything but simplistic. Line has a myriad of practical uses in drawing and composition; it is an essential graphic organizer in typographic design. Through careful manipulation of its characteristics, line can communicate complex ideas and emotions. The expressive qualities of line are only limited by the imagination of the designer.

The sum of the physical characteristics of a line—size, shape, texture, color, movement, direction, and placement within the format—are compositional considerations and also help to create expressive qualities that could communicate a host of emotions, thoughts, ideas, and moods (Figure 2-25).

Although line is most often used as an integrated element of a design, working synergistically with all the other elements, designers can also select line as the primary element of a design or the primary style of working, in general. Many designers have been known to have a significant portion of their work based on the deceptively simple line.

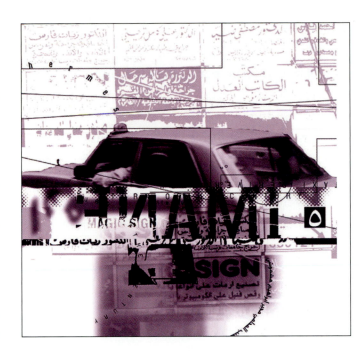

Figure 2-25
Project: Graphics in the Environment
Studio: Tarek Atrissi Design, The Netherlands
Designer: Tarek Atrissi
Another design from a series of Tarek Atrissi's personal typographic experiments, documenting the environmental graphics of the city of Beirut, Lebanon. Actual lines, implied lines, lines indicating movement and direction, lines of type, and line edges can all be found in this sophisticated composition.

EXERCISES

Exercise 2-1: Seeing and drawing line

Nearly random lines
Walk through an urban or natural environment on a sunny or cloudy day. Take a camera and a sketchbook. Look for lines in the environment. You'll certainly find lines on the cement sidewalk or above your head among the phone wires or trees. Now observe more carefully—where else can you find a line? Once you've discovered several inspiring lines, isolate them with the camera viewfinder or your own eye. Record the composition as a photo or a sketch, or both. The discovery of an interesting, random line in the natural or urban environment can lead to engaging formal compositions.

To continue the assignment, organize your line photos or illustrations into a story or a book. Give the series of images a title, but let the images tell the story.

Expressive line
Discover the expressiveness of line through your own drawing.

Using a variety of media, tools, and techniques, draw lines and/or groups of lines that respond to the definition of the following list of words:
- angry
- joyous
- lyrical
- frenetic
- fragile
- tortured
- bold
- whimsical
- dynamic
- ragged
- heroic
- sincere
- jagged

Expressive representations with line
Using the types of lines created in the previous exercise, render a representational image in line to discover how one subject can be affected by the way in which it was drawn.

Select one subject for a series of drawing studies from the following list of objects:
- horse
- potted plant
- lizard
- human figure in action
- tree
- eagle

Procedure
On separate 8 x 11-inch formats, select one media and execute a rendering of the subject in a representational way. You may use simulated grays, but the modulations of tones should only be of line. Continue the drawing study, but with at least five to ten different media, tools, substrates, and techniques.

Techniques
- Contour—vary line weight within the subject and try to create an illusion of mass.
- Outline—use only one weight or thickness of line.
- Draw the subject in the style of a contemporary or historic artist or designer.
- Draw the subject using only vertical lines (vary the weight of line or not).
- Draw the subject using only triangles, circles, squares, and rectangles of one line weight.

Exercise 2-2: Composing with line as the primary element

Line movement, direction, and spatial dynamics
Create a series of line drawing compositions that specifically explore movement, direction, and spatial depth. Select several differently sized formats—standard sizes are good, but you may use custom sizes, as well. Using horizontal, vertical, and diagonal lines of equal and/or varying thickness and simple lines of

your own design, create three separate compositions, each having a distinct feeling in regard to the speed of movement (slowly meandering to quick), density of activity (simple to complex), and amount of depth (shallow to infinite).

In a variation of this assignment, create a composition as a whole in response to several emotions stated in the list found in Exercise 2-1, Expressive line. For example, instead of creating one line that feels "happy," create an entire composition of lines reflecting that emotion. All the lines, movement, direction, and spatial dynamics should contribute to the emotion selected.

Studying lines, edges, and corresponding alignments

Discover how the underlying linear framework of a professional design contributes to the organization of a composition and enhances the expressiveness of the design.

Select several professional examples of design found in this book.

Lay tracing paper over the image and draw the graphic lines and edges (including format) found in the composition; draw dashed lines to indicate any line of vision. Remove the tracing paper, and study the drawing on it. Notice the purposeful alignment of the lines and edges within each composition and the skeletal-like structure that creates connections and order. Try describing the feeling the designer was trying to communicate with the structure of the composition.

Conceptual lines of type in composition

Select a thought-provoking quote from a well-known designer or other inspirational source. The following is an example from this chapter: "To get one great idea, you need to start with a lot of ideas." —Linus Pauling

Type your selected quote in Adobe Illustrator, InDesign, or QuarkXPress. Think of the sentence as a line drawing and manipulate the line size, weight, tone, length, typeface, and placement on the page so that it visually complements or reflects the meaning of the quote. The typographic line drawing should also conceptually respond to the page as a whole. Solid or implied lines may be added to the composition to enhance the visual concept and interest.

Remember to steer away from obvious clichés. Do not manipulate the line of type into the actual content of the quote—rather than a simplistic representation, think abstractly.

Shape

Chapter 3:
Shape

composition {

hierachy balance type scale rhythm
shape unity

message motion format line color depth texture

Objectives

- Define and explore the varieties of shape
- Gain an understanding of shape in composition
- Become aware of shape and the illusion of spatial depth
- Recognize the potential expressiveness of shape

What Is Shape?

As noted in the previous chapter, the element of line is a specific and distinct visual component of design and has many roles to play in composition, image making, and communication. Traditionally, and with significant frequency, one of the major roles of line has been to delineate a *shape* (Figure 3-1).

A **shape** is a configured or delineated area on a format, created either partially or entirely by lines (outlines, contours) or by color. Shapes may be drawn by hand with traditional techniques and materials such as crayon, chalk, paint, ink, pencils, or markers. Or shapes can be rendered with computer software or "captured" in a photograph.

Figure 3-1

Poster: *Make-A-Wish Gala, 2005*

Studio: Sommese Design, Port Matilda, PA

Art director: Lanny Sommese

Technical assistance: John Heinrich

Client: State College, PA, Make-A-Wish Chapter

As seen in this delightful poster for a children's charity, line delineates shape and shadow.

Usually, a shape is recognizably discrete from all other areas, including other shapes and the area around the shape. The appearance of a shape can be straight and angular or curve softly. Shapes can appear to be flat or dimensional, solid like a rock, or transparent and amorphous, like clouds (Figure 3-2).

Flat Shape and Volumetric Form

Starting on the most fundamental level, a shape is essentially flat—meaning, it is actually two-dimensional and measurable by height and width. A shape may be filled with unmodulated color on a printed page (Figure 3-3) or computer screen; shapes may be drawn as a simple outline, a contour, or a gesture (Diagram 3-1).

Figure 3-2

Poster: *Southern Exposure*

Studio: MendeDesign and Volume, San Francisco, CA

Art directors: Eric Heiman and Jeremy Mende

Designers: Amadeo DeSousa, Eric Heiman, and Jeremy Mende

Client: Southern Exposure

This poster displays a range of interesting shapes, including flat shapes, amorphous shapes, and letter shapes.

Figure 3-3

Logo: Ecco Press©

Studio: Louise Fili Ltd., New York, NY

Art director and designer: Louise Fili

Client: HarperCollins

Flat shapes of letters filled with unmodulated colors.

Outline

Contour

Gesture

Filled Shape

Diagram 3-1

Shapes

Figure 3-4

Logo: Light Gear©

Studio: Mires Design for Brands, San Diego, CA

Client: Light Gear

In this application, we see a logo that uses a flat shape with an illusion of receding into space. The illusion gives the shape of the man a more powerful look and feel—appropriate for the content of this footwear company. "Wanna be light on your feet? Then power up with these."—Scott Mires

Shapes can also be drawn so that they seem to occupy three-dimensional space—measured in height, width, *and* depth. A flat shape can have the illusion of receding into the picture plane, as seen in Figure 3-4.

When *more* than the one side or plane of a shape is depicted, and it seems to have the *illusion* of containing **volume** (the illusion of space within it), and the illusion of existing in three-dimensional space, the shape may be called a **volumetric form** (or simplified to *form*)**, as seen in Diagram 3-2 (left). Forms are often filled with modulated (light to dark) color. Modeling form gives it the illusion of existing in three-dimensional space and containing volume, *plus* the illusion of having weight or **mass**—relative density or solidity, as in Diagram 3-2 (right).

Diagram 3-2

A form has the illusion of containing volume and the illusion of spatial depth (left). A form filled with a modulation of color, in light and shade, creates the illusion of volume and spatial depth, plus mass (right).

Figure 3-5
Logo: PACESM
Studio: Louise Fili Ltd., New York, NY
Art director and designer: Louise Fili
Client: PACE restaurant

In addition, depicting cast shadows helps to enhance the illusion of depth and mass, as seen in the letterforms created by Louise Fili in Figure 3-5.

Photographs depicting actual objects will usually contain complex modulations of light and color; this allows highly definitive perceptions of volume, mass, and spatial depth (Figure 3-6). Much can be learned about shape, light, and space in the study of basic photography.

Knowledge of the techniques for rendering shape and form—as well as letter shapes and forms—is gained through the study of *drawing.* The study of drawing and photography is essential to design and very helpful in conjunction with the study of design. Since composition is primarily concerned with the interaction and arrangement of shapes (and lines, colors, and textures on a format), a basic knowledge of the characteristics of shape, whether as a photograph or drawing, is necessary in order to use shapes effectively for practical compositional purposes and expressiveness.

Figure 3-6
Photograph: Old Tree, Morocco
Photographer: David Halliday, New Orleans, LA
Copyright David Halliday, 1998

Types of Shapes

All shapes may essentially be derived from three basic delineations: the square, triangle, and circle. Each of the basic shapes have corresponding volumetric forms or solids: the cube, pyramid, and sphere (Diagram 3-3).

Please note that many designers and design educators use the words shape and form interchangeably. Also, some use the word form interchangeably with the word composition.

Shapes within Shapes

In our study thus far, shapes have been seen for the most part as single, distinct entities with an outline delineating the outer edges of the shape. Continued analysis of shape reveals that within a single shape, many shapes may be found; for example, the human figure posed in action or repose may be seen and analyzed as a group of circles, ovals, triangles, and rectangles. The same can be said of any other complex shape. The overall shape can be discerned, as well as the many shapes within it (Diagram 3-4).

Awareness of shape should extend to its internal complexities because both the outer boundaries of the shape and all the shapes within it may have an effect on the interactions of the elements within a composition.

As discussed in the previous chapter on the element of line, *edges* play an important role in composition. The edges of a shape (noted also as line) can be used to direct the viewer around a composition in a visual path, and the edges of shapes may be aligned so they correspond to one another. To have control of shapes and their alignment and correspondence to each other and the format, consideration should include both the primary overall shape and the secondary shapes that may be found within each shape.

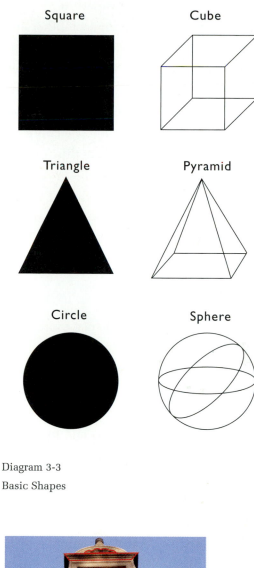

Square Cube

Triangle Pyramid

Circle Sphere

Diagram 3-3
Basic Shapes

Diagram 3-4
A shape may contain many smaller shapes within its outline.

Underlying Structure of a Composition

In composition, shapes interact with each other and with lines, typefaces, colors, textures, and the shape of the format. Once all of the elements are arranged on a single page or screen, the overall composition itself can be analyzed and divided into large areas that define the underlying structure of the composition—see Diagram 3-5 for an example of this.

Defining the underlying structure of shapes within the composition will assist in analyzing the composition in regard to balance and unity. These principles of design are discussed in Chapters 7 and 10.

Beyond the Basic Shapes

From the basic group, most other shapes can be created through additions to, subtractions from, and combinations of the three fundamental shapes. Adobe Illustrator drawing software recognizes the square, triangle, and circle as basic shapes. In addition to these, you will also see spirals and hexagons in Adobe Illustrator's basic shape tool palette. The shape tool in this drawing software is indicative of those shapes that are considered to be fundamental to drawing and design.

Within and beyond the basic group, shapes can be generated in a range of sizes (width, height, and depth), textures, and colors. They can be completely closed or open—with the viewer mentally finishing the closure. Shapes can also be seen as rigid and static or softly curvilinear, as seen in Diagram 3-6.

Whether a drawing or a photograph describes the myriad of objects found in nature or the built environment, or whether a drawing of shape is nonobjective (without representation of a known object) and meant to be symbolic of an action, emotion, or idea, shapes have distinct characteristics and style. On a stylistic level, shapes have important visual differences that affect communication. The basic styles may be grouped into two broad categories: geometric and organic (Diagram 3-6).

Diagram 3-5
Defining the underlying structure of the composition can help in analyzing whether the composition is well organized and balanced.

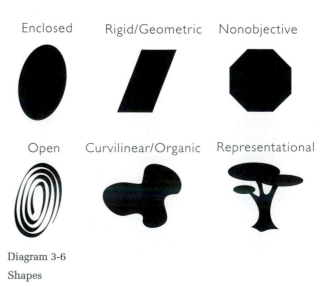

| Enclosed | Rigid/Geometric | Nonobjective |
| Open | Curvilinear/Organic | Representational |

Diagram 3-6
Shapes

Diagram 3-7

The Adobe Illustrator drawing software delineates basic shapes that are created by designating points on the computer screen. The Shape tool draws basic shapes quickly without having to designate points. The points appear automatically.

In addition, using the tools of computer drawing programs (specifically, employing the Bézier Curve tool), organic shapes can be drawn with specific calculations or the designer can use the curve tools in a more free-form approach.

Figure 3-7

Logo: Crawford Doyle Booksellers

Studio: Louise Fili Ltd., New York, NY

Art director and designer: Louise Fili

Illustrator: Anthony Russo

Client: Crawford Doyle Booksellers

Louise Fili and Anthony Russo adeptly echo Art Deco styling in the logo design for Crawford Doyle Booksellers.

Geometric Style

Shapes created with straight edges, precise curves, and measurable angles are **geometric** or mechanical in stylistic appearance. In geometry and in design, these types of shapes have names such as rectangles, squares, triangles, hexagons, octagons, circles, trapezoids, and parallelograms. However, geometric shapes can also be drawn with any number of complex angles—these are called polygons. In Adobe Illustrator, rectilinear shapes can be drawn quickly with a corresponding shape tool, or points can be designated and a complex shape can be generated with many angles of varying degrees (Diagram 3-7).

Art Deco Style

The **Art Deco** period (1920–1939) in art and design is still admired today for the use of stylistically bold geometric shapes reflecting an interest in the built environment and industry of the Machine Age. Notably, Art Deco styling often simplified organic shape and form into a more flat and geometric appearance. The style is found in contemporary designs for the purpose of capturing its visual and philosophical quality or simply to create a nostalgic feeling for the era in which the style was created, as seen in Figure 3-7 (see also Figure 3-3).

Organic Style

Organic, biomorphic, or curvilinear shapes and forms seem to have a naturalistic feel and stylistic appearance (Figure 3-8). The curving and soft edges seem organic in comparison to exacting geometric structures (straight, angular, and hard-edged). Organic shapes may be drawn with precision and contain gracefully choreographed curves, or the shapes can be handled freely for a spontaneous or ragged appearance (Figure 3-9).

Organic shapes may also reach the point of appearing misty or shadow-like; these may be called amorphous shapes (Figure 3-10).

Figure 3-8

Logo: Malama

Studio: Louise Fili Ltd., New York, NY

Art director: Louise Fili

Designers: Louise Fili and Mary Jane Callister

Client: Malama

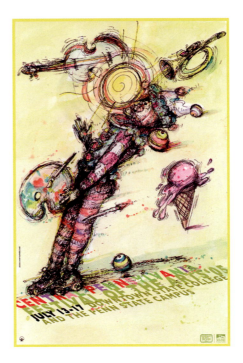

Figure 3-9

Poster: *Central Pennsylvania Festival of the Arts 2005*

Studio: Sommese Design, Port Matilda, PA

Art director and designer: Lanny Sommese

Technical assistance: John Heinrich and Ryan Russel

Client: Central Pennsylvania Festival of the Arts

Figure 3-10

Poster: *Southern Exposure*

Studio: MendeDesign and Volume, San Francisco, CA

Art directors: Eric Heiman and Jeremy Mende

Designers: Amadeo DeSousa, Eric Heiman, and Jeremy Mende

Client: Southern Exposure

Art Nouveau Style

During the **Art Nouveau** period (1880–1910) of design and fine art, designers such as Alphonse Mucha (Czech. 1860–1939) produced a highly interwoven, organic style of shape that has inspired generations of creative visual thinkers, in regard to both drawing and composition (Figure 3-11). The Art Nouveau style was concerned on a visual level with celebrating sensually organic shape. On a philosophical level, Art Nouveau practitioners were bringing together and redefining the division between the fine and applied arts in order to give value and meaning to all common objects. This stylistic philosophy was considered to be new for its time and revolutionary in thought, and was thus called the "New Art" or Art Nouveau (the French). As with Art Deco styling, the Art Nouveau style is still admired and adapted for use in contemporary design (Figure 3-12).

Figure 3-11

Advertising poster for F. Champenois, printer and publisher, Paris, 1898

Alphonse Mucha (1860–1939) © ARS, NY

Private collection, Paris, France

Photo credit: Snark / Art Resource, NY

Figure 3-12

Logo: The Grand Café

Studio: Red Flannel, Red Bank, NJ

Art director and designer: Jim Redzinak

Client: Self-assigned

The fantastic curves and curls of this lettering project reflect an influence from the Art Nouveau period of art and design.

Typographic Shapes and Letterforms

In graphic design, a letterform or the numerals and alphabet of letters known as a typeface, are also shapes—albeit highly specialized ones that visually symbolize the sound of language. Letters or type are often geometric in character; however, organic curvilinear type exists as well. And, like basic shapes, type can be mathematically perfect in proportion—such as the Futura type family—or it can be more organic in appearance—such as the free-form style of a designer's own handwriting, a script typeface, or custom lettering as seen in Figure 3-13.

Type is so extremely important to the graphic designer that the complexity of type shapes, their relationship to composition, and their communicative impact will be explored in its own chapter.

Positive and Negative Shapes (Spaces)

"I first was made conscious of positive and negative shape relationships in a freshman two-dimensional design course in college. While I certainly had intuitively used the play between figure and ground while doing woodcuts in high school, I was not aware of the larger implications of the concept. I learned that the interplay of shapes was variable, based on what one focused on. If you focused on the negative field, it came forward and assumed the positive role. This could become particularly odd when looking at large letterforms, say on posters, where the negative shapes could persuasively negate readability. But the larger role this concept has played in twentieth-century design is to help maintain the two-dimensional surface while engaging in a variety of potentially spatial effects. So, one could say that bringing negative shapes to the surface and giving them an equal role with the positive helps maintain a certain truth . . . the page is flat. By asserting this flatness, designers have produced some very powerful imagery."—Harold Bruder, artist and teacher

Geometric

THINKING CREATIVELY

Script

In Appreciation

Figure 3-13
Typographic Shapes

Thus far, we have been discussing shape (form) as a recognizable or clearly delineated entity on the surface of the format, whether a printed page or screen. In design, the immediately discernable shape is known as the **figure** or **positive shape** (or **positive space**). However, when composing elements on a format, awareness must also extend to the area between and around positive shapes—the interstices or the areas known as the **ground** or **negative shape** (or **negative space**). The ground or negative space may appear to be unoccupied and without shape and thus of no true compositional importance. In fact, most students and novices tend to think of the ground as empty space, and do not regard it as having any vital role in composition. Yet, the seemingly unoccupied areas do have shape and do significantly affect design. The ground actually takes shape—negative shape (Figure 3-14).

Negative shape may be descriptive of an object, as noted in the clever designs of Lanny Sommese (Figures 3-14 and 3-15), or the negative area can be a nondescript space, but of compositional value nonetheless. Whether representational of an object or nonobjective, the negative area or ground carries visual presence—a color, texture, and visual importance that will significantly affect a design.

Figure 3-14

Poster: *Central Pennsylvania Festival of the Arts 2002*

Studio: Sommese Design, Port Matilda, PA

Art director and designer: Lanny Sommese

Technical assistance: Mike Martinyuk

Client: Central Pennsylvania Festival of the Arts

Note the clever use of negative space among many of the positive shapes. The negative areas are in many places representational shapes—look closely and find the images for yourself.

Figure 3-15

Magazine illustration

Studio: Design Park, Seoul, Korea

Art directors: Hyun Kim and M. J. Shin

Design/illustration: Lanny Sommese

Client: Design Park, Seoul, Korea

In this illustration, note the negative spaces between the porcupine's spines. Sommese's clever handiwork with negative shapes is well known in the professional field.

Diagram 3-8

The historic Chinese symbol for the interconnection and harmony of life forces: yin-yang.

Equivocal space as seen in a "checkerboard" composition—the white and black shapes can be seen equally as either positive or negative shapes.

Figure 3-16
Logo: "2004 Pet Extravaganza"
Studio: Sommese Design, Port Matilda, PA
Art director and designer: Lanny Sommese
Technical assistance: John Heinrich
Client: State College, PA, Pet Extravaganza

Figure and Ground Reversals

At times, the positive and negative shapes can be arranged in a composition to equally represent *either* the positive or the negative areas. The traditional example is the yin and yang (or yin-yang) symbol of life balance known from historic Chinese philosophy and culture. A simple checkerboard is also a good example of an equal and interchangeable distribution of positive and negative shapes. In each example, the figure and ground are capable of a "reversal"—meaning the figure *and* the ground can be seen interchangeably, as either a positive or a negative shape. This ambiguity or confusion of determining which shape is positive and which negative is called **equivocal space** (Diagram 3-8).

The optical playfulness of equivocal space and figure/ground reversals enriches the design experience—the cleverness of the arrangement amuses and engages the viewer, as seen in Figure 3-16. Taking playful ambiguities to stylistic extreme, many artists and designers have filled whole compositions with a pattern of positive/negative shape reversals. This type of composition is called **tessellation.** One of the most well-known artists and designers of tessellations is M. C. (Maurits Cornelis) Escher (1898–1972). His optically playful compositions have fascinated viewers for generations (Figure 3-17).

Figure 3-17
Woodcut: *Day and Night,* 1938
M. C. (Maurits Cornelis) Escher (1898–1972)
Private Collection
Photo credit: Art Resource / NY

Shape Reversals in Logo Designs

Logo designs are compositional microcosms and may be studied for their economical precision in arrangement of shapes. A logo, by the nature of its application, must be a highly simplified shape and communicate broad ideas and meanings in a very limited composition. The use of positive and negative shape reversals is a visually economic way to increase the number of shapes in a very limited area. In addition, positive/negative reversals are visually engaging because of their inventive interaction of shape. For all these reasons, designers frequently use positive and negative shape reversals in logo design (Figure 3-18).

Whether in the tiny composition of a logo, the huge-scale composition of an advertisement on an outdoor board, or an animated composition on a computer screen, positive and negative shapes are elements of a design that interact and must be consciously arranged. The effect of the interactions of shape in composition is further explored in the chapters on the principles of composition.

Figure 3-18
Logo: Fusion
Studio: Mires Design for Brands, San Diego, CA
Client: Fusion

A Note on Knock-Outs

A **knock-out** is a design and production term derived from the printing industry to designate a shape or area of a composition that is defined by the area surrounding it and the color of the paper on which it is printed. Specifically (but not literally), the shape has been "knocked-out" so it will take on the color of the substrate. A knock-out is usually employed for practical reasons—it is economically effective because the technique allows the designer to use the substrate as a color without paying for additional color ink.

Type and shapes in general are often knocked-out for contrast and emphasis within a composition. Large white letters on a black background (Diagram 3-9) have greater contrast than black type on a white ground, and therefore attract more attention. However, do bear in mind that it is very difficult to read small type when it has been knocked-out. The use of type as shape and in composition is discussed further in Chapter 6.

Expressive Shape

Whether organic or geometric, literally realistic or nonobjective, shapes are used to represent and describe our environment or symbolize our ideas and emotions. The selection and choice of shape employed in a composition should be determined by what the designer is trying to communicate or express. Shapes are employed for expressive purposes in large-scale design (posters and outdoor boards) and in small-scale applications such as logos (Figure 3-19).

knock-out

Diagram 3-9
Knock-Out Type

Figure 3-19
Logo: BiPolar Swings
Studio: Rizco Design, Manasquan, NJ
Creative director: Keith Rizzi
Illustrator: Dave Ember
Client: GlaxoSmithKline, Lamictal
The organic shapes of this logo help to emphasize the biological nature of the subject matter.

Interpretations

A **representational shape** depicts a recognizable object or thing from a known environment. However, no matter how realistically rendered or perfectly recognizable or literal, shapes are always *interpretations* or *representations* of the actual world. Inherent in all representations of objects is the sensibility of the designer (or photographer or illustrator). No matter how perfectly "real" the object is depicted, the person who is drawing or photographing the objects adds his or her vision for communication purposes and style. Simply stated, representational shapes are essentially a designer's interpretation of the natural or built environment.

A shape may be called highly realistic, literal, and/or representational and labeled by the noun that is represented—such as a tree, house, eagle, scissors, lion, toaster, or rose—or the shape is labeled using a noun and adjectives: a purple, geometric tree. Yet, a tree is natural, so why would the designer create a hard-edged shape with imaginary color (rather than natural color) for something so obviously organic? Using geometric angles to delineate an obviously organic shape may be called an *abstraction* of reality. **Abstracted shapes** are simple or complex exaggerations or distortions of objects and are used for stylistic distinction and/or communication purposes (Figure 3-20).

Abstracted shapes may suggest meaning beyond the literal object. For instance, a tree having a geometric shape may suggest supernatural strength, or perhaps the meaning is even more complex, suggesting the loss of the natural environment to urban development. Or a tree may be depicted as a whimsical shape for a more lighthearted message, as seen in Figure 3-21.

Figure 3-20
Logo sketches: Liberty Hall Museum
Studio: Holloway Design, Pittstown, NJ
Art director and designer: Martin Holloway
Client: Liberty Hall Museum
The representational image of a house is accompanied by a more abstract image of a tree. Several stylistic renderings were made of the tree before the appropriate style was found.

Figure 3-21
Logo study
Studio: Red Flannel, Freehold, NJ
Art director: Jim Redzinak
Designer: Michele Kalthoff
An experimental drawing for a college whose campus is an arboretum.

In addition to communication purposes, abstractions of reality may help to create fresh and unique interpretations of common shapes. An original abstraction of even the most ubiquitous shapes may render the object that is being depicted as distinct from all others of its kind. In design, distinction among the vast amount of visual information consumed by the public is necessary to deliver a memorable message.

Nonobjective Symbols

Shapes that do not represent specific objects in the environment are **nonobjective shapes**. These types of shapes are meant to symbolize an idea, rather than refer to a thing or object (Figures 3-22 and 3-23). Within symbolism, there is an opportunity to explore a far-reaching meaning.

The representational shape of an apple refers primarily and literally to itself; if abstracted (distorted, flattened, skewed), the shape of an apple may symbolize ideas beyond the object itself. However, a circle, which has no specific object reference, may symbolize many different kinds of objects (a ball, the sun, an eye), as well as broad ideas, such as infinity and timelessness—this is because a circle has no beginning and no end. A circle could also symbolize the solid earth or an abyss, depending on its size, color, and placement on the page or screen. Because nonobjective shapes are not bounded by literal meaning or associations, they usually have a greater range of communication than realistically drawn representational objects or abstracted objects. A logo design will often contain nonobjective symbolic shapes because a broad interpretation is necessary to create a *unique* mark that will represent the complex identity of a corporation.

Figure 3-22
Logo: Financial Corporation
Studio: Red Flannel, Freehold, NJ
Art director and designer: Jim Redzinak
The nonobjective shapes of this logo have an interlocking structure that speaks of the strength and multifaceted operations of the corporation.

Figure 3-23
Logo/Experimental drawing: Construction company
Studio: Red Flannel, Freehold, NJ
Art director and designer: Jim Redzinak
Overlapping circles and geometric lines create an optical effect suggesting a sense of movement—suggesting the industry and activity of a construction company.

Summary

Shape is the element that embodies communication. On an individual basis, geometric and organic shapes— whether flat or volumetric, representational or literal, abstract or nonobjective—have many practical purposes in composition and expressive qualities that can be employed for communication. When interacting within a design, the individual qualities of shape and form combine with other shapes and elements to expand and enhance meaning and communication.

With awareness and practice, a student of design can employ shape for effective communication in a variety of applications, from the microcosm of a logo or the large format of an outdoor board or a poster, to packaging (Figure 3-24), advertisements, or brochures, and even to the depth of a one-hundred-page web site.

Figure 3-24
Packaging: Scrabble™
Studio: Mires Design for Brands, San Diego, CA
Client: Hasbro™
The playfully "flying" geometric shapes communicate that the game inside the box is fun. "The reconfigured and rescaled, time-honored elements of the Scrabble brand thrust forward out of the frame and into the mind." —Scott Mires

EXERCISES

Exercise 3-1: Shapely harmonic connections

The study of composition (design) is primarily concerned with the interaction and arrangement of shapes, as well as lines, colors, and textures on a format. A basic knowledge and awareness of the characteristics of shape, whether as a photograph or drawing, are necessary in order to use shapes effectively for practical and expressive purposes within a composition.

These exercises explore a variety of shapes through drawing and photography.

Flat shapes

Learning to create a series of shapes that have similar qualities is important to understanding compositional correspondence—how elements relate to one another.

There are different types of shapes: organic, geometric, etc. Using the lessons and knowledge acquired from drawing courses, draw four simple, flat shapes

that have similar qualities—for example, four curving shapes or four rectangular shapes. Arrange the shapes on a page so that they seem to relate to one another and there seems to be a sense of flow from one to the next. Take the shape of the page (the format) into consideration. Repeat this exercise three times using computer drawing software.

The two goals of this exercise are learning to create like shapes, and learning to arrange shapes in a composition so that all the shapes relate to one another. Relatedness, whether it is in terms of establishing similarities or in terms of how each element cooperates with the other elements in a composition, teaches you to create harmonic connections.

Shape into form

Again, draw four shapes that have similar qualities—for example, four curving shapes or four rectangular shapes—but for this exercise, draw the shapes so they have an illusion of volume (depth) and mass (weight). Arrange the shapes on a page so that they seem to relate to one another and there seems to be a sense of flow from one to the next. Take the shape of the page (the format) into consideration. Repeat this exercise once using computer drawing software and the color and gradation tools or commands.

Photographic volume

In this last exercise concerning the awareness of shape in composition, you will need a conventional or digital camera. Using the lessons learned from photography courses, take a series of photographs that capture isolated flat shapes (such as shadows) and isolated volumetric forms (such as buildings). Scan or download the photos into your computer for use in the next part of the exercise.

Create several compositions where the photographic shapes are combined with drawn shapes. Your objective should remain the same as in the first two exercises: that the shapes relate to one another and there seems to be a sense of flow from one to the next. The challenge in this exercise is to blend the photographic shapes with the handmade shapes. Harmonizing various media in a single composition is a frequent challenge in graphic design—where photographic imagery is often seen in combination with flat shapes and letters.

Exercise 3-2: Initials squared

Every time we read, we are distinguishing shapes. In fact, many graphic designers prefer to use certain fonts because their shapes are more distinct, more legible. A letter is a positive shape—it is the drawn shape. Within and around a letter are negative shapes; for example, an uppercase M contains three negative shapes which look like a V, two upside down and one right side up. In typographic vocabulary, the negative space enclosed by the structural lines (strokes) of a letter is termed the counter. The capital letters A, B, D, O, P, Q, and R have counters. More interesting negative shapes can be created when letters interact, connect, or touch the edges of the counter, as will be seen in the process of the following exercise.

Using your initials, compose the letterforms within a square. The letterforms must, at some point, touch all four edges of the square. Use any font(s). Crop or reverse the letters at will. And please remember that all the negative shapes within the composition should be engaging.

You are not only designing the letterforms themselves within the square, but also the negative shapes they create when they touch each other and the edges of the square.

This exercise is particularly suited to computer drawing software. In addition to using flat shapes of letters, try a second composition creating the letters as volumetric form. Give as much awareness to designing the negative areas as the positive shapes.

This exercise can be repeated using the silhouetted shape of simple desktop objects, such as a scissors or tape dispenser. The object is to explore the design of negative areas in the composition.

Chapter 4:
Color

Chapter 4:
Color

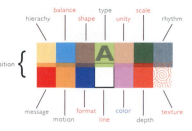

composition {

hierachy · balance · shape · type · unity · scale · rhythm
message · motion · format · line · color · depth · texture

Objectives

- Learn the vocabulary of color
- Understand the basic physical qualities of color
- Learn the fundamentals of color interactions and color in composition
- Gain an understanding of the basic technical aspects of color in print and digital processes
- Become aware of color standardization systems
- Develop sensitivity to the potential expressive qualities of color

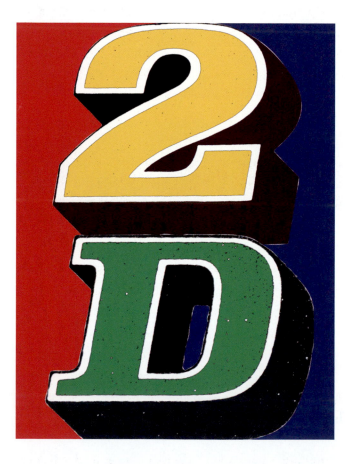

What Is Color?

"The starting point of an understanding of color is a description of light."
—Steve Beeson, physicist at the University of Arizona

Color itself is not tangible, but the surface or object from our physical environment on which color is seen can be touched. **Color** is a property or description of *light energy*, and only with light do we see color. Color does not exist without light.

The colors we *see* on the surfaces or objects in our environment are perceived and known as **reflected light** (Figure 4-1 and Diagram 4-1).

Figure 4-1
Brochure cover and spread: Taylor Guitars
Studio: Mires Design for Brands, San Diego, CA
Client: Taylor Guitars
Whether on a computer screen or the cover of printed matter such as this brochure or in the actual environment, color pervades our vision.

PANTONE 197-4

Diagram 4-1
You can touch the blue ink on the paper of this book, but not the color itself. The blue ink absorbs all colored light except the blue that is seen.

When light strikes an object, some of the light is absorbed, while the remaining or unabsorbed light is reflected. The reflected light is what we see as color. For instance, a lemon absorbs all but yellow light; the yellow light is reflected.

Pigments are the natural chemical substances within an object that interact with light to determine the characteristic color that is perceived, as in the bright yellow of lemons, the greens of grass, and browns of hair. Pigments occur naturally within an object, *or* pigments are manufactured from organic or synthetic sources in the form of powders and liquids and then added to a variety of agents such as oil, acrylic, water, or clay. The pigmented agents are put to use in coloring such things as fabric, food, cosmetics, plastic, paper, paint, and ink. For example, Pantone™ manufactures a custom set of inks used in printing processes; Pantone 197-4 (process) blue printing ink contains blue pigment, as seen in Diagram 4-1. Reflected colors are also known as subtractive colors—noted further in the sidebar (next page).

Pigmented objects in the physical environment and commercially produced pigment substances or coloring agents used for creating the color of printing inks, paint, and dyes are seen as reflected light, but the colors on computer monitors is light energy itself. This energy or wavelength of light (a **wavelength** is a scientific term for a specific kind of progressive, radiating energy) is the color—**digital color**—seen in screen-based media and computer "painting," drawing, and photographic editing software. For instance, when selecting a pure blue color in Adobe Photoshop (defined as Blue 255, Red 0, Green 0), the color seen is actually a blue wavelength of light itself.

The digital color seen in screen-based media is also known as additive color—noted further in the sidebar (next page).

Subtractive and Additive Colors

Color is divided into two physical categories: the reflected light of pigmented objects and the color seen in screen-based media as light energy. Colors containing physical pigments are known as **subtractive colors** or mixtures of pigment. The colors that we see on screen-based media is light energy itself, and are known as **additive colors** or mixtures of light. Mixing light—*adding* light waves together—creates a variety of colors. Conversely, pigmented objects absorb light or *subtract* wavelengths of light, with the unabsorbed wavelengths reflecting off the object and seen by the eye as color. Awareness of the differences between additive color and subtractive color is necessary when *mixing* colors and will be discussed again further along in this chapter.

(See Sidebar Diagram)

The two sets of colors displayed in the diagrams represent the primary group of additive colors (red, green, blue) and the primary group of subtractive colors (red, yellow, blue). The differences are noted in the diagrams and are significant in regard to color mixing with light or with paint.

Sidebar Diagram

Additive color of light:

All hues mixed together will produce white. (As reproduced in this book, the additive colors are simulated. Only on screen can you see actual additive colors.)

Subtractive color of pigment:

All hues mixed together will produce black.

Color Science

Before and following the discoveries of Sir Isaac Newton (1642–1727) and his scientific work on the nature of color, there has been a great deal studied, theorized, and written about color in the realm of physics and optics. Newton used a **prism** to split light into the **visible spectrum** (the wavelengths of light visible to the human eye), as seen in Diagram 4-2. His circular color chart, or **color wheel**, named the visible spectrum while showing the order and interrelationship of the colors (Diagram 4-3). It has been noted by contemporary scholars on the topic (such as the color theory historian John Gage) that Newton's color wheel remains today, with some modification, a standard way to chart and display color relationships.

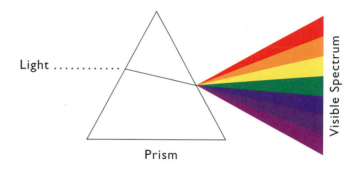

Light · · · · · · · · · · ·

Visible Spectrum

Prism

Diagram 4-2

Although this diagram is not Newton's exact drawing, it illustrates the component colors (the visible spectrum) of light.

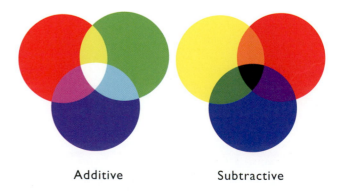

Additive Subtractive

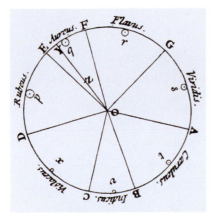

Diagram 4-3
This is a simulated diagram of Sir Isaac Newton's color wheel. Newton joined the two ends of the visible spectrum to create a color wheel. It was created to show a scheme of color mixtures and relationships. The unequal sections correlate with the proportions of Newton's spectrum.

A highly technical review of color physics and optics, as well as the historic and contemporary standardization systems for color, are not necessary for the scope of this book. If further exploration is desired, you can research the physics and optics associated with light energy through sources found in books and on the Web.

Delving into the intricacies of color would also include a study of the historic discoveries and ideas of the scientists and artists concerned with the psychological, artistic, and intellectual analysis of color. Some historic color theoreticians and scientists can be found in the following list. In addition, check the Bibliography for books that will help to expand your study of color beyond the basics presented in this chapter.

Color Theoreticians and Scientists (historic to present day)
- Aristotle (384–822 B.C.E.), Greece, philosopher and general theoretician on the topics of philosophy, physics, poetry, and biology
- Leon Battista Alberti (1404–1472), Italy, architect, artist, and scientist
- Leonardo da Vinci (1452–1519), Italy, artist, scientist, and inventor
- Sir Isaac Newton (1642–1727), England, scientist, mathematician, and philosopher
- Johann Wolfgang Goethe (1749–1832), Germany, philosopher, writer, and scholar
- Michel Eugène Chevreul (1786–1889), France, chemist
- Wilhelm von Bezold (1837–1907), Germany, scientist/meteorologist
- Nicholas Odgen Rood (1831–1902), U.S.A., scientist/physicist, artist/painter

(continued on next page)

- Albert Henry Munsell (1858–1918), U.S.A., artist/painter
- Wilhelm Ostwald (1853–1932), Latvia/Germany, scientist/chemist
- Johannes Itten (1888–1967), Switzerland, painter, teacher, and theorist
- Josef Albers (1888–1976), Germany/U.S.A., artist, color theorist, and educator
- Faber Birren (1900–1988), U.S.A., color theorist

Color Standardization Systems

Currently, many printed and Web resources can be found on the topic of color theory, each varying slightly in regard to how color should be studied, categorized, organized, and standardized. Conducted by scientists and artists both, published scholarly studies and theories have had the goal of establishing systems for the best understanding and standardization of color in design, art, and industry. For instance, the ink manufacturer Pantone offers much in the way of the study of color, in both the technical realm of printing and the creative realm of design. The Pantone web site is an excellent source for information on contemporary thinking about color for design students and professional designers alike.

Standardization has been vigorously pursued in industry in order to organize global manufacturing of colors for inks for printed matter, dyes for textiles, and digital colors used on the Web. Noted in the previous list, Albert Munsell, for instance, published studies and created charts on color standardization systems and color interactions (Figure 4-2). These studies are often used by designers and artists to gain depth and breadth of understanding of the nuances of color.

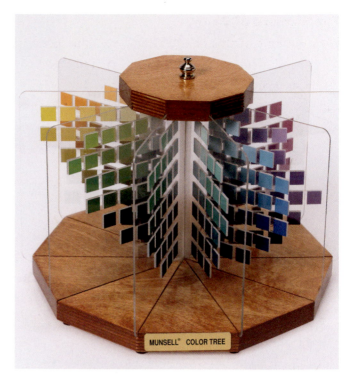

Figure 4-2

The Munsell Color Tree (Courtesy of GreytagMacbeth)
Munsell's chart (also called a color solid or color tree) three-dimensionally diagrams the basic qualities of individual colors. The outermost tip of each spoke is the basic color—light to dark versions of the color, as well as dull to intense versions, are built into the model, moving vertically and horizontal along the spokes.

The Element of Color

For the scope of this chapter and book, the focus is on color in design. Color is both a characteristic of the other basic design elements—format, line, shape, and texture—*and* a complex element in itself because of its individualistic influence in affecting a composition and its breadth of potential communication.

In practical and functional considerations of composing a design, color is essential for organizing a visual hierarchy; color also plays an important role in unifying and balancing a design. Color can create what seems to be dynamic visual energy and rhythm, or it can be employed for designing illusions of space and motion (or enhancing actual motion in screen-based media).

Equal to and perhaps surpassing the flexibility and visually expressive power of lines, shapes, letterforms, and the written word, color is a most potent compositional and communication tool. Color can, at times, conjure intense emotions and memories. Color may be perceived as mystical, whimsical, mournful, peaceful, musical, noisy, or dynamic when seen in conjunction with line, shape, and texture within the context of a design (Figure 4-3).

Figure 4-3

Racing suits: Japan Cross Country

Studio: Eiko Ishioka Inc and @radical.media, New York, NY

Creative director: Eiko Ishioka

Design: Rafael Esquer

Client: Descente

For the 2002 Salt Lake City Olympics, these series of racing suits were designed for the clothing company Descente. Esquer said he referenced human musculature, nature, place of origin, and national identity in the graphics and colors for the suits (for Canada, Switzerland, Spain, and Japan).

The bold lines and striking red and white colors of the Japanese Cross Country suits (pictured) are an excellent example of how a limited color palette can still be bold, rich, and expressive (and in this case combined with geometric line). The colors also echo those found on the flag of the country of Japan.

In regard to communicating visually, on a grand scale throughout history and across global cultures, color has been applied on far-reaching symbolic levels to represent religious ideals, royal status, or notions of death, innocence, and wealth. In the contemporary business world, color is often used to represent a brand, such as the red of Coca-Cola or the Tiffany™ turquoise-blue. The emotions, associations, symbolism, ideas, sensations, and thoughts embodied by color seem to be boundless.

The physics of light and the science of optics are interesting; however, for a designer, the element of color is all about creating and selecting colors and then manipulating those colors in a composition for organizational and expressive purposes. Through practice, a designer may develop a thought-filled "sense" for color.

Designer Rodrigo Sanchez explores a host of interesting color variations in the magazine covers for *Metropoli,* as seen in Figure 4-4.

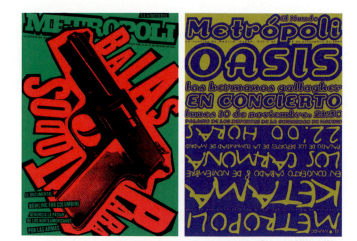

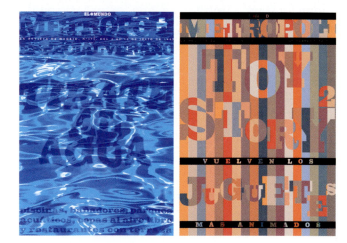

Figure 4-4
Magazine covers: *Metropoli*
Studio: Unidad Editorial, S.A., Madrid, Spain
Art director and designer: Rodrigo Sanchez
Client: EL MUNDO

Mixing and Selecting Colors

When you begin to compose with color, remember that even though we all seem to have our favorite colors, designing with color is not entirely subjective. There are far more important reasons for choosing colors for a design than your personal taste. In fact, personal taste should play only a small part in designing. All designs begin with a message to be communicated. The designer should then compose all the elements in a way that best expresses the necessary message, as displayed, for instance, in the work of artist and designer Luba Lukova. Distilling the elements to a few simple components in order to communicate a complex, emotional message is a challenging task for even the most experienced designers. Lukova is a master of communicating complex emotions within a highly simplified design, as seen in her poster for KidsUnique (Figure 4-5).

Basic to the start of designing with color is developing an awareness of the physical aspects of *mixing* color using paint, ink, and digital means, plus knowledge of the fundamental physical qualities of color (warm, cool, light, dark, etc.), and understanding how these qualities affect composition in regard to unity, balance, rhythm, hierarchy, and spatial illusions. In addition, a designer must become aware of the globally affected and often personally subjective emotional and intellectual perceptions of color.

To establish a basis for *mixing* color and selecting color for composition and effectively communicate a message, a study of color begins with:

- Understanding types of color and color qualities
- Basic color relationships noted in color wheels
- Basic color relationships beyond the color wheel
- Basic technical considerations

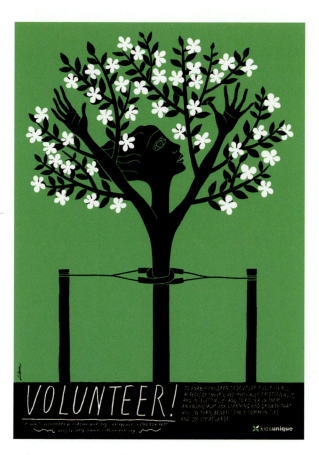

Figure 4-5
Poster: *Volunteer!*
Studio: Luba Lukova Studio, Long Island City, NY
Designer and illustrator: Luba Lukova
Client: KidsUnique
Limiting the color of the poster design to green, black, and white is both practical in an economical respect (comparatively inexpensive to reproduce) and expressive. The single green color is bright and seems in a very basic way to project an inviting, upbeat feeling and/or a feeling of innocence and sincerity—appropriate to the message being communicated.

Color Qualities

When selecting a color for a design from a computer color menu or printing ink chart (Figure 4-6), or when mixing a color with paint, ink, or light, it is important to be aware of and sensitive to the qualities of color. With awareness and knowledge, you can better mix or select and then manipulate colors in composition.

In order to differentiate the physical character of the millions of colors that exist in our environment, colors are mixed, described, and named in terms that refer to their properties or qualities. Each color has four distinct qualities:

- Hue (the color itself)
- Value (also known as luminosity, brightness, tint/light, shade/dark)
- Saturation (also known as intensity, tone, chroma)
- Temperature

Hue

Hue is the name given to the color we see. The words "color" and "hue" are often used synonymously. Although there are millions of colors in our human environment, only six words may be necessary in order to name or describe a hue. They are the names most often used in reference to the hues of the visible spectrum of light.

- Yellow
- Orange
- Red
- Violet
- Blue
- Green

A single color will usually contain more than one hue; however, the color is most often described by naming its dominant hue or dominant combination of two hues, such as red-orange, blue-green, or yellow-green.

Figure 4-6

Adobe Photoshop color menu (top)

Computer "paint" systems can mix millions of colors—far more than the human eye can distinguish.

Pantone color chart (bottom)

Color Names

A great deal of brainpower has gone into the naming of color for mass market purposes. Beyond the six names of the fundamental hues of the visible spectrum (yellow, orange, red, violet, blue, and green) and their pairs (yellow-orange, blue-violet, etc.), there are some familiar words and modifiers used to distinguish the various qualities of the basic group: brown, pink, cyan, magenta and maroon, for instance, or dark red and light blue. Colors are also named according to the origin of the coloring agent or pigment, such as in mineral colors: turquoise, cobalt, and gold. Some color names are associated with fruits: melon, lime, and peach. If you think naming color is easy, try giving names to the following group without using the six basic hues.

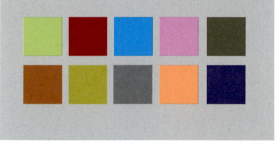

Achromatic, monochromatic, and polychromatic are additional terms used in certain instances when describing color. **Achromatic** is without hue (contains only black, white, or gray); **monochromatic** refers to having a single hue (may contain variations in brightness and darkness), and **polychromatic** consists of many hues.

In appropriate instances, designers may select a limited (one or two) color combination or scheme (a purposely related group) for a particular project solution to keep printing costs at a minimum—one color costs less money to print than two. A monochromatic scheme can reduce visual "noise" or confusion, making the composition easier to read. Limiting color can simplify the design in order to have the impact of a single hue as the identifier of a product or business entity (Figure 4-7).

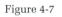

Figure 4-7
Logo and stationery design
Studio: Cinquino + Co., West Paterson, NJ
Art director: Ania Murray
Designers: Ania Murray and Jennifer Sencion
Client: Cinquino + Co.
The basically monochromatic color scheme (orange and its variations from light/cream white to dark/brown) of the identity system helps to make the design memorable. One or two dominant colors are easier to identify and remember than three or four colors.

Color Value

Value refers to the relative level of luminosity—lightness or darkness—of a color, for instance, dark blue or light green. Each color has a range of value (Diagram 4-4).

To adjust the value of a hue, two neutral colors are employed: pure black and pure white.

Black and white are colors (pigment), but they are not considered hues. The two are not found in the visible spectrum, and therefore are considered achromatic or *neutral* (without hue).

Black and white have relative value and play an important role in mixing color. Black is the darkest value and white is the lightest. Mixed together, black and white make gray. Grays are the interval neutral colors between black and white. Black and white are separately mixed into paint and ink colors to make them darker **(shades)** or lighter **(tints)**. A black and white mixture will also dilute the intensity of the hue—noted in the next section on saturation.

Even if black and white seem to be pure, some level of hue may still be discernable. A neutral black or white can appear to be "warm" (containing red, orange, or yellow) or "cool" (containing blue, violet, or green)—see Diagram 4-5 (top). (Color temperature is discussed further along in this section.) A neutral color will also react to and be affected by its placement in a composition. Placed next to or among a particular hue, the pure neutral color will seem to take on the hue itself (Diagram 4-5, bottom).

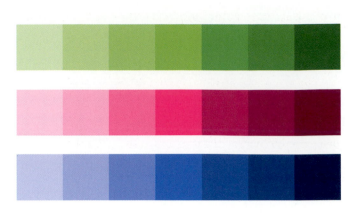

Diagram 4-4
The value gradations illustrated display the range of light to dark values of each color.

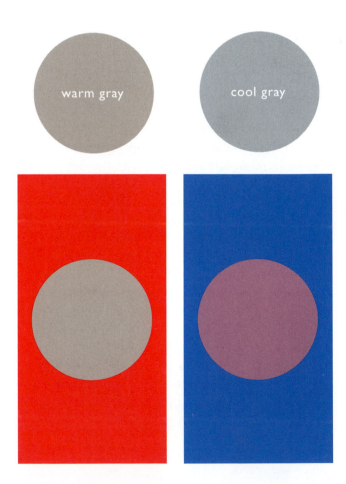

Diagram 4-5
Gray can appear to be both warm and cool (top). Surrounded by a particular hue, gray will appear to have some of the qualities of the hue (bottom).

In composition, **value contrast**—the relationship of one element (part or detail) to another, in respect to lightness and darkness—is most useful for purposes of differentiating shapes. Note the value contrast of the type (black) and substrate (white paper) of the page of words you are now reading—the value contrast most clearly differentiates the figure (words) from the ground (page). Hue contrasts alone have less impact and therefore may not be as effective for differentiating between the figure and ground images or between elements of a single composition, as seen in the grids of Diagram 4-6.

Creating an overarching value for a single composition, where the whole composition is atmospherically dark or light, affects the message that is communicated—there may be a suggestion of an uplifting feeling (Figure 4-8) or a dark and brooding feeling, depending on how the overarching value was manipulated.

Beware of narrow interpretations of dark and light values. The symbolic use of colors (including hue, value, and saturation) depends on the cultural context in which the color is seen—white can mean mourning or happiness or purity, depending on the cultural context and traditions. In the United States, dark colors often seem to represent the masculine or mysterious, dangerous or sophisticated, depending on the portion of area covered in dark colors and the imagery and use of other elements in the design. Light colors may seem sincere or innocent. Do not expect a formula for exacting symbolism from a color value, saturation, and/or hue. Symbolism is relative to both its perceptual context (the individual association and/or the culture and environment in which it is seen), and its relationship with the other elements in the design itself.

Value contrast Hue contrast

Diagram 4-6
Value contrast obviously creates the greatest differentiation between the figure and ground, as seen in the grid of highly contrasting values vs. the grid of similar values.

Figure 4-8
Print advertisement: North Carolina Department of Travel and Tourism
Agency: Loeffler Ketchum Mountjoy, Charlotte, NC
Creative director: Jim Mountjoy
Art director: Doug Pedersen
Copywriter: Curtis Smith
Photographers: Olaf Veltman and Stuart Hall
Client: North Carolina Department of Travel and Tourism
The light value of this composition (photo, text, and graphics) gives it the upbeat atmosphere necessary to communicate of the pleasure of visiting the beach on vacation.

Compare this composition with that of another in this series of ads, Figure 4-9. Note that the dark value of that composition has a brooding and dramatic feel that enhances the drama of the landscape pictured. The overall color value of each of the compositions adds significantly to the communicated feeling.

Color Saturation

Saturation refers to the brightness or dullness of a color or hue; a hue at its highest level of intensity is said to be purely saturated. A saturated color (Diagram 4-7, top row) has reached its maximum **chroma** and does not contain a neutralizing color (pure black or white are without hue) or the mixtures of the neutral colors (gray). Mixed with black, white, or especially gray, the fully saturated hue becomes dull in various degrees (Diagram 4-7, middle row). The neutral colors dull the intensity or saturation because they dilute the hue. A color mixed with gray is called a **tone** or a reduction of the fully saturated hue.

Color saturation may be selected and adjusted for practical function within a composition. A saturated color will call attention to itself when placed alongside duller tones, as seen in Diagram 4-7 (bottom).

A single saturated hue on a black-and-white page or computer screen will seem to yell "look at me" because it is the most vivid. In a composition, a bright or saturated hue has an advantage of being noticed first when surrounded by hues of lower saturation (Figure 4-9).

Diagram 4-7

Saturated colors contain no neutralizing color (top). A gradation of gray mixed with saturated color will make the color dull (middle). The saturated color draws the most attention when placed next to hues that are duller. This relationship of colors is helpful in organizing a ranking order of focal points in a design (bottom).

Figure 4-9

Print advertisement: North Carolina Department of Travel and Tourism

Agency: Loeffler Ketchum Mountjoy, Charlotte, NC

Creative director: Jim Mountjoy

Art director: Doug Pedersen

Copywriter: Curtis Smith

Photographers: Olaf Veltman and Stuart Hall

Client: North Carolina Department of Travel and Tourism

In this photographed landscape and the accompanying design, note how the bright, highly saturated color of the tent is a focal point in a composition dominated by colors of lower saturations.

A gradation of tones from a hue's highest level of saturation to pure gray may be used in compositional hierarchy, with the most intense hue being the focal point and gray as the least important element. Note that the amount of area covered in the composition is also a contributing factor to the success of a visual hierarchy. The more area that is covered with a fully saturated color, the more important it will be. The elements are all relative to each other.

For communication purposes, dull tones may seem to suggest "quiet" or "calm" in comparison to "loud" fully saturated hues. Many saturated colors in one composition may create a lively, dynamic, even rhythmic appearance, as seen in the pages of the web site pictured in Figure 4-10.

Employ colorful, saturated hues in a design because they have the potential to add importance and can be compelling and meaningful, but use them sparingly (hues cost more to print than black on white) and wisely to avoid a cacophony of colors.

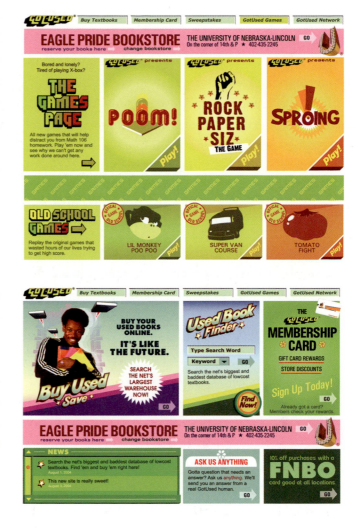

Figure 4-10

Web site pages: GotUsed

Studio: Archrival, Lincoln, NE

Designer: Clint! Runge

Programmers: Bart Johnston and Craig Kohtz

Producer: Joe Goddard

Illustrator: Carey Jaques

Animator: Cassidy Kovanda

Client: GotUsed Bookstores

Copyright GotUsed 2004

Because of the time and expense involved, buying college text-books can be a daunting task for students. The brightly saturated colors of these web pages may help to counter the difficulties by creating a lively and dynamic appearance that feels ultra-friendly and attractive to the target audience of college-age students.

Whether using two colors or ten colors on a web site, the cost of the color does not increase as it would in print. However, a web site (or a print design) with too many unorganized colors may look chaotic, and be difficult to navigate and slow to load—which could cause the visitor to leave the site. To quote the excellent, albeit often used, design idiom, less is more—as illustrated in the packaging for Vong™ food products, in Figure 4-11.

Color Temperature

A hue can also be perceived to be warm or cool in temperature. This **color temperature** refers to whether the color *looks* hot or cold. Color temperature cannot actually be felt; it is perceived in our minds through association and memory.

The warm colors are said to be reds, oranges, and yellows, and the cool colors are blues, greens, and violets (Diagram 4-8).

Keep in mind that the temperature of a hue is not absolute. Color temperature can fluctuate depending on the strength of the dominant hue within a color; for instance, a red may contain blue, making it "cooler" than a "hot" red-orange. Saturation and value will also affect the temperature of a color. Dull colors (toward gray) and dark colors (toward black) are difficult to distinguish in terms of hue because the hue is diminished and therefore difficult to name in terms of temperature.

Importantly, temperature is a contributing factor in composition and communication. Temperature is often employed in composition for practical purposes, such as contrast and hierarchy, balancing and unity, and at the same time for expressive purposes, such as to suggest a feeling of warmth, heat, or placid coolness (Figure 4-12).

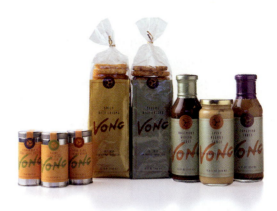

Figure 4-11
Packaging: Vong
Studio: Louise Fili Ltd., New York, NY
Art directors: Louise Fili and Mary Jane Callister
Client: Jean-Georges Vongerichten
The predominance of low saturation of color in this packaging design helps to give the simple products (crackers and condiments) a sense of quiet sophistication.

Cool Colors

Warm Colors

Diagram 4-8
Color Temperature

Figure 4-12
Magazine covers: *Metropoli*
Studio: Unidad Editorial, S.A., Madrid, Spain
Art director: Rodrigo Sanchez
Client: EL MUNDO
Hot oranges and reds contrast with icy blues in these magazine covers for *Metropoli*. The powerful contrast is visually stunning and disturbing at the same time. The orange is also used to bring attention to the center of the composition. Imagine the color temperatures inversed—think of the change in message and design.

Basic Color Relationships

Many theoretical and scientifically-based systems and their corresponding charts have been formulated to help designers and artists understand the nature of color and color relationships. Recommended for further study are the following researchers of color in art and design:

- Albert Munsell
- Johannes Itten
- Faber Birren
- Josef Albers

It is helpful to familiarize yourself with the many studies on color categorization and theory; however, each study is a full-length book in itself and too extensive to cover at this point. As an introduction to understanding the fundamental color relationships (and therefore employing in a design), a simplified pigment color wheel based on most of the hues in the visible spectrum can be a starting point for studying color interrelationships and interactions (Diagram 4-9).

The Primary Colors

The color wheel noted in Diagram 4-9 reduces color to it most fundamental hues, with red, yellow, and blue representing the **primary colors** of pigment (subtractive colors). These three primary colors are those from which all other colors are mixed.

However, it must be noted that the primary colors of *light* mixtures (additive colors) are different from the pigment mixtures that are used for mixing ink and paint. The primaries of light are red, *green*, and blue—**RGB**. The light primaries are the three basic colors from which all other colors are mixed when using digital media.

During lithographic printing, **process colors** (basic standardized ink colors) are mixed optically using a complex interlocking layering of thousand of dots. The primary colors in the printing process are cyan (blue-green), magenta (red-violet), and yellow (black is also included in the process although not always considered a primary): **CMYK** (Figure 4-13).

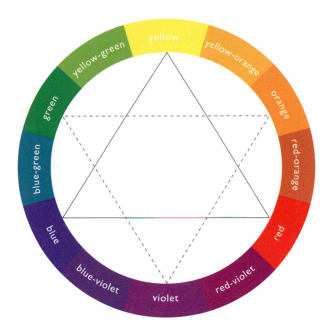

Diagram 4-9
Pigment Color Wheel

Figure 4-13
Adobe Photoshop Color Picker
For mixing color in photo-editing or drawing software on a computer, the light primaries of red, green, and blue (RGB) are used, or a specific hue is selected along with the saturation and brightness (HSB), or the color can be mixed using the process colors (CMYK).

Primary and Secondary Hues in Composition

No matter which primaries (additive, subtractive or process) are used to mix the color, the color *selected* for a design should be employed on two levels—the functionally practical and the conceptually expressive. The study of color relationships and the arrangement of color in composition starts with the *pigment* color wheel because it is this chart that diagrams the basic color relationships, color harmonies, and color interactions that we see in a *final* design on the printed page and screen-based media.

Returning to the pigment primaries, note the lines drawn to connect the three basic hues on the color wheel in Diagram 4-9. The lines drawn between the primary colors on the diagram form an equilateral triangle and indicate the equal and basic interrelationship of the most basic group of colors. Because the primary colors are the most fundamental interrelationship, they often have what seems like bold and simplistic (Figure 4-14) or innocent and nostalgic feeling (Figure 4-15) when used together in a design.

Figure 4-14

Offset photolithograph, 39 5/16" x 27 1/8". Gift of the designer. (855.1979)

Designer: Per Arnoldi (b. 1941). Spar. 1978.

The Museum of Modern Art, New York, NY, U.S.A.

Digital Image © The Museum of Modern Art/Licensed by SCALA / Art Resource, NY

The bright and basic red, yellow, and blue colors of this poster complement the simple, bold shapes.

Figure 4-15

Packaging: Late July® Crackers

Studio: Louise Fili Ltd., New York, NY

Art director: Louise Fili

Designers: Louise Fili and Chad Roberts

Illustration: Graham Evernden

Client: Late July Snacks

The red, yellow, and blue colors of this packaging system have a nostalgic feel that is meant to be evocative of the innocence of childhood.

The **secondary colors**—green, orange, and violet—are mixtures of the pigment primaries (the light secondaries are yellow, cyan, and magenta). The secondary colors have less hue contrast among themselves than the primary colors as they are mixtures and visually relate more to each other.

Pigment Secondaries

yellow + blue = green

red + yellow = orange

blue + red = violet

Beyond the Basics

Further mixtures of the pigment primaries and secondaries will yield a third set of hues that are **interval colors** between the two: red (primary) + orange (secondary) = red-orange (interval).

The three sets of hues (primaries, secondaries, and intervals) comprise the basic pigment color wheel. The color wheel may be used as a guide to mixing, and more importantly, it diagrams and aids in selecting the basic, visually harmonious color combinations.

The role and character of neutrals—white, black, and gray—in composition and communication varies in relationship to the set of hues these neutrals may accompany. White, black, and gray are often considered areas of "rest" within a group of rich hues, or they may darken or lighten a design. White and black contrasts may also be used to distinguish an image or letters within a composition.

Further study of the basic pigment color wheel (Diagram 4-10) reveals additional **color schemes**—purposely related groups of colors—which are thoughtfully selected for use in a design or image.

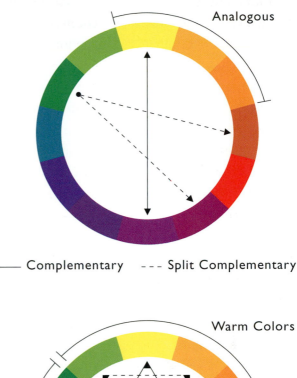

Diagram 4-10

The color wheel is used to illustrate fundamental color relationships. Analogous are three adjacent hues. Complementary are two opposing hues. Split complementary are two near hues in opposition to one hue. Triadic are three hues at equal distance from each other. Tetradic are two sets of complements. Cool and warm colors are blue, green, and violet hues vs. yellow, orange, and red hues.

Color Schemes

The color schemes presented here are not formulas or absolutes, but rather starting points for designing with color; also consider changes in value and saturation and the addition of neutrals to each scheme to add diversity and clarification between and among hues.

Monochromatic color schemes employ only one hue (may have variation in value and saturation). Monochromatic schemes establish a dominant hue identity while still allowing for contrasts in value and saturation.

A monochromatic palette can be:
- Good for unity and overall balance
- Easy to manage
- Simple, neat, clean, and/or often restrained in feeling

Analogous color schemes employ three adjacent hues. When used together in a composition, analogous colors seem harmonious and unified in appearance. The harmony is created because of their *similarity* to one another. Analogous colors seem to calmly or passively relate.

An analogous palette can be:
- A simple and harmonious group
- Similar to the monochromatic scheme, but more diverse
- One hue may be used to dominant, while two offer supporting roles

Complementary color schemes show the relationship of any two opposing hues. Complementary colors are *opposite* one another on the color wheel, and therefore seem to create visual vibrations, strong contrast, tension, or opposition when paired together in a composition.

A complementary palette can be:
- Visually dynamic and high in contrast
- May create visual "tension"
- Difficult to balance

Split complementary color schemes include three hues: one hue, plus the two colors adjacent to its complement. As a set of three, split complements interact on a more complex level than simple complements, with two of the hues in relatively close proximity to one another and one in opposition to the two. The relationship of complements or split complements makes visual connections within a composition—the sets seem to feel complete because they are a balance of opposing forces.

A split complementary palette can be:
- High contrast without the strong tension
- More diverse than the complementary scheme
- Creates harmony through a balance of opposing forces

Triadic schemes include three colors that are at an equal distance from each other. The basic triadic groups are the primary and secondary colors, although other triads exist such as red-orange / blue-violet / yellow-green. A triadic group is harmonious because of a sense of visual equalibrium—with each color being or containing one of the primaries.

A triadic palette can be:
- Diverse in color with good hue contrast
- Harmonious and easy to balance

Tetradic color schemes contain four colors in two sets of complementary pairs (double complementary). Strong contrasts, but difficult to balance and harmonize if all four colors are used in equal amounts—select a dominant color to establish a focus or anchor. A tetradic palette can have excellent variety and range.

A tetradic palette can be:
- An excellent source of variety
- Adds range to compositions

Cool colors are the blue, green, and violet hues (roughly the left half of the color wheel). Cool and warm colors are in opposition on the color wheel and seem to create visual tension or spatial "pushing and pulling" effects when composed together. Yet, when all cool hues are found in a single composition, the effect may be one of harmony—noting that they are adjacent on the color wheel and therefore alike.

A cool color palette can be:
• Like analogous in simplicity and harmony
• Easy to balance

Warm colors are the yellow, orange, and red hues (roughly the right half of the color wheel). Cool and warm colors are also in opposition on the color wheel and seem to create visual tension or spatial "pushing and pulling" effects when composed together. Yet, when all warm hues are found in a single composition, the effect may be one of harmony— noting that they are adjacent on the color wheel and therefore alike.

A warm color palette can be:
• Like analogous in simplicity and harmony
• Easy to balance

The effects described above refer to hues of full saturation and middle range in value. When composing color, the hue, saturation, and value should all be taken into consideration. As levels change in value or saturation, the expressiveness and practical usefulness of the color are affected. In addition, consider the role that neutral colors play in color relationships. Neutral colors may often be employed to give the reader/viewer a "rest" from the visual stimulation created by many hues. In a composition of dense hues, the addition of white seems to "open" a space for the design to "breathe." Black has the tendency to "close" space and create a dense or heavy feeling. These interactions, of course, are relative to the size of the area in the composition that is covered by the neutral color and the shapes that are employed. Re-examine the *Metropoli* magazine covers (Figure 4-4) to observe how black and white are used in the designs.

Infinite Variations

The basic pigment color wheel relationships are an excellent starting point for selecting colors for composition; however, color relationships, combinations, and **color palettes** (a group of colors selected for use within a single design) reach well beyond the color wheel. Combinations are limited only by the mind and imagination of the designer— variations are infinite. Color and color groupings can be found in nature, art, the history of design, and the imagery of global cultures.

The following is a short list of example color groups that can be used as a guide to creating color interactions and communication for a design. Each of the groups of colors carries its own set of associations and meanings. Research on the cultural symbolism or basic expressiveness of the color groups should be conducted before employing them for a design.
• Earth tones
• Mineral tones
• Acid colors
• Bright colors
• Dull colors
• Neon colors
• Tropical colors
• Batik colors
• Ancient Chinese ceramic colors
• Ancient Egyptian colors
• Russian Byzantine colors
• Colonial American colors
• Art Deco colors
• Victorian colors

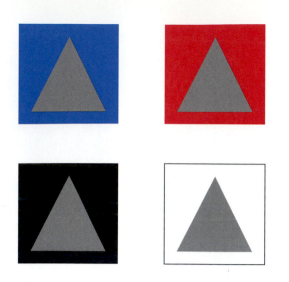

Diagram 4-11

Middle-value gray surrounded by a cool hue will appear cool and of that hue (top left). The same gray surrounded by a warm hue will now appear warm (top right). Middle-value gray surrounded by black appears lighter than when surrounded by white (bottom).

Diagram 4-12

The interaction of warm and cool colors can create a lively "pushing and pulling" of colors within the composition.

Affective Juxtapositions

A design always uses at least two colors: the figure color (positive area) and the format or substrate color (paper or computer screen). Therefore, colors should be selected in conjunction with the other color or colors of the design because the juxtaposition of colors will affect how they look individually. One color can look different, depending on the color that surrounds it. For instance, a cool color may appear warmer on a warm color background, or a mid-level gray may appear darker on a light background or lighter on a dark background (Diagram 4-11). Sensitivity to interrelationships of color is necessary in controlling color effects.

Spatial Illusion and Motion

Juxtaposition of colors may also create an illusion of spatial depth or movement. Cool colors may at times appear to recede into the pictorial space when juxtaposed with saturated warm colors—creating a "push" toward the viewer or a "pull" away from the viewer, as seen in Diagram 4-12. "Push-pull" effects are also helpful for creating visual hierarchy by pushing the most important element of the composition out toward the viewer and pulling the less important elements back into the picture plane.

Ramped colors (a smooth gradation between values or intensities) have a tendency to look dynamic, whether using two hues or one hue of two values or saturation. The gradient seems to "move" the color along in a path from the starting color to the end color (Diagram 4-13).

Diagram 4-13

Ramped color, or gradation of color, creates the illusion of movement from one side to the other.

Technical Considerations

For a student in visual communication, designing with color can be daunting. The dual responsibility of having to select and compose colors for a particular design solution and needing to understand the technical aspects of color production is, in short, exceptionally difficult. Metallic bronze ink may possibly be a good choice for a museum exhibition brochure, but in regard to printing, a metallic ink cannot be reduced in saturation or value—it is more expensive than black ink and physically difficult to work. Metallic ink doesn't always dry quickly (or dry at all on certain papers).

Printers (printing company experts) are very helpful in educating designers about the pitfalls of color printing and the nature of ink on paper. As a designer, you must constantly interact with printers in order to obtain colors that physically function well. Having a knowledgeable and conscientious technician, printer, or computer programmer guide a designer through technical color production in print or on screen-based media is essential. However, the student and professional designer should also have a basic awareness of color print production, ink mixtures, and screen "safe" colors—and their problems.

As noted earlier, basic color knowledge should include awareness of the process colors (CMYK) and the Pantone color system of ink selection. In addition, students of design should be aware that colors on the Web are, for a large part, unstable; therefore, a palette of the 256 Web "safe" colors has been standardized. The Web-safe colors are listed in the Adobe Photoshop and Illustrator and other Web software color selection directories (Diagram 4-14).

Diagram 4-14
Web-Safe Color Palette

Web-safe colors are those that are somewhat consistent and most reliable when viewed on computer monitors across platforms (Windows or Apple) and across browser software (Explorer, Netscape, Safari, etc). The platforms and browsers do, however, still display these colors slightly differently.

The myriad of technical aspects regarding color is too expansive to be discussed at this point; however, technical basics should be a part of a design education—found in specialized courses such as preparing design for printing and web site production and other courses for screen-based media.

Color and the Principles of Design

As an element of design, color affects the composition in regard to the organizing principles of design: hierarchy, balance, unity, and rhythm. The principles of design are explored in more depth in the chapters ahead; however, some fundamental strategies for composition are noted at this point.

First, the elements of the composition should be selected and manipulated in order to communicate a particular message or idea. Simultaneously, the elements should be an organizational guide to help a viewer or reader through a composition (whether a single page, booklet, or web site), in order to best present the idea or message to be communicated.

Focal Points and Visual Hierarchy

Noted in previous sections of this chapter and repeated here for emphasis, color value and/or saturation contrasts can be employed to create **focal points** (the part of a design that is most emphasized) and visual hierarchy (discussed further in Chapter 8) within a composition. For example, a palette of low-saturation colors will allow a single intense color to stand out when placed among them (and visa versa). One saturated color amid a group of neutrals (black and white) will focus attention to a particular location, as seen in the web page illustrated in Figure 4-16.

Rank the elements of a design in order of importance, then use whatever means—color hue, color saturation, or color value, along with size, shape, texture, etc.—to implement the ranking.

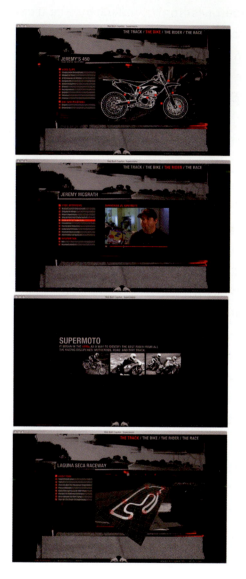

Figure 4-16

Web site: Red Bull

Studio: Odopod, San Francisco, CA

Art directors: Tim Barber, Jacquie Moss, and David Bliss

Designers: Chris Brown, Michelangelo Capraro, Gino Nave, Ryder S. Booth, and Andre Andreev

Illustrator: Alan Eldridge

Photographer: Bryan Medway

Executive producer: Kevin Townsend, Science Fiction

Producer: Gwinn Appleby

Client: Red Bull

Focal points can be used to bring attention to the product or service in an ad, or perhaps to make the main navigation menu of a web site most prominent.

Contrast of color value, saturation, and, at times, hue can be employed to create a hierarchy of visual attention that guides the viewer through a composition; nevertheless, color does not act in isolation. The size of the area (shape or ground) covered by a particular color will also affect the overall result; large areas of saturated color will dominate small areas. As the hierarchy is created, the coverage should be considered along with the quality of color used.

Color and Balance

Designing all elements as a whole, with each affecting the other, is especially critical to balancing a composition. As seen previously in Figure 4-9, one or two intense colors placed amid a group of low-saturation colors will have a great amount of visual attraction or visual importance. This occurs because the saturated color has what can be called a greater amount of "visual weight" when seen in comparison to less intense colors. If one area of a composition "weighs" heavily, it needs to be balanced in some way by other color qualities and/or elements in the design. As seen in (Figure 4-17), a composition may contain one small shape of bright or intense hue that is used to capture attention (for emphasis), while the whole of the composition is counterbalanced by large areas of less intense, neutral, or complementary colors. In Figure 4-18, the intense hues and neutral colors are equally distributed throughout the composition for overall balance.

There are an infinite variety of strategies that may be employed for balancing color. Balance of the elements is discussed in more depth in Chapter 7.

Figure 4-17

Magazine cover: *Diseno Grafico*

Studio: Estudio Mariscal, Barcelona, Spain

© 2006 Artists Rights Society (ARS), New York/VEGAP, Madrid

The saturated red hue attracts much attention because it is isolated in a field of less-intense, neutral colors (top) or a less-intense field of a complementary hue and neutrals (bottom). However, in each case, the red shapes are not overwhelming—the small, intense red is counterbalanced by large areas of less-intense color.

Figure 4-18

Magazine cover: *Metropoli*

Studio: Unidad Editorial, S.A., Madrid, Spain

Art director and designer: Rodrigo Sanchez

Client: EL MUNDO

The neutral light and dark colors and the intense hues are distributed equally throughout the composition to create an overall sense of balance among the colors.

Color and Unity

Repetition of line, shape, type (words), and texture—as well as color—throughout a single page, brochure, or web site organizes the composition on two levels. The composition feels "whole" because similar elements are repeated throughout (in various amounts), thus making visual connections (Figure 4-19). Feeling connected leads to a sense of unification and completeness. Basic color schemes are employed not only for their expressiveness, but also to unify the composition—the relationships are often harmonious and/or familiar.

For a web site, magazine, or book, repetition of color unifies the many levels or pages that a viewer must navigate and flip through. If each layer or page contains a different palette of colors, the viewer will quickly become disoriented as to the whole. Repetition—in this case with the use of color—creates continuity on the many changing screens of a multilevel web site or the many pages of a magazine.

The principles of design are interconnected—the repetition of colors may create a sense of unity and at the same time create a rhythm (or a beat or pulse) and flow within the overall composition. Note the continuity of color employed through several pages in the web site shown in Figure 4-16.

Expressive Potential of Color

Designing with color does not predictably yield a precise result. Be aware that colors *suggest* rather than precisely define. Color communication is relative—in context to the other elements of design, to the historic use of color, and to the contemporary culture in which it is seen. The colors selected for the stationery system designed by Keith Rizzi (Figure 4-20) are a personal interpretation of style for the design studio he directs with Debra Rizzi, his wife.

Figure 4-19

Web site: School of Visual Arts / MFA Design Department

Studio: Tarek Atrissi Design, The Netherlands

Art director and designer: Tarek Atrissi

Client: School of Visual Arts

The repetition of color in this web site creates an overall sense of unity and assists in making the site easy to follow.

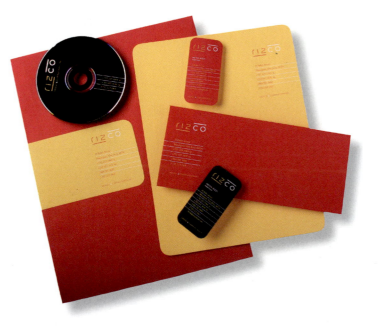

Figure 4-20

Stationery: Rizco Design

Studio: Rizco Design, Manasquan, NJ

Art director/designer: Keith Rizzi

Client: Rizco Design

Rich paper drives the colorization of Rizco's stationery program. Rizco Design selected Smart Paper's Carnival line including vibrant, vellum red and yellow papers. Custom PMS colors were derived from the paper to match engraved pieces across the board. Curved edges on all components add the finishing touch.

In addition to the basic expressiveness noted in the color schemes listed previously, colors and color groups have meanings and associations established from their historic use in design, fine art, and industry. Both the history of design and contemporary trends must be understood to visually communicate with color in a smart, analytical, and effective way.

Knowing which colors were used, and how, in historic and contemporary design, creates the option of choosing to repeat the past creatively or nostalgically without copying an established brand palette, such as the Crayola™ corporation's distinct secondary palette of yellow-orange and dark green, or the FedEx™ corporation's palette of red-orange and red-violet. It is the designer's responsibility to select a fresh palette of colors for a distinct design solution.

Colors have also been studied for their psychological and physiological implications. For instance, in the United States, studies on the color red have revealed that it may stimulate the appetite. Many food companies use red on their packaging for this reason. Some understanding of the basic psychological and physiological studies on color is very helpful in selecting color for visual communication.

Individual Interpretations

Individually, color speaks to each viewer on several levels (emotional, intellectually, and physically), and each color may be interpreted in different ways by its viewers.

Bring the color of metallic bronze into your mind's eye, and flood your visual imagination with the color. Let yourself freely associate with it. Now, ask yourself these questions: What associations do you have with the color? Olympic medals? Ancient statues? Skin color? Ancient tools? How does metallic bronze physically feel? Cold? Warm? Hot? What does the color express? Mystery? Richness? Tradition? Achievement? What other physical properties and qualities does it possess? Is it dull? Bright? Hard? Each color, selected from the multitude that exists, may suggest an emotion, a physical feeling, and/or a state of being, and each color carries many associative meanings.

There is much to be observed and read that can help in understanding the diverse meanings of color. Alexander Theroux, an author and researcher of the human experience, has written two interesting books that are eloquent compendiums on the relationship of color to historic and contemporary religion, politics, society, art, music, literature, folklore, language, business, and nature. He divides his studies (and books) into two categories: *The Primary Colors* and *The Secondary Colors*.

Theroux notes that blue is a mysterious, marvelous, and noble color, but that it is also the color that we associate with illness and raw meat. Color can often contradict itself. For instance, Theroux also notes that the blue-black sky of the nineteenth-century artist Vincent van Gogh's painting *Wheat Field with Crows* (1890) seems to express the painter's doom (Figure 4-21).

Figure 4-21

Painting: *Wheat Field with Crows* (F0779), Vincent van Gogh (1853-1890)

Auvers-sur-Oise, July 1890

Oil on canvas 103 x 50 cm

Amsterdam, Van Gogh Museum (Vincent van Gogh Foundation)

A blue-black sky in this Post-Impressionist painting seems to suggest an ominous feeling. Note as well the carefully composed orchestration of warm and cool contrasts, the balance of red color on either side of the composition and the center, and the myriad of lines that create both atmosphere and shapes. A study of the history of fine arts can greatly enhance the study of graphic design.

Van Gogh may have evoked a sense of doom by painting a blue-black sky, but Theroux also tells us of the fluctuating expressiveness of color by citing this quote from Grace Mirabella, editor of *Mirabella* magazine, who said, "A blue cover used on a magazine always guarantees increased sales at the newsstand. It is America's favorite color."

Research color symbolism on the Web for further information on this rich and diverse topic.

Branding with Color

Because primary colors for the most part are predictable in their expressiveness—often seeming to feel simple, innocent, pure, and wholesome—many corporations have adopted primary color palettes for the identity of their products and services. The red, blue, yellow, and white color palette employed by Interstate Bakeries Corporation for their Wonder® Bread uses the primary colors and white for a feeling of childlike playfulness and purity. In the United States, the primary colors are so often associated with children and the secondary colors with adolescents that these palettes have become cliché. Yet, as seen previously in Louise Fili's packaging for Late July crackers (Figure 4-15), you can still work with the primaries and have them appear fresh—essentially by adjusting the color qualities in a way that is not repetitive of other designs. Expanding on a well-known color relationship and manipulating the physical feel of a color by making it dull or dark may result in a unique palette.

A unique palette may assist in creating an outstanding design solution. Although the Tiffany corporation may be associated with the single color of turquoise-blue, the Tiffany identity is actually a palette of colors—an interaction of turquoise-blue, navy blue, and white. The palette of colors used in the Tiffany identity system contributes significantly to the emotional and intellectual ideas communicated: preciousness and sophistication (suggested by the turquoise gemstone color), understated elegance, and good taste (suggested by white and the restrained subtlety of a limited palette).

In contrast, the basic but unique FedEx identity employs bright white and two highly saturated colors: red-violet and red-orange. The hue pair and white suggest a friendly, lively energy. The colors are simple, warm, and bright in feeling. The interaction of white, red-violet, and red-orange may suggest that the complexity of overnight shipping is friendly and fast. In addition, the limited number of colors and saturated hues may make the FedEx design easy to remember and see in the crowded visual environment.

Note the rich color palette found in the package system for Tate's Bake Shop™ cookies by Louise Fili (Figure 4-22). Analyze this set of colors in terms of physical qualities and associative meaning. What do you learn?

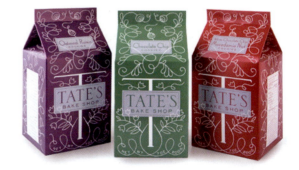

Figure 4-22
Packaging: Tate's Bake Shop cookies
Studio: Louise Fili Ltd., New York, NY
Art director: Louise Fili
Designers: Louise Fili and Chad Roberts
Client: Tate's Bake Shop
What color relationships and interactions are used in the graphics for this packaging design?

Summary

In designing with color, you need to become aware of the various qualities of color (hue, value, intensity), and basic color relationships (primaries, complements, warm/cool, among others), develop an understanding of the interactions of color involved in composition, and learn basic technical considerations in printing and on the Web. Also, you should become as familiar as possible with the many meanings and associations of color across global cultures. Each hue and color palette has emotions to communicate, thoughts to evoke, and a story to tell. A successful designer selects each hue (and its value and tone) for its role in the physical composition and its individual expressive value, while simultaneously selecting companion colors to create an engaging interaction (Figure 4-23).

Selecting the most suitable and unique palette of colors—and uniting and arranging them for clear reading—should lead to successful visual communication.

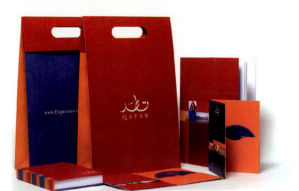

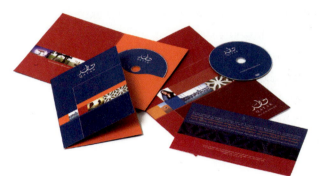

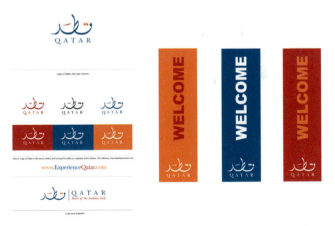

Figure 4-23

Identity system: Qatar

Studio: Tarek Atrissi Design, The Netherlands

Art director: Tarek Atrissi

Client: Qatar Tourism Authority

This complex identity system for Qatar has a deeply saturated color palette that provokes the senses and reflects a richness of cultural experiences that may be found in this small, Middle Eastern country.

EXERCISES

Exercise 4-1: Exploring color qualities in composition

Value exploration

1. Read the entirety of directions in this exercise, then select a color photograph, either of your own or from a good "stock" photography source. Stock photography is created by professionals, compiled by a commercial company, and *sold* to many different designers for use in a variety of applications. Free stock photography can be found on the Web, for instance try *www.morguefile.com*.

 The image of the photo should have a strong contrast of values and contain clearly delineated, simple shapes, such as a single figure seated on a chair or a group of buildings.

2. On paper or the computer screen, using either a freestyle method or tracing, draw or trace the outlines and contours of the images in the photograph into a composition that delineates five levels of value, including light, middle, and dark values. You can crop and edit the image of the photograph for visual interest.

3. Using a computer or acrylics on heavy paper, paint the image, but limit the color to five values of only one hue. Think about creating a focal point with the distribution of values and saturation and equally dispersing the darkest and lightest values throughout the composition.

Warm and cool, bright and dull colors

1. Create a dense composition of bold, block letterforms. The letters can be freely arranged and do not need to create words, but should bleed off the edges of the paper on all four sides.

2. Select a palette of seven hues that have a variety of warm, cool, dull, and bright variations.

3. Colorize the letterform composition to create an illusion of dynamic space advancing and receding in regard to the picture plane.

Exercise 4-2: Color symbolism exploration

Color palette resource list

Individual colors are said to have psychological meanings and symbolism, yet the symbolic nature of color is not exact or reliable or permanent. Color perception fluctuates based on culture, age, environment, and the mood, educational background, and experiences of the viewer. In short, there are no absolutes. However, a few generalizations can help to establish a guide for thinking about color symbolism.

Research color and create a list of hues and color qualities, noting some of the many symbolic meanings generated by color. The list should consist of, but does not need to be limited to:

- Single hues: red, pink, yellow, tan, orange, green, blue, brown, violet, white, gray, or black
- Hue groups: pastel colors, dark colors, light colors, saturated colors, dull colors, natural colors, or acid colors

Searching for colorful definitions

Select a palette of three to five colors that are suitable to communicate the following:

- Elegance
- Freshness
- Anger
- Surprise
- Sincerity
- Innocence

Exercise 4-3: Color history and meaning

Research and re-create the following palettes:

• European Art Deco period colors

• Indian Batik colors

• Ancient Egyptian colors

• Ancient Chinese ceramic colors

• Northwest Coast Native American textile colors

Report on the source of the color and symbolism or meaning of the colors.

Exercise 4-4: A color portrait

Self-analysis is always helpful, especially when it can help us understand the relative importance of things. As Socrates said, "The unexamined life isn't worth living."

Select five colors that symbolize aspects of your personality (virtues, vices, or both), for example: optimistic, intellectual, romantic, willful, or independent. Using a photograph of yourself, create a self-portrait using the color palette that symbolizes your personality and character.

Texture and Pattern

Vladimir Stenberg's Russian Constructivist poster (Figure 9-22) kicks off its rhythm from bottom to top, and then back again, with the repeated images of the cameraman echoing the form of the leg. Repeated pattern, diagonals, color, and layout work together, so you can "feel" the kick to the left. Tadanori Yokoo's sardonic self-promotional poster (Figure 9-23) relies on both pop art and Japanese motifs to make its point: he will commit suicide if you don't give him work. Fortunately, clients responded.

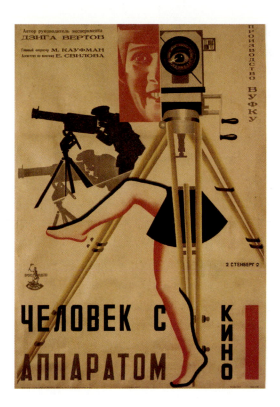

Figure 9-22
Poster
Vladimir Stenberg (1899–1982) © VAGA, NY.
Chelovek s Kinoapparatom, 1929.
Lithograh, 39 1/2" x 27 1/4". Arthur Drexler Fund and purchase (128.1992) The Museum of Modern Art, New York, U.S.A.
Digital Image ©The Museum of Modern Art/ Licensed by SCALA/ Art Resource, NY.

Figure 9-23
Poster
Designer: Tadanori Yokoo
Tadanori Yokoo (b. 1936). Made in Japan, Tadanori Yokoo, 1665.
Silkscreen, 43" x 31 1/8". Gift of the designer (696.1966)
The Museum of Modern Art, New York, U.S.A.
Digital Image © The Museum of Modern Art/ Licensed by SCALA/ Art Resource, NY.

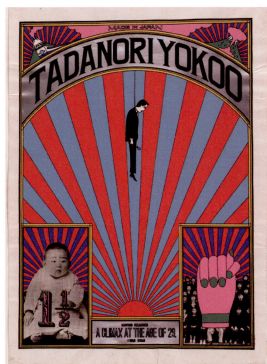

Emphasis

What is the most important element on the page? This is the first thing the reader will see as they begin to read. It is up to the designer to decide what the viewer will see. This can be achieved through scale (the size of one shape or thing in relation to another), visual weight (the illusion of physical weight on a two-dimensional surface), color, and also through the arrangement of all the elements on the page. In this culture, we read left to right and top to bottom, and it is up to the designer to decide how to guide the reader's eyes through the design. We can think of reading text as akin to reading a musical score (Figure 9-20).

Kean University student John D. San Jose takes what could have been a lackluster assignment and through the use of rhythm creates a visual identity for the New Jersey Consortium of Middle Schools that rotates off the page. This is achieved through both form and color (Figure 9-21).

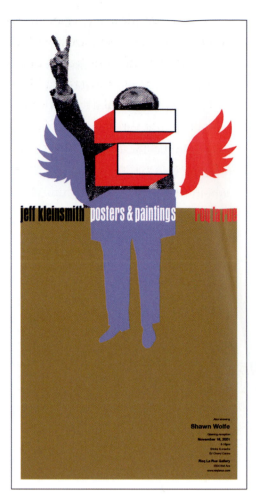

Figure 9-20

Poster: *Roq La Rue/Shawn Wolfe*

Designer: Jeff Kleinsmith

Client: Roq La Rue Gallery

For the raucous poster announcing work by Shawn Wolfe at the Roq La Rue gallery, designer Jeff Kleinsmith establishes a one-two beat with repeated wings and then punches a crescendo forward through the use of bright red and perspective. The large green field serves as the final coda.

Figure 9-21

Visual identity

Studio: The Design Studio at Kean University, Union, NJ

Art director: Steven Brower

Designer: John D. San Jose

Client: Gail Hilliard-Nelson, Ed.D, New Jersey Consortium for Middle Schools, Kean University

Designing a university publication *Q*, which high-lights the research papers of professors from various disciplines, could be a very dry affair. Instead, student designer Brian Buttacavole turns it into a rhythmical-ly discordant affair through the use of a circular motif and bright colors. Establishing the design scheme on the cover, the pattern continues and builds through-out (Figure 9-18). For the travel magazine, shown in Figure 9-19, color and shape work together to create style and movement.

Figure 9-18
Publication cover and inside spread: *Q*
Studio: The Design Studio at Kean University, Union, NJ
Art director: Steven Brower
Designer: Brian Buttacavole
Client: Dr. Toufic Hakim, director, the Office of Research and
Sponsored Programs, Kean University

Figure 9-19
Magazine cover: *United Airlines Hemispheres*, April 2002
Design firm: Morla Design, Inc., San Francisco, CA
Art director: Jennifer Morla
Designers: Jennifer Morla and Hizam Haron
Illustrator: Jennifer Morla
Client: *Hemispheres* Magazine/Pace Communications
"The April 2002 cover of United Airlines magazine *Hemispheres* features the artwork of Morla Design. Neo-Modern in feel, the de-sign is a playful combination of ellipses and circles. *Hemispheres* is the most award-winning in-flight magazine in the United States; 500,000 monthly copies are read by two million people on United flights all over the globe."—Morla Design, Inc.

Negative Space

A background pattern of rotating arrows on a gray field interrupted by the bright red hand, and typography contained within, replicating life lines—the piece shown in Figure 9-16 is the visual equivalent to a cool piece of music with subtle undertones. The book cover, shown in Figure 9-17, attempts to evoke a smoky nightclub through the use of dark negative space. Fortunately, the budget was able to afford spot matte and gloss varnish, which adds to the character of the jacket. The simple title was an added bonus, as well.

Figure 9-16
Brochure spread
Studio: Gee + Chung Design, San Francisco, CA
Creative director: Earl Gee
Designers: Earl Gee and Fani Chung
Client: DCM-Doll Capital Management

Figure 9-17
Book cover: *Bebop and Nothingness* by Francis Davis
Studio: Steven Brower Design, New York, NY
Designer/Illustrator: Steven Brower
Client: Macmillan

Texture and Pattern

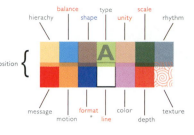

composition {
hierachy · balance · shape · type · unity · scale · rhythm
message · motion · format · line · color · depth · texture

Objectives

- Define texture
- Gain an understanding of the different types of texture
- Explore methods of creating texture
- Define pattern
- Explore the different types of pattern
- Gain an understanding of the expressive potential of texture and pattern

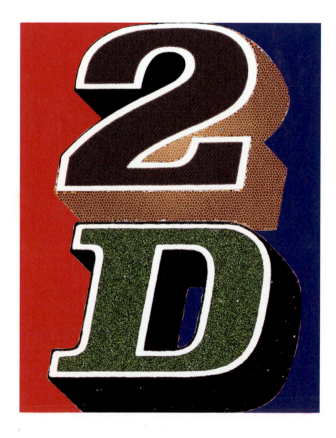

What Is Texture?

Much of our known world is perceived through our sense of touch. Our touch helps to define the environment around us, as well as to help us feel danger, happiness, pain, and comfort. Touch helps us to survive and thrive.

Seeking to activate our compelling sense of touch, designers employ the element of texture within compositions. **Texture** is the actual tactile quality of a surface, or the simulation or representation of such a surface quality. Textures that are seen and/or touched stimulate both associations in the mind and physical sensations within our bodies, as seen in Figure 5-1.

Designing to stimulate the sense of touch is a powerful way to connect to the viewer—it is physical, direct, and may also incite emotion and communicate in a very basic way. Without the aid of written language, textures can inspire us to feel (Figure 5-2).

Figure 5-1

Poster: *Immortality*

Studio: Alfalfa, New York, NY

Art director: Rafael Esquer

Client: Self

Texture, color, and an intellectual, pondering mood dominate this poster design. As stated by the designer: "[This] double-sided poster was created as part of a promotion for a paper. Images and words from many sources were chosen 'to depict the immortal quality' of the medium. The juxtaposition of images and text draws the reader in and creates a beguiling atmosphere, while the treatment of the typography (different typefaces used in a variety of colors, sizes, and states of legibility) adds texture and meaning to the overall composition. These posters are included in *Page Layout: Innovation, Inspiration, Information,* published by Duncan Baird Publishers in 2000."

Textures have a great variety of qualities: pitted, rough, fuzzy, slick, glossy, soft, smooth, wrinkled, grainy, gritty, prickly, bumpy, or any combination. Used in design, textures can suggest a host of emotions. Texture can be delightful, sensual, and ruggedly athletic; textures can repel and be seen as aggressive. Textures can be contemporary in look and feel (Figure 5-3), or they can transport a person back in time to childhood or to the ancient past. Think of fuzzy cotton fleece or chipped and cracked stone walls (Figure 5-4), and you may find yourself in any number of previous times of life or eras—just by feeling or seeing a vivid texture.

The quality and character of texture used in a design is determined by the message that needs to be communicated.

Figure 5-2

Book cover: *The Ruined Map* by Kobo Abe

Publisher: Vintage Books, New York, NY

Art director: John Gall

Designer/Illustration: John Gall and Ned Drew

Client: Vintage Books

The planks and shards of wood and the smooth glass bottle pictured in this book cover design add texture (and textural contrast) that appeals to and compels our sense of touch. The ragged and rough textures of the wood help to express a "disquieting" emotion.

Previous / Next
0 / 1 / 2 / 3 / 4 / 5 / 6

Figure 5-3

Web site: 5in5o.com

Studio: 5in5o, Elizabeth, NJ

Art director and designer: Cesar Rubin

Client: 5in5o

Textures of the urban scene are the focal imagery of this web site design.

Rough Texture Pitted Texture Smooth Texture

Diagram 5-1

Textures are also characteristics of other elements: a square shape filled with a rough texture, a line with a pitted texture, and type with a smooth texture.

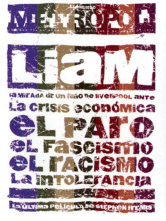

The Element of Texture

Designers employ textures in a variety of ways to compel a viewer to touch or to make a sensory connection or association to the area of texture in a design. The uniquely physical nature of texture attracts a great deal of visual attention within a composition and therefore should be considered, like color, both as an individual element of design and as a characteristic of the other elements of line, shape, type, and format, as seen in Diagram 5-1 and Figure 5-5.

Figure 5-4

Photograph: "Hall Fire"

Photographer: Derek Lilly, U.K.

Source: MorgueFile.com

Depicted in this photograph are the actual textures of a 500-year-old wall.

"The fireplace 'Down Hearth' of the original 'Hall House' at Cole House in Kenn Nr. Clevedon [England], dating back to approximately the 1400s."—Derek Lilly

Figure 5-5

Magazine covers: *Metropoli*

Studio: Unidad Editorial S.A., Madrid, Spain

Art director and designer: Rodrigo Sanchez

Client: EL MUNDO

Distressed type simulates a rough texture.

Although texture can be considered an element of design because of its powerfully compelling role in composition, texture never stands alone—it is always found in conjunction with a line or shape, letters or format. In addition, textures may also be found within the imagery of an illustration or photographs, as seen in the examples in Figure 5-6. Using the element of texture effectively in design requires an awareness of its visual characteristics, placement in a composition, and potential in communication.

Types of Textures

Texture can be divided into two broad types in order to better understand its visual characteristics and usefulness as an element of design.
The two categories of texture are:
- Tactile textures (also called actual textures)
- Visual textures (simulated or represented)

Figure 5-6 (top)
Book illustration: *summer nantucket drawings*
Illustrator: Rose Gonnella
Natural textures rendered with colored pencil.

Figure 5-6 (middle)
Photograph: "Moor Pathway"
Photographer: Derek Lilly, U.K.
Source: MorgueFile.com
Textures can be captured in a photograph.
 "A pathway to the moor in the Gordano Valley, taken as the frost began to melt, as the sun warmed up." —Derek Lilly

Figure 5-6 (bottom)
Photograph: Untitled (street scene)
Photographer: Robert Cole
This photograph of a street in New York captures the textures of the city, provoking the sense of touch (among other senses and emotions).

Textures that have *actual* tactile quality and can be physically touched and felt are called **tactile (or actual) textures**. In addition to stimulating the sense of sight and the mind, tactile textures can stimulate the sense of touch. When touching the paper of this book, you are actually feeling its tactile character. The cover of the book has a distinct (albeit subtle) texture separate from the pages of the book because of the different types of papers used. Along with the paper used for a design, specialized printing processes can add tactile effects, as seen (indirectly) in the photograph of the texture in Figure 5-7.

Conversely, **visual textures** are those created and seen in photographs, screen-based imagery, and illustrations (Figure 5-8), or rendered within shapes (figure or ground), lines, or type—on any part of a design (Figure 5-9). The textures captured in photos or illustratively rendered are *not* actually tactile. Rather, these images are representations or simulations of texture. Visual textures are recognized through our sense of sight and interpreted as tactile through our mind.

Figure 5-7
Brochure cover and first page: Crenshaw Associates
Studio: Rizco Design, Manasquan, NJ
Art director and designer: Keith Rizzi
Client: Crenshaw Associates
The embossed (raised) gold and engraved ink on Fox River Confetti paper on the cover, along with imprinted gold type on the interior vellum sheet, communicates sophistication, elegance, and experience—which is required for an outplacement firm dealing with senior-level executives.

Figure 5-8
Poster: *Central Pennsylvania Festival of the Arts 2003*
Studio: Sommese Design, Port Matilda, PA
Art director and designer: Lanny Sommese
Technical assistance: Nate Bishop and Joe Shumbat
Client: Central Pennsylvania Festival of the Arts
The lively visual textures in this design help to create a celebratory feeling to promote an arts festival.

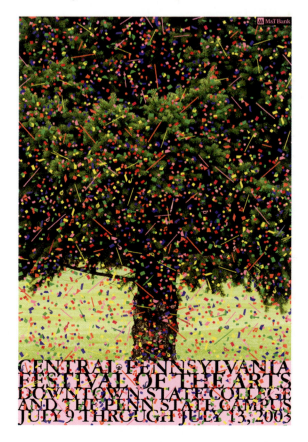

Visual textures may trigger an emotional response by stimulating the sense of sight and a *memory* associated with the feel of the texture. The texture could suggest to the viewer a physical state of being or a particular feeling, such as frightening decay (in the image of heavily peeling paint and crumbled plaster) or comfort and tenderness (in the image of soft fabrics or fur). As seen in the print ad in Figure 5-10, once the viewer recognizes that there are visual textures of a dog in the design, a memory may be triggered causing an emotional response to the soft feel of the hair (suggesting comfort). A further extension of memory and emotion may recall some positive qualities of a dog, such as loyalty and strength. In total, *all* of the elements of design work together to create the emotion of surprise and elicit sympathy—in large part due to the use of visual texture.

Although both visual textures and tactile textures stimulate the sense of sight and may trigger the mind to think, or suggest a feeling, only tactile textures can compel the viewer through immediate or *direct* contact—using the sense of touch. The communication potential of tactile texture is *not* necessarily stronger than visual texture; however, it is certainly more direct. For instance, a printed brochure created on or with a rough surface of heavy, corrugated paperboard can stimulate the senses of sight and touch, feeling rugged and strong. By actually touching the paper, there can be a direct, physical response to the design.

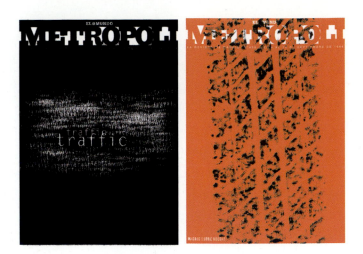

Figure 5-9
Magazine covers: *Metropoli*
Studio: Unidad Editorial, S.A., Madrid, Spain
Designer: Rodrigo Sanchez
Client: EL MUNDO
The gritty textures pictured in these designs are simulated, not actual.

Figure 5-10
Print ad: "No Surgeon in the World Can Help This Blind Man See"
Agency: Saatchi & Saatchi, New York, NY
Creative director: Bob Isherwood
Client: The Guide Dogs for the Blind Association
A contrast in textures creates surprise and makes a dramatic point in the design of this print ad by Saatchi & Saatchi worldwide creative director Bob Isherwood.

NO SURGEON IN THE WORLD CAN HELP THIS BLIND MAN SEE. BUT A DOG CAN.

Try going blind.

Walk to the corner of the street with your eyes closed.

Post a letter with your eyes closed.

Buy a loaf of bread with your eyes closed.

Discover how the simplest tasks become a nightmare with your eyes closed.

Now walk to the corner of the street and post a cheque with your eyes wide open.

THE GUIDE DOGS FOR THE BLIND ASSOCIATION
Department 3, 9 Park Street, Windsor, Berkshire SL4 1JR.

Paper, in fact, is one of the most dominant vehicles for tactile texture in a printed design. Since paper comes in a vast of array of colors, tones, and textures, it is important to study, in depth, the character and nature of paper as a tactile element. The study of paper can be pursued in a materials and techniques course and is touched upon a bit later in this chapter. At this point, it is important to note that paper (as a substrate for a printed design) contains tactile texture and should be considered on both a functional level (is a smooth paper needed for many layers of ink?) and a conceptual level (what will rough paper communicate in conjunction with the other elements of the design?).

Local vs. Imaginary Texture

When a texture is depicted naturally or in a normal context, such as fur on a cat (Figure 5-11), or a piece of rough sandpaper found in a carpenter's tool box, or the crinkled skin of an orange, the texture is called **local texture**—that is, local to the object on which it is naturally found.

When a designer creates an image for a design that depicts the texture of cat fur on an orange or sandpaper in the shape of human hands, the texture is no longer considered local texture; rather, it is called imaginary texture. **Imaginary texture** is purposefully depicted in abnormal or unnatural ways in order to expand the meaning and message of an image or design. For instance, imaginary textures may be helpful for creating a visual simile—a construction worker's hands are rough like sandpaper. Or imaginary textures can be employed for simple emotional effects—a fur-covered orange is shocking or funny, depending on the other elements in the design. The element of texture can help communicate in dramatic, serious, humorous, clever, and at times, hilarious ways.

Imagine cat fur on an orange. Visual surprises in regard to texture are often incorporated within a composition to expand the meaning of the host object or for expressive purposes, for fun, or for more serious purposes, as seen previously in Figure 5-10.

Figure 5-11
Photograph: "Ginger"
Photographer: Derek Lilly, U.K.
Cat fur is a familiar and interesting texture—seen here "local" to its host object (said cat Ginger).

Creating and Selecting Texture

Employing the element of texture in design—whether tactile or visual, local or imaginary—requires skill in creating texture and the knowledge of where to gather or find textures for reproduction. Textures can be handmade using a variety of traditional image-making materials, such as paints, pens, or crayons. In addition, the infinite variety of textures found in our environment can be captured through photographic processes (digitally or with film) and transferred to a design. Various types of paper can be used to add tactile texture to a design, or tactile textures can be created through mechanical processes. Whatever the method of producing texture, the character, quality, and amount used should be inextricably connected to the message that is being communicated within the design.

Since design primarily involves the reproduction of texture in printed matter (posters, brochures, books, etc.) or within screen-based images, most of the textures used for design will be visual textures. However, much thought should also be given to the selection and manipulation of tactile textures because this category of texture does appear frequently in the form of paper for printed matter.

Tactile Textures

Designers must be aware of the *actual*, tactile texture in a printed design because the texture will certainly affect the message communicated, as well as the cost of production.

First consideration is given to the printing substrate. The substrate should be selected for cost-effectiveness, specific use, and expressiveness. Paper or paperboard is the primary substrate for brochures, books, magazines, and posters; however, printing can also be produced on synthetics, such as plastic or vinyl. Second, tactile textures can also be created through mechanical processes, produced by specialized printing companies.

Texture of the Substrate

Although designers have employed wood, vinyl, and rubber as substrates for particular projects, paper is the primary printing substrate used in design. There is much to be studied in advanced design courses concerning paper for both practical function and communication; however, at this point of study, our focus concerns the basic textures found in paper. Each paper texture will have its own visual characteristics, as seen in Diagram 5-2. Collect your own paper samples and keep a personal swatch book as a valuable resource for your design efforts.

Diagram 5-2
Actual textures can be found in the great variety of paper available for printed designs.

The textural characteristics of paper should be selected to contribute to the overall message of a design for compositional purposes—as a focal point or to separate various categories of information, as seen in Figures 5-12 and 5-13.

Standard Textures Found in Paper
- Cockle: wavy, rippled, puckered surface
- Gloss: slick, shiny surface
- Laid: smooth surface that includes translucent lines running horizontally and vertically in the paper
- Linen: resembles linen cloth and has a slightly embossed surface
- Vellum: smooth, translucent
- Woven: smooth, even surface

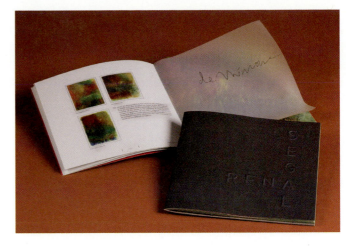

Figure 5-12
Catalog and inside spreads: Rena Segal exhibition
Studio: The Design Studio at Kean University, Union, NJ
Art director: Steven Brower
Design: Tricia Decker and Stephanie Heller
Client: Kean University, CAS Gallery
The vellum paper in this catalog provides a tactile separation between the various sections of the book. The heavy cover paper contrasts with the lightweight pages of the interior for practical and visual purposes. The heavy paper is helpful in creating strong and durable protection for the papers within. Note how the pitted texture and handwritten words printed on vellum paper add to the tactile quality of the design. The uneven, natural shapes of the letters echo the nature-oriented imagery displayed in the catalog.

Figure 5-13
Brochure: Music Education
Studio: The Design Studio at Kean University, Union, NJ
Art director: Steven Brower
Design: Erin Smith
Client: Kean University, Department of Music
A simple lightweight and smooth paper is used for this brochure primarily for functional reasons—making it inexpensive to commercially print and easy to mail and carry. The vellum is employed to give the inside a hint of elegance and importance, as well as to functionally separate the title page from the body of text inside. Also, the cover typography and the overall design is a collage, used to bring together the variety of content found inside the brochure to the front page in a visually tactile and compelling way.

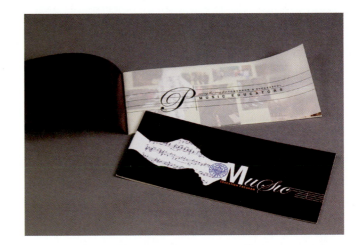

Mechanically Produced Tactile Textures

There are several mechanical printing techniques that can produce tactile textures on a finished printed design. A designer may specify them to be executed, but cannot produce these effects by hand.

Mechanically Produced Tactile Textures

- Embossing and Debossing

 Embossing involves a mechanical process of producing shapes or images (on various materials) that are raised above the surface of the material. **Debossing** involves the process of producing shapes or images that are pressed into the substrate (paper, for instance), making the shapes impressed below the surface.

 The embossed letters on the Rena Segal catalog cover (Figure 5-12) creates a simple, compelling tactile texture that gives the artist's name emphasis and importance.

- Stamping

 Stamping is a mechanical process that uses heat and pressure to adhere film to a variety of materials. Many glossy, shiny (foil), or opaque colors of film are available in the stamping process (Figure 5-14).

- Engraving

 Engraving involves a mechanical process of incising an image or design into a hard, flat metal surface. Ink is forced into the incised areas and transferred to paper through pressure (the paper is pressed into the inked areas) using a press. Gravure is another such mechanical printing process.

- Letterpress

 In contrast to engraving or gravure, **letterpress** is a printing process that involves a design (primarily of letters) created on a raised surface. Ink is rolled over the raised area and transferred to paper by means of a press.

Figure 5-14

Book cover: *summer nantucket drawings*

Studio: Russell Hassell, New York, NY, and South Beach, FL

Art director and designer: Russell Hassell

Illustration: Rose Gonnella

Client: Waterborn

Opaque stamping was used for the title and author's name on this book cover because conventional printing ink would soak into the paper and not allow for a high contrast of colors. The stamping allowed the designer to place type on textured colored paper and maintain clarity and distinction of the type. In addition, the image was "tipped-on" (mechanically glued) for a collage-like effect.

- Laser-cutting

 Cutting paper with the precision of a laser is a specialize technique that does not involve ink. Rather, in **laser-cutting**, the paper is cut (burned through with a laser beam) with precision that can yield fine tactile results, as seen in Figure 5-15.

Further study of these specialized printing processes will reveal the intricacies and variety of the procedures. Examples of various printing techniques can be found through the companies that specialize in the various processes. Search for the companies on the Web and request samples.

Visual Textures

Using skills learned in photography, drawing, painting, and various other image-making media, a designer can create a great variety of textures.

Some of the media and techniques that can be employed include:

- Photography
- Painting techniques
- Collage
- Hand-printmaking
- Drawing techniques

Photography

Capturing natural or fabricated textures in the environment through photography is perhaps the quickest and most often used method of creating visual texture. In the natural and built environment, there is an amazing array of textures that can be photographed and used for a great variety of communication purposes. Look for textures in the obvious vast expanses—the landscape, sea, sky, and cityscape—and also in the less obvious places—a close-up on the stem of a flower, an insect wing, or the concrete at your feet on a city street.

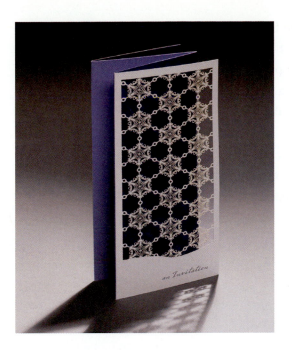

Figure 5-15

Invitation: Kean University Holiday Celebration

Studio: The Design Studio at Kean University, Union, NJ and Cinquino + Co., West Patterson, NJ

Designer: Erin Smith

Illustration: Erin Smith and Cindy Vasquez

Client: Dr. Dawood Farahi, President, Kean University

Laser-cut pattern creates tactile texture.

By using photographic filters, photo-editing software tools and filters, and other special effects, a simple photograph can be manipulated to simulate or enhance visual texture. A filter such as mezzotint can add a grainy texture to an otherwise flat image. Filters should be used *sparingly* because they are not unique—they are standard in photo-editing software and therefore are used by many. Photos that are manipulated and treated with filters or special effects can look fresh and interesting, if handled with thought and purpose (Figures 5-16 and 5-17), rather than merely for decorative effect.

You can learn about filters and digital textures through the study of photo-editing software such as Adobe Photoshop. It is important to bring knowledge from various sources into play when designing.

Painting Media and Techniques

Creating visual textures can also be accomplished through a variety of traditional painting and drawing materials and techniques, which can then be photographed or scanned for printed applications. Along with the traditional image-making materials, media, and/or techniques that are used for creating visual texture for a printed or screen-based design are some lesser known techniques, such as impasto and trompe l'oeil.

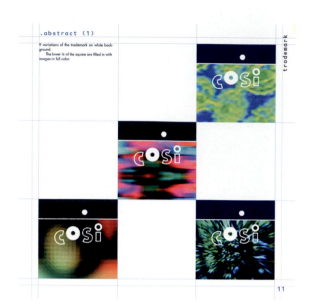

Figure 5-16

Logo: COSI

Studio: Estudio Mariscal, Barcelona, Spain

Client: Ohio Center of Science and Industry

© *2006 Artists Rights Society (ARS), New York/VEGAP, Madrid*
This logo design incorporates a variety of textures that provoke curiosity and excitement. As described by the designers: "We designed the corporate identity, the communication applications, and the signposting for the new Ohio Center of Science and Industry, housed in a building project by Arata Isozaki. The project aimed to reflect the COSI's own philosophy, that of teaching science through games, adventure, and personal experiences."

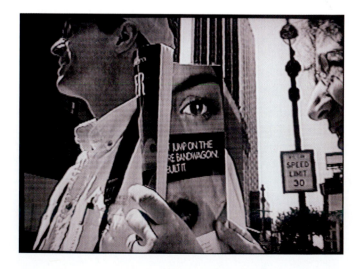

Figure 5-17

Photograph: "Jump on the Bandwagon"

Photographer: Donald Lokuta

Incorporating a texture made with line further heightens the tactile feeling of the street environment pictured in this photograph.

The traditional technique of painting with oils or acrylics offers much in the way of creating textures. Surfaces can have thick layers of paint that appear shiny or dull. When the paint is very thick, the surface and technique is called **impasto**. The thick paint creates a highly tactile, textural quality—and a stunning visual texture when reproduced in print or on a screen-based image. Both thin and thick layers of paint can show the tracks of the paintbrush over a surface. The visible brush strokes can enhance the tactile sensation of the surface, as seen in Figure 5-18.

There are also painting techniques specifically developed to simulate all manner of textures—to the point of appearing real. **Trompe l'oeil** means literally "to fool the eye" in French. It is a visual effect drawn or painted on a two-dimensional surface where the viewer is in doubt as to whether the object (or texture) depicted is real or a representation. Traditionally, the image depicted was created with paint, and the viewer would be looking at a canvas (a single piece of artwork). The purpose was to trick the viewer into touching the painting. The artist was trying to create a strong and compelling attraction to the image in order to elicit a direct emotional connection and response. In design, trompe l'oeil illustrations (Figure 5-19) may be used much in the same way—compelling a viewer to touch, experience, and respond.

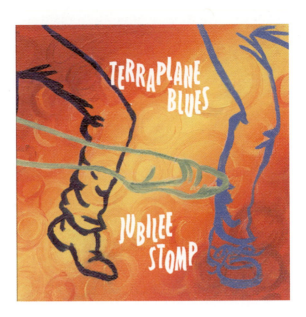

Figure 5-18
CD cover: Terraplane Blues, "Jubilee Stomp"
Studio: Steven Brower Design, New York, NY
Art director and designer: Steven Brower
Illustrator: Janna Brower
Client: Terraplane Blues

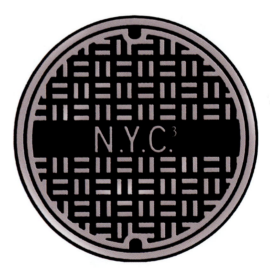

Figure 5-19
Floor graphics: NYC³ photography exhibition
Studio: Office of University Relations at Kean University, Union, NJ
Creative director: Robert Cole
Art director and designer: Richard Dooley
Client: Kean University, CAS Gallery
The repetition of short, thick lines in the floor graphics create a simulated chunky texture that is meant to look as real as possible (a trompe l'oeil technique) to re-create the utility plates found on city streets.

Collage

An often-employed image-making technique, **collage** involves the cutting and adhering of different bits of materials onto a two-dimensional surface. The materials that can be used for a collage are limited only by the imagination of the designer. One purpose of using collage is to bring together specific materials to communicate a mood, emotion, or idea through a tactile sensation, as seen in Figure 5-20. Another approach is to simply cut and paste together disparate images for humorous effects (Figure 5-21).

Collage can be created from actual cut and pasted printed matter, which is then scanned or photographed and reproduced for the design, or a collage-like approach is often used that simulates cut and pasted pieces of paper, as seen in Figure 5-22. The latter is used when a faster or simpler production method is necessary, but a collage-like effect is still desired for the jarring or playful juxtapositions of shape.

Figure 5-20

Book cover: *Secret Rendezvous* by Kobo Abe

Publisher: Vintage Books, New York, NY

Art director: John Gall

Design/Illustration: John Gall and Ned Drew

Client: Vintage Books

The book cover pictured uses a collage technique that combines a variety of pieces of printed matter and images into an intriguing whole design—one that appeals to both our mind and our senses.

Figure 5-21

Book cover: *Roger Ebert's Book of Film*

Studio: Steven Brower Design, New York, NY

Art director: Deborah Morton Hoyt

Designer: Steven Brower

Client: W. W. Norton

Using cut and pasted photographs, collage can yield some very humorous effects because of the disparate and unexpected juxtapositions of images.

Figure 5-22

Magazine cover: *Diseño Gráfico 40*

Studio: Estudio Mariscal, Barcelona, Spain

Client: Diseño Gráfico

© 2006 Artists Rights Society (ARS), New York/VEGAP, Madrid

Using computer drawing software, the designer created collage-like imagery in this strikingly graphic magazine cover.

Traditional Hand-Printmaking

Most often employed for art and illustration, traditional hand-printmaking techniques can produce distinct visual textures because of the unique quality of the surfaces and/or tools involved in the process. Through awareness and use of these various techniques, you have the opportunity to expand your repertoire of creating textures.

- Lithography: an image is drawn with soft crayon on flat blocks of limestone or metal plates, then the image is inked and printed; photographic lithography is also available.
- Etching: an image is created with thin lines incised into a metal plate; the lines are etched into the plate with acid, then inked and printed.
- Woodcut: images that are carved into the surface of smooth blocks of wood, then inked and printed (Figure 5-23).

Drawing with Dry Media

The artist Vincent van Gogh—whose painting of crows flying over a wheat field was noted previously in Chapter 4—was also well known for his drawings that employed a repetition of lines, dots, and marks to create visually textural images. Van Gogh's drawings can be studied for his inventive, masterful technique for visualizing shape and form; studying the graphic work of fine artists is helpful in regard to inventive image-making techniques and should be pursued in conjunction with the study of design.

Many fine artists and designers since van Gogh enjoy inventing and drawing visual textures to attract attention and to communicate a feeling or message. In the poster shown in Figure 5-24, by designer and illustrator Lanny Sommese, the lush repetition of line creates volumetric form (using a contour drawing technique and value gradations) and a visually rich and exciting textural surface. Each of the drawing tools—such as pens, crayons, pencils, or charcoal—has the potential to produce rich, visually textural images and surfaces. In addition to the study of design, the study of drawing can enrich and expand a designer's visual repertoire.

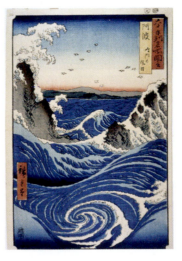

Figure 5-23

Japanese color woodblock print: *The Whirlpools at Awa: Naruto Rapido*

Artist: Ando Hiroshige (1797–1858)

Victoria and Albert Museum, London, Great Britain / Art Resource, NY

Figure 5-24

Poster: Circus Zirkus

Studio: Sommese Design, Port Matilda, PA

Art director and designer: Lanny Sommese

Technical assistance: John Heinrich

Client: Sommese Design

The repetition of line and the sumptuous linear texture helps to communicate the message of the poster—the commotion, excitement, and variety of a circus.

Pattern

As noted previously, repetition of line or shape has the potential of producing a rich visual texture. When an image is composed of a *consistent repetition* of a single visual unit or elements within a given area, it is called **pattern**. Patterns visually activate a surface area and often create a distinct visual texture. Pattern in contemporary design may still have the same allure as it had for ancient cultures. The consistently ordered, visual texture of a pattern is attractive and compelling to the eye and often carries a symbolic message.

Patterns have a great history of use. There are patterns found on ancient Chinese pottery and ancient Egyptians used patterns on baskets. In Great Britain, the Scots have used plaid patterns in textile design as the graphic identity of a family (clan) since approximately the late fifteenth century. On the North American continent, the Native American Navajos developed unique patterns for use in their textile designs (Figure 5-25).

Figure 5-25

Red and blue "Germantown" rug. Navajo, c. 1880.

Piers Morris Collection, London, Great Britain

Werner Forman / Art Resource, NY

"Although scholars have not been able to put a precise date on the beginnings of Navajo loom weaving, evidence points to a time after the group's migration into the Southwest from the north, and most likely the second half of the seventeenth century."
—From *Navajo Textiles: The William Randolph Hearst Collection* by Nancy J. Blomberg. *www.uapress.arizona.edu/books/bid49.htm.*

In regard to Navajo weaving…"as cultural outsiders (non-Navajos) we learn about [the] Navajo art form from books, deductive reasoning and observation…Navajo weavings are statements defining the artist's relationship to her natural surroundings and her personal standards relative to geometry, color, proportion and spiritual relation to the Earth. One cannot view early Navajo weavings without recognizing the suggestion of regional rock formations and deep space. These visual observations or perceptions, combined with natural dyed wool whose color source is derived from plant, animal or mineral pigments, results in a tapestry of relationship and relatedness revealing an appropriate holistic cultural statement in [art] form." —Andrew Nagen, who appraised, bought, and sold old Navajo rugs and blankets in Corrales, New Mexico, from 1976 to 2005.

Excerpt from an article that originally appeared in *The Wingspread Collector's Guide to Santa Fe, Taos and Albuquerque*, Volume 15. *www.collectorsguide.com/fa/fa085.shtml.*

Basic Patterns

"Nature has striped the zebra. Man has striped his flags and awnings, ties and shirts. For the typographer, stripes are rules; for the architect, they are a means of creating optical illusions. Stripes are dazzling, sometimes hypnotic, usually happy. They are universal. They have adorned the walls of houses, churches, and mosques. Stripes attract attention."

—Paul Rand, from *A Designer's Art*

Stripes are the tightly grouped repetition of lines within a whole design or a given area of a design, as seen in Figures 5-26 and 5-27. Stripes are perhaps the most basic and widely used pattern in design. And, as the renowned designer Paul Rand noted, "Stripes attract attention."

Figure 5-26
Logo: IBM
Art director: Paul Rand (1914–1966)
Image held by the IBM Corporate Archives
Internationally recognized and honored, Paul Rand was one of the most reputable and inventive designers of the twentieth century. The IBM logo exhibits his world-famous stripes.

Figure 5-27
Poster
Artist: Cassandre (Adolphe Mouron) (1901–1968)
Copyright. Les Vins Nicolas. 1935
Bridgeman-Giraudon / Art Resource, NY
Cassandre, an internationally renowned designer, displays his playful use of stripes.

In addition to stripes, the same may be said for other types of repetitive groupings of shape and line such as plaids, polka-dots, or paisleys (all names given to commonly used patterns), as seen in Diagram 5-3. Or pattern can simply be the orderly repetition of a single shape (Figure 5-28).

Loosely Patterned

The repetition of shape that characterizes patterns is a forceful element, yet a designer may not always employ or want a strictly consistently ordered pattern. A visual texture caused by a repetition of elements (line, shape, color, and texture) can also be created without the strict order of a precise pattern, as seen in Figure 5-29. One objective of pattern and visual texture, whether loosely structured or tightly ordered, is to compel the viewer to sense a tactile quality.

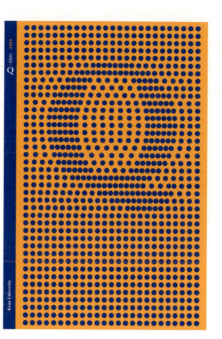

Figure 5-28

Journal: "Q"

Studio: The Design Studio at Kean University, Union, NJ

Art director: Steven Brower

Designer: Brian Buttacavole

Journal advisor: Dr. Toufic Hakim

Client: Kean University, Office of Research and

Sponsored Programs

An embossed pattern is visually dramatic.

Floral

Plaid

Paisley

Micro-checks

Polka-dots

Checkered

Diagram 5-3

Common Patterns

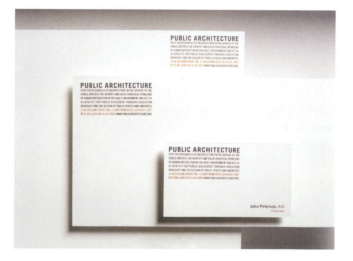

Figure 5-29

Stationery: Public Architecture

Studio: MendeDesign and Volume, San Francisco, CA

Designer: Jeremy Mende

Client: Public Architecture

The repetition of lines of type creates pattern and visual texture and combined with its strict rectangular shape, the design is evocative of a sturdy building structure, thereby relating to the architectural content.

Using a simple repetition of shapes to create a visual texture and pattern can contribute to the expressiveness of a design and can be used on a functional level as well, creating a focal point or an area of emphasis, as seen in the graphics of Figure 5-30.

Repetition of shapes and visual textures can also appear to have the illusion of movement—the repetition moving the eye from one shape or line to the next in succession. The stunning and highly illusionary visual textures of Eiko Ishioka and Rafael Esquer's designs for the winter Olympic games perfectly communicate the speed and excitement of the athletes (Figure 5-31). In the packaging design seen in Figure 5-32, the illusion of motion is flickering, again perfectly communicating a quality of the subject matter.

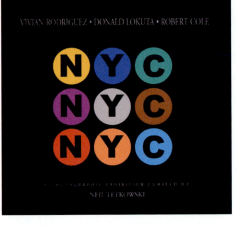

Figure 5-30

Catalog cover: NYC³ photography exhibition

Studio: Office of University Relations at Kean University, Union, NJ

Creative director: Robert Cole

Art director and designer: Richard Dooley

Client: Kean University, CAS Gallery

The repetition of circles and letters on the catalog cover create a focal area and playfully echo the signage found in New York City subway stations.

Figure 5-31

Racing suits: Spain Alpine Skiing, 2002

Studio: Eiko Ishioka Inc and @radical.media, New York, NY

Creative director: Eiko Ishioka

Designer: Rafael Esquer

Client: Descente

As stated by the designer: "Descente felt that the winter Olympics, an event that happens only once every four years, would be the perfect opportunity to showcase not only their renowned technology, but also an innovative approach to the design of high-performance sportswear. They wanted to look outside the existing notions of sportswear design and knew they needed the fresh input of someone outside of the conventional fashion and sportswear design worlds. Descente's goal was to find a designer who could bring power, intelligence, and grace to sportswear design."

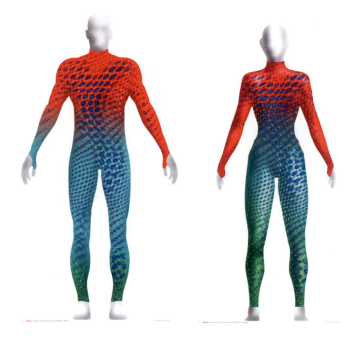

Figure 5-32

Logo and packaging: NoBo™ brand

Studio: Mires Design for Brands, San Diego, CA

Client: Wal-Mart

The concept as explained by the designer: "With fierce competition from fashion-friendly retailers like Target and Kohl's, Wal-Mart began a move from cheap to chic. As part of this broad strategic effort, the retail giant needed to infuse its flagship teen brand No Boundaries [NoBo] with a stylish, edgy attitude."

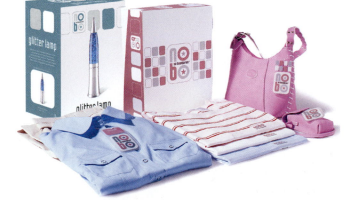

In a screen-based design, visual textures can be simulated in a variety of ways, which can be enhanced through *actual* movement. An animated "scroll" across the screen of groups of letters or shapes will certainly increase their attraction—see the screen shot (a still image) in Figure 5-33.

In addition, the visual textures and patterns can be set in motion (using video, film or digitally for screen-based applications) to enhance their textural quality—a tightly packed group of small dots can jump or jiggle, and stripes can sway or flicker, or swell and retract. Motion opens a vast opportunity for expanding the meaning and message of visual texture and pattern in any screen-based design.

Summary

Rousing both our senses of sight and of touch, texture (and pattern) compels the viewer to feel the design, as well as to see it. Texture can conjure emotions, prickle or soothe our skin, or transport us to times past, to near or distant environments, atmospheres, and places. Patterns have a range of expressive qualities as well, from the formal and serious to the informally playful and all manner of combinations in between.

Designers can create texture through a great variety of image-making media, or textures can be captured in a photograph. In screen-based media, textures are enhanced through movement; in print materials, textures can be actual. Whether simulated, represented, or actual, textures have visual presence and potential for communication.

Activating texture for design purposes involves an awareness of how to create textures, as well as an understanding of how texture reacts and responds to all the elements of design in composition.

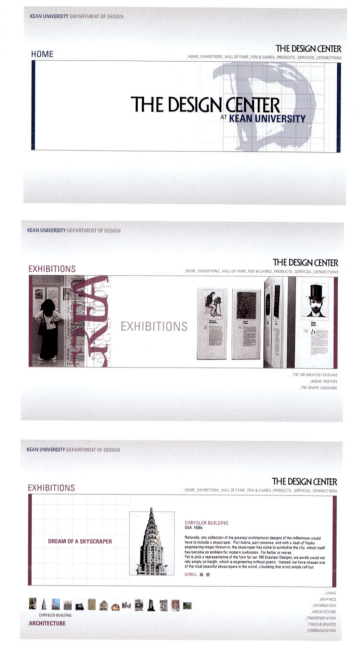

Figure 5-33
Web site: The Design Center
Studio: lava dome creative, Bound Brook, NJ
Art director and designer: Michael Sickinger
Client: Kean University
The moving, overlapping layers of letters in this
web site design create a compelling visual texture.
Visit the site at *www.kean.edu/~designct*.

EXERCISES

Exercise 5-1: Texture creation

Using any media and technique, but without representational imagery, simulate the following textures:

- Rough
- Smooth
- Pitted
- Gritty
- Bumpy
- Crinkled
- Soft
- Hard
- Wavy
- Grainy
- Woven

Exercise 5-2: Photographic textures

Find materials that have the textures created in the previous exercise. Scan the actual textures, print them, and organize them in a notebook for future reference and resource.

Exercise 5-3: Communicating with textures

Draw or photograph textures that evoke the following emotions, thoughts, or ideas:

- Decay
- Elegance
- Peace
- Sensuality
- Fear

Exercise 5-4: Collage

Research the work of artists and designers who use collage. Write notes on the various materials and methods used. Keep the notes as future resource.

Gather your own materials for a collage and create a composition based on one of the following:

- Variety in nature
- Subtly of fabrics
- Ruggedness of building construction

Exercise 5-5: Ancient patterns

Part one

Research one (or more) ancient culture(s) to discover the development and meaning of pattern in the culture's art and design (pottery, textiles, or painting).

Compile pattern images on a CD or printed images in color, and bind your images in a small notebook or folder. Keep the images as a visual resource for adaptation into future projects and applications in advanced design classes.

Part two

Using a contemporary color palette and/or shapes, create a pattern that echoes an ancient style. Note the motifs and compositions used in ancient designs—adapt the spirit of the style without actually copying the designs.

Chapter 6:

Type

Chapter 6:
Type

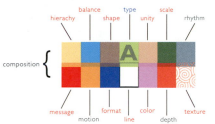

composition {
balance · type · scale
hierachy · shape · unity · rhythm
A
message · format · color · texture
motion · line · depth

Objectives

- Understand how to use type as a design element
- Gain awareness of the different classifications of type
- Discover the physical characteristics and applications of type
- Understand type as a visual organizer of information
- Learn how to use the expressive qualities of type
- Learn the rules concerning type
- Understand how to use type on the Web

Type as a Design Element

Type is as much a two-dimensional design element as any other. Indeed, if you begin to view type as line and shape, it will not only help you with your composition, it will also increase your appreciation of type overall. The construction of each character contains all the same elements as any image: tension, unity, contrast, and harmony. The shapes are the same, as well: geometric or organic or a combination of both. Upon close examination, many **typefaces**—a single set of letterforms, numerals, and signs unified by consistent visual properties—are as elegant and pleasing to the eye as Greek sculpture, and as expressive as painting. Still others contain discord. Most, however, are built with balance and harmony in mind, and, of course, legibility.

Classifications of Type

There are two main classifications of type: **display type** (most often used as headings) and **text type**, or **body copy** (used in the body of text). In large display type, headlines or single words form relatively large shapes on the page. In text, it is the entire mass, known as a **text block**, that forms the overall shape. The other classifications of type are serif, sans serif, and script (shown in Figure 6-1). Serif type originated during Roman times, when words were carved into stone. The tool that was used to carve the type—called a punch—created a shape at the end of the stroke, which became known as a **serif.** These small "feet" are seen on the earliest **roman** typefaces, which are now referred to as **classical** type. Roman typefaces comprise western alphabets, such as English, French, German, Spanish, etc. It is generally believed that serif type is easier to read. Since we read by recognizing the outer shape of a word, as opposed to the individual **characters** (letterforms, numbers, or punctuation marks), serifs help form a distinct shape in each word for us to distinguish. Serif type is by and large used to convey a sense of elegance and sophistication.

Sans-serif typefaces—or simply put, type without serifs—first occurred in the mid-nineteenth century, and were created by simply cutting the serifs off existing typefaces. They were originally known as "**grotesques**," which is the way readers who were accustomed to classical typefaces reacted to this new type. In the early part of the twentieth century, sans-serif type was greatly refined. These sleeker, more streamlined versions were known as "**modern**." Sans-serif type conveys a feeling of geometry and cleanliness.

Script typefaces were originally designed to echo handwriting. To the contemporary eye this may seem hard to believe, as handwriting fonts today imitate modern handwriting, which usually is little more than scrawl. When script typefaces were first designed, good penmanship was the norm, and they reflected the beauty of form that existed then.

Often, script typefaces are used to represent elegance, such as on wedding invitations. Setting a script face poorly, such as in all **caps**—that is, all **capital** (uppercase) letters—not only defeats the purpose of the delicate typeface, it also makes it extremely difficult to read.

In the mid-twentieth century, as sign painting became popular with the increase in commerce, sign or **brush scripts** came into play. These thicker and bolder typefaces have the opposite effect of their stylish ancestors, as they appear informal and spontaneous. Using typography that imitates other sources, such as street signs, is known as **vernacular** typography.

Figure 6-1

Serif, sans serif, script, and brush script.

Communicating with the Audience

The designer's task is to communicate to the audience the message that is contained within the text—to advance, enhance, extend, organize, and articulate the language within. It is an exchange of information or ideas, and the fact that there are words indicates that they are intended to be read. The design is therefore about something, not merely decoration. And what it is about is the written word.

Consequently, legibility is a paramount concern. If the point size, which is the size of the type, is set too large or too small, it can be hard to read. If the distance between two lines of type—which is known as **line spacing** or **leading**—is too close together or too far apart, the effect is the same. If there are too many words on the page, this too can be off-putting. It is the goal of the designer to invite the reader in with type that is easily read—not a challenge.

Our eyes perceive the mass of text on a page as color—not in hues, but in shades of gray. The "grayness" of the body copy adds to the overall appearance of the page; if it is too heavy or too "dark," it will be less inviting to the viewer. The headline (or title, in the case of book covers) not only informs, it also sets the tone for the page. Often the headline and subhead (or subtitle on books) are used for dramatic effect, attracting attention to interest the viewer in the subject matter. All these elements form a composition, no different from any other. The arrangement can be visually pleasing or create tension, but, more importantly, it should convey specific information and meaning, as that is the essential purpose of type.

Type and Balance

Simply put, a sense of balance is what we are all striving for in life. This is not always the case in design, since design is contingent upon the context. Symmetry in design is a conservative arrangement of all the elements on the page. Very often the overall effect is one of stasis, of everything placed in an even pattern, with equal weight on all sides of the composition. The novice designer tends to design in this manner.

One caveat with symmetry is that there can be too much of a good thing. Used across too many pages, it can lead to uninteresting and unadventurous design, and tedium can set in. However, tension, created by asymmetry, can sometimes hold the viewer's interest.

Since type is intended to be read, it should be inviting to the viewer. Entry points and the flow of the text should be easily and quickly understood. The size and placement of the display type and body text should guide the viewer through the text.

Drop (or Initial) Caps

Drop (or **initial**) **caps**, which are large characters at the beginning of a paragraph, signal the viewer where to enter and begin reading. These are not simply decorative elements, although recent design trends would imply so. They are a way of leading the eye, as a guide showing where to enter the text. If used within the text of an article, the traditional rule had been that they should signal a shift in subject matter or tone—this is no longer commonly practiced. Today, drop caps are sometimes applied to break up the gray of the text, rather than to call attention to what is being stated. If used in this fashion, the designer should place them on differing visual planes, so that the eye is guided around the page and not in a noticeable horizontal or vertical direction.

Proportion

A sense of proportion is key to good design. All elements on a page have a visual weight, or size, and relate to one another. The size of the image plays off the size of the headline, which has a relationship with the size of the text, and so on. Every component on the page has a connection with every other one. Designers can create a sense of proportion by arranging these elements in a formal or classical manner by setting equal spacing between the **head** (headline or title), **deck** (descriptive copy), and photograph. Or tension can be created between these elements with uneven spacing, an asymmetrical arrangement, changing the size of the components, etc. Each item should create dramatic effect. Should the art have the main impact, or would large text be more dynamic? It is the combination of large and small elements, and the use of positive and negative space, that ultimately creates a true sense of balance or tension on the page.

Each element on the page has an optical weight that should be considered in order to maintain proportion. A large black mass is heavier than a smaller one. The text on the page is gray—depending on the typeface, leading, and point size, this gray can be perceived as lighter or heavier. Photographs and illustrations can be light or dark; the weights of these elements can be altered. Applying a lighter tone that is less than one hundred percent, or **screening back**, will reduce the mass of a large headline. Adding white space can open up the spread, thus making it more inviting.

Unity

All the components on the page have a relationship. They are not islands that stand alone, but integral pieces of a whole. This may seem improbable with such disparate elements as a photograph and type. It helps to think of everything as a unit that should fit together—the mood of each should reflect the other. This should hold true not only from spread to spread, and page to page, but throughout the publication as a whole.

This unity is also true for illustration. Illustrations are often commissioned work that conform to your design scheme and are thereby an easier fit. Still, whether commissioned, found, or supplied, everything should work together, so that the parts will show unity within the whole design.

Negative Space

To the untrained eye, a page is meant to be filled. Any empty area is wasted space, unwanted and undeveloped real estate. If we were to follow this as a rule, what a cramped environment the world would be. The same is true of the page. Elements need air around them, a place for the reader to breath. The use of white (empty, negative) space achieves not only that, but creates positive tension in the layout, elevating the importance of what is on the page. It also gives a sense of relief, a place for the eye to rest.

Hierarchy/Emphasis

What is the most important component on the page? This is the first thing the viewer should see. By arranging the hierarchy of the design and setting that element at the top position to give stress or importance to it—meaning **emphasis**—the designer can influence what the viewer sees **first**. This can be achieved through scale, weight, and color, and also through the arrangement of all the elements on the page. In western culture, we read from left to right and from top to bottom—keep this in mind when arranging the design elements to guide the viewer's eyes through the design.

Type Alignment

Type alignment—the style or arrangement of setting text type—is very important to the nature of a design that uses type. **Justified** body text (set flush right and flush left) creates a feeling of constancy and classical formality. It is used well in a design that does not call attention to itself, where the literary content of the text is paramount. Books, which are by nature more formal than magazines, utilize this as a unifying organizational device. Justified text can be problematic,

though, in that it creates uneven kerning from line to line, dependent on how many characters comprise each line. **Kerning** is the adjustment of space between pairs of characters **(letterspacing)**, and **tracking** is the adjustment of space between words **(word spacing).** This can be controlled in even mathematical increments.

It is not enough to expect the computer software to create good justification—the designer must sometimes correct the letterspacing. You should also be aware of an excessive amount of hyphenation caused by this format. In particular, be sure to watch out for a **ladder effect;** that is, too many hyphenated lines one after the other, which creates the impression of a ladder or steps. However, it is not advisable to simply shut off hyphenation, since the software would then compensate by spreading each line out farther, creating too much open spacing per line.

An old rule that has been forgotten of late is that punctuation should "hang." That is, in **hanging punctuation,** simple punctuation marks, such as commas and hyphens, should be set slightly outside the copy block in justified text to create an even column appearance. Otehwise, these marks can create a hole within the text, a break that ruins the box-like effect of justification.

Body copy that is set **flush left** or **rag right** (justified on the left only) has the opposite effect from justification. You do not need to worry about kerning, since each word is set with standard tracking, and you can also control the hyphenation manually. It has a looser, more freewheeling feel. Still, rag right or unjustified text carries with it its own set of concerns. The right edge of the type can form odd-looking shapes that are distracting from the text and should be corrected.

So, text alignment is a matter of choice—some designers prefer an even line length, while others think a variation between lengths is best.

Applications of Type

There are basic differences between newspapers, magazines, and books. Newspapers and magazines are essentially ephemera, to be enjoyed and then discarded. They achieve a certain intimacy with their readers, similar to the familiarity of television. They lend themselves to intimate and immediate viewing before being bound together for recycling. Often they utilize flush left, rag right type to create this immediacy.

Books are more akin to film. With a poster up front (the jacket), they have a solidity and implied permanence that magazines do not, and they are weightier, both in feel and content. They imply a certain stature as they sit upon a shelf. Justified type is usually the norm.

Type for Expression

Type can take on an expressive quality. Handwriting has become increasingly popular in recent times, perhaps to counteract the onslaught of computer-generated type. It is the way of humanizing a work, fashioning an individual solution that reflects the creator's personality and skill. Ironically, there are many "handwriting" typefaces on the market, which defeats the purpose. Type can be just as expressive. As always, scale, proportion, and the relationship between all the elements can evoke a mood, a thought, or an image.

Type as Symbols or Illustrations

Another way to approach type is as a pure design element, or illustration. There is a certain resonance when doing so. Perhaps it strikes in us a primordial chord, our shared ancestral experience of hieroglyphics. It can also be a lot of fun. Creating images purely out of type adds a sense of whimsy to a design, and treats information in an unexpected manner, as seen in Figures 6-2, 6-3, and 6-4.

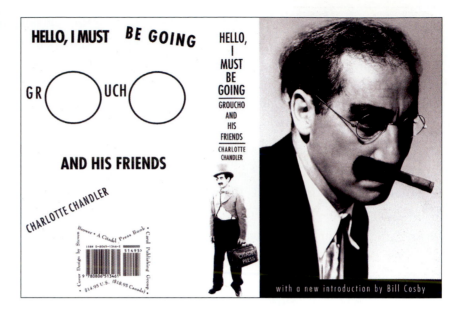

Figure 6-2

Book cover: *Hello, I Must Be Going* by Charlotte Chandler

Studio: Steven Brower Design, New York, NY

Designer: Steven Brower

Client: Citadel Press

This cover design captures the personality of the book's subject in a variety of humorous ways. On the front, Groucho Marx's image is used as an icon without type being necessary. There are not many personalities so famous that they are instantly recognizable, and therefore require no title to inform the viewer who they are. On the spine, he has packed his bags, enacting the title. On the back, his visage is reduced to a purely typographical solution. Every element was key, including the UPC code that must appear on the back cover of all books today. The starkness of black and white represents the honesty and forthrightness of Groucho's humor, as well as the film era from which he comes. Any additional color or ornamentation would have been superfluous.

Figure 6-3

Book cover: *FDR: Architect of an Era* by Rexford G. Tugwell

Studio: Push Pin Studios, New York, NY

Illustrator/Designer: Seymour Chwast

Client: Macmillan

Seymour Chwast morphs the D in these famous initials into the visage of the man himself.

Figure 6-4

Advertisement

Studio: Steven Brower Design, New York, NY

Designer: Steven Brower

Client: AIGA

The American Institute of Graphic Arts (AIGA) is the largest organization for designers in the country. They hold annual conferences at different locations where designers come to attend workshops and seminars. Since the conference was to be held in New Orleans, the theme of the event was jambalaya, a food dish with many ingredients. Here, the word forms a Mardi Gras mask for this advertisement for attendees, thus setting the mood.

Type and Image Synergy

It is possible to take this a step further, so that the type and the imagery form a seamless unit, one which could not exist without the other, as illustrated very well in Figures 6-5, 6-6, and 6-7.

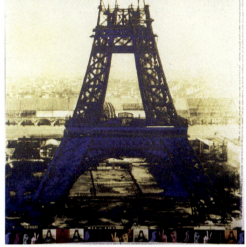

Figure 6-5

Poster: SVA

Studio: Pentagram, New York, NY

Designer: Paula Scher

Client: School of Visual Arts

Paula Scher's poster for the School of Visual Arts in New York City (commonly known as SVA) creates creates the abbreviation completely from archival photographs, which are then tinted. The handwritten type works in concert with the overall effect of a typographic solution that is comprised of no set type.

Figure 6-6

Book cover: *It's Kind of a Funny Story* by Ned Vizzini

Studio: Number 17, New York, NY

Art directors: Emily Oberman and Bonnie Siegler

Designer: Wade Convay

Client: Miramax Books

This playful cover combines three elements: type, the body, and maps. "The main character does tons of drawings of maps of the inside of his head. We decided to make one for the cover."—Number 17

Figure 6-7

Magazine cover: *Colors*

Studio: Number 17, New York, NY

Creative direction: Emily Oberman and Bonnie Siegler

Designer: Wade Convay

For this cover of *Colors* magazine, type and photography is seamlessly wed. A global culture magazine, each issue takes a theme and analyzes it. This issue's theme is fans.

Less is More

Bauhaus teacher and architect Mies van der Rohe's **"less is more"** philosophy means just that: you can achieve more by removing visual clutter and simplifying the design. By balancing the various elements of negative space, type, and image, a whole greater than the sum of the parts can be achieved to satisfying effect. An uncluttered approach to design is important, and ultimately most of the designs that withstand the test of time possess this quality. Obviously, as is always the case with design, context is everything. How complex, multifaceted, or stark a design is should always be based on the material it is communicating, and also who the intended audience is.

Another thing to consider is who you are collaborating with. Editors and writers love the written word, even more than designers. Their tendency, therefore, is to be verbose. Designing becomes a balancing act, and it is the designer's duty to ensure not only that the text doesn't overwhelm the page, but also that the design doesn't overshadow what is being said.

The Rules of Type

It is a common mistake among young designers to think that quirky novelty type equals creativity. Of course, this couldn't be further from the truth. If anything, for the viewer, it has the opposite effect. Rather than being the total sum of individual expression, it simply calls attention to itself, detracting rather than adding to the content of the design. A quirky novelty type is no substitute for a well-reasoned conceptual solution to the design problem at hand.

As a general rule, no more than two typefaces should be utilized in any given design, usually the combination of a serif and a sans serif. There are thousands to choose from, but the fewer you work with, the better you will get to know the intricacies of each one. Here are some classic typefaces in the two main categories:

SERIF

Bodoni

Caslon

Cheltenham

Garamond

SANS SERIF

Franklin Gothic

Futura

Gil Sans

News Gothic

Trade Gothic

Utilizing a combination of these typefaces should be adequate to solve most design needs. Keep in mind that each typeface has a **type family**—a complete selection of style variations, such as bold, italics, and small caps, based upon a single typeface design—to add variety and emphasis to your page.

How Not to Use Type

There will always be rules giving advice on how to design with type, but information regarding how NOT to use type is sometimes more important.

1) You should never condense, extend, or stretch type. This leads to unwanted distortions. Much care and consideration went into the design of every typeface, and they should be treated with respect. There are thousands of **condensed** (taller than it is wide) or **extended** (wider than it is tall) **typefaces** to choose from, without resorting to the horizontal and vertical scale functions (Figure 6-8).

2) Do not use text type for display purposes. Even though a computer can enlarge type way beyond the type designer's intention, this may result in distortions.

3) Do not use display type as text type. Often display type that looks great large does not work well in a smaller size and can be difficult to read.

4) Do not stack type—the result is odd spacing that looks as if it is about to tumble on top of itself. The thinness of the capital letter I is no match for the heft of a K sitting on top of it (Figure 6-9). As always, there are ways to achieve stacking successfully, but this always requires care. Also, as noted, much care should be given to the spacing within the characters of each word. This is not as simple as it seems—the computer settings for type are rife with inconsistencies that would need to be corrected optically. Certain combinations of letterforms are more difficult to adjust than others. It is paramount that even optical (as opposed to actual) spacing be achieved, no matter the openness or closeness of the kerning. It helps to squint at the copy, view the type upside down, or backwards in a light box or sun filled window in order to achieve satisfactory spacing.

Figure 6-8
Artificially condensing type leads to distortions.

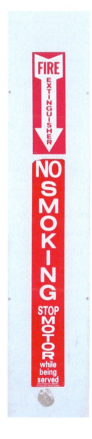

Figure 6-9
Stacking type of differing widths creates unbalance.

5) You should be cautious in the use of drop shadows. These days, shadows can be rendered easily and convincingly in programs such as Adobe's Photoshop and Illustrator. The problem, though, is that it is overdone. Therefore, the wholesale usage of soft drop shadows has become the typographic equivalent of clip art—the viewer knows they have seen it before. Rather than being evocative of a design style, it now evokes the software program it was created in.

Hard drop shadows—ones that are 100 percent of a color—are easily achieved on the computer, and can be placed behind the main text. This method is generally employed when the main text is not showing up well enough against the background, either because of a neutral tone or an image that varies in tone from dark to light. The handed-down wisdom is: if you need a drop shadow to make it read, then the design isn't working. And solid drop shadows always look artificial, since in reality there is no such thing as a solid shadow. There should be a better solution to readability problems. Perhaps the background or the color of the type can be adjusted, or the type should be paneled or outlined. There are an infinite number of variations that are possible.

Also, if you must use a solid drop shadow, it should never be a color. Have you ever seen a shadow in real life that was solid blue, yellow, or green? It should certainly never be white. Why would a shadow be one hundred percent lighter than what is, in theory, casting the shadow? White shadows create a hole in the background, and draw the eye to the shadow and not where you want it to go: to the text.

6) It is also common today to see very wide columns of body text set in small point size. The problem is that a very wide column forces the eye to move back and forth while reading, tiring the reader. On the other hand, a very narrow measure is also objectionable because the phrases and words are too cut up and the eye jumps from line to line. Viewers do not read letter by letter, or even word by word, but phrase by phrase. A consensus of opinion favors an average of ten to twelve words per line.

7) Too much leading between lines also makes the reader work hard, jumping from line to line, and too little leading makes it hard for the reader to discern where one line ends and another begins. The audience should always be paramount in the designers approach—it is the audience that defines the level of difficulty and ease with which text is read, and not the whim of the designer or even the client. As designer Eric Gill said in 1931, "A book is primarily a thing to be read."

Choosing the right typeface for your design can be quite time consuming—there are thousands to choose from. Questions abound. Is the face legible at the setting I want? Does it evoke what I want it to? Is it appropriate to the subject matter? There are no easy answers.

Breaking the Rules

Of course, there are always exceptions to the rules. An infinite number of typefaces can be used within one design, particularly when employing a **broadside style** solution (mixing many type styles on a single, large sheet of paper, typically printed on one side), as seen in Figure 6-10. This style was developed with the **wood type** (typefaces carved in wood) settings of the nineteenth century (Figures 6-11, 6-12, and 6-13). Other styles utilizing a myriad of typefaces are those influenced by the Futurist and Dada art movements of the early twentieth century.

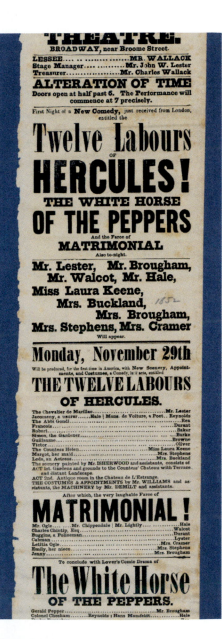

Figure 6-11

Poster: "Card a Minor" (top left)

Design firm: Modern Dog Design Co., Seattle, WA

Designer: Michael Strassburger

Client: E. B. Lane/Arizona Department of Health

Modern Dog Design makes the most out of a broadside design in the posters warning against selling cigarettes to minors.

"Posters encouraging and rewarding store clerks to card minors. Each poster is done in English, as well as Spanish (on the reverse side) to reflect the large Hispanic population in the state of Arizona."—Junichi Tsuneoka

Figure 6-12

Poster: "Must Be 18" (top right)

Figure 6-13

Poster: "Guess Their Age and Lose" (bottom)

Figure 6-10

Theatre broadside from the 1840s.

Robert N. Jones stated in an article in the May 1960 edition of *Print* magazine: "It is my belief that there has never been a typeface that is so badly designed that it could not be handsomely and effectively used in the hands of the right . . . designer." Of course, this was before the novelty type explosion that took place later that decade, and again, after the advent of the Macintosh computer. Still, Jeffrey Keedy, a contemporary type designer whose work appears regularly in *Emigre*, concurs: "Good designers can make use of almost anything. The typeface is the point of departure, not the destination." Note the caveat "almost." Still, bad use of good type is much less desirable than good use of bad type.

Figure 6-14
Magazine cover: *Print*, Nov/Dec 2000
Studio: Steven Brower Design, New York, NY
Art director/designer: Steven Brower
Photography: Wide World Photos
Client: RC Publications
This cover of *Print* uses different typefaces on an advertising sandwich board for a period feel and statement on the then current economy.

Figure 6-15
Magazine: *Scenario*
Studio: Steven Brower Design, New York, NY
Art director/designer: Steven Brower
Illustrator: Jonathan Twingley
Client: RC Publications
Scenario magazine published screenplays accompanied by illustrations. For Sam Peckinpah's classic *The Wild Bunch,* the use of nineteenth-century wood type works well with illustration and graphic elements.

Typography for the Web

On a computer monitor, some fonts are easier to read than others. Letterspacing is not an automatic feature of HTML (hypertext markup language); however, fonts created specifically for the Web do take letterspacing into account.

When designing for the Web, designers use cascading style sheets, also called CSS, to separate design considerations from other markup considerations. They are master lists of instructions that specify how text should appear on a web site, including fonts, font sizes, and margins, and they allow designers to determine a set of characteristics for the text on a web site, including baselines, line spacing, word spacing, and kerning (letterspacing).

An HTML tag can be embedded in the style sheets code to provide alternative standard fonts for a web site—in case the viewer's computer does not have the indicated font installed—offering at least three default font possibilities, in order of preference.

Another way type (text) is displayed on the Web is by using specific software, such as Adobe Photoshop and Illustrator, to save type as image files (JPEG or GIF files). When type is created and saved in this manner, it doesn't matter if viewers have the font on their computers; it will be interpreted as a fixed image rather than as type (HTML text sizes and line lengths can appear in various ways, depending on the operating system and how the user sets preferences in the web browser).

Font Sizes

Points are the units used to measure type in print. On a computer screen, pixels are the units of measurement. Mac OS offers a default resolution of 72 pixels per inch to match the print arena, where 72 points equal one inch. Understanding typographic resolution is necessary because the default preferences in Windows are set at 96 ppi, and at 72 ppi in the Mac OS. Be aware that 12-point type in Windows is 16 pixels tall, while 12-point type on a Mac is 12 pixels tall. These numbers will vary with the user's choice of screen resolution. Web sites can be viewed from a computer monitor, and now even from a kiosk, iPod™, and mobile phone screen; legibility should be taken into account when choosing fonts because of these new, smaller screens.

Color and Value Contrast

Color and value contrast can enhance or detract from readability on a computer screen. Using Web-safe colors (which can be selected in Photoshop palettes) when designing will help to avoid **dithering**, which can happen when the browser tries to approximate a color by combining adjacent pixels of color that the viewer can see. Large areas of text or color can become difficult to view.

Common Windows and Mac Fonts

Serif
- Courier New
- Georgia
- Times New Roman

Sans serif
- Arial
- Comic Sans
- Geneva
- Helvetica
- **Impact**
- Lucida
- Verdana

(continued on next page)

Visual Hierarchy and Navigation

Most importantly, and not unlike print applications, typographic design on the Web should be logical (in terms of information hierarchy and content), make navigating the web site easier for the visitor, and make information gathering easy.

Critical Pointers

- Divide content (type) into units and subunits.
- Logically order information using type according to size and weight.
- Logically separate and group sections or zones of information, such as titles, subtitles, paragraphs, section breaks, and links to new pages.
- Provide enough negative space around text to make it more readable and to provide "breathing space."
- Type should work (aesthetically and in voice) with the web site concept or theme.
- Avoid endless text scrolling; divide pages with graphics or arrows.

Text Design

Just as a book or magazine with a successful interior design directs the reader and allows for ease of reading, a web site's text design must do the same. Indicate to the reader when one page stops and another begins by using a grid, template, or graphic devices. Endlessly scrolling through text, page after page, is not user friendly, will detract from orderliness, and can create viewer fatigue. Conversely, too little type or text on a page can irritate the visitor by forcing them to move to the next page often in order to keep reading.

In print, a long paragraph (or long line length) can work well if designed thoughtfully, using a highly legible typeface and appropriate leading ratio. On the Web, a long paragraph or line must be read by scrolling, making the text far more difficult for the visitor to access and comfortably follow. For the ease of readability, it is best to divide long paragraphs into shorter ones. Web guru David Siegel advised: "Clarity. Brevity. Bandwidth."

One example of a barrier would be a photograph of a mayor on a town web site with no text identifying it. Because screen readers cannot interpret images unless there is text associated with it, a blind person would have no way of knowing whether the image is an unidentified photo or logo, artwork, a link to another page, or something else. Simply adding a line of simple hidden computer code to label the photograph 'Photograph of Mayor Jane Smith' will allow the blind user to make sense of the image.

Accessible Design Benefits Everyone

When accessible features are built into web pages, web sites are more convenient and more available to everyone—including users with disabilities. Web designers can follow techniques developed by private and government organizations to make even complex web pages usable by everyone, including people with disabilities. For most web sites, implementing accessibility features is not difficult and will seldom change the layout or appearance of web pages. These techniques also make web pages more usable both by people using older computers and by people using the latest technologies (such as personal digital assistants, handheld computers, or web-enabled cellular phones).

With the rapid changes in the Internet and in assistive technologies used by people with disabilities to access computers, private and government organizations have worked to establish flexible guidelines for accessible web pages that permit innovation to continue."

Summary

Choosing the right type for your design can be quite time consuming; there are literally thousands to choose from. Questions abound. Is the typeface legible at the setting I want? Does it evoke what I have in mind? Is it appropriate to the subject matter? There are no easy answers; however, as discussed here, there are evocative reasons to use a certain type.

Legibility needs to be considered within the context of what is being published. The reader/audience experience should always be paramount in the mind of the designer. Form should always follow function, especially where typography is concerned. Designing with type can be at once the most liberating and the most difficult task in the life of a graphic designer.

EXERCISES

Exercise 6-1: Shakespeare poster

Design a Shakespearian poster: an assignment in reductive communication.

Posters are afforded scant seconds on the average for viewing on the street. How do you communicate effectively and forcefully? Shakespeare is a good choice because the themes of his plays or major scenes can be described concisely, thereby allowing to a clear conceptual approach. Students should be familiar with the material; do not confuse the time period of the play with the era in which in was written. Watch for inappropriate typography; a common cliché is the use of blackletter or "old English" typography to connote Shakespeare's time. A more appropriate approach would be the utilization of type that is evocative of the play.

Exercise 6-2: Type Designers Club call for entries

Design a mailer that goes out to designers to solicit them to enter the annual awards show.

Exercise 6-3: Music concert poster

Design a music concert poster with only handwritten type. If you are left-handed, use your right hand, and if are right-handed, use your left.

Exercise 6-4: Book cover title

Create a book cover title that is an image created entirely out of type. It has to be easy to read and also the image should be recognizable.

Exercise 6-5: Type specimen book

Create a type specimen booklet for an imaginary type house, sixteen to twenty-four pages long, featuring different settings of each typeface. Use literary quotes as examples, or design the same as a web site for a type house.

Principles of Composition

Balance

Chapter 7:
Balance

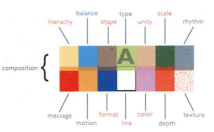

Objectives

- Define the principle of balance
- Learn about the strategies for creating balance
- Review the different types of balance
- Understand the expressive potential in the principle of balance

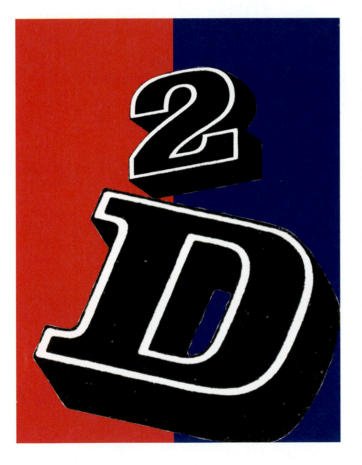

What Is Balance?

By definition, **balance** is stability or equilibrium created by an even distribution of visual weight on each side of a central axis. In two-dimensional design, balance is also created by an even distribution of weight among all the elements of a composition.

In design, weight is not defined as an actual or physical gravitational force, but rather as a visual force or **visual weight.** Every element of a design carries energy—a sense of force, strength, or *weight*. In design, this strength or weight refers to the relative amount of visual attraction or importance or emphasis the element carries in the composition.

As seen in the historic poster design by El Lissitzky (Figure 7-1, following page), the elements of shape, color, type, and line are "playing off" one another in a balance of visual energy. The elements all have relative visual weight. They are placed in such a way as to evenly distribute that weight throughout the composition in order to achieve a feeling of overall balance.

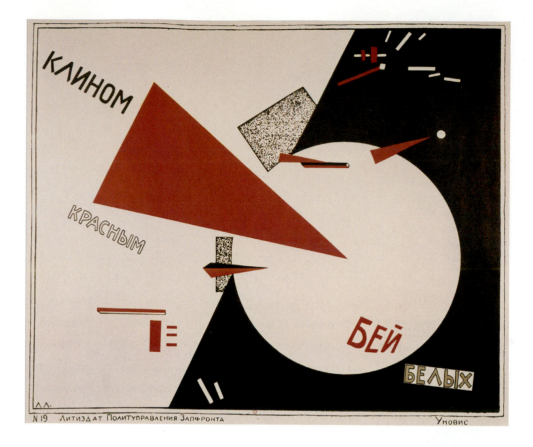

Figure 7-1

Poster: *Hit the Whites with the Red Wedge* © ARS, NY

El (Eleazar) Lissitzky (1890–1941)

Photo Credit: Snark / Art Resource, NY

The amount of visual weight of elements is dependent on their size, shape, color, and texture—along with several other factors, such as their location or placement in the composition. Determining and manipulating visual weight is central to creating balance.

Equal Distribution

As with physical or actual weight, balancing a design could be an even distribution on each side of a central axis—think of a child's teeter-totter—as shown in Diagram 7-1 (also revisit Figure 7-1). The axis may be horizontal, vertical, or both and clearly delineated as a line, edge, or shape, or a negative area may act as the dividing line of the composition.

Diagram 7-1

Vertical Axis

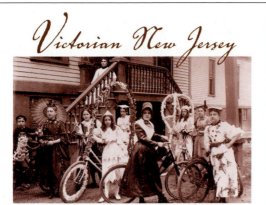

Or, visual weights can be evenly distributed *without* a clearly defined axis. See the page compositions in Figure 7-2 for examples of several types of balanced distribution of visual weights.

The Need for Balance

The relative factors determining visual weights are explored further along in this chapter. First, an understanding of the necessity for overall compositional balance must be established.

As you select the elements of a design, without a word of direction, you intuitively make choices that balance the design. Almost automatically, you sketch lines, shapes, and type and shuffle their arrangement until all the elements in the design feel as though they work in equilibrium. This semiconscious drive toward equilibrium or balance is likely compelled by an innate human need for stability, both physically and psychologically.

Figure 7-2
Book: *Victorian New Jersey*
Studio: Office of University Relations, Kean University, Union, NJ
Art director: Robert Cole
Designer: Richard Dooley
Photographer: Guillermo Thorn
Client: Kean University Press

Top: In the title page of this book, balance is created by evenly distributing the elements (type, color, texture, shape) equally from top to bottom—working from a centrally located, horizontal axis (the photograph image).

Middle: For the credits page, the axis or dividing line is the vertical negative space.

Bottom: In the third composition, a clearly defined axis is not in use. Nonetheless, the elements still have an overall balanced feel.

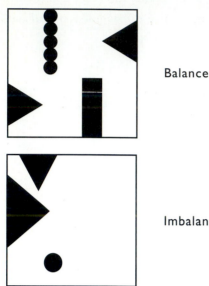

Balance

Imbalance

Diagram 7-2
There is a need for balance in order to give the design
a feeling of equilibrium and stability.

Notice the need for balance within your own body—
a fall or a loss of equilibrium causes dizziness that
in turn creates an uncomfortable feeling or nausea.
Recovery comes when the dizziness subsides and
stability returns.

Externally, you can also notice the need for balance
in your daily life. Within the arrangement of liv-
ing spaces, the combination of foods eaten, and the
clothes worn, note the choices made to create balance.
At the start of the day, you may choose a light colored
T-shirt and automatically grab a pair of dark pants to
complement and balance the color of the shirt. Think
about the arrangement of furniture in a living space;
a bed, desks, chairs, and tables are carefully placed
throughout the room for both functional and aesthetic
purposes. Usually, furniture is arranged for practical-
ity and comfort. Imagine eliminating balance in your
living space by pushing all the furniture into one cor-
ner or piling it all into the center of the room. A lack
of equal distribution or balance seems irrational, is not
practical, and feels uncomfortable.

Also with two-dimensional design, the need for the
viewer to feel or sense balance is essential for practi-
cal purposes and to comfortably engage the viewer
in the composition. A design that is poorly balanced
might frustrate the viewer and perhaps motivate
them to want a rearrangement of the elements—seek-
ing equilibrium of the elements in their own mind.
The lack of balance could disturb the viewer to the
point that the design is perceived as somehow unfin-
ished or "wrong" (Diagram 7-2).

Do be aware that there are many occasions where what "feels" balanced and correct to one viewer may feel out of balance to another. The reason can be as simple as personal taste—the viewer may not *like* the way the designer has created balance. An untrained eye may find a well-balanced composition challenging, tenuous, or difficult to understand, or simply too unfamiliar in arrangement to comprehend.

The compositions in Figure 7-3 exhibit several approaches to successfully balancing the elements. Yet, some viewers may find the sophisticated compositions challenging to their sense of equilibrium and balance.

Strategies for Balancing a Composition

Although balance is perhaps more personal in feel than the other design principles and often intuitive in application, there are some generalized strategies for composing that may result in a successful and/or sophisticated balance of elements. By studying and using the principles of balance (and combining them with other design principles), a composition should function harmoniously and deliver the intended message.

Visual Weight of the Elements

The first strategy for composing balance involves awareness, understanding, and manipulation of visual weight. Even though visual weights used in two-dimensional design are *not* actually affected by the earth's gravity, imagine that you can hold a line or a color in your hand. If the line were large and thick, it would probably feel heavy. If you could hold the color bright red, it would also feel heavy due to its color saturation and intensity (Diagram 7-3).

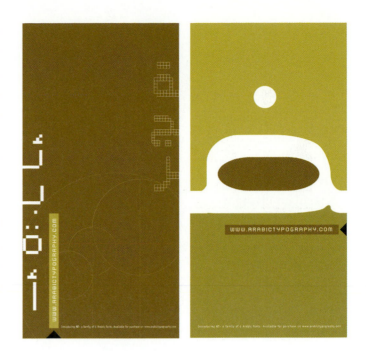

Figure 7-3
Promotional postcards: Arabictypography.com
Studio: Tarek Atrissi Design, The Netherlands
Art director and designer: Tarek Atrissi
Calligraphy: Samir Sayegh
Client: Self-initiated

Bright tone Dull tone

Diagram 7-3
Shown are two tones of the color red. The bright tone has more visual weight than the dull tone.

In general, the characteristics and qualities of a particular element determine its visual weight, whether mighty or frail.

Consider the following characteristics and qualities of an element in determining visual weight:
• Orientation and location of an element on the format
• Size of an element
• Whether an element is figure or ground
• Color: hue, saturation, value, and temperature
• Line: color, texture, and thickness
• Shape: color, volume, and mass
• Type: color, volume, and mass
• Texture: density, and size of area covered
• Pattern: color, and size of area covered

For instance and in general, large, bright orange forms containing textural detail will have a tendency of visually weighing more than smaller, delicate blue ones. Small, brightly hued shapes may have more visual weight than a single shape that is dull in color. Easy to neglect or forget, the negative areas or negative shapes (the ground) of the composition will also have weight. Large areas of negative shape may have more weight than small areas of positive shape, as seen in the design by the renowned, early twentieth-century artist and designer Gustav Klimt in Figure 7-4.

In addition and relative to the format (noted in Chapter 1), dynamically oriented elements will attract more attention (more visual weight) than statically oriented elements.

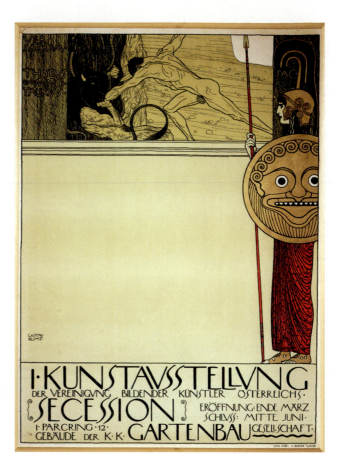

Figure 7-4
Poster for the first exhibition of the "Secession,"
Austria, 1897 Gustav Klimt (1862–1918)
Historisches Museum der Stadt Wien, Vienna, Austria
Photo Credit: Erich Lessing / Art Resource, NY
The "empty space" or negative area centered to the left of the shapes is an integral part of the whole, with the weight of the large void balancing the many smaller and complex shapes, lines, colors, and type around it.

Diagram 7-4

A large shape is heavier in comparison to a small shape.

Cool/cold colors weigh less than warm/hot colors.

Dull tones are lightweight; bright hues are heavy.

Black often weighs more than white.

Patterns or textures have heavy visual weight compared to shapes without pattern.

No list is definitive and no formulas should be sought; however, the examples shown in Diagram 7-4 can be used as *starting points* for gaining awareness of how the qualities of elements might, generally speaking, "weigh in." These comparable visual weights are extremely simplified in order to create a starting point for awareness and understanding. Be aware, too, that visual weights are always determined in comparison and *interaction* within a composition. It is not possible to determine the weight of an element in isolation. Comparisons and cross-comparisons need to be made to an entire composition to determine and establish which elements have the most visual weight.

A list or diagram is only a starting point for awareness and should never be considered definitive. Balancing the elements is a process of constant adjustment and readjustment until equilibrium is reached.

Factors Affecting Visual Weight

Understanding how to determine the general visual weight of individual elements is the first step toward understanding and manipulating balance. Understanding the additional factors affecting visual weight and how the visual weights play against each other and interact within a composition is the next challenge.

Factors affecting visual weight and the considerations relative to the *interaction* of visual weights include:
- Density (or number) of elements in a given area
- Isolation and emphasis of an element in the composition (focal points)
- Position/placement on the printed or digital format (single or multiple pages)
- Line of vision
- Actual movement (screen-based media)

Density or Number

Crowds attract attention. Many shapes grouped together may create a highly energized area within a format because large numbers of shapes, forms, textures, and/or lines attract attention and therefore a great amount of visual weight. To balance numerous shapes, a designer must choose variables of equal visual weight—creating a counterweight to balance the group.

In Cipe Pineles's poster design for the Parsons "Design for the Environment" competition (Figure 7-5), the single, large shape of an elephant (superimposed with a group of small letterforms on a red field) is in balance with a group of ten, smaller animal shapes, because there is an equal distribution of visual weights—one large shape (elephant), containing a bright red rectangle with many small letters, is balancing the herd of smaller shapes above it.

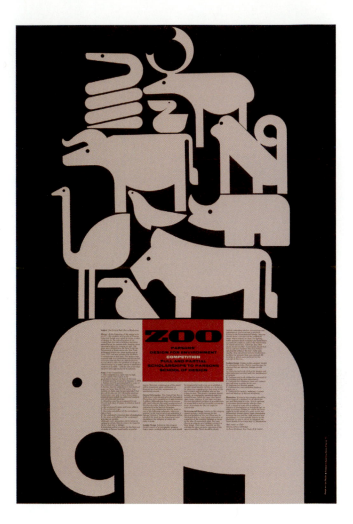

Figure 7-5

Poster: Parsons "Design for the Environment" competition
Art director and designer: Cipe Pineles (1908–1991)
The Anna-Maria and Stephen Kellen Archives Center for the Parsons New School for Design and the Archives and Special Collections, RIT Library, Rochester Institute of Technology. The many small shapes at the top of this composition are balanced by one large shape at the bottom. The red rectangle also plays into the balance of shapes by adding to the visual weight of the area.

Use the examples shown in Diagram 7-5 to begin to understand how the qualities of the elements combined with the number of elements used may be paired to create a balance. Try creating several pairs of your own.

Isolating Shape/Focal Points

Although many shapes may command attention because of their clustered number, *isolating* a single shape may also have a great amount of visual weight. Isolating a shape focuses attention on it (focused attention = more visual weight). Think of the full moon in the sky. In its isolation, the moon has a great amount of visual importance since it is alone (and by far the largest shape in the sky) and therefore without much competition from other shapes (tiny stars). The isolated, unchallenged moon is the center of emphasis in the composition—the focal point.

Diagram 7-5

Five circles can be equal in visual weight to one large square of equal area.

Two large, brightly colored squares may have the same visual weight as a series of ten smaller squares in the same two colors.

One tiny red dot balances a very large blue half-circle.

A rectangle containing a pattern of many gray stripes weighs equally with six smaller orange rectangles.

A focal point carries a great amount of visual weight and must be balanced accordingly with the other elements of the composition. In the packaging label design for Bella Cucina™ oils (Figure 7-6), the designers chose to focus on or emphasize the image of a fruit (tangerine and lemon) by centering the colorful images in the composition—the central placement, strong color, and familiar shapes in total have a great deal of visual weight in comparison to the accompanying elements.

However, the designers balanced the focal area by equally distributing several lines of complex type neatly and compactly above and below the central image. The two groupings of type balance the overall composition by having enough visual weight of their own. The viewer's eye is attracted at first to the fruit, and then comfortably moves above and below the center to read the type.

Note that balance is only one principle of composition. Balance must be set to work in conjunction with all other principles of composition, such as unity, rhythm, and visual hierarchy (arranging elements according to emphasis). Compositions usually contain a focal point and a visual hierarchy; however, having a primary center of focus and a secondary focus (and so forth) does not preclude having a balanced composition. Balance may still be achieved through counter visual weights (Figure 7-7).

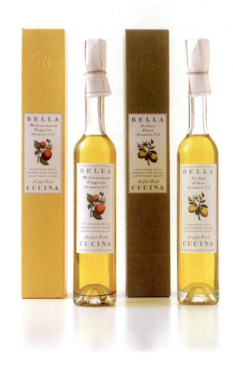

Figure 7-6
Packaging: Bella Cucina oils
Studio: Louise Fili Ltd., New York, NY
Designers: Louise Fili and Mary Jane Callister
Client: Bella Cucina

Figure 7-7
Print advertisement: North Carolina Department of Travel and Tourism
Agency: Loeffler Ketchum Mountjoy, Charlotte, NC
Creative director: Jim Mountjoy
Art director: Doug Pedersen
Copywriter: Curtis Smith
Photographers: Olaf Veltman and Stuart Hall
Client: North Carolina Department of Travel and Tourism
The very bright orange tent is a focal point of the composition because all other colors are muted in tone in comparison. A close secondary focal point is the letter "P" button on the left side of the composition. The shape draws attention because it is an isolated light area within a dark area. The two small focal points are balanced by an overall large expanse of the complex shapes

Position of Elements within the Composition

In addition to the visual weight of the elements mentioned previously, another potential balancing factor affecting weight is the location or position held by an element on a single-page or multiple-page, printed or screen-based format.

In Western cultures, the specific position on the page has a relative weight—generally, the top and center areas, respectively, have the most visual weight.

To simplify learning and begin the study of the relative visual weight of a particular position or placement within a composition, think of dividing the single composition or complex format into several general areas, such as:
• Top
• Bottom
• Left
• Right
• Center
• Interstices of the areas listed above
• First in a series of printed or screen-based pages (front)—to last printed or screen-based page (back)

In a single printed page or web page composition or other screen-based media, the top areas may have more visual weight than the bottom position. In general, the top of the page or screen holds a great amount of visual weight because the viewer has the tendency to look at the top first.

The reason for this top-heavy importance stems, in part, from the progressive way printed matter is read in the U.S., Europe, and South America (and other individual countries). A traditional communication medium, such as a book or a newspaper, is usually read (in many, but not all languages) from the top left across to the right and then down, or simply from the top down.

The reading progression from the top to the bottom is fairly common and ingrained for several large groups of the world's peoples. Variations do occur, however; in the globally recognized newspaper *The New York Times,* for instance, the lead story is always placed on the top right. The lead photo is frequently (if not always) found at the top center.

In many newspapers and magazines, the focus or area of emphasis is usually created by a large image in the *top center* of the format (or occupying the whole area below the publication title). The strong image usually found just below the publication title at the top center of the page is balanced by a variety of other elements on the page, including the publication title itself, images, headlines, and the shapes of body type (columns). Many newspapers around the world use this kind of compositional balance—where the large, full-color (or black-and-white) image in a top center position is in a counterbalance with the publication title, headlines, the expanse of gray text on the full page, and smaller color images at the bottom of the page.

The strength of any particular area of the composition will also be dependent on the visual weight of the elements occupying the position (the balancing factors such as the size and color of the shape). The *center* of a printed page or computer screen, for instance, may have a great amount of weight because a viewer has the tendency to look to the center first when *no* stronger elements appear at the top of the composition. The center of the page is often seen as a natural balancing "hub," with all of the elements seeming to rotate around a core. In this instance, the center has the most weight.

In another instance, the left side of the screen in a web page design may have more visual weight than the right side because the right side is not necessarily fixed in place or predictable (due to the ability of the visitor to resize the screen and cropping the right side). The left side of a web page is often the position of choice for the site's navigation menu.

The bottom of the composition (in the case of a newspaper page, for instance) carries some relative visual weight too, because there is a sense of stability perceived by this "anchored" area. Elements at the center bottom of the page follow an illusionary pull of gravity and may feel as though they are well-grounded, anchored (no further space to move to), and therefore secure. However, in a web page design, the bottom is less important, again, because the position is (often) not necessarily fixed. Designers are correcting this unpredictable, awkward, and balance-breaking situation on a web page by creating a design within a small, designated area and fixing or securing the design area using software technology to do so. The fixed area of web page composition allows the designer to have greater control over the placement and balance of elements.

In a multiple-page print format (book, magazine, brochure, or newspaper), the cover usually carries more visual weight than subsequent pages or sections. The reader is directed in a physical way to start with the cover—it is on *top* of all the other pages. Once past the cover, the reader is compelled to go further because of interest found in the imagery, graphics, and content (information) of the booklet, book, or brochure (Figure 7-8).

Figure 7-8

CD and DVD boxed set: *Once in a Lifetime,* The Talking Heads

Studio: Sagmeister Inc., New York, NY

Art direction: Stefan Sagmeister

Design: Matthias Ernstberger

Cover paintings: Vladimir Dubossrsky and Alexander Vinogradov

Creative supervision: Hugh Brown

Client: Rhino

With its bright and saturated palette of color and complexity of shapes, the front cover and inside front cover of this DVD booklet carry the most visual weight within the entire format—making the front cover the focal point of the multiple-page composition. In addition, the front and back covers, inside covers, each page, and each spread of pages contains a balanced composition within itself.

"Titled *Once in a Lifetime* and containing three CDs and one DVD, this panoramic Talking Heads collection features cover paintings by the Russian contemporary artists Vladimir Dubossarsky and Alexander Vinogradov. The paintings contain all of my favorite visual icons: babies, bears, severed limbs, and bare-naked people (except a guy in boxers on the inside front cover). The extreme format of the packaging not only allows for easy storage in standard record store bins, it also handily obstructs access to all CDs behind it. It contains over one hundred rare photographs and extensive essays."—Stefan Sagmeister

Although a multiple-page (screen) web site does have a first page or home page (somewhat like the cover of a book), the viewer or reader of a web site does not necessary enter at the home page. Unlike a book, there isn't a physical directive to start at the cover. Nor does a web site have a numbered order of screen pages, or a linear progression. Once the viewer enters the site, he or she should be able to move to any screen page on the site, in any order. Therefore, the balance of the whole web site format does not necessarily need to progress in a linear way and most often does not. However, each screen page of a web site should contain a balance of the elements (Figure 7-9).

Since the top, center, right, and bottom areas of a design tend to hold the most visual weight (respectively), it follows that the very left edges of the format and the middle areas in between the main areas of the page will likely have less. However, to repeat and reinforce: the visual weight of the position of the elements is highly relative to other balancing factors, such as the format (print or screen-based), the qualities of the elements, their size, and their number in the composition. All is relative in the process of balancing a design.

Line of Vision/Directional "Pull"

Return again to the way in which a newspaper or book is read (in the U.S.)—from top left to bottom right. The *direction* (a line of vision) in which a newspaper or a book is read also affects the forces within a composition in regard to visual weight and balance. For instance, in the U.S., there is a tendency to read from left to right, with a pause or ending point at the right, and therefore, this rest area carries much visual weight. The directional pull from left to right is very strong—the direction it eventually leads the viewer in has a great deal of visual weight. (In some countries other than America and Europe, the directional pull may be different—involving a right to left directional pull. There are many aspects of design that should be considered in their cultural context. It is the responsibility of the designer to understand the audience.)

Figure 7-9

Web site pages: SVA Masters Program

Studio: Tarek Atrissi Design, The Netherlands

Designer: Tarek Atrissi

Client: School of Visual Arts

Each screen page of this web site has an orderly balance of elements. The structured arrangement makes for clarity of navigation, as well as to express a feeling of order and intelligent organization—qualities that reflect the content.

Look again at Cipe Pineles's poster for Parsons "Design for the Environment" competition (Figure 7-5). As noted previously concerning Pineles's composition and repeated here for further exploration, one large shape at the bottom (containing a complexity of type) is in balance with the many complex shapes at the top of the composition. In addition, Pineles balances the left and right areas in a subtle, but clever and effective way. The usually weighty right side of the composition is balanced by the pointedly left-facing direction in which all the creatures are gazing. The pull of a line of vision and the counter pull to create balance can also be examined in Figure 7-10.

Actual Movement

Imagine an insect buzzing around your face. It does get your attention. In screen-based media, moving or animated images within the design usually capture a great amount of attention when seen in comparison to still images. Movement therefore can add extra visual weight to an element or group of elements. Look at any web page or screen-based design that has animated elements—notice the pull or strength this area has in comparison to the other stable elements in the design. It is likely that the animation is a focal point (with greatest weight) or a close second, if the design is well balanced. However, too much animation can cause confusion and upset the compositional balance. All factors must be considered. Elements interact in a multitude of ways to create a composition. It is the designer's responsibility to effectively juggle all the variables (qualities, density, isolation and focal point, position, direction, and movement of the elements) to achieve a well-balanced success.

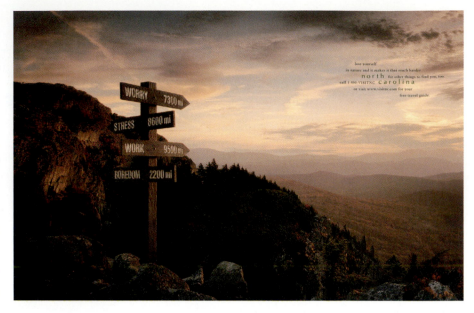

Figure 7-10

Print advertisement: North Carolina Department of Travel and Tourism

Agency: Loeffler Ketchum Mountjoy, Charlotte, NC

Creative director: Jim Mountjoy

Art director: Doug Pedersen

Copywriter: Curtis Smith

Photographers: Olaf Veltman and Stuart Hall

Client: North Carolina Department of Travel and Tourism

The signpost placed on the left side of the composition points to the right—creating a very strong line of vision. Balance is achieved through the counter visual weights that include an expanse of shapes in the landscape, bright color, and type. Imagine the imbalance if the signpost had been placed at the right of the composition.

Types of Balance

Once an understanding of visual weight is established, the next order of study is in regard to the overall type of balance used in a composition of either a single-page or multiple-page printed or screen format. There are several ways to structure the visual weights; each structure produces a different expressive mood.

The two main types of balance structures are **symmetry** (equal distribution of visual weights on both sides of a central axis) and **asymmetry** (equal distribution of visual weights without a central axis). In addition, a third structure may be considered, that being **radial** (or all-over) **balance**, symmetry which is achieved through a combination of horizontally and vertically oriented symmetry where the elements radiate out from a point in the center of the composition, or an extensive repetition of an element or elements.

A simple diagram of the three types of balance can be seen in Diagram 7-6.

Diagram 7-6
Symmetrical Arrangement (top)
Asymmetrical Arrangement (middle)
Radial Arrangement (bottom)

Figure 7-11
Logo: Jean-Georges Vongerichten
Studio: Louise Fili Ltd., New York, NY
Art director: Louise Fili
Designers: Louise Fili and Mary Jane Callister
Client: Jean-Georges Vongerichten
The symmetry found in this logo composition creates
a formal mood.

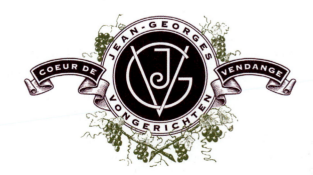

Symmetry

A symmetrical design uses similar or identical elements arranged on both sides of a positive (figure) or negative (ground) horizontal or vertical axis—often creating a strong and obvious division. Because each side of the composition is a mirror image of the other (or nearly so), symmetrical arrangements may, at times, seem to feel neat, or orderly and/or formal (Figure 7-11), or stable and direct. These feelings may be tapped to contribute or reinforce the message of the design (Figure 7-12).

Note in Figure 7-13 how the simplicity of the symmetrically balanced composition contributes to the clarity and immediacy of the message, which is necessary for a promotional campaign meant to inform the public, such as the "Dial 311" campaign.

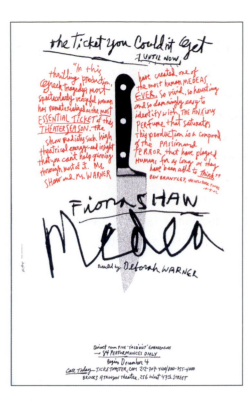

Figure 7-12

Poster: *Medea*

Studio: Spotco, New York, NY

Art director: Gail Anderson

Designer: James Victore

Client: Scott Rudin, Daryl Roth, Stuart Thompson, producers

The image of the knife, the red color text, *and* the sharply split, primarily symmetrical balance of the composition expresses the dramatic content of the play *Medea*.

Figure 7-13

Product branding campaign: Dial 311

Studio: @radical.media, New York, NY

Designer: Rafael Esquer

Media: Print, environmental graphics, and television

Client: The City of New York

The simplicity of symmetry in this series of public service advertisements provides the viewer with immediate and clear access to the pertinent information. Bold shapes and bold contrasting colors also contribute to the successful delivery of information.

Asymmetry

An asymmetrical design has a balance of visual weights, although the composition is not arranged as a formal distribution of similar elements on both sides of a central axis. Asymmetry relies on the positioning and interaction of dissimilar elements using a refined balance of visual weights to arrive at a sense of equilibrium throughout the composition (Figure 7-14). Note the asymmetry in the cover of the brochure in Figure 7-15 and a series of screen-based designs in Figure 7-16.

Negative space often plays a significant role in asymmetrical compositions, as seen in Figure 7-15. The large, negative area balances the weight of a smaller group of shapes. In addition, analyze the many compositions found in this chapter or throughout the book to see how visual weights are asymmetrically balanced.

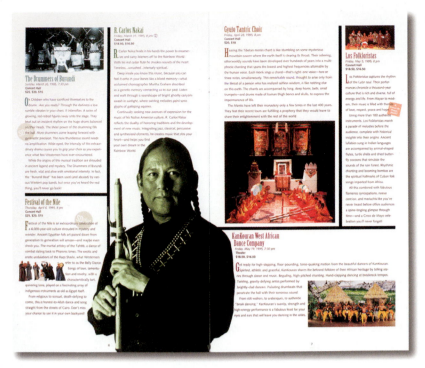

Figure 7-14

Brochure page spread: California Center for the Arts

Studio: Mires Design for Brands, San Diego, CA

Client: California Center for the Arts

Shapes, lines, colors, and type are arranged in an asymmetrical way through careful balance of the visual weights.

Figure 7-15

Brochure cover and branding: Qatar: An Identity for a Country

Studio: Tarek Atrissi Design, The Netherlands

Design and art direction: Tarek Atrissi

Client: Qatar

The elegant asymmetry of this brochure cover design is meant to be a reflection of the elegance and sophistication of the country of Qatar. "The unique and large-scale project of design: the visual identity of Qatar, a small country in the Arabian Gulf. Project included designing the logo for the country and the entire visual language and various web and printed promotions used to promote tourism and business in the country. For more information and to download the press release: *www.atrissi.com/qatar.*" —Tarek Atrissi

Figure 7-16

TV graphics: *Saturday Night Live* opening sequence

Studio: Number 17, New York, NY

Art directors: Emily Oberman and Bonnie Siegler

Client: *Saturday Night Live*

Each screen is asymmetrically balanced and done so for excitement. As stated by the designers: "We represented the dynamic energy of New York City at night by using abstract animation of colored bars."—Oberman and Siegler

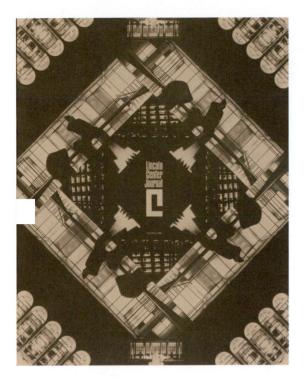

Figure 7-17

Journal cover: Lincoln Center Journal for October 1968

Designer: Cipe Pineles

Archives of Lincoln Center of the Performing Arts, Inc.

Perfectly symmetrical four-way mirrored imagery creates a dynamic radial balance for this performing arts journal.

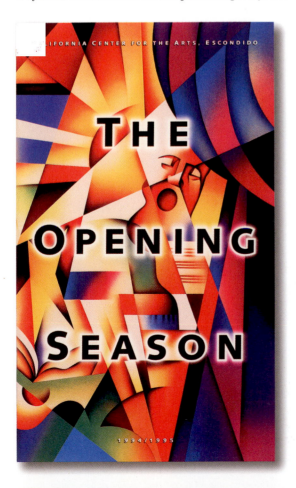

Radial Balance

Strictly defined, radial balance is a type of symmetry where the elements radiate out from a point in the center of the composition (Figure 7-17). This type of balance seems to create a spinning or dynamic sensation; however, the organized repetition of elements also has a unified look and feel.

Often a composition will have a radial symmetry, but not necessarily be perfectly ordered or tightly structured. The focal point may not be directly in the center, and the elements may be somewhat unequal in size and shape. Nonetheless, the overall appearance is one of centrally focused, radiating balance (Figure 7-18), and the whirling sensation is still felt.

Through a study of the principal of balance, you can begin to better control the arrangement of elements within the format. Remember as you work, actual compositions are complex affairs that involve many variables and interactions. *Arrangements are precarious. Moving, adding, or changing the color or texture of just one element will cause the entire design to shift in balance.*

Achieving balance can be an obsessive pursuit, as noted in the magazine cover designs by Rodrigo Sanchez (Figure 7-19).

Figure 7-18

Brochure cover: California Center for the Arts

Studio: Mires Design for Brands, San Diego, CA

Client: California Center for the Arts

The excitement captured in color and the loosely-structured radial balance expresses the energy and diversity of the arts center for which this brochure cover was created.

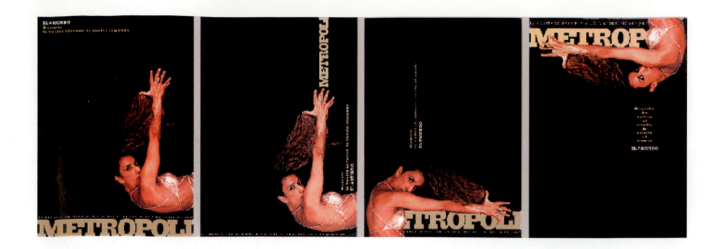

Figure 7-19

Magazine covers: *Metropoli*

Studio: Unidad Editorial, S.A, Madrid, Spain

Art director: Rodrigo Sanchez

Client: EL MUNDO

As displayed in this group of designs for a magazine
cover, shown on a web site, balance of one group of
elements can be achieved in many different ways.

Expressive Balance

"The meaning of the work emerges from the
interplay of activating and balancing forces."
—Rudolf Arnheim, art and film theorist, perceptual
psychologist, and author of *Art and Visual Perception*

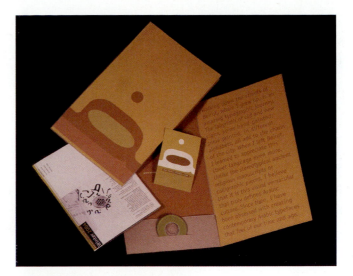

The type of balance employed can contribute to the
expressive communication of the design. Symmetry
often creates a formal or orderly mood; asymmetry
produces dynamic tension—a harmony of dissimilar
forces (a seeming contradiction in terms, yet fully
accepted in regard to basic design principles). Asym-
metric designs may agitate or disturb the viewer be-
cause of the challenging method of balance, or the
asymmetry might delight a viewer intellectually
through a playful or interesting countering of visual
weights (Figures 7-20 and 7-21).

Figure 7-20
Postcard and font packaging: Arabictypography.com
Studio: Tarek Atrissi Design, The Netherlands
Art director and designer: Tarek Atrissi
Calligraphy: Samir Sayegh
Client: Tarek Atrissi Design
Asymmetry creates an intellectually stimulating and sophisticat-
ed design for this promotional postcard and font packaging.

Figure 7-21
Web site: Arabictypography.com
Studio: Tarek Atrissi Design, The Netherlands
Art director and designer: Tarek Atrissi
Calligraphy: Samir Sayegh
Programming: Paul Klok
Client: Tarek Atrissi Design
Seen on this home page, Atrissi creates a dramatic visual
balance for an unusual web site. "The first online communication
platform for Arabic Typography, with an identity created for print
promotional usage, as well as the web interface of the web site. It
is a modern use of Arabic calligraphy and typography and a fresh
and unique experimentation of Arabic Type in the field of New
Media."—Tarek Atrissi

There are times when a designer may employ both symmetrical and asymmetrical elements within a single design—the symmetrical elements provide some stability, while the asymmetrical elements offer an unexpected twist (Figure 7-22) or a challenging dynamic feeling (Figure 7-23).

Summary

Studying the work of designers will help you see how compositions are structured and balanced. Explore professional compositions—and your own—to understand the placement of the elements in the format, and the visual weight each carries. Note as well the symmetry or asymmetry of each composition; the way a composition is balanced has strategic importance to the visual hierarchy and can add stability or, conversely, a dynamic feeling. The balance of the elements, in conjunction with the other principles of design, helps to communicate thoughts and express emotions to the viewer. As you expand awareness of the principles of balance, your ability to design and communicate should become more sophisticated.

Figure 7-22

Book cover: *Americans in Paris: A Literary Anthology,*
edited by Adam Gopnik
Studio: Number 17, New York, NY
Art directors: Emily Oberman and Bonnie Siegler
Designer: Alison Henry
Client: The Library of America
The symmetry of the border pattern combines with a touch of asymmetry in the type design to give this cover understated wit and charm. As stated by the art directors: "The design is based on traditional airmail stationery. The moving airplane is a sweet added twist."—Emily Oberman and Bonnie Siegler

Figure 7-23
Poster: SOEX
Studio: MendeDesign and Volume, San Francisco, CA
Designers: Amadeo DeSousa, Eric Heiman, and Jeremy Mende
Client: Southern Exposure (soex.org)
Left to right symmetry adds stability to this otherwise diversely balanced, complex composition.

EXERCISES

Exercise 7-1: Freewheeling

Many designers think through all their decisions, making critical choices before designing. Usually, academic studies require us to be critical thinkers, making decisions in a meticulously thoughtful way. Occasionally, however, intuition can free our thinking from learned boundaries and open new paths to creativity.

Using a continuous and rapid drawing technique, start from the left vertical side of a rectangle, and draw curving lines, moving the lines around the page or screen. Vary the weight of line. Be energetic! Compose a balanced asymmetrical arrangement.

On a new page or screen, start from the bottom edge and move around the page. Execute this warm-up exercise four times, starting at all four edges of a page.

This process allows for a sensate (and immediate) experience. Gut decisions make this exercise happen. The rapid gestural movements force you into "feeling" the act of balancing.

Exercise 7-2: Destroying symmetry and retaining balance

When arranging a symmetrical design, you can follow a formula. Divide the page in half with a vertical axis and evenly place similar or identical shapes on both sides of the axis. Each side should be a mirror image of the other. Arranging a balanced asymmetrical composition is more of a challenge since there is no formula. Each element's visual weight and position must be carefully considered.

- On a 10-inch square, design a symmetrical composition using solid black shapes.
- Make a copy of it.
- Cut the copy into one-inch horizontal strips.
- Then cut the one-inch strips in half, vertically.
- Now, on another 10-inch square, rearrange the strips to form a new composition that is *both* balanced and asymmetrical.

Compare the original symmetrical composition to the asymmetrical composition. You can reduce the compositions on a scanner or copy machine in order to place the comparative designs in your workbook.

Designing an asymmetrical composition allows you to utilize your intuitive sense of balance, as well as train yourself to "read" or feel the weight of pictorial/visual elements and assess the capabilities of the page to bear weight. (Did you find that if you moved one piece, you had to rethink or readjust the entire composition? Caveat: On this one, don't think too much—just feel it!)

Exercise 7-3: The reach of a star

A composition can be balanced even when there are expansive areas not occupied by shape. Unoccupied areas of the page—also known as open space or negative space—can play a very active role in the design. Far from being empty, open space can affect the visual weight of the composition of shapes and colors. Open spaces can isolate a shape, making a visually heavy focal point. Open space can "lighten" an otherwise naturally heavy position on the page. Depending on its color, size, placement, and relationship to shape and form, open space can be more or less active. All areas of a page—whether the positive area/figure or the negative shape/ground—must be considered when balancing a composition.

Using a recognizable image, such as a pineapple, letter, or star, arrange the image so it is touching two edges of the container. The image should not touch the two remaining edges, yet the composition should be balanced. As you are composing, also make note of the compositions that are not in balance—ask yourself why. Understanding why a composition is not balanced will help you focus on those ways to create balance most successfully.

A composition with a good amount of open space—if the open areas are considered—can be surprising, engaging, and balanced.

Exercise 7-4: Variable interactions

When composing a web page, poster, painting, or drawing, balance is determined through a complex interaction of the visual weights of the elements.

On a very fundamental level, a large black shape may be seen as heavier than a small black shape when placed side by side on a page or screen. In order to balance the composition, you may need to make the large shape a cool blue and the smaller shape a bright, hot red—manipulating the visual weights. On this level, balancing a design may be easy. Yet, for sophisticated compositions, you need to understand how to balance complex interactions of visual weights.

Design at least five different asymmetric compositions using a single palette of shapes. Once the palette is established, do not alter the shapes to balance the composition—instead, alter the composition to create balance. You will need four blank sheets of paper.

The shapes palette includes three groups:
- First group: Using colored paper, cut out shapes in various colors and sizes, including warm and cool hues, bright and dull tones, and light and dark values. Color-aid™ brand paper or another type of art paper works well. You might also choose to paint swatches with acrylics or print out swatches using an ink-jet printer. Or this project may be executed entirely on the computer with painting or drawing software.
- Second group: Choose photographic imagery from magazines. Cut the imagery into circles, squares, and triangles of various sizes.
- Third group: Gather patterns from various sources. Cut the patterns into a variety of small shapes.

Using a selection from the shapes gathered, experiment with several compositions. When determining the balance of the various visual weights, consider size relationships, the interaction between complexity and simplicity, the placement of shapes within the format, the weight and power of color, the rela-tionship of the number of shapes (six complex shapes vs. one simple shape, for example), and the use of open space.

A single set of shapes can be balanced using a variety of interactions. Recognizing that visual weights vary relative to their interactions increases your ability to control balance and create more sophisticated designs.

Exercise 7-5: Renaissance vs. Baroque

The main difference between Italian Renaissance compositional modes (developed by the artists of the late fifteenth and early sixteenth centuries) and Baroque compositional modes (from the seventeenth century in Italy and Belgium) is the way in which the internal elements interact with each other and with the edges of the format.

The term Renaissance, when referring to composition, implies a kind of congruity (and lack of aggressive movement) and clearly defined planes that appear to recede into space; and the term Baroque, which literally means irregularly shaped, as is a Baroque pearl, is often associated with sweeping diagonal forms conveying an extreme sense of movement and tension. At times, the figures in Baroque works may seem to move out toward the viewer, while we can think of the Renaissance space as moving back, behind the picture plane.

Compose a design using the fifteenth and early sixteenth century's modes of composition. In the first composition, use a Renaissance mode. Design a composition where all the elements—shapes, forms, lines, silhouettes, letterforms—are mostly parallel to the edges of the page and recede behind the picture plane. In the Baroque composition, use shapes or elements that, for the most part, counter the edges of the page; that is, have strong diagonal thrusts or curving movements. Take size and scale into consideration, as well. Also, you may choose a theme in order to express an idea or emotion. For example, the Renaissance composition could be about peace or de-

votion, and the Baroque composition about war, an intense psychological subject, or a grandiose vision. Subject matter—the content—affects the way we compose elements.

A study of historic compositional structures in art and design can provide you with a great understanding of design and an enormous range for your own work. Try studying great historical masters and contemporary works regarding the use of balance.

Exercise 7-6: The Spirit Line: an homage to Native American Navajo weavings

Within the distinct overall pattern of a Navajo weaving, there is an element that is called the spirit line. "The spirit line is a thread that originates in the center and breaks through the border of the weaving so the spirit can escape; it is a bridge into and out of reality . . . or a tether to tie the piece to the world. For me, it is there so my spirit can escape the obsession with the perfection of the piece," says tapestry artist Nancy Kozikowski.

Design a balanced, *nearly* symmetrical composition using a grid. In each unit of the grid, design like shapes and/or form. Choose one spot wherein to break the grid pattern.

A perfectly symmetrical grid might feel suffocating. Breaking the pattern or symmetry in one spot allows for visual interest and surprise, and a place to take a breath.

Exercise 7-7: Color orchestration

We are forced to make initial decisions about hue, value, and saturation in our color choices. Then we must assess the different weights of the hues in order to maintain a balanced composition.

Design a balanced asymmetrical composition and then introduce color and maintain the balance. Choose five low-intensity hues of different values and one high-intensity hue.

The low-intensity hues will physically dominate the space; however, the bright hue should have enough visual weight to move our eye around the composition and create balance.

Orchestrating a composition with a network of colors forces us to consider color as a part of the total unit instead of as separate from the design statement.

Visual Hierarchy

Chapter 8:
Visual
Hierarchy

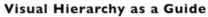

Objectives

- Understand the use of visual hierarchy in design
- Understand connections and meaningful interstices within a composition
- Learn how to organize and control the reading of a composition
- Discover visual hierarchy in web sites

Visual Hierarchy as a Guide

Life is complicated. Balance is a basic need. Who would rather live or work in a cluttered environment? If each day began with no objectives or schedule, how would we accomplish what we need to do? How do we make a distinction between what is important and what is not? We seek out organization as a guide. The same can be said of graphic design, where we make use of **visual hierarchy** to arrange the elements according to emphasis.

It is not as easy as simply making one object large and another small. Oversized objects indeed draw attention, but the same is true of greatly reduced ones, which can draw the viewer in for closer examination.

In this culture, we read from left to right, and top to bottom. The top left corner is generally the entry point into a design. Understanding this is paramount, because it helps you understand how your piece is being viewed and where you have captured the audience's attention. We also tend to be center oriented, focusing on the middle of the page. The same is true with typography—centered type in the middle of the page makes us feel the most comfortable, as it is

balanced. A way of creating tension in any design is to move objects off center. Diagonals are another way of leading the viewer's eyes to where you want; in essence, they form arrows pointing to information.

Graphic design is also the organization of information. If all elements are given equal weight and value, the reader can be confused about the importance of information on the page. If everything has equal weight, tedium can set in; therefore, contrast and scale are paramount.

Hierarchy of Design Elements

When presented with a design, the audience first views the mass as a whole. Imagery combined with typography forms the **layout** (the arrangement of type and visuals on a printed or digital page), which is perceived as a mass on the page. We tend to see elements in terms of the **foreground** (the part of a picture or scene that appears nearest the viewer) and the **background** (the part of a picture or pattern that appears to be in the distance or behind the most important part), or positive and negative space. There are three main planes in a design: foreground, **middle ground** or **midground** (an intermediate position between the foreground and the background), and background. Once those planes are established, the viewer begins to enter the piece by deciphering the information presented. The designer needs to give visual clues as to where to enter.

In the dramatic poster in black, white, and red shown in Figure 8-1, Luba Lukova reinforces the content of Shakespeare's play with graphic imagery. She also achieves a visual magic trick by forcing our eyes to the bottom right of the poster first. Achieving this through scale and diagonal direction, the thickest stem of the sword brings us in, and points toward the upper left where the type conveys the information.

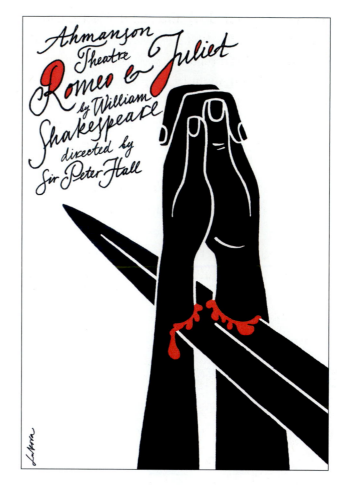

Figure 8-1

Poster: *Romeo and Juliet*

Studio: Luba Lukova Studio, Long Island City, NY

Designer/Illustrator: Luba Lukova

Client: Ahmanson Theatre

Lester Beal was hired by the Rural Electrification Administration in the 1940s to promote the development of electricity in remote areas. Because much of the audience was thought to be poorly educated, his posters were graphically simple and direct. He used arrows as a means to guide the viewer through the information. In the poster shown in Figure 8-2, the viewer's eye is led from right to left, top to bottom, to make the point that people could benefit greatly from using electricity to power water pumps.

In the poster shown in Figure 8-3, the order of information is traditional: left to right, top to bottom. The arrows guide the viewer through the piece, so there is no question where the eyes should go. It is only by achieving this that the payoff works—the concept that only after "blood, sweat, and tears" do we break through (or crack) and think creatively.

Figure 8-2

Poster: *Running Water*

Designer/Illustrator: Lester Beal

Client: The Rural Electrification Administration,

U. S. Government

Lester Beal (1903–1969), Running Water-Rural Electrification

Administration, 1937

Silkscreen, 40" x 30", Gift of the designer. (223-1937)

The Museum of Modern Art, New York, NY

Digital Image © The Museum of Modern Art/ Licensed by SCALA/

Art Resource, NY

Art © Estate of Lester Beal/ Licensed by VAGA, New York, NY

Figure 8-3

Poster: *Thinking Creatively*

Studio: The Design Studio at Kean University, Union, NJ

Designer: Steven Brower

Client: Kean University and the Art Directors Club of New Jersey

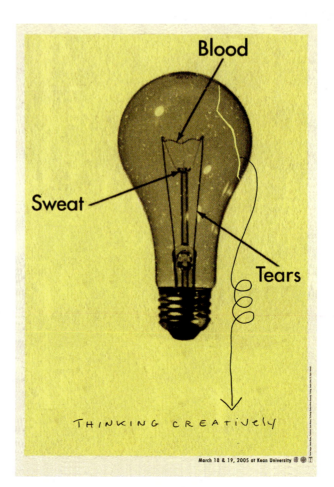

Visual Contrast

Graphic design is indeed a balancing act. By combining two major elements, typography and imagery, the designer can control how information is to be conveyed. Hierarchy in design is the act of guiding the viewer's eye through a piece. It is also a way of denoting the importance of the information; for example, on a book cover, the title generally takes the most important role and is prominent. However, in the case of a nonfiction book where the title may not carry much meaning yet the subtitle is descriptive, the color of the subtitle may be more eye-catching and therefore supersede the larger although "quieter" title. It is the designer who uses contrast to lead the viewer through the information and images in the order that is intended. What do you want them to see first? Where should their eyes go next?

Ways to Create Contrast

- Size and scale
- Color
- Harmony and tension
- Clarity and consistency
- Location
- Shape
- Levels

One way to create hierarchy is through the use of scale (Figure 8-4). Larger objects are what we view first when looking at a composition. Again, this can be offset by various factors; smaller objects of brighter colors or odd placements can draw our attention away. Amorphous shapes will also attract our eyes when placed against geometric ones. Very large or, conversely, very small objects will gain our attention; darker or brighter objects on the page also demand our consideration. The use of diagonals—anything that is not perpendicular or horizontal to the visual plane—draws us in, and pointers, such as arrows, are perceived as directionals, much like road signs.

Figure 8-4

Publication: *Oxymoron*, Vol. 2

Studio: The Pushpin Group, New York, NY

Designer: Steven Brower

Art directors: Steven Brower and Seymour Chwast

Client: *Oxymoron*

For this editorial layout, the title and body text are all working in concert. Through size and color (black), the name of this piece is loudly announced; in contrast, the body text is small. The context for this is a scholarly publication with sophisticated content; therefore, the expectation is that the reader is willing to invest in a complex, but rewarding reading experience.

Color contrast plays a major role in how we perceive importance. Lighter colors recede; brighter colors come forward, demanding notice. A larger mass of black can call attention to itself, but so can a small mass of white within a black field. Anomalies can create attention; in a field of repetition, a differing object will stand out.

Alignment is another means of gaining attention. If something is only slightly off, it will look like a mistake. However, if it is greatly out of alignment, it not only looks intentional, it also commands notice. This creates a tension that can lead the viewer into the piece.

Levels of Hierarchy

Within a design, there can be several levels of hierarchy—that is, what demands your attention first is the first level, next the second level, and so on. A general rule is to hold it to three levels so the work doesn't appear too dense and therefore unapproachable. As always, this depends on the context. If the viewer is willing to participate longer, more levels can be utilized.

In Figure 8-5, the reader is presented with a visual puzzle: a mass of typography that might be difficult to enter. The scale of the typography remains the same throughout, and the title of the book itself is no larger than some of the story titles. Still, there is no doubt as to the book's title. This is achieved through color, mass, and position. The larger colored panels on the left of the front cover give a clear signal as to what is most important. Lastly, the decreasing panels at the bottom bring your eye to this third level of information.

Figure 8-5

Book cover: *The Anchor Book of New American Short Stories,* edited by Ben Marcus

Designer/Art director: John Gall

Client: Vintage Books

Perception

Perception is very important in creating the levels of hierarchy in a composition. Divide an 8 $\frac{1}{2}$ x 11-inch page into halves horizontally. The perception is that the bottom half is slightly smaller than the top. You can compensate for this optical illusion by placing the dividing line slightly above the measured half (Diagram 8-1). Likewise, the bottom of the page carries more visual weight, due to our experience of gravity. Therefore harmony—or tension—can be achieved by placing objects that appear heavier either in the bottom (more harmonious) quadrant or the top (tension filled) quadrant. This tension, or lack thereof, can draw our attention to the object, or away, thus controlling the viewer's eye once again.

Diagram 8-1

The top diagram is divided in the mathematical center, creating the illusion that the panel on top is smaller. In the bottom, the dividing line is centered visually, slightly above the mathematical center.

In Figure 8-6—a perfect example of a "one-two punch"—the viewer reads the title first and then moves to the combination of the question mark and hand, which form one unit. By clear and concise hierarchy, the speed at which the viewer is guided through makes the design work. For the Op-Ed illustration for the letters page in *The New York Times* (Figure 8-7), the content dealt with the indecipherable complexity of New York City subway maps. Through parody and the use of the given design elements of the map, the humorous message is revealed, from left to right.

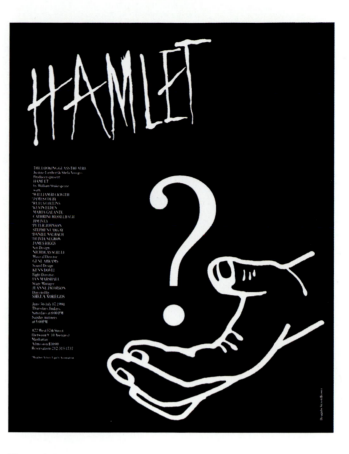

Figure 8-6

Poster: *Hamlet*

Studio: Steven Brower Design, New York, NY

Designer: Steven Brower

Client: The Looking Glass Theatre

Figure 8-7

Illustration: Op-Ed letters page

Studio: Steven Brower Design, New York, NY

Illustrator/Designer: Steven Brower

Client: *The New York Times*

An interesting case in point, the fiction book cover shown in Figure 8-8 leads you from top to bottom, down the center of the piece by utilizing various cues. At the top, the small words "a novel" appear. Next, the two curves of the cutout images meet and form an arrow pointing downward. The inverted lips in the art continue the downward directional, leading the eye to the main information: the title. The author's name and a quote from *The New York Times Book Review* at the bottom of the frame lead the eyes back up to the title.

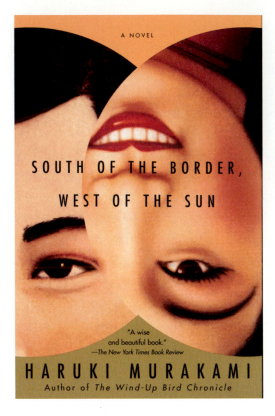

Figure 8-8
Book cover: *South of the Border, West of the Sun* by Haruki Murakami
Designer/Art director: John Gall
Client: Vintage Books

The book cover design in Figure 8-9 also plays down the center. First, we perceive the white dot dropping out of the field of green, which we next realize is a disembodied head. Finally, the form of the body brings the eye down to the information below. Since we read left to right, top to bottom, there is no doubt what the title is, in Figure 8-10. What is interesting, though, is how **cropping** (cutting an element so the entire element is not seen) the photo reinforces both the title and the words "a novel" as the hands of the figure force your eyes back to the information on top. And, in what is a rather dense design, where type and image appear to be on the same plane and of equal weight (Figure 8-11), the designer uses direction to guide us through (as seen in the accompanying diagram). Top left are the letters "Met . . ." and the "T" extends downward, leading the eye to the next part of this single word, ". . . ropo . . ." which is itself a diagonal, pointing down and to the right—to the conclusion ". . . lis" at the bottom.

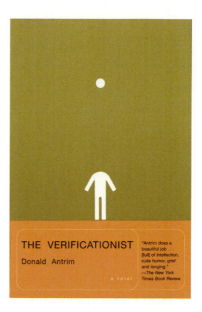

Figure 8-9
Book cover:
The Verificationist
by Donald Antrim
Designer/Art director:
John Gall
Client: Vintage Books

Figure 8-10
Book cover: *Up in the Air* by Walter Kirn
Designer/Art director: John Gall
Photographer: Stephen Swintek/Getty Images
Client: Vintage Books

Figure 8-11 and diagram
Poster: *Metropolis*
Designer: E. McKnight Kauffer (1890–1954)
E. McKnight Kauffer. Metropolis. 1926. Gouache, 29 1/2 x 17"
(74.9 x 43.2 cm)
Museum of Modern Art, Given anonymously

In Figure 8-12, the large mass of the N on the left is offset by the thinness of the V and A forms. Still, the scale of these letterforms, which stand for the "New Visual Artist" whose work is contained within the pages of this special section of *Print*, gain your attention first. Moving across the spread to the right, the introduction to the section is next. Lastly, the table of contents (TOC) on the rightclues the reader in about what is to follow.

Two thirds of the cover image shown in Figure 8-13 is photography. The photograph contains diagonals that lead the eye back to the publication title. The focus of the photography is very tight, bringing you next to the small figure of the British soldier. On the ground of the photograph are parallel diagonal lines that lead the eye to the bottom right, where the name of this special issue appears. Again, most of the real estate of the cover shown in Figure 8-14 is taken over by photography. The reader's eye is actually led around the cover. After the publication title, which gains attention with position and brightness of color, the head of the woman entering the door pulls your eye in next, and leads you toward the center figure. The title of the issue is handled subtly: the last few letters appear on the door on the left and cast a shadow on the wall behind the seated figure.

Figure 8-12

Magazine: *Print*

Studio: Steven Brower Design, New York, NY

Designer/Creative director: Steven Brower

Client: F & W Publications

Figure 8-13

Magazine: *Print*

Studio: Steven Brower Design, New York, NY

Designer/Creative director: Steven Brower

Photographer: Melissa Hayden

Hand lettering: Scot Menchin

Client: F & W Publications

Figure 8-14

Magazine: *Print*

Studio: Steven Brower Design, New York, NY

Designer/Creative director: Steven Brower

Photographer: Richie Fahey

Client: F & W Publications

THE TROJAN WOMEN

BY EURIPIDES

In Figure 8-15, the shape of the page is what has the largest impact; the extreme horizontal is the first thing you notice. Next, the small figure on the left commands your attention, by virtue of the unexpected diminutiveness. Your eyes are then pulled to the right, to the title, and then lastly to the image of destruction on the far right.

Emphasis

Larger or smaller typography is yet another means to call attention to information—and to give emphasis to the different levels of hierarchy—sometimes even within the same line. It can be compared to speech, where words are emphasized or whispered, depending on their context.

Words are used to illustrate the point in Figure 8-16 (top and bottom). For the speech by Huey Long, governor of Louisiana in the 1930s, larger type pops up unexpectedly within the body text. Much like patterns of speech, which vary in tone and volume, the typography is given a full range of sizes. This device is also used to emphasize the wildness of what is being said. On the cover, through the use of cropping, similar emphasis is placed on Long's fist, rather than his visage.

Figure 8-15

Poster: *The Trojan Women*

Studio: The Design Studio at Kean University, Union, NJ

Art director: Steven Brower

Designer: Jason Washer

Client: The Theater Department at Kean University

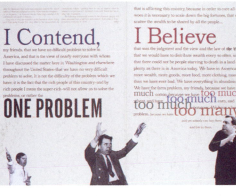

Figure 8-16

Publication: *The Nose*

Studio: The Pushpin Group, New York, NY

Designer: Steven Brower

Art directors: Steven Brower and Seymour Chwast

Client: The Pushpin Group

Another cover for *Print*'s Regional Design Annual was designed and ready to go to the printer, but when the events of 9/11 occurred, the decision was made to change the cover to make a statement about the event (Figure 8-17). The statement was more important than the particular issue itself. Nothing stands in the way of this impact. The whiteness of the background (or negative space), the black of the logo, and the smallness of the only line on the cover all work in unison to reinforce the impact of the broken heart, with the crack originating in the lower left, a metaphor for where Manhattan was attacked.

Perceived Mass of Units

Objects or typography placed close together within a composition form a unit—the perception being that they are one object. Therefore, the mass of the unit is essential in creating greater or lesser hierarchy within a design. Elements that work in ensemble can result in a sum that is greater than the parts.

Figure 8-18 shows a wonderful example of combining many different devices in a single work to great effect. The overall mass of the piece is black. Despite the amount of black on the page, though, the area that demands your attention first is the white type, known as **drop-out** (or knocked-out or reversed-out) **type**, as it is actually the white of the page that drops out from the printed color. Next the viewer follows the red. The larger mass brings your eye to two diagonals. The first is the cello, which leads your eye to the left; the second is the brighter bow, which leads you to the bottom—where the third level of information is contained: the what, when, and where of this performance.

Figure 8-17
Magazine: *Print*
Studio: Steven Brower Design, New York, NY
Creative director/Designer: Steven Brower
Client: F & W Publications

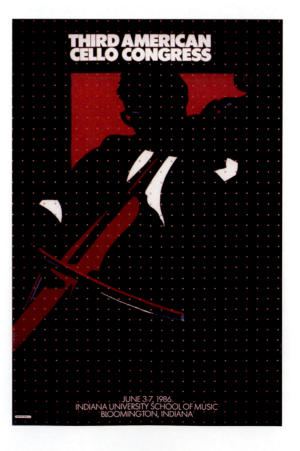

Figure 8-18
Poster: *Third American Cello Congress*
Studio: Milton Glaser, Inc., New York, NY
Illustrator/Designer: Milton Glaser
Client: Indiana University School of Music

Illusion of Space

Another way to change the levels of hierarchy is with the illusion of space. The printed page is intended to be viewed flat and head on. Through the use of perspective, an object can demand attention by its position on the visual plane. If a larger object is closer to the viewer in the bottom quadrant, which is perceived as the foreground, it is possible that a smaller, lighter object appearing in the middle ground will catch our eye first.

The type in the background of the book cover in Figure 8-19 is a list of all the myriad authors included in the anthology. Not only are they all given equal weight and size, the editors and the name of the volume are as well. It is only with color that the title of the book stands out. The primary point of entry is the colorful illustration.

Visual Hierarchy for the Web

Visitors on the Web seek out not only specific information, but also entertainment and education. The designer needs to guide the viewer through a site, as though it were a guided tour. That's where a major graphic design principle comes into dominant play: visual hierarchy. Web technology may be changing rapidly, but graphic design principles are constant, and they apply to web design.

An important issue distinctive to most web design is where to place the prime parts of a web page—usually the left side edge and the top of the page are where the directories reside. This is the case because this area of the screen is most reliably fixed in place. The right and bottom portions of a screen can change depending on the operating system, browser, and monitor in use by the visitor to a web site.

However, if the perimeter of the image area of a web site is set fixed in the middle of the screen, as in the Kean University Design Center web site (*www.kean.edu/~designct*), then the main directory or navigation menu can be placed in areas other than the left and top.

Figure 8-19

Book cover: *The Psychedelic Reader*, edited by Timothy Leary, Ralph Metzner, and Gunther M. Weil
Studio: Steven Brower Design, New York, NY
Designer: Steven Brower
Client: Citadel Press

With both possibilities in mind, a designer must employ (as with all good design) the principles of visual hierarchy, balance, and unity.

Web Site Design Considerations

- Use constant design considerations of size, shape, weight, and color to create visual hierarchy—to guide the user from the most important content to the least important.
- Since the browser window can be resized, and smaller screens may cut off on the right side, a designer must emphasize the left side and top of a page or create a fixed image area to ensure that the entire design is viewable.
- Always establish an easily understood hierarchy of directories (menus or navigation bars).
- The information architecture of directories should be visually enhanced by a consistent treatment of the font and icons or buttons to create an ordering from most significant to least important.

Grids

In order to establish visual hierarchy *and* unity, most web designers employ a grid. It is best to establish a visual grid (a repetitive, modular compositional structure) to help maintain order, create a sense of "geography and location," and make it easy for the visitor to quickly locate various options and information. When you position elements such as directories or buttons consistently, the visitor will know the location of these elements on all other pages of the site, which will help the visitor to use it more efficiently. With a strong grid layout, the visitor can have a smooth passage through a formidable amount of information. Working within the grid's structure, a designer must further guide and direct the viewer by designing a visual hierarchy. When establishing a web site's visual hierarchy, the same holds as in print—how the audience reads (left to right, or right to left, or top to bottom) must be taken into account. Therefore, the language of the visitor helps dictate how to direct the visitor's reading of the site.

Animation and Visual Hierarchy

On a web site, establishing visual hierarchy can be assisted by a slightly animated feature called a "rollover." When a visitor "rolls-over" or passes the cursor arrow over a menu or directory selection (a link button), the area under the cursor becomes brighter in color or changes to a contrasting color or size or texture (or any combination). The change is made in order to draw attention to the link button and thus increase its clarity and importance. Once a selection has been made by clicking on the link, the web site screen changes to the selected page. The link button (now the "visited" link) often remains in the new, brighter color so the visitor knows that the selection has been accomplished. This aspect of the visual hierarchy is important because it lets the visitor know, at a glance, where they are, and already have been, within the web site.

Type, graphic elements, and imagery can all be animated—programmed to move automatically—to direct the viewer toward important content. Anything that moves in any way will immediately call attention to itself and thus raise its level within the overall visual hierarchy. Movement and animation are very specific uses of visual contrast, and highly effective forms of visual hierarchy in web sites.

Contrast

If a web page lacks visual contrast, not only will the page be difficult to read, it will also not be able to efficiently direct the viewer's attention to what is of most importance. A lack of contrast results in visual dullness. Visual contrast aids visual interest and definitely aids in creating the "guided tour" that is necessary to direct the visitor's attention.

Also, it is important to note that very similar to print, darker type on a lighter background—with sufficient contrast in value between the two colors—aids readability. And just as in print, light type on a dark background hinders readability, even though there is value contrast. Keep in mind that colors with little value contrast inhibit readability, for example, medium-value red type on a light-value orange background.

The typography on a web site helps aid visual hierarchy by:

- Establishing consistent directories to guide the visitor through the content
- Nesting smaller elements inside bigger content categories
- Enhancing navigation
- Selecting the color and value of type to enhance readability and remain consonant with the creative direction of the site

As Nick Law, design director of R/GA, astutely points out: "A systematic designer's strength is in making information-rich web sites coherent. Using the classic design elements of color, shape, and composition, together with typographic and iconic systems, they create a sensible hierarchy of entry points into a page. They emphasize and enhance the information architect's functional intent."

Summary

The creative and expressive potential of the dramatic use of visual hierarchy is great. Bold statements can be made by the designer that will add to the content of a work—how a reader is guided through a work can be as important as what is actually written.

It is the responsibility of the designer to be clear and consistent while interpreting and translating the intentions of any design for the viewer. If the design is unclear as to where the viewer's eye should go or inconsistent in the cues that are being sent, the viewer can become frustrated and give up before the information is communicated.

EXERCISES

Exercise 8-1: Self-portrait

Write five phrases about yourself; for example, a phrase describing your appearance or illuminating a specific talent or skill—any statement you would want the world to know. Then compose the five statements into a visual hierarchy on an $8\frac{1}{2}$ x 11-inch page.

An addition or another version of the exercise is to write five nouns that describe yourself, for example:

Student

Child

Lover

Designer

Athlete

Or more creative nouns that are symbolic:

Owl

Kitten

Love Bird

Guerilla

Cougar

Then design pictograms or symbols for these and put them into a hierarchical order.

Exercise 8-2: Business card

Design a business card for yourself. Decide what is the most important piece of information you want to convey, and design the card with that in mind.

Exercise 8-3: Book cover

Design the cover of a nonfiction book, 6 x 9 inches in size, where the subtitle of the book is more important than the title. Solve the problem of how to convey this and still clearly show which is the title and the subtitle.

Exercise 8-4: Poetry

Take a piece of poetry and using size and color, emphasize the words you feel are most important.

Chapter 9:
Rhythm

Chapter 9:

Rhythm

composition {

hierachy · balance · type · shape · unity · scale · rhythm

message · motion · format · line · color · depth · texture

Objectives

- Understand how the printed page can replicate music
- Learn how to create a visual pulse
- Explore the nature of pictorial rhythm structures
- Achieve visual rhythm through the simultaneous use of multiple elements
- See the rhythm in nature

Do You See the Beat?

One might assume that there is not much of a relationship between the printed page and music, but that is incorrect. In fact, image and type on the page can indeed replicate the musical experience visually. Repeating or varying elements can set up a pattern or **rhythm**, similar to a beat, that causes our eyes to dance around the page. Within that beat, certain emphasis can be achieved. Color, too, can set up a repetition or pattern that is the visual equivalent of beats or pulses. Texture is yet another means to convey pulses or even emotion. Timing can be set by the intervals between the position of the objects on the page. Just as in music, a pattern can be established and then interrupted, slowed down or speeded up. This also can be achieved through alternating darkness and light, positive and negative space.

Often these devices are utilized when representing music itself, such as in the case of CDs or posters announcing a musical event. Still, this rhythm can be used for its own sake, to create an arresting image and convey information in an unexpected way.

Repetition and Variation

As in music, patterns are established and then broken through. By building expectations, accents can be created that enhance and inform. Once this visual rhythm is achieved through the repetition of pattern, any variation within will break the rhythm, producing the visual equivalent of a pulse or beat. These can either create a slight pause or bring the entire piece to a halt, depending on the intent of the designer.

Milton Glaser's poster *Geometric* (Figure 9-1) challenges the viewer on many levels. Through the use of geometric shapes the expectation is one of symmetry, but the opposite is true. Anomaly abounds as shapes jut out from the edges. Although forms appear to mirror each other in position, they vary more than they echo. The result is a modern, jazz-like composition with sharp edges and brusque changes in tempo, reinforced by pattern and color.

Glaser's album cover (Figure 9-2) of reflected light is the visual equivalent of the content itself. The bands of color set up a pattern that is repeated, much like music itself. The musical union takes place as each figure repeats the arrangement of the other. The three bands of color which mirror each other are akin to a riff being played by one musician and in turn repeated with some variation by a second. The black background sets an even tone for the bright color to work off of. The literal meaning of collaboration becomes a visually compelling and musical work.

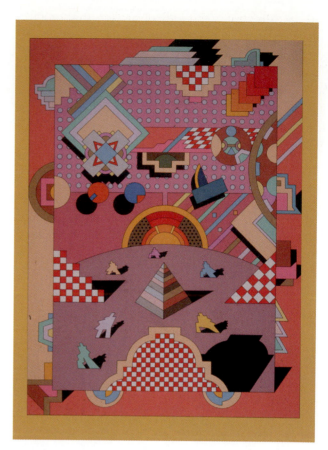

Figure 9-1
Poster: *Geometric*
Studio: Milton Glaser, Inc., New York, NY
Designer: Milton Glaser
Client: German Bank Association

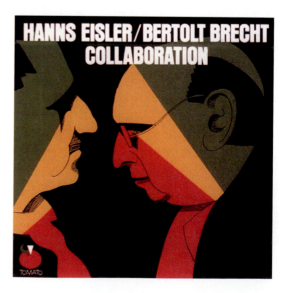

Figure 9-2
Album cover: *Hanns Eisler/Bertolt Brecht Collaboration*
Studio: Milton Glaser, Inc., New York, NY
Designer/Illustrator: Milton Glaser
Client: Tomato Records

Figure 9-3 illustrates the *lack* of pattern that ends in a musical effect. The overall layout is one of figure and ground, causing the viewer's eyes to rock back and forth between the white feather and the silhouette cut out of it. The type—none of which is set on a horizontal plane—varies continually in size and position, leading the viewer from top left to bottom right, with loud beats for emphasis, till there is a crescendo of the title of the play, and a whisper of the author and director and an announcement of the dates.

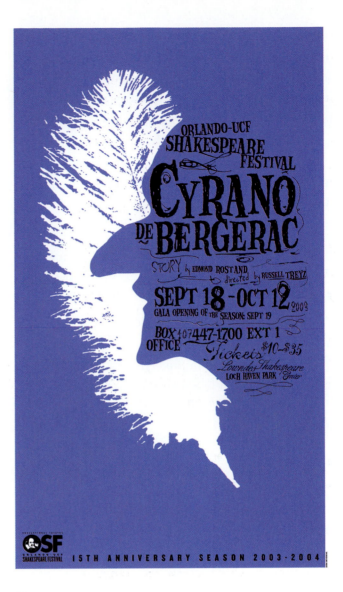

Figure 9-3

Poster: *Cyrano de Bergerac*

Design studio: Lure Design Inc., Orlando, FL

Designer: Paul Mastriani

Client: Orlando-UCF Shakespeare Festival

"Cyrano de Bergerac, by Edmond Rostand, was challenging because everyone pretty much knows the story of the man with the large nose, and although we thought that that image was very important, we didn't want to present it in the traditional way. Within the script, there was a reference to a white feather and that representing Cyrano's soul. So it seemed natural to have the feather be the main graphic and Cyrano's silhouette knocking out of it. The type—a mix of altered fonts and hand lettering—was used to reflect writing with a quill pen: imperfections, ink splatters, and flowery gestures." —Paul Mastriani

Through the interplay of foreground and background, the melody of the musical piece being played is experienced. The colored pattern of the background is hidden by the black foreground, reversing our expectations of dark receding and color coming forward. The mostly organic foreground shapes contrast with the geometric, albeit askew patterns of the background. The overall effect is a replication of the music being played by the pianist (Figure 9-4).

The logo shown in Figure 9-5 is for EMP, a museum dedicated to the music of the Pacific Northwest. Echoing both the occurrence of him lighting his guitar on fire and the intensity of his music, this logo replicates the experience of listening to a Jimi Hendrix guitar solo: hot and peaking in the center, with a crescendo and decrescendo in the beginning and end.

Figure 9-4
Poster: *Julliard Piano*
Studio: Milton Glaser, Inc., New York, NY
Designer: Milton Glaser
Client: The Julliard School
"I found a fragment of a Chinese wallpaper design that I combined with a strong black drawing—somewhat influenced by one of my favorite artists, Felix Vallotton. The two worlds coexist nicely."
—Milton Glaser

Figure 9-5
Logo: Hendrix
Studio: Modern Dog Design Co., Seattle, WA
Client: EMP

The poster for Fritz Lang's classic film *Metropolis* is an Art Deco tour de force. The repeated patterns of the architectural facade establish a machine-like rhythm that echoes the movie's content (Figure 9-6).

In contrast, in the raucous poster by E. McKnight Kauffer (Figure 9-7), it is both pattern and anomaly that convey a musical experience. The large circles set up an exuberance that seem to spin before your eyes. This is reinforced by the smaller O's within the word, and the white lines within the type. Diagonals and complementary colors set down the beat, and the repeated pattern of figures marching at the bottom of the page and then receding to the background serve as a coda.

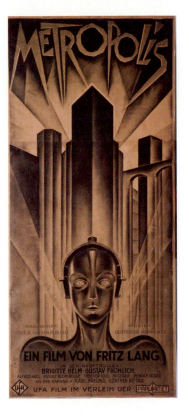

Figure 9-6

Poster: *Metropolis*

Designer: Heinz Schulz-Neudamm (20th CE). Metropolis. 1926.

Lithograph, printed in color. 83 X 36 1/2"

Gift of Universum-Film-Aktiengesellschaft. (80.1961)

The Museum of Modern Art, New York, NY, U.S.A.

Digital image ©The Museum of Modern Art/ Licensed by SCALA/ Art Resource, NY

Figure 9-7

Poster: *Metropolis*

Designer: E. McKnight Kauffer

E. McKnight Kauffer. *Metropolis*. 1926.

Gouache, 29 1/2" x 17" (74.9 x 43.2 cm).

Museum of Modern Art, Given anonymously.

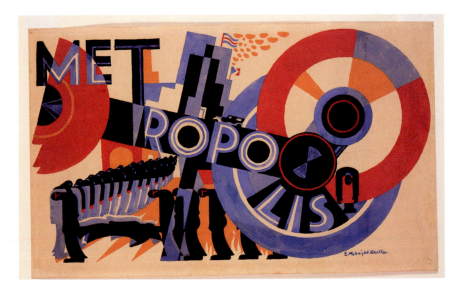

Feet dance over a subtle circular pattern in the background, and the typography dances along (Figure 9-8). A green leg juts out, adding an unexpected accent. The type also dances. Altogether a feeling of "Jubilee" is conveyed.

The dancer is made modern through the act of cut up and abstraction, which increases the visual experience of the dance (Figure 9-9). No longer bound by physics, the dancer moves around the page within a single frame. Rand's dance poster achieves rhythm and movement through unexpected abstraction. A simple photograph of a dancer would convey the dynamic of movement based on our experiences. Instead, he cuts out and rearranges the body parts in a collage to increase the visual equivalent of dance movement on the page. Leaving white around the cutouts carries our eyes around the background of flat red.

Figure 9-8
CD cover: Terraplane Blues, "Jubilee Stomp"
Studio: Steven Brower Design, New York, NY
Art director/Designer: Steven Brower
Illustrator: Janna Brower
Client: Terraplane Blues

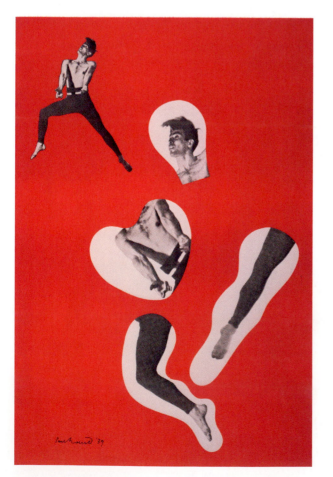

Figure 9-9
Magazine: *Art Direction*
Designer: Paul Rand
Poster, Paul Rand (1914–1997), Front cover of
Art Direction magazine, March 1939, silkscreen,
91 x 61 cm (35 4/5 x 24 in.) Library of Congress
Prints and Photographs Division, Washington, D.C., U.S.A,
[LC-USZC4-5049]

Through the simple repeated pattern of rectangles with alternating background colors—each with a different tone—a musical rhythm is established, which relates directly to the subject matter (Figure 9-10).

The repeated rectangles set up the beat, alternating in contrasting color in Figure 9-11. The grid of wagging tongues alternate within a set grid with alternating colors, evoking the act of gossip spreading from mouth to mouth.

Figure 9-10
Book cover: *Songwriters on Songwriting*
by Paul Zollo
Studio: Steven Brower Design, New York, NY
Art director: Ruth Jenson
Designer: Steven Brower
Client: Da Capo Press

Figure 9-11
Book cover: *Scorpion Tongues* by Gail Collins
Studio: Steven Brower Design, New York, NY
Art director: Richard Aquan
Designer: Steven Brower
Client: William Morrow and Sons

There are even more ways to create visual "music": timing, spacing, pulse, beat, and stresses. The negative space between each object creates a "silence" before the next beat; the greater the negative space, the longer the pause between beats. It is up to the designer to control these pulses, silences, and stresses within the work. In Figure 9-12, Glaser's portrait of the Grateful Dead's Jerry Garcia is the visual equivalent of their music: at once intricate and intense.

Setting Up the Rhythm with Balance

Occasionally symmetry in design results in a too conservative composition. The effect is one of equilibrium, but this can lack visual interest. Often the use of symmetry to create balance results in type and imagery that is centered on the page, utilizing centered alignment on either side of a vertical axis. Designers can use other balancing strategies to add the feeling of rhythm in their applications, such as proportion, unity, negative space, and emphasis.

Figure 9-12

Poster

Studio: Milton Glaser, Inc., New York, NY

Illustrator/Designer: Milton Glaser

Client: AIGA

"I chose this portrait originally done for *Rolling Stone* as an image for my 2000 show at the American Institute of Graphic Art. It shows Garcia beginning to fade from memory, even though his music may endure."—Milton Glaser

Proportion

A sense of proportion is key to good design. All elements on a page have a visual weight that play off one another. The size of the image plays off the size of the headline, which has a relationship with the size of the text, and so on. Every component on the page has a connection with every other one. The designer can create a sense of unity by arranging these in a formal or classical manner: equal spacing between the head (or title), deck (or subtitle), and photograph. Or you can create tension between these elements with uneven spacing, an asymmetrical arrangement, and changing the size of the components. Each item should create dramatic effect. Should the art have the main impact, or would large text be more dynamic? It is the combination of large and small, and the use of positive and negative space, that ultimately creates a true sense of balance or tension on the page.

Each element on the page has an optical weight that should be considered. A large black mass is heavier than a smaller one. The text on the page is gray; depending on the typeface, leading, and point size, this can be lighter or heavier. Photographs and illustrations can be light or dark—the weights of these elements can be altered. Applying a lighter tone or screening back a large headline will reduce its mass. Adding white space can open up a spread, making it more inviting. Moving away from the central axis can offset the symmetry, allowing the reader to "feel" the punctuation and pulses of the unaligned items (Figure 9-13).

Figures 9-13

Posters: *Side Man*

Studio: The Design Studio at Kean University, Union, NJ

Art director: Steven Brower

Designers: Vincent Gabriel (top and middle) and

Stephanie Heller (bottom)

Illustrator: Vincent Gabriel

Photographer: Stephanie Heller

Client: Theater Department, Kean University

These three student posters offer differing interpretations of the same play. Vincent Gabriel's Art Deco-influenced pieces infuse the musical experience with cubist like forms; Stephanie Heller presents a much cooler form of jazz, more in line with the era of the play.

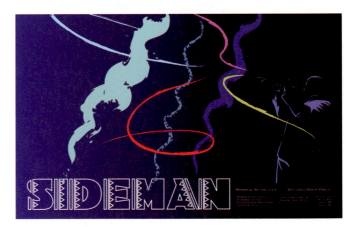

Unity

All the components on a page have a relationship. They are not islands that stand alone, but integral pieces of a whole. This may seem improbable with such disparate elements as a photograph and typography. The mood of each should reflect the other. It helps to think of everything as a unit that fits together. This is the case not only from spread to spread, and page to page, but within the publication as a whole. Of course, when hiring an illustrator, it is easier to commission work that conforms to your design scheme. Still, whether commissioned or supplied, everything should work together, as the whole is the sum of all its various parts. Once unity is established through repeated pattern, it can then be broken, both in graphics and music.

Inspired by the unusual crossing of his hands while playing, the tightly cropped photograph of George Gershwin (Figure 9-14) establishes an unusual pattern. Using appropriate period type, his name itself becomes piano-key-like, to theatrical effect.

In Figure 9-15, through the use of a regular pattern of rectangles, alternating colors, and symbols, an even rhythm of pulses and beats is set up: left to right, and top to bottom.

Figure 9-14
Book cover: *Gershwin* by Edward Jablonski
Studio: Steven Brower Design, New York, NY
Art director: Ruth Jenson
Designer: Steven Brower
Client: Da Capo Press

Figure 9-15
Brochure cover
Studio: Gee + Chung Design, San Francisco, CA
Creative director: Earl Gee
Designers: Earl Gee and Fani Chung
Client: DCM-Doll Capital Management

Rhythm in Nature

In nature we experience a different form of rhythm, or seasons, as the passage of time. The swaying back and forth of trees in the wind or the waves of the ocean set up an experience of rhythm, of time and place. Replicating nature in painting has been a constant since the very beginning of the discipline. Artists would spend long hours exposed to the elements, attempting to capture their surroundings.

Milton Glaser's landscapes achieve exactly that (Figure 9-24). The repeated patterns of dashes and lines, replicating fields of grain, work in concert with the gentle slope of valleys and hills to re-create the experience of nature and environment. Analogous and monochromatic color also adds to the pleasant recreation of this inviting place and time.

Figure 9-24
Silk screen prints: The Tuscany Prints
Studio: Milton Glaser, Inc., New York, NY
Artist: Milton Glaser

In similar fashion, in Figure 9-25 the branches and color establish a gentle tone, while the diagonal type adds a louder accent.

Luba Lukova uses the metaphor of an immigrant setting down roots and growing out of an earlier foundation as an expression of social experience in Figure 9-26. By echoing the growth of the limbs—repeated in two larger patterns—with other repetitions within the two main limbs, our eyes are lead from bottom to top and in two directions at once in a musical fashion.

Figure 9-25
Poster: *Cooperstown*
Studio: Milton Glaser, Inc., New York, NY
Designer/Illustrator: Milton Glaser
Client: Cooperstown Chamber Music Festival, Inc.
"Fourth in a series of annual posters for a music festival
that employs the recurring theme of musical cows in a
variety of situations."—Milton Glaser

Figure 9-26
Poster: *Immigrant*
Studio: Luba Lukova Studio,
Long Island City, NY
Designer/Illustrator: Luba Lukova
Client: Immigrant Theater

Summary

Although generally a static medium, graphics on the printed page can replicate the musical experience. By using pulses, beats, and accents, the reader can be guided through a rhythmic happening that at once surprises and satisfies. Visual rhythm can be used as a means to an end, to keep the audience engaged. The possibilities are as infinite as the various styles of music that exist throughout the world.

EXERCISES

Exercise 9-1: Music interpretation

Visually interpret a piece of music. This is not to be simply a translation of lyrics onto the page. Rather, it should be a representation of the rhythm and emotion of the piece.

Exercise 9-2: Rhythmic design

Create a rhythmic design with a definite beat in mind and have others pound out the beat as they see it.

Exercise 9-3: CD package

Design a CD package that reflects the music that is contained within.

Exercise 9-4: Concert poster

Using only cut paper, design a poster for a Reggae concert.

Chapter 10:

Unity

Chapter 10:
Unity

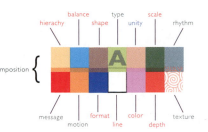

Objectives

- Define and understand the principle of unity
- Learn how to employ correspondence
- Realize the purpose of a grid
- Discover the origins of the grid in history
- Understand the purpose of a template
- Comprehend alignment's use in unity
- Appreciate the use of flow within a composition
- Gain understanding of integrated positive and negative space
- Be able to employ unity with variety

The Principle of Unity

When you peruse or just wander through a web site, do you ever wonder how the web designer was able to provide a good sense of location no matter where you are in the site? Or how a graphic designer manages to make the inside of a book (such as the one you're holding) look like every page is part of the same totality? In order to get all the type, photographs, illustrations, and graphic elements to work together as a whole entity, a designer must employ the principle of unity.

There are many ways to achieve what we call **unity**, where the elements in a design look as though they belong together and visually hold together in an integrated structure. A designer must know how to organize visual elements into a cohesive composition, as well as establish a common bond among them, as seen in Figure 10-1, a web banner and web site for Sprite.

Unity is one of the primary goals of composition—the goal is to establish an integrated whole, rather than unrelated parts. Unity should be employed in single design formats, such as a poster or logo, and across multiple pages or units, such as a magazine interior, web site, or a packaging system. One or more compositional strategies may be employed to achieve unity. Some of them are:

• Correspondence
• Grid
• Template
• Alignment
• Flow
• Integrated Positive and Negative Space

Correspondence

In order for a composition to hold together visually, the designer needs to build in a degree of congruity—agreement among the visual elements in the composition—which is called **correspondence**. Correspondence can be established in a variety of ways.

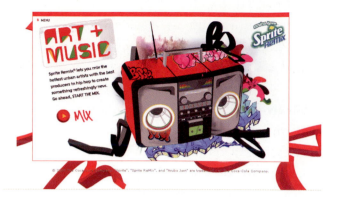

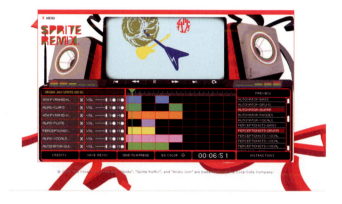

Figure 10-1
Web banner and web pages
Agency: Butler, Shine, Stern and Partners, Sausalito, CA
Client: Sprite
Notice that certain visual elements are consistent on the web banner and the pages of the web site: the red, green, and yellow color palette for the font, same headline font, general color palette, treatment of graffiti-like linear elements and visuals, inset frame on the web pages, style of images, and the overall look and feel for the brand.

Repetition

When the viewer notes *like elements* in a single composition, across multiple pages and throughout a web site, that **repetition** builds a sense of place—of correlation for the viewer—and creates coherence in the visual work. A designer can repeat any number of elements to help establish consistency, as in the poster by Modern Dog where line, handwriting, and color are utilized to create correspondence (Figure 10-2). A sense of location is crucial on a web site, where the visitor must try to easily find information by locating buttons in the same positions on most or all of the pages in the site. Repetition also establishes continuity in a web site's visual "look and feel," as shown in Figure 10-3.

- Repeating an element—such as color, value, shape, texture, or type—can establish correspondence among visual elements.
- Repeating a direction, also, can establish correspondence.
- Establishing a style, such as a linear style, sets up a visual connection or correspondence among the elements.

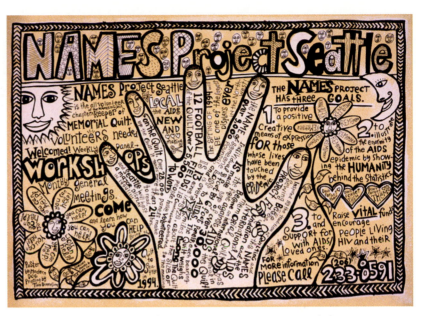

Figure 10-2

Poster: *Names Project Seattle*

Studio: Modern Dog Design Co., Seattle, WA

Designer: Robynne Raye

Black outlines and lines, as well as a consistent treatment of forms, unify the composition in this poster advertising the Seattle appearance of the Names project —a gigantic handmade quilt—as a memorial of AIDS victims.

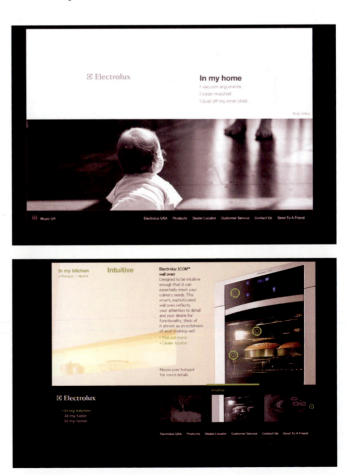

Figure 10-3

Web site: Electrolux

Studio: R/GA, New York, NY

Audio design: Daniel LaPlaca

Copy: Jeff Babson and Todd Brown

Designers: Ernest Rowe, Nathalie Lam, and Nina Schlechtriem

Interaction design: Mauro Cavalletti and Scott Weiland

Production: Bridget Andresen and Julia Rubinic

Programming: Ed Bocchino and Chris Hinkle

Quality assurance: Jennifer Liang

Client: Electrolux

Continuity

Continuity—the handling of design elements, such as line, shape, texture, and color, to create similarities of form, and also called similarity—can help to establish correspondence in a composition. Very simply, it can be said that continuity is used to create family resemblance. For example, if you were designing stationery, you would want to handle the typography, shapes, colors, and any graphic elements on the letterhead, envelope, and business card in a similar way to establish a family resemblance among the three pieces. Establishing correlations is critical when creating a branding system, as shown in Figure 10-4.

Figure 10-4

Corporate branding system: Wind River Systems

Studio: Morla Design, Inc., San Francisco, CA

Art director: Jennifer Morla

Designers: Jennifer Morla and Carrie Ferguson

Client: Wind River

© *2005 Morla Design, Inc.*

"Wind River Systems is a leading provider of embedded software and services for smart devices. Embedded systems are found in numerous end products ranging from laser printers to automotive braking systems. Morla Design was hired to create all print and online communications, including the creation of all photographic and diagrammatic language. Our solution, incorporating a series of "building blocks," alludes to the diversity of end product uses and visually illustrates Wind River's business."
—Morla Design, Inc.

When shapes or forms share a similar appearance or have similar characteristics, a common language of form is developed in a visual solution. To establish correspondence in the poster in Figure 10-5, Luba Lukova masterfully employed several compositional strategies.

Figure 10-5

Poster: *War and Peace*

Design studio: Luba Lukova Studio, Long Island City, NY

Designer/Illustrator: Luba Lukova

Client: Villa Julie College, Baltimore, MD

Lukova not only utilizes correspondence among elements—repeating colors throughout the composition—she also utilizes linear elements combined with flat color to describe forms, which fashion a common language of form to hold this work together. Also notice the parallel vertical movement of the central image in relation to the type in the upper right corner. "This is a poster for an exhibition of my posters at the Villa Julie College. It is called *War and Peace*. I wanted to convey the message about the price we pay for peace. The idea for the poster came after watching a film about the handicapped U.S. soldiers returning from the battlefields in Iraq. They were learning how to walk with temporary prosthetic legs made out of metal wire very similar to bird cages."—Luba Lukova

Grid

Open up a magazine. How many columns do you see? How are the visual elements organized? All the elements, display and text type, and visuals (illustrations, graphics, and photographs) on the pages of a magazine, book, newspaper, or web site are almost always organized on a grid, which aids in establishing a unified visual appearance in a work. A **grid** is an underlying guide—a modular, compositional structure made up of verticals and horizontals that divide a format into columns and margins. Margins are the spaces around the type and other design elements. A grid becomes exceedingly necessary for applications where a great amount of information must be organized, as for an academic journal such as *Q*, shown in Figure 10-6.

Figure 10-6

Interior spread: *Q*

Studio: The Design Studio at Kean University, Union, NJ

Art director: Steven Brower

Designer: Brian Buttacavole

Client: Dr. Toufic Hakim, Office of Research and Sponsored Programs, Kean University

Within the columns of text on a grid, the title, subtitle, and visuals all must be integrated and composed into a visual hierarchy to enable reading.

History of the Grid

Mankind's first involvement with the grid began as soon as we stopped living as hunter-gatherers and began our agrarian society. The first grids appeared in the fields, as even rows of seeds attempted to replace the wilderness. Indeed, the history of the grid is a history of our need to at once control and imitate nature. The Greeks, in their pursuit of absolute beauty, based the proportions of the Golden Rule on what was found in nature, thereby establishing a series of grids in which we were intended to create and admire.

As soon as there was written communication, so too there was the grid. Hieroglyphics appeared sequentially and ordered within neat panels. The illuminated manuscript during medieval times had regular columns and margins that repeated from page to page. During the Renaissance, artists developed the grid further, using it as a means to explore perspective and also to re-create what was before their eyes. Johannes Gutenberg's development of the printing press, circa 1450, further established the grid as part and parcel of the written word, as the molten metal characters sat neatly within a rectangular mold.

Thus, the pendulum began to swing forward. Whenever the grid was to be submerged—such as during the explosion of wood typefaces and Broadside pamphlets during the nineteenth century—there was someone like William Morris (1834–1896) and the Arts and Crafts movement in England to bring it back into use. Around that same time, the advent of newspapers and magazines cried out for a format to create in on a monthly, weekly, or daily basis. The organic forms of Art Nouveau were to be replaced with the structured forms of Koloman Moser (1868–1918), of the rebellious Vienna Succession (beginning in 1897), and the

underlying geometric grid of German artist, architect, and designer Peter Behrens (1868–1940). To follow was the De Stijl school ("The Style," started in 1917) in the Netherlands, where Piet Mondrian (1872–1944) taught and raised the grid to an obsessive level. In Germany the Bauhaus began in 1919, founded by Walter Gropius (1883–1969), and the grid took hold as the foundation of modern design. Gropius would later turn the reins of the school over to Ludwig Mies van der Rohe (1886–1969), whose "less is more" slogan became the yardstick for all graphic design—*all* design—to be measured by. The new typography took hold, and each character of faces, such as Futura, Frutiger, and Gill Sans, was based on a tight geometric grid within itself.

And so it continues till this today. Some see the grid (or lack thereof) as the struggle between order and chaos; others rebel, viewing the battle as the mêlée between confinement and freedom of expression. A swing to the left and a swing to the right. Hopefully graphic design will never achieve stasis.

Practical Considerations of the Grid

A grid's proportions and spaces provide the consistent visual appearance for a design; a grid underlies and structurally holds together all the visual elements. Employing a grid is a way for a designer to establish unity for either a single-page format (for example, a poster or outdoor board) or multiple-page format (such as a web site or newspaper). The specific graphic design or advertising assignment, strategy, concept, and budget help determine the number of pages in the piece. For print media, the size and shape of the paper is an important consideration in establishing a grid. There are many standard size papers and traditional ways of dividing them into workable units.

There are many grid options. There are even and odd numbered grids, ranging from one to four and sometimes even six columns. A grid need not be ironclad; for the sake of drama or visual surprise, you can break from the grid occasionally. If you break the grid too often, however, the visually consistent structure it provides will be lost. How do you know which grid to use for a design? Consider the design concept, format, and the amount of information that needs to be designed. Each format has a different structure and presents different considerations. Often, magazines have several grid options that work together, shown in the three sample grids used in this book designed by Steven Brower (Figures 10-7 through 10-9).

When you have many elements to organize—display type, text type, and visuals—you usually need to establish an underlying structure that can provide help in maintaining clarity, legibility, balance, and unity. This is especially true when you are working with a multiple-page format where you need to establish a flow or sense of visual consistency from one page to another.

Figure 10-7

One-column grid: *2D: Visual Basics for Designers*

Studio: Steven Brower Design, New York, NY

Designer: Steven Brower

Publisher: Thomson Delmar Learning

Figure 10-8

Two-column grid: *2D: Visual Basics for Designers*

Figure 10-9

Alternate two-column grid: *2D: Visual Basics for Designers*

Template

If you study advertising campaigns, you'll notice that there seems to be an underlying **template**—a designed, underlying compositional structure used as a guide for arranging visual elements—that is utilized for individual ads in a campaign. The visual changes, and the headline changes, but the compositional template stays the same. Other elements that are maintained might include the color palette, font family, style of images, or visuals from the same photographer or illustrator. That is the way most campaigns are designed, where the template is constant: the photograph, line, image, and copy are all positioned in the same place in each individual ad. The specific "feel" or specific message of each ad may be different due to the mood and subject of the photograph or illustration coupled with the copy; however, *the template is maintained*. Each photograph or illustration can depict different visuals and each headline can say something different, but all are related by theme, concept, and template. In Figure 10-10, a print ad campaign for Jamba Juice, the template in each ad is identical; the first part of the headline, the Jambaism number, is at the top of the page with a star separating it from the arched "Jambaism." Lastly, in this justified alignment of type and images comes the logo in a separate colored division of the ad.

Templates are also employed in graphic design for such applications as a series of posters, a brochure where each page is based on a template, a book jacket series, a web site, or any multiple-page document.

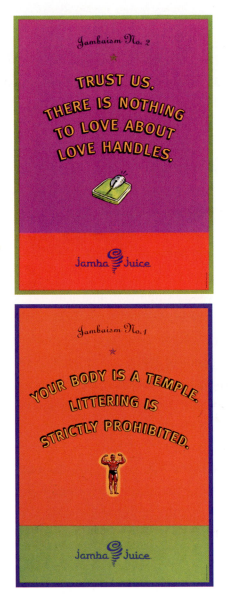

Figure 10-10

Print ad campaign

Advertising agency: Butler, Shine, Stern and Partners, Sausalito, CA

Client: Jamba Juice

"For Jamba Juice, the agency created an "ism" for the brand. We called it "Jambaism" and defined it as "the belief in being good on the outside, as well as the inside." Our thinking centered around the observation that most users of the brand tended to be nutritional managers. Those are the folks who exercise daily and only put good stuff into their bodies. And that is a limited audience. We wanted to get at a broader target, one that was more inclusive than the somewhat narrow target of the healthy lifestyle folks. So, Jambaism was born. And like any religion, we had our set of values. Our Mantra. And we put it on everything, including T-shirts, cups, straws, floor tiles, and, of course, ads."

—John Butler, creative director, Butler, Shine, Stern and Partners

Grid (Structures) for Organizing Web Site Design

A grid is the central ordering system, a framework, a template system, used to create a uniform layout from page to page in web sites, while allowing for some variation. The grid divides and organizes the screen-based page—just as it does in print—into columns with defined widths and spacing, margins, and alignment of text and pictures; it also establishes positions for the standard elements on the page. Often, there is more than one grid per web design to allow for the various types of content and applications.

The template is the master single unit of a grid and is used to guide the placement of every element—text, headers, and graphics—in the web design; a template system or grid is a group of templates related in visual design. The graphics are the visuals or images, including the navigation tabs and buttons, photographs, illustrations, trademarks, and logos.

By maintaining a template system or grid, the visitor will have an easy time locating titles, information, and navigation graphics, thus enabling a smooth passage around the site. A template is created so that the design is consistent throughout the web site and the content can be easily updated.

The template system or grid is a plan of how the pages will "flow" to ensure ease of navigation when using the links, and a sense of where a visitor is anywhere throughout a web site—a sense of location/geography—ensures a pleasant experience for the viewer.

To be successful on a government, educational, editorial, or commercial web site, a grid should be closer to a traditional well-organized design than to more experimental design and thinking. A well-designed web site for information purposes is not really about experimental thinking—it is about creating a well-planned grid.

The **home page** is the primary entrance to a web site that contains the central navigation system; however, not every visitor enters through the home page. A visitor might click through from another web site, entering at a specific page rather than the home page. If you can enter a web site from any point, what does this mean in terms of designing? It means you need to design a grid that works well, with the headers, body, and footers consistently placed. It is standard to make the identifier header (the name of the company, group, or organization) as the home page "button"; this way, no matter where you enter the site, you can always click on the logo/wordmark/header and start at the beginning. Consistent use of color is also important to navigation and clarity of position on the site.

Most of the time, a successful web site has a well-organized grid with the header/navigation/footer in the same place on every page. This way it doesn't matter where you enter the site—it behaves like any well-designed printed matter, as seen in the highly structured site for the Smithsonian (Figure 10-11), where vertical rules can almost be drawn along the columns of text and columns of images.

Alignment

Visual connections can be made between and among elements, shapes, and objects when their edges or axes line up with one another. **Alignment** is the positioning of visual elements relative to one another so that their edges or axes line up. The eye easily picks up these relationships and makes connections among the forms. A flush left alignment is utilized for the text in the Smithsonian web site in Figure 10-11.

Figure 10-11

Web site home page and exhibitions page: Smithsonian

Interactive studio: R/GA, New York, NY

Designers: Andrew Clark, Christian Kubeck, Jean Kapp, Nick Law, and Rei Inamoto

Interaction design: Ted Metcalfe

Production: Anja Ludwig and Kip Voytek

Programming: Michael Roufa and Tom Freudenheim

Quality assurance: Juliana Koh

On a web site for a museum, a grid is critical to organizing a dense amount of information, making it accessible and frustration-free, as well as aesthetically pleasing to museum visitors.

Traditional alignments of type in graphic design (shown in Diagram 10-1) are:

• Centered: the type is aligned on a central axis
• Flush left/ragged right: the vertical alignment of lines of type is at the left margin
• Flush right/ragged left: the vertical alignment of lines of type is at the right margin
• Justified: the type is aligned with both edges flush or evenly aligned
• **Runaround**: the type is contoured to follow the edge of a visual element, such as a silhouetted photograph

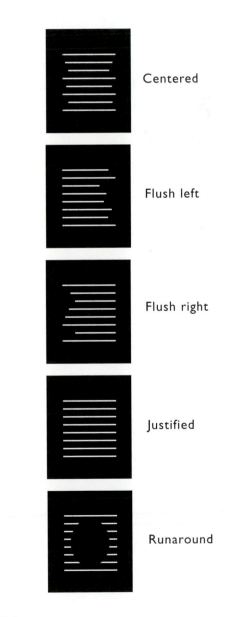

Diagram 10-1

Traditional Alignments of Type

Besides type alignment, other design decisions contribute to unity, such as in the position of photographs in relation to the alignment of type or to one another (Figure 10-12), and in the design solution for the color and fonts shown in Figure 10-13.

Figure 10-12
Book cover and interior: *A Year in Chocolate* by Alice Medrich
Studio: Morla Design, Inc., San Francisco, CA
Art directors: Jennifer Morla and Alice Medrich
Designers: Jennifer Morla and Hizam Haron
Photographer: Michael Lamotte
Copywriter: Alice Medrich
Client: Warner Books
© 2005 Morla Design, Inc.

"Warner Books asked Morla Design to design Alice Medrich's 132-page book *A Year in Chocolate*. We created a clean design that stands apart from the traditional chocolate brown covers crowding the dessert category. The book is divided by seasons with the cover design incorporating a sequence of four seasonal, recipe photographs. Chapter dividers continue the look of the front cover, and the recipe photography is shot in full bleed, with corresponding text and quotes on facing pages."—Morla Design, Inc.

Figure 10-13
Collateral: San Francisco Public Library Laureates Dinner
Studio: Morla Design, Inc., San Francisco, CA
Art director: Jennifer Morla
Designers: Jennifer Morla and Carrie Ferguson
Client: San Francisco Public Library
© 2005 Morla Design, Inc.

"The San Francisco Public Library fundraiser honors nationally acclaimed authors for an evening of dinner and literary conversation. Morla Design chose to letterpress classic fonts and printer's ornaments onto invitations, bookmarks, programs, and bookplates in reference to classic bookmaking and printing."—Morla Design, Inc.

Flow

In order for a layout to be effectual, it must hold together. It must seem organically integrated. Unity can be established in a variety of ways, for example, by the use of a specific color palette, the treatment of the visual elements (correspondence in treatment), or by establishing a visual flow from one element to another. The viewer easily picks up these relationships and makes connections among the forms.

Flow is the arrangement of elements (deliberate or intuitive) in a design so that the viewer's visual action is led from one element to another through the design; also called movement. Flow is also connected to the principle of rhythm, which is, in part, about a sense of movement from one element to another. In the poster shown in Figure 10-14, esteemed American designer Paul Rand arranges images within shapes— shapes that direct the viewer's eyes, creating a flow from one visual element to another. Also, the space between and surrounding visual elements is thoughtfully engaged.

Figure 10-14

Poster: Front cover of *Direction* magazine,
March 1939 by Paul Rand (1914–1997)
Silkscreen, 91 x 61 cm (35 4/5 x 24 in.)
Library of Congress Prints and Photographs Division,
Washington, D.C. [LC-USZC4-5049]

Positive and Negative Space

In a successful positive/negative relationship, the positive and negative spaces are interdependent. Considering all space within a composition as active forces you to take into account the *whole* space, thereby helping to establish unity. Aspiring designers tend to focus their attention on the visual elements (photographs, illustrations, graphic elements). They create or place elements into a composition and assume the background or remaining blank space or white page will need no more attention. After all, it's the visual elements the viewer will be looking at—correct?

By studying design, you learn that even the blank spaces (whether you call those spaces the background, negative spaces or shapes, interstices, or just the rest of the page) add to the sum total of the visual effect and the overall unified feel of the compositional space (Figure 10-15). When each **interstice**— the space between visual elements—is considered, the whole composition will have greater unity. When visual elements are tactically grouped, the remaining space may seem more organized. **Grouping** entails ensuring that visual elements that are near one another have an express visual relationship to one another. Grouping is an important principle related to rhythm.

Certainly, as you become more and more versed in graphic design principles and solve more design problems, you will be able to visualize and manage these positive and negative spatial relationships almost intuitively as you work.

Figure 10-15

Packaging: Xerox Digital Fonts Packaging Prototypes

Agency: April Greiman, Made In Space, Inc., Los Angeles, CA

Designer: April Greiman

Client: Xerox

"The obvious thing in the mid-1980s, the beginning of the digital design revolution, was to actually take the X in Xerox and treat the three categories of fonts—serif, sans-serif, and square-serif— and 'apply' a digital treatment to each of the X's to demonstrate the different contents therein."—April Greiman

Unity with Variety

Within a unified composition, variety adds visual interest. A level of **variety**—a diversity of visual elements, that is, different types or kinds of visual elements—can exist and still allow for continuity, as in the wild posting series campaign for Sun Microsystems ("wild posting" is the practice of placing multiple print advertisements in highly visible outdoor locations in major cities). Each wild posting has very different imagery and colors (Figure 10-16); however, notice the embedded "S" curve that parallels the elongated linear "S" shape in the body copy type treatment, which is consistently composed in each posting, and the logo, web site address, and body copy, which are consistently positioned on the left side of each posting.

Figure 10-16

Wild posting campaign: Sun Microsystems

Advertising agency: Butler, Shine, Stern and Partners, Sausalito, CA

Client: Sun Microsystems

"BSSP recently helped Sun Microsystems unveil its new branding campaign and related advertising that demonstrates the company's commitment to the concept of sharing, a core value across the organization since its inception."—Butler, Shine, Stern and Partners

Contrast in Unity

When visual elements are put in opposition to illustrate or emphasize differences, visual contrast is established. In visual communication, **contrast** is the difference in visual properties that makes a shape, form, or image distinguishable from other shapes, forms, or images and from the background. In Figure 10-17, contrast is established. Contrast can be established by any of the formal elements: color, shape, or texture; it can also be presented in size, direction, type, alignment, and position.

Contrast can be established with the following comparisons:

• Bright vs. dull
• Geometric vs. organic
• Thick vs. thin
• Smooth vs. rough
• Big vs. small
• Straight vs. curved
• Serif vs. sans serif
• Flush left alignment vs. flush right alignment
• Center vs. off center

Including like visual elements in a composition helps to establish unity. However, when all visual elements are similar, a visual sameness (visual monotony) can occur—the composition lacks variation. Juxtaposing visual elements—contrasting them—helps to establish drama and visual differences that can communicate mood or an idea, and provide graphic impact.

Figure 10-17

Logo

Studio: Modern Dog Design Co., Seattle, WA

Client: Marixa

This is a logo for a high-end store that sells women's clothing and accessories. The X in MARIXA is in visual contrast to the knock-out type of the remaining logo letters; however, the logo is unified. Also, the words Alternative American Style are smaller than MARIXA, aiding the visual hierarchy of the logo.

Breaking the Grid

Grids offer sturdy structure with possible scope. When a designer randomly breaks a grid, or breaks a grid often, the stability of the grid is defeated, no longer offering the structural armature that is its purpose. However, a designer can purposefully and advantageously break out of the grid to create a visual surprise for the viewer. Some designers decide specifically how they will challenge the grid; for example, a grid unit can be broken in a third or a quarter of the unit, or a designer might ignore the grid entirely for one page in a multiple-page document. There are innumerable ways to break out of the grid and still maintain the unity that the underlying grid is meant to provide. A grid offers constraints with options!

Varying a Template

Besides employing identical templates in an advertising campaign or any series, some designers use templates where there is variation in the composition, color palette, and type of imagery, yet the campaign or series still holds together and manages to maintain a look. The variation doesn't interfere with the unity of the entire campaign or the way it addresses the viewer. By varying the image, location of the visual elements, or color palette, there is some variety and the viewer is treated to visual interest. Inherent in varying a template is establishing unity with **varied repetition**—where certain standard visual elements and measurements repeat, while the treatment of one or two visual elements varies. For example, a designer can create a template where the position of the title, author's name, and photograph remain the same on all covers, but the specific photograph varies from cover to cover.

Intense Variety

In visual communication, the opposite of unity is chaos, disorder, and confusion. Where the design solution doesn't communicate, the viewer isn't able to understand the intended message. Chaos is a result of not establishing immediate relationships among visual elements and from not establishing greater visual relationships through a thoughtful overall arrangement. Is it possible to establish intense variety and still have unity? The answer is a resounding yes; however, you must find some way to unify the composition. Whether you unify the composition using any of the strategies or principles outlined in this chapter or find another way, the composition must hold together as a unit in order to solve the visual communication problem. It can appear visually turbulent, and border on disorder, but ultimately the *composition must be held together visually* by some means.

Summary

There are many ways to achieve unity. Five of the most important means are correspondence, grid/template, alignment, flow, and positive and negative space relationships. When you repeat an element, such as color, shape, texture, or a visual element, you may establish a visual connection or correspondence among the elements. The confluence of corresponding elements, along with design decisions, contributes to the "look and feel" (the general appearance and overall emotional expression) of an application.

Since visual connections can be made between and among elements, shapes, and objects when their edges or axes line up with one another, alignment contributes to establishing unity. By establishing a visual flow from one element to another, a designer can aid in establishing unity. In a successful positive/negative relationship, all space is interdependent, thereby aiding to establish unity. Within a unified composition, variety adds visual interest. A level of variety— a diversity of visual elements, that is, different types or kinds of visual elements—can exist and still allow for continuity.

EXERCISES

Exercise 10-1: Alignment

Mostly, we think of aligning elements—visuals or letterforms—on a straight axis. Visual connections can be made between and among elements, shapes, and objects when their edges or axes line up with one another. The eye easily picks up these relationships and makes connections among the forms. (Reminder: Alignment is the positioning of visual elements relative to one another so that their edges or axes line up.)

Part 1

Write either one long, incisive sentence or a limerick about yourself. Then choose and draw an object (for example, a plant or a walrus) that relates to the content of what you've written. Find another visual that relates to your content. Using either computer-generated type or handwriting, align the letterforms to the visuals along a straight axis.

Part 2

Using the same text content and visuals, this time compose the text to run around one or both visuals. Position the visuals in the format. The typed or handwritten letterforms will follow the contours or the edge of a visual element, such as a silhouetted photograph.

Part 3

Follow the edges of the drawn object with your words; that is, run the words around the object to follow its contour.

Correspondence and unity are immediately created between an object and letterforms when the alignment of the type imitates the contour of an image.

Exercise 10-2: Correspondence

Good poetry has a felt rhythm, correspondence, and unity—just like good design. Tapping into a poet's mind will help you find your abilities in establishing correspondence within a composition.

Find a profound poem; for example, *Formula* by Langston Hughes or *Asphodel, That Greeny Flower* by William Carlos Williams, and excerpt some lines to use in this exercise. On a triptych format (three connected or related panels), design a composition that has correspondence by doing the following:

- Utilizing a linear technique, draw ten either representational or nonrepresentational shapes on a spare page.
- Design a pattern or visual texture.
- Arrange your ten shapes on all three panels, creating a visual path that moves our eyes from one shape to another.
- Add handwritten words from the poem, placing them strategically around the composition.
- Finally, add your pattern or texture (and a color if you choose) to various positions on the triptych, again with the goal of creating a visual path.

Exercise 10-3: You're square (a grid)

Squares might seem dull because all four sides are plainly equal. But squares can be surprisingly interesting. A grid of squares can be dynamically pulsating.

- Divide a page into a grid of square units.
- Compose images or type to be positioned within each square.
- You may rotate your images and type, or use them upright, but keep your square units at 90-degree angles.
- You may use borders, rules, flat areas of tone, and black or white units.
- Make your squared composition dynamically pulsating by highly contrasting size, shape, texture, and tone.
- Through this exercise, you will learn to create dynamic movement within the confines of a grid.

Composition, Illusion, and Screen-Based Media

Proportion and Scale

Chapter 11:
Proportion and Scale

composition {

hierachy · balance · shape · type · unity · scale · rhythm

message · motion · format · line · color · depth · texture

Objectives

- Recognize the use of proportion
- Understand the role of harmony
- Become conscious of scale

Proportion

Proportion is the comparative size relationships of parts to one another and to the whole. Elements or parts are compared to the whole in terms of measure and/or quantity. For example, the size relationship (measure) of an average-height person's head to his or her body is a proportional relationship; the viewer *expects* there to be one head (quantity) and for the head to be in a particular proportion to the (average) body (Figure 11-1). Also, if the head is *not* in a logical proportion to the body, then the viewer would expect that other elements or parts might be out of proportion, as well. That expectation implies a "standard" relationship among elements, such that if one varies from the "norm" or standard, then another element-to-whole relationship should vary in the same manner. When the viewer's expectations are intentionally challenged, the designer creates a visual surprise, possibly a surreal solution or a disjunctive appearance.

For designers and artists, there is also an additional implied meaning to proportion, an aesthetic arrangement—a harmonious or agreeable relationship of parts or elements within a whole. In design, **harmony** is agreement within a composition, where elements are constructed, arranged, and function in relation to one another to an agreeable effect. Art critic John Ruskin said: "In all perfectly beautiful objects there is found the opposition of one part to another and a reciprocal balance." Certainly, Ruskin's view bestows value on aesthetics and beauty. Today, a designer can deliberately alter expected proportion in a composition with the hope of creating a graphic impact that is not "conventionally" or "classically" beautiful or even remotely about beauty.

Figure 11-1
Web site: Hip Hop Translator
Agency: Butler, Shine, Stern and Partners, Sausalito, CA
Client: Sprite
The human figures are in a logical proportion, themselves, as well as to their environments. From web page to web page, harmony is established through agreement in color palette, use of graffiti-like drawn elements, and the playful integration of figures, drawn elements, and backgrounds within environments.

Ideal Proportions: The Golden Section

From the time of ancient Greece on, artists, architects, and musicians have been interested in determining ideal proportions. They looked to math for a system of creating ideal proportions that could be applied to the visual arts, music, and architecture. The **golden section** is a ratio; the mathematical formula is:

$$a : b = b : (a + b)$$

If you think of the golden section as a rectangle, then side a is to side b as b is to the sum of both sides. The formula can be explained this way: the smaller of the two parts relates to the larger part as the larger part relates to the two parts combined. The golden ratio can also be expressed as a number which is 1 : 1.618 (the golden ratio is difficult to express as a fraction). The proportions of the golden rectangle can be expressed in the ratio of the parts to the whole. The **golden ratio** is a ratio of length to width; also referred to as the golden mean, golden number, or divine proportion.

In Western art, shapes or structures defined by or based on the golden section have been considered aesthetically pleasing by many artists, designers, and architects, where the notion of ideal proportions dominate thinking. For example, architect Le Corbusier used the golden ratio as the basis of his modular architectural system. The golden ratio is still used today in graphic design, fine art, and architecture. Graphic designers utilize the golden section for grid systems and page formats. Although the U.S. standard size page (8½ x 11 inches) (Diagram 11-1) and the European standard size page (210 x 297 mm) are not golden section proportions, a golden section can be inscribed in each. Likewise, a web site's proportions are not golden section based; however, a golden section can be inscribed in it.

Psychological tests have been conducted to determine if viewers have visual preferences—any type of preferences—from line lengths of typography to colors to proportions. In the nineteenth century, German psychologist Gustav Fechner, who was interested in visual aesthetics, conducted tests which he believed demonstrated that when subjects were shown a range of rectangles, they invariably chose the golden rectangles as the most aesthetically pleasing ones.

People in the visual arts have different views on ideal proportions, depending upon their culture, education, and philosophy. Some think pursuing ideal proportions is an important pursuit; others find different ways of addressing scale, proportion, grids, and page formats without turning to mathematical ratios.

Diagram 11-1

A golden section seen in the format of an 8 1/2 x 11-inch page.

Scale

In a design, **scale** is the size of an element *seen in relation* to other elements within the format. Scale is based on proportional relationships between and among elements, which is controlled by the designer. Along with utilizing fundamental principles, scale must be controlled for many other reasons.

- Understanding and manipulating scale can lend visual variety to a composition.
- Scale adds dynamism and positive tension to relationships between and among shapes and forms.
- Manipulation of scale can create the illusion of three-dimensional space.

Traditionally, architects show a person standing next to or in front of a model or illustration of a building in order to best give an idea about the size of the building; the person is understood in scale to the building. In general, we best understand the size of visual elements in relation to other visual elements, whether they are recognizable or nonrepresentational.

Deliberately altering or playing with "normal" scale can be used to intentionally communicate particular ideas or feelings. In the twentieth century, Surrealist artists such as Belgian Modern artist René Magritte distorted scale to create irrational relationships; many artists and designers continue to manipulate scale with interesting effect. In Figure 11-2, a public service advertisement for the United Negro College Fund, a visual surprise (a rocket blasting off from a child's head) is used to illustrate the message.

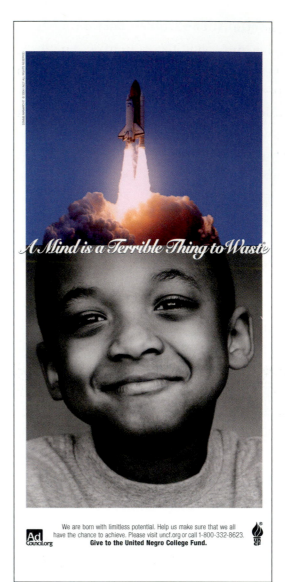

Figure 11-2

Public service advertisement

Volunteer agency: Y & R, New York, NY

Producer agency: The Ad Council

Sponsor organization: United Negro College Fund

Campaign web site: www.uncf.org

Visual Contrast

Scale adds visual contrast, which is crucial to visual interest or dynamic compositions. When visual elements are put in opposition in order to illustrate or emphasize differences, **visual contrast** is established. In visual communication, contrast is the difference in visual properties that makes a shape, form, or image distinguishable from other shapes, forms, or images and from the background (seen in Figures 11-3 and 11-4).

Contrast can exist in line, color, size, shape, texture, typeface, and alignment. Some examples of visual contrast are:

- Big vs. small
- Thick vs. thin
- Straight vs. curved
- Straight vs. angled
- Smooth vs. rough
- Serif vs. sans serif

Figure 11-3

Logo

Studio: Modern Dog Design Co., Seattle, WA

Client: Greenstreet®

In this logo for a manufacturing company in the gift market, the abstracted yellow floral shape is largest and creates visual variety. Coupled with the green leaf shape on its left and part of the letter "G," it is the visual focal point of the logo. The name "Greenstreet" recedes into space because it becomes smaller as it moves away from the viewer into the distance, and the letterforms become smaller and thinner in contrast to the flower and the initial letter "G."

Figure 11-4

Poster: *Our Allies Need Eggs, Your Farm Can Help*

Herbert Bayer (1900–1985) © ARS, NY. c. 1942.

Silkscreen, 20 1/4 x 30" (51.4 x 76.1 cm). Gift of the Rural Electrification Administration. (110.1968)

The Museum of Modern Art, New York, NY

Digital Image © The Museum of Modern Art / Licensed by SCALA /Art Resource, NY

In this historic work by Bayer, monumentality is established by contrasting the size of the egg in the foreground with the burning buildings in the background. This contrast in scale, enhanced by the extreme light and dark lighting, results in dramatic communication.

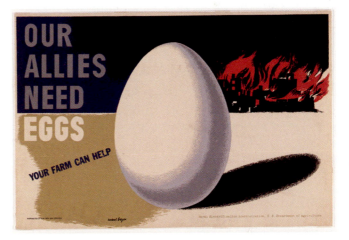

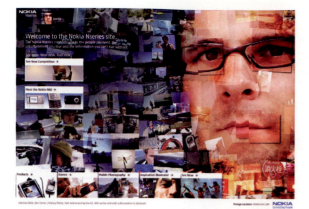

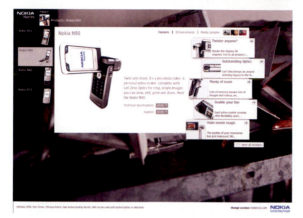

Contrast of Scale and Emphasis

Scale and proportion help us to manage visual hierarchy and establish focal points. When the size of shapes or forms are contrasted to allow one visual element to become a point of focus (due to the manipulation of scale), then scale is used to aid in establishing a visual hierarchy in a composition; this is called **hieratic scaling.**

In Figure 11-5, the home page for Nokia N series, one large portrait is juxtaposed against many smaller images; the face becomes the focal point of the page. The contrast of the face's warm colors against the cooler colors of most of the smaller images enhances its position as the focal point. In the interior spread for a brochure design for Levi's (Figure 11-6), a close-up of a face on the left page is juxtaposed against a figure that is seen (almost) from head to toe; this scale difference creates impact.

Figure 11-5

Web site: Nokia N Series

Studio: R/GA, New York, NY

Copy: Dov Zmood, Jamie McPhee, and Jason Nichols

Designers: Brian Votaw, Christian Olson, Ian Spalter, Jeannie Kang, Mini Ham, Nina Schlechtriem, Patrick Kalyanapu, Sara Golding, Takafumi Yamaguchi, William Wong, and Winston Thomas

Interaction design: Carlos Gomez, Chris Colborn, and Manuel Lima

Programming: David Marrow, Isabel Staicut, Lisa Trujillo, Martin Legowiecki, Mat Ranauro, Narunas Bakauskas, Randy Loffelmacher, and Scott Prindle

Production: Beth Mihalick, Janice Schiffman, Paola Colombo, and Todd Walker

Quality assurance: Jason Wisek, Judy Martinez, Sassania Campagnie, and Todd Kovner

"R/GA created an interactive product experience that goes beyond dry technical information to deliver compelling, real-world examples of the benefits of Nokia's N series devices. User-generated photography was integrated into landscapes that illustrate the creative and adventurous lifestyles of the Nokia N series owner. The site's visual design, interactive environments, and Flash animation are a stylish, poetic reflection of the culture of early adopters—the target market for the Nokia N series (*http://www.nokia.com/nseries*)."—R/GA

Context

Each visual communication application has an external size—the size of the format itself. For example, an outdoor board is very large and usually a standard size. What is the external size of a visual communication solution in relation to the person viewing it? What is its size in relation to the environment in which it is viewed? What is its size in relation to other visual communication solutions near it or like it? In other words, the solution's scale in relation to the viewer and the world helps determine its impact on the viewer and its expressive quality. Where and how a viewer sees and experiences a graphic design or advertising application will partly determine the scale and impact of the piece itself. In Figure 11-7 an unconventional advertising campaign for Charlotte Mecklenburg Department of Transportation, we see an outdoor campaign in context. A piece such as a business card that is held in hand by the viewer has a different human scale reference than is experienced with an outdoor board or a projection on a building; this is also called relational reference or external scale.

Figure 11-6

Brochure: Levi's Original Spin

Design studio: Morla Design, Inc., San Francisco, CA

Art director: Jennifer Morla

Designers: Jennifer Morla and Gordon McNee

Photographer: Jock McDonald

Copywriter: Penny Benda

Client: Levi Strauss & Co.

"Morla Design was retained to handle the brand identity for Levi's Original Spin, including logo development, store design, consumer brochure, point-of-purchase materials, and sales associates collateral. Designed to appeal to a fifteen to twenty-four-year-old audience, Levi's Original Spin is based on the consumer as the creator of their own jeans (versus the more traditional approach of 'fit' which appeals to an older audience). Store design and brochure layouts enhance the spirit of individuality with black-and-white photographs of 'personalities' that illustrate the various style options. Loosely leaded type and hand-drawn 'spin' motif expand on this concept of individuality. The customers are encouraged to be their own stylists by 'combining these options and creating their own jeans'."—Morla Design, Inc.

Figure 11-7

Advertising campaign: "SIGNS ON BIKES"

Agency: Loeffler Ketchum Mountjoy, Charlotte, NC

Creative director: Jim Mountjoy

Art director: Doug Pedersen

Copywriter: Lee Remias

Agency producer: Sarah Peter

Account executive: Jason Carey

Client: Charlotte Mecklenburg Department of Transportation

"The goal was to promote biking as a lifestyle, while highlighting the city's efforts at becoming more bike-friendly. We used real bikes with signs attached and placed them in newly installed bike racks around busy uptown areas in Charlotte. The bikes became both the medium and the message."—Loeffler Ketchum Mountjoy

Contrast of Scale and the Format

Not only does a designer need to consider the size and scale of one element to another, a designer must also consider the size and scale of all elements within a composition in relation to the format. A designer must consider the internal proportions to the outer size of the format.

In Figure 11-8, the context is how big the format is taken as a whole; context also affects internal proportions. Scale is comparative; scale *within* a design will change the total effect. What would work on the scale of a business card would probably not work on an outdoor board. The size of elements in relation to the format is critical to consider. On the home page of the R/GA web site, seen in Figure 11-9, the scale of the image is large in relation to the screen; there is one large visual on the screen-based page. This size relationship, along with the use of the illusion of depth in the image, creates great impact for a home page. On another page of the same web site, the visuals are small and many for a practical purpose—these images are part of a timeline, which the visitor can click on to see an enlarged image.

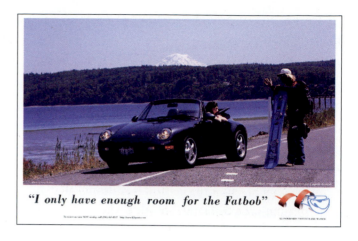

Figure 11-8
Advertisement: K2 FatBob
Studio: Modern Dog Design Co., Seattle, WA
Client: K2
In print advertising, the relationship of visual to headline here is big visual to smaller headline.

Figure 11-9
Web site: RGA.com
Agency: R/GA, New York, NY
Broadband: Marcia Bernard and Stephen Barnwell
Copy: Barry Wacksman, Chapin Clark, Cheryl Brown, Jeff Schulz, Josh Bletterman, Karen Spiegel, Katherine Santone, and Lara Haarhoff
Designers: Brian Votaw, Garry Waller, Heath Hinegardner, Jeannie Kang, Jeff Baxter, Nick Law, Nina Schlechtriem, and Pablo Gomez
Interaction design: Cindy Jeffers, Daniel Harvey, Ivy Mahsciao, Mauro Cavalletti, and Ryan Leffel
Production: Adam Blumenthal, Christopher Dugan, and David Frankfurt
Programming: Chris Hinkle, Daniel LaPlaca, Geoffrey Roth, Isabel Staicut, Jason Scherer, Lisa Trujillo, Michael Black, Patrick Fitzgerald, and Regina Yadgarov
Quality assurance: Daniel LaPlaca, Diane Lichtman, Edwin Quan, and Todd Kovner

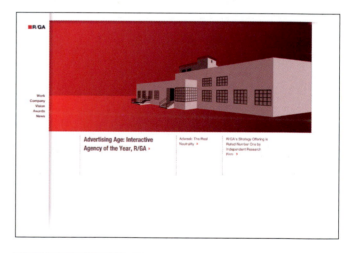

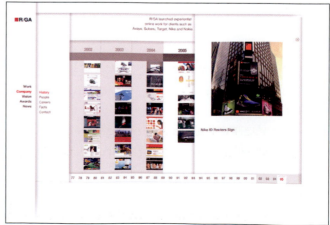

There are many points to consider regarding scale and the format.

- Big visual elements in a small format can make the format feel or appear larger than it is.
- Many small visual elements in a small format might make the format seem smaller than it is.
- A large visual or letterform on a business card might seem much smaller on a poster.
- Great contrast in scale within a given format might increase the illusion of depth.

Summary

Proportion is the comparative size relationships of parts to one another and to the whole. Elements or parts are compared to the whole in terms of measure and/or quantity. In design, harmony is agreement within a composition, where elements are constructed, arranged, and function in relation to one another to an agreeable effect. In a design, scale is the size of an element or form *seen in relation* to other elements or forms within the format. Scale is based on proportional relationships between and among forms, which is controlled by the designer. Scale adds visual contrast, which is crucial to dynamic compositions. In visual communication, contrast is the difference in visual properties that makes a shape, form, or image distinguishable from other shapes, forms, or images and the background. The scale of a graphic design solution in relation to the viewer and the world helps determine its impact on the viewer and its expressive quality.

EXERCISES

Exercise 11-1: Proportion

Part 1

Choose a novelist and a book by that novelist.

Part 2

Find or create a visual that is appropriate to conveying the content of the novel for a book jacket design.

Part 3

Arrange the author's name, novel's title, and visual

three different times, varying the proportions of each to the other.

Exercise 11-2: Harmony

Harmony relates to the unity of all parts in the design. A layout can contain harmony of line, shape, tone, color, and treatment.

Part 1

Homage to Mondrian

Divide a screen-based or print page into uneven quadrants. Ensure that the page is balanced and the divisions look harmonious in relation to one another and to the format.

Part 2

Choose one letter, for example, a K or an S. Position the letter on a screen-based or print page. Draw five-shapes, of varying sizes from big to small (though no bigger than the letterform), that relate to the letter in terms of shape, treatment, and tone.

Exercise 11-3: Scale and conventional size relationships

In reality, the viewer usually expects objects and people to be in their "conventional" size relationships. For example, a chair is smaller than a building, and an apple is smaller than a person.

On a page, held in the landscape position, compose an interior space with objects in conventional size relationships.

Exercise 11-4: Scale and unconventional size relationships

Homage to the Surrealist artist René Magritte, who created improbable size relationships and other visual surprises in many of his paintings.

On a page, held in the landscape position, compose an interior space with objects in unconventional size relationships.

Chapter 12:

Illusion
of Depth

Illusion of Depth

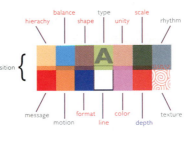

composition {

hierachy · balance · type · scale · shape · unity · rhythm

message · motion · format · line · color · depth · texture

Objectives

- Define and understand the picture plane
- Become conversant on how to create volumetric illusion
- Consider basic factors in creating the illusion of spatial depth
- Understand perspective, and the differences between linear, perceptual, and atmospheric perspective
- Understand compositional structures related to the illusion of depth
- Realize the practical and creative considerations of designing for the illusion of depth

The Picture Plane

Being able to manipulate the picture plane allows a designer the ability to evoke different conceptions of reality through spatial illusion. Different types of illusion permit a range of visual communication and more potential for creative expression.

The **picture plane** is the flat, two-dimensional (planar) surface, such as a printed page or screen-based page, on which a designer organizes a composition. Some call it an imaginary transparent plane that coincides with the face of the page or substrate on which a composition is built; others call it a "transparent front wall" between the viewer and the objects that are seen. In some cases, the picture plane acts as a transparent plane of reference, onto which a designer places elements to establish the *illusion* of three-dimensional forms in space.

A designer can maintain the integrity of the picture plane—the flat two-dimensional surface—or a designer can manipulate the picture plane to create the illusion of three-dimensional space. As soon as you hint at the existence of a three-dimensional space on a flat surface, you are creating illusion. In order to successfully create the illusion of spatial depth on a two-dimensional surface, you must understand how to manipulate the picture plane.

Position of the Picture Plane

Depending upon where shapes are positioned on the picture plane and how a designer approaches the composition, shapes may *appear* to be in front of, behind, or at an angle to—but not parallel to—the picture plane.

To learn how to manipulate the picture plane, one must first understand the *relative position* of the picture plane in any pictorial space. Where is the picture plane? There are several ways to approach visually positioning the picture plane when building a composition.

- If you think of a page or a computer screen as a windowpane, then the picture plane is the plane closest to you (like a glass windowpane) and all other forms move behind it (as if you're looking through a glass windowpane), as seen in Figure 12-1.
- The picture plane can act as a back wall (as opposed to the idea that it is a forward windowpane), where all forms *appear* to move forward, toward the viewer. The forms are in front of the picture plane, which is now positioned as the "back wall." In the case of Figure 12-2, the imaginary front plane seems to disappear for the viewer.
- The picture plane can be "positioned" in the middle of the space where some parallel planes and opposing planes appear to move in front of the picture plane and some move behind the picture plane (Figures 12-3 and 12-4).

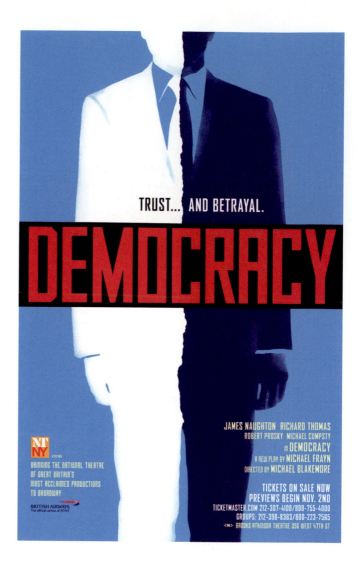

Figure 12-1

Theater poster: *Democracy*

Design firm: Spotco, New York, NY

Art director: Gail Anderson

Designer/Illustrator: Sam Eckersley

The word "Democracy" defines the picture plane as the plane closest to the viewer; the man's figure is positioned behind "Democracy."

"A complex show, our goal was to strip the poster down to its most basic elements. The show focused on one man's struggle to find allegiance, while living two lives; one as the devoted personal assistant to the leader of Germany, and the other as the equally devoted role of a double agent. Addressing current ideas that many Americans can relate to, the use of patriotic colors and militant type seemed appropriate."—Spotco

Figure 12-2

Poster: *The Best of Jazz–1979*

Design studio: Pentagram, New York, NY

Partner/Designer: Paula Scher

Client: Columbia and Epic Records and Tapes

© CBS Inc.

The typographic treatment, arranged at angles, sits in front of the picture plane, defined by the background color or Kraft paper and the black-and-red border, which acts as the back wall.

"The assignment: Get twenty names on a poster. Big. Do it fast. Make it cheap. The solution: Paula Scher organized wood type at angles and tangents in a Russian Constructivist manner. The poster was printed on Kraft paper in red, white, black, and yellow ink. At the time the poster was created, the design looked radically different. Initially it was rejected from every show; then it was embraced everywhere and widely imitated ('and became a stylistic noose around my neck,' says Scher)."—Pentagram

Figure 12-3

Logo

Studio: Modern Dog Design Co., Seattle, WA

Client: Magazineline.com

In this logo for an online business that sells magazines, the red underline defines the middle space. Both the descender of the letter "g" and the hand appear to be in front of the red underline. The red rectangle (representing a magazine) appears to be slightly behind the red underline penetrating it, with the hand clearly positioned in front of the red rectangle.

Figure 12-4

Poster: *The Delgados*

Studio: Modern Dog Design Co., Seattle, WA

Designer: Michael Strassburger

Client: Crocodile Cafe

The blue rectangle defines the picture plane positioned in the middle of the illusory pictorial space. The male figure in the bottom right corner is in front of the blue rectangle, and "THE DELGADOS" typography moves behind the blue rectangle; yet "CROOKED FINGERS" is confined and cut off by the edges of the blue rectangle to create a disjunctive juncture. The space is further enhanced by the car being positioned behind "THE DELGADOS" typography and "CROCODILE" is positioned behind the male figure.

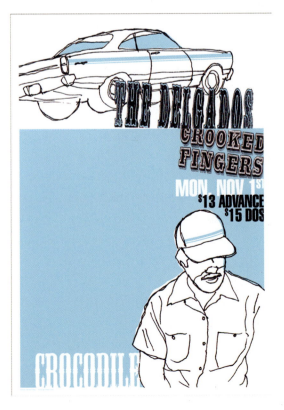

Any mark can appear to shift the position of the picture plane. For the most part, the position of the picture plane determines the type of space in a composition. A designer must be constantly aware of the "position" of the picture plane in order to have control over the internal compositional space that is being built. In the logo for LUX Pictures, the letter "L" defines the picture plane (Figure 12-5).

The Illusion of Spatial Depth

In general, there are two possibilities when designing a two-dimensional surface. A designer can:

- maintain the flat surface, *or*
- create the illusion of spatial depth.

The **illusion of spatial depth**, or what is commonly referred to as the illusion of three-dimensional space, can be shallow or deep, recessive or projected. In this study, it is easiest to comprehend illusion as we move *from shallow to deep.*

There are a variety of ways to create the illusion of three-dimensional space:

- Shapes and overlapping shapes and forms
- Line, angles, and warps
- Volumetric forms
- Linear, perceptual, and atmospheric perspective
- 3D software

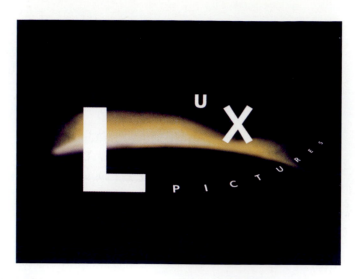

Figure 12-5

Logo, letterhead, and business card

Design firm: April Greiman, Made in Space, Inc., Los Angeles, CA

Client: LUX Pictures

"The word 'LUX' was really played out as 'light' in space, and 'lighting' effects to 'underscore' this new identity for a start-up company. A bit like the old Hollywood tradition, we added, in web-animated version, the 'klieg light' panning over the logo."
—April Greiman

Creating Illusion with Shape and Overlapping Forms

To create the illusion of shallow space, all one needs to do is overlap shapes, as seen in Diagram 12-1. Composing shapes that overlap immediately implies one shape is in front of another, thereby implying spatial depth (Figure 12-6). Changing a line's width can also invoke depth, as seen in the Polaris logo (Figure 12-7). When a shape contains diagonal components or is an uneven oval, then it may imply depth in a composition. Overlapping planes in combination with marks/strokes will also create the illusion of space.

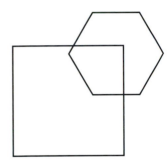

Diagram 12-1
Shape Overlapping Shape

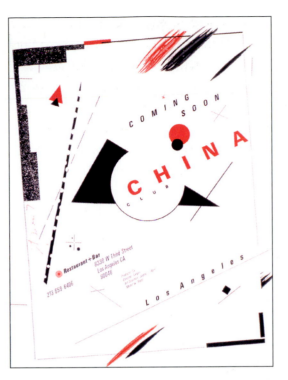

Figure 12-6
Advertisement
Design firm: April Greiman, Made in Space, Inc., Los Angeles, CA
Client: China Club Restaurant and Lounge
"This restaurant of the late 1970s wanted to integrate both the old and the traditional, in color and in form, and be very contemporary and bold, as well. Although we used the 'chopsticks' in the identity, we tended to apply the logo in nontraditional ways, and with other modern elements, shapes."—April Greiman

Figure 12-7
Logo
Design firm: Louey Rubino, Santa Monica, CA
Client: Polaris
Using a changing line to denote one shape covering another, this logo presents the illusion of three-dimensional space.

Creating Illusion with Line, Angles, and Warps

Line is an element that can be utilized in a variety ways to create compositions with spatial illusion. If you simply draw a diagonal line on a screen, that diagonal implies spatial depth.

A diagonal line can *appear to penetrate* the picture plane, conjuring up another dimension. Draw one diagonal on a page. What happens to the picture plane? The picture plane *appears* to tilt and, immediately, the illusion of space existing behind (or perhaps even in front of) the picture plane is implied. In Figures 12-8, 12-9, and 12-10, the direction of the elements—the angles and direction of linear shapes—creates the illusion of depth.

Figure 12-8

Logo

Design firm: Liska + Associates, Chicago, IL

Client: IREM (Institute of Real Estate Management)

"The Institute of Real Estate Management (IREM) provides training and acts as a governing body to set standards for professionals in the real estate industry. Our complete rebranding program for IREM included identity materials for each of its divisions, connected by a unifying logo that suggests the architecture of a building."—Liska + Associates

Figure 12-9

Logo

Studio: Modern Dog Design Co., Seattle, WA

Client: K2

The two blue shapes and white shape sandwiched between them form the illusion of a ski slope. The edge of that portion of the logo is parallel to the angled stroke of the "K," enhancing the feeling of movement.

Figure 12-10

Logo

Design firm: Liska + Associates, Chicago, IL

Client: Terra International

"Terra International manufactures and provides seed, equipment, and supplies to agribusinesses. We produced this logo when we worked on a complete rebranding and identity program that applied the company's identity to everything from signage and packaging to silos and trucks." —Liska + Associates

Horizontal or vertical lines grouped together can create the illusion of a warped surface, a surface that rises and falls, as in the poster by Herbert Bayer (Figure 12-11).

Creating Illusion with Volumetric Forms

When diagonals link with verticals and horizontals to form planes, we get the illusion of space on the two-dimensional surface. A plane can move in front of or behind the picture plane. When planes are joined or connected to build volumetric forms, illusion is invoked as well. A volumetric form is a two-dimensional image with an appearance of having three dimensions and/or solidity or mass (see Figure 11-9, home page for R/GA).

Although volumetric forms are often thought of as representational images, they can also be nonrepresentational. Place one volumetric form on a page, and the viewer infers spatial depth; overlap volumetric forms, and even greater spatial depth is implied. The compositional space can be logical or disjunctive, as seen in an ad for K2 (Figure 12-12).

The illusion of volumetric space can be:
• Shallow or deep
• Volumes that float freely or link with one another
• Nonrepresentational, abstract, or realistic
• Planes that read rationally, imitating the true physical world
• Planes that move in relation to one another and can only be understood amidst themselves within their own spatial system

The illusion of shallow space—space that has little depth or relatively few planes of spatial depth, and seems relatively close to the viewer—can communicate differently than the illusion of deep space—an arrangement of forms where there is considerable distance between the plane closest to the viewer and the one farthest away from the viewer. How the forms will contribute to or subtract from the illusion of spatial depth depends upon which forms—or if all forms—are in focus.

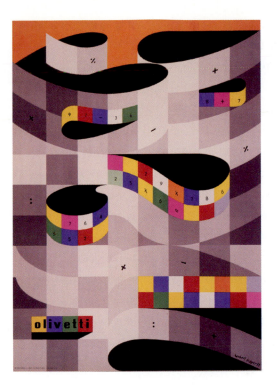

Figure 12-11

Poster: *Olivetti*

Herbert Bayer (1900–1985). © ARS, NY. 1959.

Offset lithograph, 27 1/2 x 19 5/8" (69.8 x 49.8 cm).

Gift of the designer. (39.1960)

The Museum of Modern Art, New York, NY

Digital Image © The Museum of Modern Art / Licensed by SCALA / Art Resource, NY

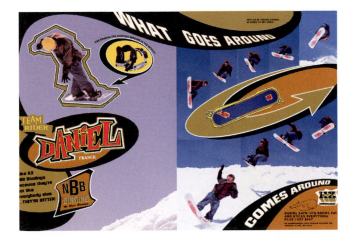

Figure 12-12

Advertisement: "Daniel"

Design firm: Modern Dog Design Co., Seattle, WA

Client: K2

Disjunctive space is created, for an exciting effect, by the placement of elements that seem out of place.

Creating Illusion with Linear Perspective

Linear perspective is a schematic way of translating three-dimensional space onto a two-dimensional surface—of creating the appearance of spatial recession. It is based on the idea that diagonals moving toward a **vanishing point** or points will imitate the recession of space into the distance and create the illusion of spatial depth. In traditional linear perspective, spatial depth is indicated by the convergence of parallel lines toward a *vanishing point*—the point at which parallel lines seem to converge and then disappear from the viewer's sight along a horizon line. Diagonal lines represent the convergence of lines in space.

- One-point perspective: when converging diagonals move toward one vanishing point along a horizon, it is called one-point perspective (Diagram 12-2). Moving away from the viewer, parallel lines appear to converge at one point (the vanishing point) somewhere in the distance, both imbuing objects with form or mass and yielding the notion of visual depth. (Vertical lines do not converge.)

- Two-point perspective: in two-point perspective, two vanishing points are established along the horizon line (Diagram 12-3). When diagonals recede toward one of two vanishing points along a horizon line, it is called two-point perspective. (Vertical lines do not converge.)

- Three-point perspective: in three-point perspective, two vanishing points are established along the horizon line, and one vanishing point is established either above or below the horizon line to which the vertical lines vanish or converge.

In other words, every right-angle line in the design will eventually converge on one of the three perspective points (Diagram 12-4).

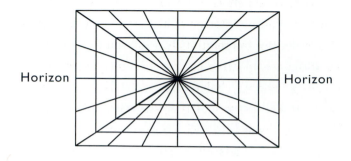

Horizon Horizon

Diagram 12-2
One-Point Perspective

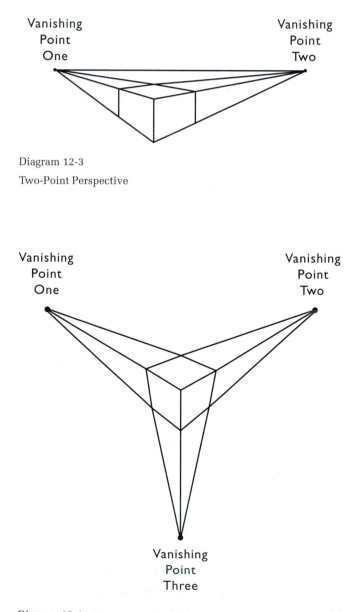

Vanishing Vanishing
Point Point
One Two

Diagram 12-3
Two-Point Perspective

Vanishing Vanishing
Point Point
One Two

Vanishing
Point
Three

Diagram 12-4
Three-Point Perspective

Perspective schemas are used to represent rational interior spaces, exterior spaces, and environments, and to control the relationships of figures and objects in space. Perspective affords the designer a way of creating rational, balanced, controlled, and *idealized* representations of the real world, in terms of depicting distance, depth, proportion, and point of view. Italian Renaissance artists and architects were interested in portraying the world in a humanistic, rational way. Some credit fifteenth-century Italian artist and architect Filippo Brunelleschi with the first perspective drawing. Fifteenth-century Italian architect Leon Battista Alberti, in *Della Pittura*, is credited with codifying the principles of linear perspective.

Borrowing from conventional perspective schemas, designers can use planes that recede into the pictorial space to create the illusion of spatial depth without using formal conventional one-point, two-point, or three-point perspective, as seen in Figure 12-13, where the typographic treatment of the title *Copenhagen* forms a receding planar shape that is counterpointed by a grey plane moving at another angle into the distance, resulting in a very dynamic spatial illusion.

Based on the normal perception of average size relationship in space, larger forms are understood to be closer to the viewer, and appear to become smaller as they recede into space, moving away from the viewer. As forms move into the distance, they appear to become smaller and smaller. This notion is based on "normal size" relationships; for example, if a very short person were standing in the front of a room, close to the viewer, with a very, very tall person standing in the back of a room, the "standard" size relationship would be skewed.

Perspective also conveys the position of the designer in relation to the two-dimensional work; that is, how close the designer was in relation to the things seen, as well as the eye level of the designer. Taking the position of the designer or artist into account says something about "man" in relation to their creations.

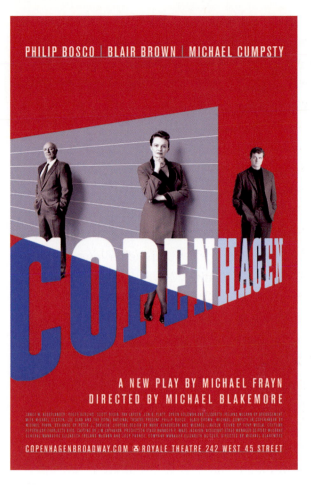

Figure 12-13
Poster: *Copenhagen*
Studio: Spotco, New York, NY
Countering planes create dynamic space and communicate the tension of the play's subject matter.

Eye Level and Point of View

Eye level is the designer's line of vision in relation to the subject (things seen and being depicted), manifested as an imaginary line running through a two-dimensional composition and indicating the position of the overall viewpoint, as well as whether you can see the top, bottom, or center of forms. The designer determines the eye level—whether it is above, below, or centered in relation to what the viewer sees or the space being created. It should be noted that mixing eye levels in a single composition can create the effect of disjointedness or disjunctive composition—this can be used intentionally.

Point of view is determined by our position and the angle of our vision in relation to the thing being seen. For example, we know that a television has a top, bottom, and four sides. Your position in relation to the television would determine how many sides of it you would be able to see from any one given point. From above, you would see the top. If you were far away from the television, you would see it in its entirety, but could not possibly see all sides simultaneously.

Perspective, both linear and perceptual, allows you to represent forms as they appear to the eye from different points of view. Depending upon the viewer's point of view—that is, one's position and height—parallel lines recede at different angles toward the vanishing point along the horizon line.

Convergence

In reality, the front plane of a cube is parallel and equal in width to the back plane. However, in order to depict a cube on a two-dimensional surface, you must depict the back plane as smaller, narrower than the front plane, so that the cube appears to be receding into space. The cube follows the visual laws of perspective; the parallel lines that comprise its planes move toward a vanishing point and appear to converge (rather than remaining parallel).

A good analogy is a railroad track. You know that tracks run continuously parallel. However, as you look down the tracks, they seem to converge along the horizon, which is the imaginary line where the sky meets the ground/land (Diagram 12-5). Perspective imitates this illusion and creates convincing spaces.

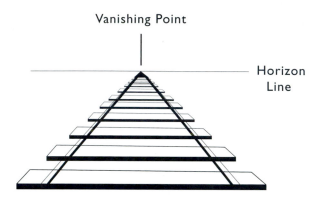

Diagram 12-5
Illusion of Convergence

Foreshortening

When you cannot see the total length of a form due to your point of view, that form is seen in **foreshortening**, which is the representation of forms on a two-dimensional surface by distorting the length that is projecting toward the viewer or receding away from the viewer. You draw the form by reducing its length or parts in order to create the illusion of depth and distance. For example, if you want to draw an arm that is perpendicular to you, you must reduce the true length of the arm to its perceived length.

Creating Illusion with Perceptual Perspective

There are more widely used, less structured perspective systems or looser methods of translating spatial depth, based on perception and the visual reading of recession into space. These methods are called perceptual perspective or "eyeballing."

Eyeballing—a rather strange sounding term—refers to the process of recording perceptual information without the use of a perspective system. You use visual perception to make judgments about depicting space, interstices, and depth.

Novices tend to draw what they know rather than what they see. For example, when drawing from life, novices tend to draw tables with the top planes tilted up since they *know* that tables have tops. You would see the top of a table if you were looking down on it; otherwise, you would see the top plane recede into space and should draw it accordingly. When learning to draw perceptually, you need to become a keen observer, someone who actively looks and records what is seen.

Condensing

In representational works, you usually compress perceived space into a theater-like or box-like stage setting where there is some sense of the floor and wall and, at times, a sense of the ceiling. Generally, the space being translated onto a page is much, much larger than the page; for example, think of representing a bedroom on an 11 x 17-inch page. You must compress the imagery and the space it occupies, in order to translate what you see in three dimensions into an illusion of spatial depth on the two-dimensional surface.

You condense or compress the expanse of your vision onto a standard rectangular format, such as a poster, when creating representational illusions of what you actually see.

Vertically and horizontally extended formats are appropriate for particular types of extended vision, illusion, and expression.

Creating Illusion with Atmospheric Perspective

Another type of perspective—atmospheric perspective—is utilized in the visual arts. The atmosphere has a graying effect on forms seen from a distance. Fog clouding your visual field is an extreme example of this effect. The interposition of the atmosphere between the viewer and things seen causes forms to appear to lose detail, blur at the edges, alter in hue, and diminish in intensity and value. Forms that are closer to you appear in sharper focus than those that are farther away from you. Objects and figures appear to lose detail and clarity as they move away from you into the distance. The atmosphere intercedes between the viewer and the thing seen to reduce clearness of vision.

An atmospheric spatial effect can be represented on a flat surface if the designer takes into account the effect the atmosphere has on color, shape, form, texture, and detail from a distance, which we call **atmospheric perspective;** it is also called aerial perspective.

You can use the element of value to create atmospheric illusion. Gradations of light and dark values can create space. Variations and gradations of value can create spatial illusions. Very simply, dark values appear to be closer to us than lighter values.

Value is one of the four qualities of color. When you add hue, saturation, and temperature to value, utilizing all the qualities of color, you can create amazing illusions of spatial depth.

Light and Shadow

We see by virtue of light; it illuminates forms. When a form is completely bathed in light, there are few or no shadows. When a form is lighted from one side or from an angle, then the side away from the light is in shadow. In order to create the illusion of volumetric forms that relate to the way we see naturally, it is necessary to establish a logical flow of light that touches all the forms in its path; the light acts both to model the forms and to establish a unified path of vision.

Chiaroscuro is an Italian word that means "clear and dim," and defines a style that utilizes light and shadow to create the illusion of depth and space.

Light and shadow can be created by controlled:
• Planes of light and dark
• Shading
• Hatching
• Atmospheric field (density)

Atmospheric Illusion
There are many things to consider when creating atmospheric illusion; some are:
• Warm vs. cool (temperature) colors
• Bright vs. low chromatic intensities (saturation) of colors
• Transparent vs. opaque tones and colors
• Close values
• Minute shifts in hue
• Where a color "sits" in pictorial space

Color and the Illusion of Depth

Hues are brighter and values have more contrast when they are closer to you; as hues and values move away into the distance, they appear to become less saturated—become grayer and grayer. The atmosphere intercedes between the viewer and the thing being seen to reduce the intensity of colors (Figure 12-14).

The visual position of the picture plane also tells the viewer something about the position of the designer in relation to the work; that is, how close or far, to the right, center, or left, and therefore the position of the viewer in relation to the internal space.

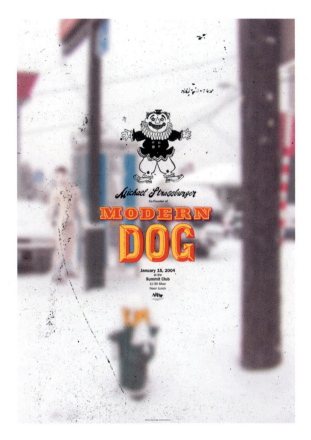

Figure 12-14
Poster
Studio: Modern Dog Design Co., Seattle, WA
Designer: Michael Strassburger
Close and light values obscure the photograph behind the typographic treatment, creating the illusion of depth and positioning the picture plane where the typography sits.

3D Spatial Illusion for Screen-Based Media

Rather than have a web site or web page parallel to the picture plane, 3D design software aids a designer in making some or all of the images on a web page look three-dimensional—volumetrically solid and positioned at an angle to the picture plane. The same techniques of creating the illusion of depth in print applications also apply to web site design; in addition, a web site may incorporate actual time (with viewer interaction), streaming video, Flash graphics, and animations that can enhance the illusion of depth.

In the design of a web site, a designer can utilize 3D modeling animation and visual effects software to create or enhance the illusion of volume and depth. With specific software, a designer can distribute elements in what seems like 3D space—image layers can be put into motion, while the objects on them can be made to look both volumetrically solid and animated within the illusionary space, as in Figure 12-15.

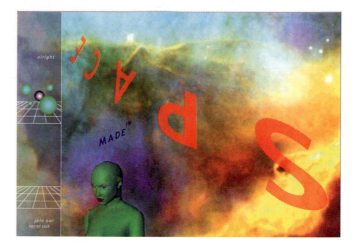

Figure 12-15

Web site Flash introduction

Design firm: April Greiman, Made in Space, Inc., Los Angeles, CA

"Our site was, as per the 'spatial' presence in all of our work, important to have ultra-interactive and dimensional, like a journey through space! Interactivity, layers of space, through words and images are tantamount in the design effort."—April Greiman

Creative Considerations

A composition with space behind the picture plane affects the viewer differently than the illusion of space moving in front of the picture plane. The difference in how the picture plane is manipulated is not qualitative; however, it can potentially create different effects and communicate diverse meanings (Figure 12-16).

Line, overlapping planes, linear volumes, value, the full range of color—these all create internal space and deny the flat reality of the two-dimensional surface. Each type of illusion has its own characteristics and potential for communication, and should be viewed and utilized in relation to the designer's intention, audience, subject matter, and philosophy.

It is important to understand that either maintaining the flatness of the two-dimensional surface or the creation of illusion carries with it different meanings, potential philosophies, and associations. Contemporary designers have choices for creating illusion.

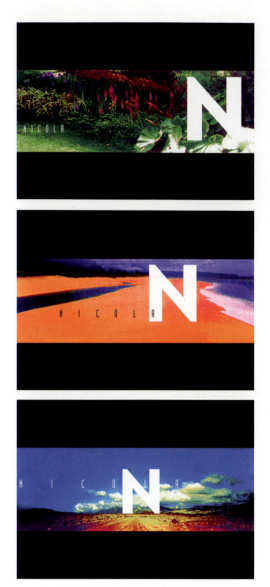

Figure 12-16

Outdoor mini-billboards

Design firm: April Greiman, Made in Space, Inc., Los Angeles, CA

Client: Nicola Restaurant

The "N" on one outdoor board (floral background) seems relatively close to the viewer. In the outdoor board with the beach as the background, the "N" seems a bit farther away from the viewer; and the "N" in the last outdoor board seems to sit on the horizon, far from the viewer, with the titled plane coming out from the picture plane.

Composition

In design, a composition is a structure of relationships. Elements are utilized in compositions to create forms, evoke feelings, and communicate messages and meaning. Separately, the elements are like musical notes. Put musical notes together, you get music. Put design's formal elements together, and you start to form a composition. A successful composition comes from a designer who evaluates, both intellectually and intuitively, how all the elements work together, controlled by the principles of composition—unity, visual hierarchy, balance, and rhythm. Once you begin to control elements and principles, distinguishing each interaction, you can build compositions that have the illusion of spatial depth.

You must consider:

- Spatial relationships
- Relationships of hierarchy and subordination
- Relationships of equivalence and difference
- Distinctions between shapes that appear flat and those that create illusion
- Distinctions between manner (type) of forms
- Distinctions between shallow and deep space
- Distinctions between rational space and disjunctive space

Historical Note about the Picture Plane

"The belief that one could represent man in a real setting and calculate his position and arrange figures in a demonstrably harmonious order, expressed symbolically a new idea about man's place in the scheme of things and man's control over his own destiny."
—Kenneth Clark from *Civilization*

In early Italian Renaissance painting, all space and movement occurred from the picture plane back, as though the viewer were looking through a windowpane. Various artists in the European Baroque period challenged the Renaissance "windowpane" position of the picture plane, moving forms in front of the picture plane, thereby creating a heightened dramatic spatial effect. Movement in front of the picture plane can dramatically engage the viewer's space. For example, think of comic book illustration and the way a punch is depicted, appearing to come forward at the viewer. In Figure 12-17, a historical public service poster *Are You Doing All You Can?*, the hand busts through the picture plane to confront the viewer, coming into the viewer's space for dramatic impact.

Figure 12-17

Poster: *Are You Doing All You Can?*, 1942

Designer: unidentified poster-maker

Photographer: Terry McCrea

Producer: General Cable Corporation

Photomechanical lithograph, 71.1 x 55.9 cm (28 x 22 in.)

National Museum of American History, Smithsonian Institution

Gift of General Cable Corporation

Both artists and designers have used a heightened type of spatial illusion to fool the viewer's eye. When pictorial space or objects are rendered so that the viewer is fooled into thinking the two-dimensional surface is actually three-dimensional space, we call that trompe l'oeil. Used in Ancient Roman painting, and then again in the Italian Renaissance through the seventeenth century in the Netherlands, the nineteenth century in America and still used today, as in this poster by Spotco (Figure 12-18), trompe l'oeil depictions never cease to delight viewers by asking the question "what is real?"

Figure 12-18

Theater poster: *Bklyn*

Design firm: Spotco, New York, NY

Art director: Gail Anderson

Designer: Darren Cox

Photographer: Geoff Spear

Posted to the fence, the peeling poster appears to come off the surface of the page so that it seems we can touch it.

"At the heart of this musical are street performers' efforts to lift themselves out of their dreary reality through music. We attempted to evoke some of that gritty street feel while at the same time, give a sense of hope. After shooting a set in the studio, hand-drawn elements were added in post, along with scratches from old film negatives."—Spotco

In the past, designers used photomontage, created by cutting and pasting images together, to create visual surprises. Now imaging software can create illusions that are visual surprises, as in the advertising campaign for North Carolina Department of Travel and Tourism (Figure 12-19).

Summary

The picture plane is the flat two-dimensional (planar) surface, such as a printed page or screen-based page, on which a designer organizes a composition. A designer can maintain the integrity of the picture plane, the flat two-dimensional surface, or can manipulate it to create the illusion of three-dimensional space.

Depending upon where shapes are positioned on the picture plane and how a designer approaches the composition, shapes may *appear* to be in front of, behind, or not parallel to the picture plane due to spatial illusions.

There are a variety of ways to create the illusion of three-dimensional space, using line, shape, overlapping forms, volumetric forms, and linear and atmospheric perspective. Creating the illusion of depth on a two-dimensional surface involves utilizing and controlling fundamental design principles.

Linear perspective is a schematic way of translating three-dimensional space onto the two-dimensional surface, of creating the appearance of spatial recession. Perspective affords you a way of creating rational, balanced, controlled, and idealized representations of the real world, in terms of depicting distance, depth, proportion, and point of view. There are more widely used, less structured perspective systems or looser methods of translating spatial depth, based on perception and the visual reading of recession into space, called perceptual perspective. In the rational world of perspective, forms are in proportion.

When building compositions, the designer must control many factors and utilize design principles in order to create compelling illusions of spatial depth.

Figure 12-19
Print advertising campaign
Agency: Loeffler Ketchum Mountjoy, Charlotte, NC
Creative director: Jim Mountjoy
Art director: Doug Pedersen
Copywriter: Curtis Smith
Photographers: Olaf Veltman and Stuart Hall
Client: North Carolina Department of Travel and Tourism
"Our objective was to convey North Carolina's message (natural scenic beauty and restful relaxation) with extraordinary creativity. The resulting work made our limited media and production dollars work twice as hard and resulted in increased inquiries and visits to the state."— Loeffler Ketchum Mountjoy

EXERCISES

Exercise 12-1: Warm up exercise: Diagonals in front and behind

- Draw an object, figure, shape, or letterform that moves from the top of the page to the bottom, moving at an angle from the upper left to the bottom right.
- On that shape or object, draw diagonal lines that move at an extreme angle.
- Now, draw diagonal lines with a very slight angle (almost horizontal) across the entire surface behind the object.

Exercise 12-1: Affect the surface— a warped illusion

The surface of a page or screen, for the purpose of design discussion, is two-dimensional; it's flat. As soon as a designer places a line, a letter, or a graphic on it, he or she starts to energize the surface. A good designer can manipulate the energy of the surface for specific expressive effects. The designer may choose to maintain the inherent flatness of the surface or create illusion of space and/or shifting movement.

By drawing lines completely across the page, create an illusion of a warped or shifting surface.

- Vary the distances between lines and/or width of the lines. Try to create a feeling of swelling or warping space.
- Once you've created a "warped" composition, select, copy, and paste it onto another electronic page.
- On the second composition, select long vertical sections of the composition, then drag them horizontally.
- Maintain the illusion of a warp and add a sense of surface shifting. Compare the two compositions to gain a better understanding of the varieties of spatial illusion.

Note: Lines in varying hues could add dimension to the warping effect. Try to discover which combinations of hues and tones affect the surface most and least. This exercise is easily accomplished and extended using a computer drawing program.

This exercise gives you practice in controlling the spatial qualities of the page and creating illusion. Historical note: During the 1960s in the U.S., many artists and designers (for example, painter Bridget Riley and designer Wes Wilson) were interested in denying the inherent flatness of the surface by creating the illusion of space with shifting movement. Whether it was a psychedelic poster design or op art painting, designers and artists were "altering" vision.

Exercise 12-2: Visual path: optical movement and blurring

It is critical for a designer to be able to establish a visual path for the viewer.

- Using a series of only horizontal lines, start drawing or ruling a line on the left side of the format.
- Stop the line.
- Leaving a space, start the line again connecting it to the right side.
- Keep doing this process, establishing a visual path that is brought about by the open spaces between all the lines.
- Then, blur the lines.
- This exercise forces you to concentrate on establishing an entry into the composition and a visual path for the viewer.

Exercise 12-3: Linear perspective

Linear perspective is a schematic method for representing the appearance of objects, as they recede into the distance (move away from us) in the actual world.

Using a loose version of one-point perspective, draw a box.

1. First, above the center of an 8 ½ x 11-inch page, draw a horizon line (a horizontal line across the width of the page).

2. Determine the vanishing point by marking a spot at mid-line.

3. Approximately two inches below, about center of the page, draw a rectangle. Draw diagonal lines from the top two corners of the rectangle to the vanishing point.

4. Draw a horizontal line between these two "vanishing lines." This is the back of the box. Darken the lines between this horizontal and the box, and erase the rest of the vanishing lines up to the horizon.

Going further: Try placing rectangles in different positions on the page in relation to the vanishing point and horizon line.

Learning to create a loose version of a perspective schema allows you to understand the inherent logic of this type of formalized space.

Exercise 12-4: Illusion of atmosphere: field density

Hatching is a drawing technique that is used to create value or the illusion of atmosphere, where lines are drawn in close proximity, usually parallel. When two series of parallel lines cross over or intersect, it is called **crosshatching**.

Build up a dense field of value with hatching and crosshatching.
- The hatching may be in any direction.
- Vary the density of the field at different areas of the page (print or screen-based).
- Some areas should be more open and others more opaque.
- Your goal is to create the illusion of atmosphere.

When one series of lines crosses another line group, it gives the illusion of pushing the first series back into space. If groups of lines constantly cross one another, the space behind the picture plane will seem to constantly move farther back. An illusion of deep, lush atmosphere is created. The flat surface is transformed into a dense field through the buildup of lines in close proximity. Varying the density of hatched lines yields a sense of shifting atmosphere, a feeling that the veil of atmosphere is penetrable.

Exercise 12-5: Volume through value

Can we have different types of atmospheric perspective? Different types of illusory space? The concrete reality of a page can be denied in a variety of ways.
- On a grid of one-inch squares, using a very light pencil (or a drawing program), create volumetric shapes using linked vertical, horizontal, and diagonal lines.
- Draw diagonals by moving from corner to corner of the grid, in order to maintain a rational perspective.
- Avoid creating flat shapes; create volumetric forms.
- Create planes that are linked to other planes.
- As you establish forms, notice where they are in relation to the forms next to them, behind them, or in front of them.
- Once you have drawn the volumetric shapes in line, eliminate the lines by turning each plane of each form into either one value or a slightly gradated value.
- Determine a light source that is coming from the top left or top right.
- If you wish to have a logical space, then the light source must appear consistent.
- If you vary the light source, then the space will appear ambiguous. Your choice.

Planes of value give great volume to forms in space. In nature, we see forms in light and shadow, not line; therefore using light and shadow is a naturalistic mode of representation. This is a highly effective way to create the illusion of space and light.

Exercise 12-6: Gradate it

By manipulating values, the illusion of atmospheric perspective can be created. And the subtler the shift or the more gradual each incremental value step makes for the greater illusion of space.

- Divide your page (print or screen-based) into four equal boxes.
- Then divide it once again, by drawing two lines through the center and from corner to corner.
- On the divided areas, using either black and white tempera paint or a paint program, paint a gradated series of values (tones) that make the areas seem to advance or recede.
- At the outside edge of the page, you may start with either darker values or lighter values. Also, you may alternate.

If you choose to have all the values darker at the center, the spatial illusion will be different than if all the values are darker at the outside edges. The spatial illusion tends to appear more shallow, flatter, if you alternate between darkening the outside edges and the center.

Exercise 12-7: Field density revisited— layers of type

Homage to Warren Lehrer and Jan Baker

Have you ever listened in on a conversation and thought that peoples' voices sounded interesting? Or have you ever thought of visualizing a conversation? Well, here's your chance to explore visual sound. Go into a restaurant, coffee shop, or listen to a conversation at home. Record the words of the conversation. Follow these guidelines:

- If you're using a computer, dedicate a different font to each person speaking and/or to major changes in voice quality. If you're writing by hand,

change the weight of your hand to accommodate changes in voice quality.
- If people interrupt one another, draw the words over each other.
- If a person repeats himself, write the words over the last sentence.
- Position words and sentences on the page to reflect meaning and intention.
- Align the sentences to create visual paths.

The buildup of letters over one another creates a dense illusory atmosphere on the surface and a somewhat shallow space. Usually letterforms or type reassert the inherent flatness of a page or canvas because we assume that a surface must be flat in order to write on it, but in this exercise, letterforms will create the illusion of space and depth by virtue of placement and layering which will create values.

Exercise 12-8: The shape of depth

Shape, as well as line, may be employed to create the illusion of depth on the surface of a page. Spatial illusions can energize a composition and engage the viewer.

- Explore spatial illusions by creating a composition that uses a variety of shapes and forms to create a maximum amount of depth.
- Use shading and tones of gray or color to create cast shadows, patterns, and atmosphere.
- As you move into the depth of the page, decrease detail and size to enhance the sense of infinite space.
- You might try a second composition in which you use only letters.

This exercise gives you practice in using shape to control the spatial qualities of the page.

Illusion
of Motion

Illusion of Motion

Objectives

- Understand how to design with dynamics, in regard to motion
- Learn how to create the illusion of movement and the passage of time on a two-dimensional surface

Moving Along

Graphic design is the organization of information. How that information is conveyed is the domain of the designer, who wants to grab and maintain the attention of the viewer. Attracting attention is often the main goal of a design: a poster on the street is intended to stop you in your tracks, and a book cover needs to draw you over to it from across the store. Designers can achieve this through the use of dynamics within their designs.

One of the first things a designer needs to be aware of is how the material gains the notice of the audience: what is it they see first and where are their eyes guided to next? It is up to the designer to lead the way. Often this can be achieved through the illusion of motion.

If everything rests too comfortably within a design, we might not pay it any attention. A centered object whose weight rests in the lower quadrant below an imaginary horizon line makes the viewer feel comfortable, as that replicates what we experience in life: an object of weight resting on the ground as a result of gravity (Diagram 13-1).

Therefore, moving away from the central axis creates tension and calls attention to the design. Anything leaning forward, whether it is an image or italic type, gives the illusion of movement. Type that has moved off the imaginary horizon line and is spread around the page causes the viewer's eyes to follow it. Indeed, it is the movement of our eyes as we look around the page that creates the illusion of movement on a two-dimensional page (Diagram 13-2).

Another means of movement within design is the action of turning a page, thereby creating a cinematic illusion within a book or magazine. For example, objects can appear in a fixed position within the grid, and then be moved to a new position on subsequent pages. They can also become smaller or larger, creating a different kind of surprise for the reader. Some ways to create movement are:

• Pacing
• Similarity and anomaly
• Shape
• Color
• Placement on the axis

Diagram 13-1
Static Design

Diagram 13-2
Type and the Illusion of Movement

Pacing

When designing a magazine or book interior, the designer has the opportunity to move text and images through space. As the reader turns each page, there is the opportunity to surprise with the unexpected. Unlike static, poster-like book jackets and covers, these pages can function much the way a film does—over time and space. The placement of the art or photos on each **spread** (two facing pages) creates a dramatic effect and has a relationship with what has gone before. You can build tension as each page unfolds, creating a cinematic experience for the viewer. Rather than viewing an ordinary, random group of elements, the designer has the opportunity to guide the reader through material that has been made exciting with the controlled use of pacing.

Similarity and Anomaly

Another way to establish the illusion of motion is to set up a repeated pattern and then break the form (Figures 13-1 and 13-2). As viewers, we process information quickly. As we read from left to right, our mind fills in the blanks with what is expected—even if something is missing. Once a similarity is established, breaking form will create a sense of motion and objects will seem to move subtly within the established pattern.

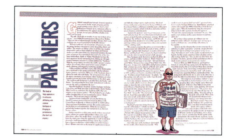

Figure 13-1

Magazine spread: *Print*

Studio: Steven Brower Design, New York, NY

Designer: Steven Brower

Client: *Print*/RC Publications

For this special advertising review in *Print*, a grid was established that stood apart from the other sections of the issue. The body text remained static within the grid, as did the placement of the headline type. However, the headlines themselves and the position of the art and photography change, creating the illusion of movement within the confines of the grid.

Figure 13-2

Book cover: *Jazz*, edited by Nat Hentoff and Albert McCarthy

Designer: Roy Kuhlman

Client: Grove Press

The repeated pattern of dots within a panel was created with a hole punch and paper. By keeping the holes within the same basic pattern yet moving them slightly, the illusion of movement is created, causing the viewer's eyes to dance from left to right. This is further enhanced by the color and play of positive and negative space, undulating from the surface to deeper space. The movement is at once visual and musical, echoing the subject matter.

Shape

Shape is another way to create motion. Moving away from symmetry, odd or amorphous shapes can bring your eyes around the page. Shape can lead your eyes in an unexpected way, back and forth, similar to the way film works. Arrowheads are identifiable as pointers, sending us in the direction intended (Figure 13-3).

In the book cover shown in Figure 13-4, the designer creates movement by combining several devices. A repeated pattern, or grid, is established, but then it is rotated slightly left of the axis. The rectangles change in shape and alternate between red and black. By adding negative space to the right and seemingly cropping the bottom of the composition, the entire composition appears off kilter, leaving the viewer with a sense of moving unsteadily upward.

By utilizing amorphous shape—some abstract and some representational—and unexpected color, our eye is drawn to the black wrought-iron staircase in the lower right. Through the use of **forced perspective** (the representation of forms on a two-dimensional surface by distorting the length that is projecting toward or receding away from the viewer, also called foreshortening), Kuhlman leads us down the unseen stairs and onto the street, reinforcing the title of the book as we begin our journey along with the writer.

Figure 13-3
Logotype
Studio: Number 17, New York, NY
Art directors: Emily Oberman and Bonnie Siegler
Designer: William Morrisey
Client: Orbitz
This logotype is for an online travel site. "Leisure travel is about going and coming. We tried to express that with the arrows in the O of Orbitz. We also implied speed with the italic type."
—Number 17

Figure 13-4
Book cover: *A Walker in the City* by Alfred Kazin
Designer: Roy Kuhlman
Client: Grove Press

Luba Lukova's poster *Immigrant* contains a sense of movement that replicates our understanding of nature and growth (Figure 13-5). The mass of the illustration rests at the bottom, as the branches and leaves grow upward and outward, beyond the picture plane at the top. The design of the branches and the repeated pattern of the leaves reinforce the sense of movement throughout.

Color

Color is still another way to lead the eye around the page. Contrasting color can create tension and pull the viewer's eye in different directions (Figure 13-6). Differing hues can speed up or slow down the sense of movement.

Figure 13-5
Poster: *Immigrant*
Studio: Luba Lukova Studio, Long Island City, NY
Designer: Luba Lukova
Client: Immigrant Theater Festival

Figure 13-6
Book cover: *Nadja* by André Breton
Designer: Roy Kuhlman
Client: Grove Press
By filling in the spaces in this large hand-drawn type, and utilizing the alternating primary colors of red and yellow, one is guided left to right and top to bottom, with the red fields acting as an accent as you make your way down.

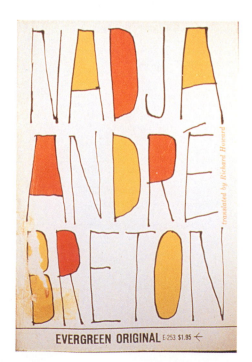

In the poster shown in Figure 13-7, Dick Elffers created a sense of movement based on music. He employed several devices to do so: at the top left, he placed the largest title type, and also the brightest color, red. Your eyes are then drawn in several directions at once. The white space between the colored shapes gives you pause, before you pick up speed. The large black top of the string instrument pulls you over, but the bright blues, greens, yellows, and purples pull you back. The entire piece becomes the visual equivalent of a music composition, perhaps a single movement.

In Figure 13-8 the illusion of movement is created through repetition. In fact, the concept here is one of imitating film. Indeed, in each small panel sprockets appear, and the intended effect is to replicate film rapidly going through a projector, which creates the illusion of movement through still pictures. The colors are monochromatic. It is the employment of white that carries our eyes around, and the slightly altered image of the eye staring back as it changes from panel to panel within the composition. You begin on the top left, where the title appears on a white background. Your attention is led to the eyes, left to right and top to bottom, until the word "festival" appears. Finally the payoff of the poster is the word "FILM," which is reversed-out white and is the boldest and largest type on the page.

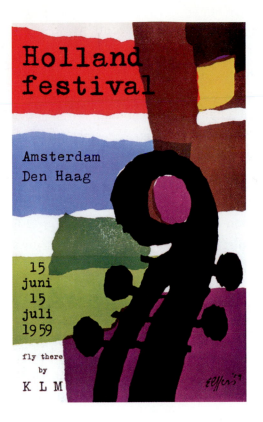

Figure 13-7
Poster: *Holland Festival 1959*
Designer: Dick Elffers
Client: Holland Festival
Courtesy of the Stedelijk Museum

Figure 13-8
Poster: *Holland Film Festival 1959*
Designer: Dick Elffers
Client: Holland Film Festival
Courtesy of the Stedelijk Museum

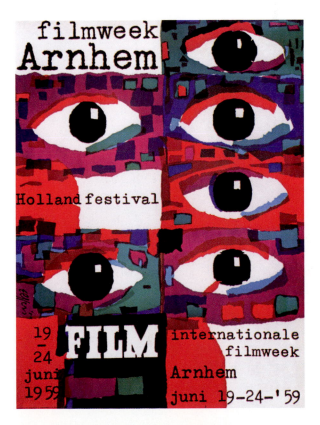

Flat, simplistic shapes set up a colorful, happy sense of movement in Figure 13-9. Again, white is used to separate and to give the viewer's eye a place to rest, before journeying through these abstract faces and musical instruments. The concept behind this poster is to replicate the audience's pleasant experience of attending the festival.

A sense of movement is created in a very geometric, organized fashion in the poster shown in Figure 13-10. Utilizing only three colors—black, magenta, and yellow (the red is produced by the overlay of magenta on yellow)—this poster is a study in tension. The main thrust, created by the black and yellow, is one of homeostasis, as the majority of the visual weight appears parallel to the picture plane or horizon line. The tension is created through the use of magenta and complementary black bands that run at 45-degree angles to the plane. The type at the bottom, which is the visual payoff, rests on a horizontal axis. Again, the movement as we are led through the design is quite musical, with the information being the final coda.

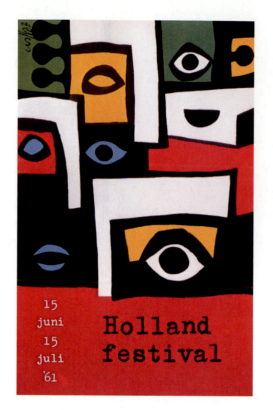

Figure 13-9
Poster: *Holland Festival 1961*
Designer: Dick Elffers
Client: Holland Festival
Courtesy of the Stedelijk Museum

Figure 13-10
Poster: *Holland Festival 1969*
Designer: Dick Elffers
Client: Holland Festival
Courtesy of the Stedelijk Museum

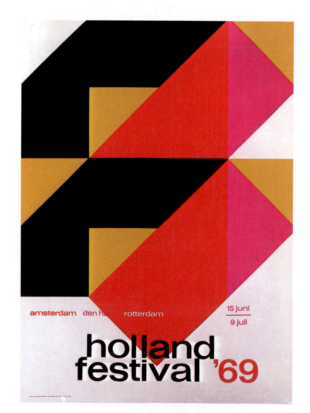

An impression of movement is created through the contrasting, differing design patterns and colors used to create the American flag seen in Figure 13-11. Your eye is pulled in all directions at once, which is the intent of the publication itself. The type leads you down the page, turns an abrupt 90-degree angle, and then turns back to the horizontal axis once again. And in Figure 13-12, a sense of movement is established with the initial darker blue characters for each word, and is continued through the use of a colorful pattern, which is brought forward with flat, negative space. The image of a saxophone player juts out of the singer's dress, further enhancing the design by giving it the sense of movement that is felt in a musical performance.

Figure 13-11
Magazine cover: *Print*
Studio: Steven Brower Design, New York, NY
Designer: Steven Brower
Client: F & W Publications

Figure 13-12
Poster: Newport Jazz Festival
Studio: Milton Glaser, Inc., New York, NY
Designer: Milton Glaser
Client: Newport Jazz Festival

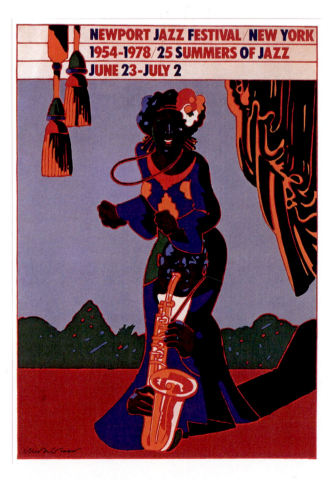

Placement

Since our expectation is for objects to appear centered and resting on an imaginary horizon line, moving any objects off this axis creates a sensation of movement. By placing both the figures and the type off the central axis, the Stooges swing across the cover of the book shown in Figure 13-13. Diagonals replicate our real-life experience of form as defying gravity. Rather than a static stance, Laurel and Hardy provide typical comic relief as they try to climb over the "wall" of the letterforms seen in Figure 13-14. The diagonal of the type accentuates the feeling of movement.

The cover of *The Complete Films of Buster Keaton* plays off the star's celebrated athletic prowess, on display as he replaces letterforms in Figure 13-15. Given our understanding of gravity, tension is created as we anticipate him crashing downward. The movement of a parade is replicated as each of the

Figure 13-13
Book cover: *The Three Stooges Scrapbook* by Jeff Lenburg, Joan Howard Maurer, and Greg Lenburg
Studio: Steven Brower Design, New York, NY
Designer: Steven Brower
Client: Citadel Press
The Stooges pack up and take off on the back cover, no doubt to escape whatever calamity they created.

Figure 13-14
Book cover: *The Complete Films of Laurel & Hardy* by William K. Everson
Studio: Steven Brower Design, New York, NY
Designer: Steven Brower
Client: Citadel Press

fifty states march across the cover of *Print* magazine (Figure 13-16). By creating a literal horizon line of blue, the red foreground serves as the plane that the figures march against. The illusion of movement of the "legs" of those on parade goes in the opposite direction of how the banners are read, so that they move to the left of field. Further movement is created through the use of alternating yellow and green against a sea of red. In Figure 13-17, through the use of hand-drawn, curved scrawl, the viewer is led from top to bottom in a playful way that imitates the nature of what the poster is announcing.

Figure 13-15

Book cover: *The Complete Films of Buster Keaton* by Jim Kline

Studio: Steven Brower Design, New York, NY

Designer: Steven Brower

Client: Citadel Press

Figure 13-16

Magazine cover: *Print*

Studio: Steven Brower Design, New York, NY

Designer: Steven Brower

Client: *Print*/ F&W Publications

Figure 13-17

Poster: *Cinderella*

Studio: Steven Brower Design, New York, NY

Designer: Steven Brower

Client: First Avenue Playhouse

The Illusion of Motion

The illusion of motion can be added to two-dimensional design by using such techniques as blurring, cropping, and sequences. Through the use of repetition, designing beyond the edge of the page, and artificially representing speed, the designer can create movement beyond the limitations of the printed page.

Blurred Imagery

Using photography is an effortless way of instilling the feeling of movement in a design, as we immediately associate the image in a photograph with our experience of such an event. We know that bicycles move forward, and so when we encounter one in a photograph, our expectation is that it is moving forward. Along these lines, a blur in a photograph of a bicycle rider connotes movement—not because we always see the blur in life, but rather because we have accepted as fact in photography that a blurred image equals motion (Figures 13-18 and 13-19).

This understanding carries over to typography, and it does indeed create a feeling of movement. Still, since the advent of Photoshop and other similar computer photo-editing programs, blurred type is an overused effect today. Unless used judiciously, the result can feel hackneyed.

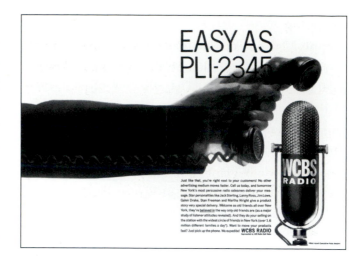

Figure 13-18
Advertisement
Designer: Lou Dorfsman
Client: CBS
The blurred and stepped image of the hand stretching across the picture plane gives a feeling of urgency, and creates motion in what is in reality a single-page advertisement.

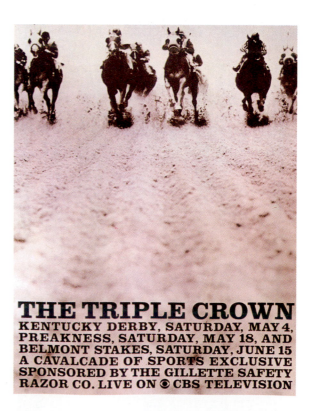

Figure 13-19
Advertisement
Designer: George Lois
Client: OTB
Although we would expect to see the speeding horses at a racetrack running left to right in a design, here they are charging head on us. Frozen in time, it is the blurred foreground and the forced perspective in the photograph that evokes motion.

Cropping

Cropping is another way to achieve a sense of movement, as the reader is led off the page and forced to wonder how or where the picture ends. By cropping in on the photograph of Louisiana governor Huey Long (Figure 13-20), a more dramatic pose is created, which replicates the act of thrusting his arm upward. Cropping a photograph is one way to achieve the illusion that something else is happening out of sight.

Sequence

Sequence is yet another means of attaining the illusion of movement. Similar to comic strips or books, panels can be used in magazines (Figure 13-21) to indicate the passage of time—moving from left to right, and top to bottom. By slightly or greatly altering the image, the passage of time can be compressed or expanded.

Figure 13-20

Publication: *The Nose*

Studio: The Pushpin Group, New York, NY

Art directors: Steven Brower and Seymour Chwast

Designer: Steven Brower

Client: The Pushpin Group

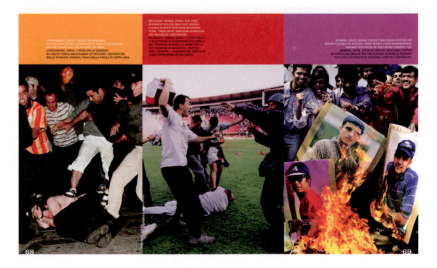

Figure 13-21

Magazine spread: *Colors*

Design studio: Number 17, New York, NY

Creative directors: Emily Oberman and Bonnie Siegler

Designer: Wade Convay

Client: *Colors* magazine

Through the use of both color and sequence, the reader is led left to right through this spread about violence at sporting events. "A global culture magazine, each issue takes a theme and analyzes it. This issue's theme is fans."—Number 17

A more typical form of sequential art is the comic book (Figure 13-22). Read from top left to bottom right in our culture, figures move through time and space. Varying panel and figure sizes can add to the overall cinematic effect, although reading a comic is a very different experience from watching a film—much of the action takes place between the panels, allowing the reader's imagination to fill in the blanks.

In the advertisement for televised football shown in Figure 13-23, a comic-book style layout is put to good effect. Geometric in structure, the referee gives a different hand signal in each panel, and the large, central panel serves as a loud accent among the smaller, quieter movements.

Figure 13-22

Comic book: *Goodnight*

Artist/Writer: Janna Brower

Figure 13-23

Advertisement

Designer: Lou Dorfsman

Client: CBS

As the rocket is shown lifting off from left to right in Figure 13-24, the size of each panel it is contained within becomes taller—rising—and replicating what one would experience during an actual blast off. The design in Figure 13-25 is a play on the period in which Edward R. Murrow toiled: early black-and-white television, complete with a vertical hold that doesn't always work.

E-Motion

Designing for the printed page is very different from designing for the Web, which is literally "motion graphics." Here, actual animation—such as what is created in Flash—dances around the visual plane. Even the simple act of scrolling down the page creates movement. All this is more closely related to the film world and animation than to print, although the same basic techniques still apply—it is up to the designer to guide the viewer through the work in the order that is intended.

Summary

The printed page needs to be only as static as the designer intends. Vibrant, lively graphics are as unlimited as your imagination. Motion can bring a dynamic feeling to your work and thereby create more interest for the viewer. Rather than resting on the picture plane, your design can guide the viewer's eye and coax the viewer's imagination beyond what they see or expect. The designer can bring the various moving elements of design into full swing and take the audience along for the ride.

Figure 13-24
Advertisement
Designer: Lou Dorfsman
Client: CBS

Figure 13-25
Book cover: *Edward R. Murrow: An American Original*
by Joseph Persico
Studio: Steven Brower Design, New York, NY
Art director: Ruth Jenson
Designer: Steven Brower
Client: Da Capo Press

EXERCISES

Exercise 13-1: Sequential map
Draw a map of your daily travels to and from school or work in a sequential fashion.

Exercise 13-2: Graphic calendar
Using the grid of a monthly calendar, record your daily activities, within each panel, in a graphic and/or illustrative manner.

Exercise 13-3: Cropped storyboarding
Create a grid on a page. Using photographs from magazines, crop the images and paste them into the panels to convey a story without words.

Exercise 13-4: Speedy advertisement
Design an advertisement for a hybrid automobile that conveys a sense of speed.

Motion for Screen-Based Media

Motion for Screen-Based Media

Objectives

- Be able to identify screen-based media and list the types of applications used
- Become familiar with the practical considerations for and the advanced technology needed to create screen-based media
- Understand motion aesthetics
- Realize the basic function of a storyboard
- Understand the use of typography and sound in screen-based media

Types of Screen-Based Media

Video, film, and digital media are utilized in screen-based visual communication. The applications of these media usually involve the passage of time and motion. What that means is these media are not still, as is print; for example, a print ad (Figure 14-1) or book jacket is a still image. Digital media are newer than video and film, but many of the same principles apply to visual communication applications created for all these media. Regardless of the media used (often they are combined), a contemporary designer must apply sound design principles to traditional print media and screen-based media.

Figure 14-1
Advertisement: "New York is Eating It Up!
Levy's Real Jewish Rye" 1952
Art director: Robert Gage
Offset lithograph, 46 x 30 inches. Gift of Doyle, Dane,
Bernbach Agency. (133.1968)
The Museum of Modern Art, New York, NY
*Digital Image © The Museum of Modern Art /
Licensed by SCALA / Art Resource, NY*
Although time is suggested in this advertisement, it is a still
image, unlike Flash graphics or a web film. The progressive
bites of the rye bread, in real life, would take time
and happen over time.

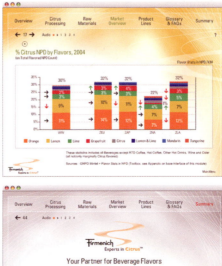

Figure 14-2
Interactive presentation: Firmenich Experts in Citrus™
Studio: lava dome creative, Bound Brook, NJ
Creative director/graphic designer: Michael Sickinger
Production: Michael Sickinger and Sam Indrawis
© *Firmenich Inc.*
"The Firmenich Experts in Citrus platform is a tool that was
developed by Firmenich to showcase their expertise, quality,
and proficiency creating citrus flavors. In the beverage industry,
citrus flavors are a very large segment and big business. From that
glass of orange juice you drink in the morning to the cup of citrus
flavored tea you may drink at night, almost all beverages have
some type of flavor applied to it. This Flash presentation gave an
in-depth look into Firmenich's citrus flavoring capabilities and
provided a robust and easy to use interface for their global sales
force that could be played from any laptop computer."
—Michael Sickinger

There are many visual communication applications that can be screen-based.

Advertising Applications
• Web banners
• Floater ads for rich media
• Online films
• Web sites
• Digital displays
• Flash graphics

Graphic Design
• Television titles
• Film titles
• Television moving graphics
• Web sites
• Flash graphics
• Information design (maps and charts) that incorporate motion
• Digital displays
• Presentations
• Game Design

Various technologies—including the Internet, personal communication devices, mobile phones, and the consolidation of communication technologies, such as television, cable, and the World Wide Web—have accustomed the audience to different types of visual experiences, including rich media and advanced web technology. Screen-based media can also offer faithful storytelling, that is, a story unfolding in time as it does in reality. Motion in screen-based media unfolds in time and can include sound; it therefore has the potential to communicate messages and evoke feelings in ways different from print.

The goal of a visual communication motion design is to create a dynamic, multi-sensory visual experience for the viewer in screen-based media. Some experts say that sensory experiences enhance audience interest (and recall) in a brand or social cause. Whether the application is the integration of Flash graphics (Figure 14-2) into a web site or web banner (a stand-alone application), it is an opportunity to communicate.

For example, about Figure 14-3 and supporting this notion, creative director Michael Sickinger says: "The supporting Flash movie for this concept reinforced the idea of hot and cold taste sensations with hot and cold imagery and graphics animating to upbeat techno music."

Graphic design and advertising design problem-solving applications can involve screen-based media, such as animation, video, streaming media, and Flash graphics, as in Figure 14-4. Screen-based media can support graphics that move over a period of time; also called four-dimensional design. In order to create moving graphics, the designer must be well acquainted with the necessary technical issues, production techniques, and software, such as Adobe Photoshop, Adobe Illustrator, Macromedia Flash, Final Cut Pro™, and Adobe After Effects. However, one must consider the formal elements of design (line, shape, color, texture) as well as apply two-dimensional design principles to screen-based visual communications. Like any other visual communication application, screen-based media can communicate a message and be expressive. The audience may not know how to critique successful motion design, but they will be aware if your motion solution is *not* fluid, forceful, or aligned in makeup with the other visual components of the piece.

Figure 14-3

Product concept: Polar Flare

Studio: Firmenich Inc., Flavors Creative

Marketing Studio, Plainsboro, NJ

Art director/graphic designer: Michael Sickinger

© Firmenich Inc.

"During the energy drink boom of the early 2000s, energy drinks were coming out in many shapes and sizes. In order to stand out, there needed to be some point of differentiation. As a flavor company, Firmenich's challenge was to create a beverage that had flavor characteristics like no other. Polar Flare was developed as an energy drink concept having both heating and cooling sensations when drank, packed with B-vitamins, as well as other energy ingredients used in functional beverages. The name Polar Flare was a spin off of the cosmic phenomenon from the sun, "Solar Flare," which was reflected in the design of the logo. The supporting Flash movie for this concept branded Polar Flare as Hip, Edgy, Fun and Sexy. More of a lifestyle beverage that would be consumed at night clubs, on the go, or as a mixer."—Michael Sickinger

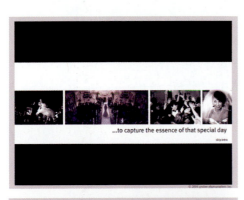

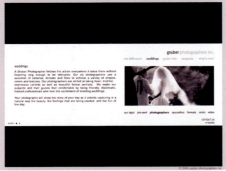

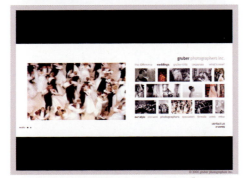

Figure 14-4

Web site: Terry DeRoy Gruber Photographers Inc.

Studio: lava dome creative, Bound Brook, NJ

Creative director/graphic designer: Michael Sickinger

Programming and production: Michael Sickinger and Will Rahilly

Photography: Terry DeRoy Gruber Photographers Inc.

© Gruber Photographers Inc.

"Gruber Photographers Inc. is a sophisticated New York City wedding photography studio specializing in photographing weddings for socialites, celebrities, artists, and personalities. Gruber photo teams shoot weddings in the candid, unobtrusive, style frequently called wedding photojournalism—a storytelling, fly-on-the-wall photography that Terry Gruber pioneered with artistic black-and-white wedding photography in New York. The web site had to be elegant, smart, and clean. At first, the design of the web site started out as a CD-ROM given away to future brides, showing the difference a Gruber photographer can make on that special day. This design was then applied to their web site and can be seen at www.gruberphotographers.com."—Michael Sickinger

Whether screen-based media is incorporated into other media or stands alone, the designer must be conversant with the following considerations:

• Concept
• The function of the design application
• Theories fundamental to motion
• Narrative forms of storytelling (linear and nonlinear narrative forms)
• Planning of action
• Sequencing of images for maximum graphic impact and communication
• Integration of different media (if relevant)
• Communication, which is the transmission of information or meaning to the audience

As with creating concepts and visuals for television commercials, screen-based media can involve narrative forms (storytelling for linear, nonlinear, realism, abstraction, and experimental), sequencing of images and events, composition, and visual and motion variables (characteristics, attributes, or qualities). In Figure 14-5, showing the web site for Jansport™, Modus™ incorporates a tongue-in-cheek movie where the hero—a woman carrying a pink Modus bag—protects herself from attack by Ninjas. Below the movie frame, the web site copy reads: "More warrior than tourist, the Modus traveler is no shrinking violet. The bags serve as protectors of the adventurous soul. Go forth. And choose your bag wisely."

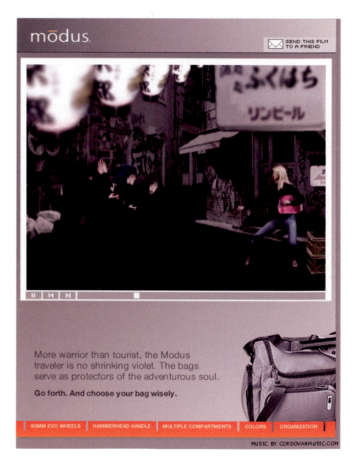

Figure 14-5
Web site: Jansport
Advertising agency: Butler, Shine, Stern and Partners, Sausalito, CA
Client: Jansport Modus

Motion Aesthetics

Motion aesthetics refers to the process and consideration of how composition creates impact over time in a design. Fundamental to screen-based media is the individual **frame**—a single, static image, one of many composed together to create motion graphics. Frames are created once, but connected and used in multiples over time. A **temporal relationship**—the relationship or interplay between two separate events or images—exists in screen-based media and involves **chronology**—the order of events. For example, in Figure 14-6, the visual of an open road indicates the beginning of the road trip, as well as the beginning of the Flash piece. A screen-based design solution is composed of a number of media items (events, frames, images, and sound), each of which has its own duration. These can be combined into a whole by specifying the temporal relationships among the different items. Temporal relationships also refer to the relationships between frames.

As in all graphic design, one must consider the **spatial relationships**—the distance between the thing being seen in relation to the viewer, such as how far or how close, and the shifts between near and far. Visuals or images can be seen from a **close-up shot** (a shot that is zoomed in on), a **medium shot** (seen from a medium distance), or a **long shot** (seen from far away). For example, in Figure 14-7, an animated logo for MTV Productions, we see a variety of shots, starting with a long shot and moving toward a close-up.

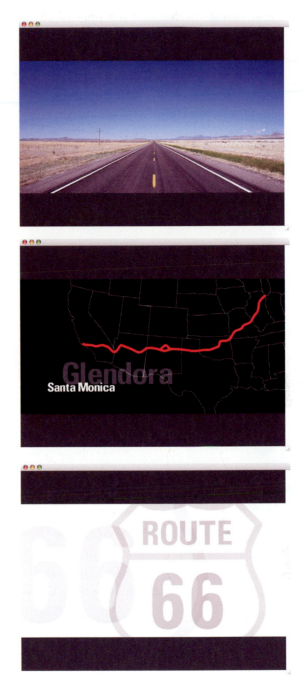

Figure 14-6

Promotion concept: Route 66 Fast Food

Studio: Firmenich Inc., Flavors Creative Marketing Studio, Plainsboro, NJ

Art director/graphic designer: Michael Sickinger

© *Firmenich Inc.*

"Route 66 was a theme developed as a concept for Firmenich's Savory business unit. The idea behind Route 66 was that you could take a Route 66 road trip with a bunch of your friends, and on your journey, enjoy a delicious burger and fries, which have theme names of major cities along the way, such as: Chicago Blues Burger, Albuquerque Rodeo Burger, and the LA Bistro Burger, just to name a few. Get your kicks on Route 66."

—Michael Sickinger

The way a designer interposes different types of shots—each frame forming spatial relationships with the others—creates rhythm and contrast. **Rhythmic relationships** in screen-based media can also be created by the duration of each shot, and—the same way as in print—by the interaction of visuals, with contrast and variation. For example, in Figure 14-8, the use of an abstract animation of colored bars creates rhythmic interplay between frames of this opening sequence for the television show *Saturday Night Live*.

Figure 14-8
Opening television sequence:
Saturday Night Live
Studio: Number 17, New York, NY
Art directors: Emily Oberman and
Bonnie Siegler
"We represented the dynamic energy of New York City at night using abstract animation of colored bars."—Number 17

Figure 14-7
Animated television logo
Studio: Number 17, New York, NY
Art directors: Emily Oberman and
Bonnie Siegler
Designer: Keira Alexandra
Client: MTV Productions
"An astronaut planted the flag on the moon to declare the start of music television (MTV). So we decided that MTV Productions (their film company) should be represented by the moon man leaving the moon to search for new frontiers (film)."—Number 17

2D

The Storyboard

Most designers, art directors, and film directors utilize a storyboard to plot out their motion design. Used to visually explain an idea, a **storyboard** is a series of drawings, sketches, or photographs of the key shots in a planned television commercial, film, video, or any motion graphic, which are also accompanied by text. It helps to visualize the motion and acts like a diagram before it goes into production. A storyboard serves several purposes. It aids the designer and/or creative team in visualizing the idea. The creative team then uses the storyboard to sell their idea to the creative director, and the design studio or agency uses the storyboard to sell the idea to the client. After the client approves the idea, the storyboard is used to explain the idea to the film or television director or to the Flash or interactive designer. Seeing an idea in visuals, almost like a cartoon strip with action in the form of drawings, helps everyone to better understand how the idea will play out in motion, over time (Diagram 14-1).

Diagram 14-1
Storyboard

Production in Screen-Based Media

Motion aesthetics, planning, and basic production techniques are involved in any motion project. We must also become familiar with screen-based terms and take into account screen-based matters.

- **The Narrative/Storyline**
 The process of telling a story or giving an account of something, including the chronology, with a beginning, middle, and end, although not necessarily in that order.

- **Sequence**
 The particular order in which frames are arranged or connected; it is also the order of actions or events in the narrative (linear or nonlinear).

- **Duration**
 The period of time that the motion exists.

- **Pacing/Tempo**
 The speed and/or rhythm at which the screen-based application unfolds and moves.

- **Montage**
 The use of visuals composed by assembling and overlaying the different visuals or materials collected from different sources.

Visual Basics for Screen-Based Media

In this book thus far, we have learned that when designing, we must consider all the formal elements and apply all the principles of composition. Everything that applies to print also applies to creating a **visual composition,** a whole, unified arrangement of visual elements on a page, screen, or window that moves over a period of time. Each frame must be considered, as well as how each frame flows into the next frame, and the overall impact of the total frames as a group. Equally, each web page must be considered, as well as how each page flows into the next page, and the overall impact of the entire web site. When considering the overall screen-based piece, certain concerns are critical to create impact.

Proximity

Grouping elements should enhance their content and communication. All visual elements must seem related, but some visual elements will create groupings due to proximity. The negative space around each visual element and between visual elements reveals how they are related by meaning and function.

Contrast

Without contrast, all visual elements would look the same, resulting in monotony. Establishing contrast produces impact because it helps to create distinction and visual diversity and, most importantly, makes a distinction among visual elements, helping set up the hierarchy of information in the screen-based application. As with any visual communication application, the designer must build clear levels of the significance of information on a page or in motion to help the reader glean information and to enhance readability and comprehension.

Repetition and Alignment

Repetition works to inculcate ideas in the audience. Just as a "hook" in music—that is, a repeated series of notes or a phrase—works its way into the subconscious of the listener, visual repetition will also cause a graphic design to remain in the mind of the viewer. Beats and rhythms can be established as an underpinning to the design, with other information overlaid. Indeed, with motion graphics, percussive or musical beats can be combined with rhythmic animation to enhance the effect.

Alignment is one of the key principles in successful graphic design for print, as well as for motion graphics. As in music, the viewer will recall alignment that was seen before. When the viewer sees an alignment held throughout or changed in a meaningful way, that creates a remembered template to anchor the piece in the viewer's mind. The motion design solutions may also feel and appear more ordered as a result of alignment.

Type and Graphics

Determine headings and subheadings in terms of color, size, and weight to distinguish the hierarchy of type from one another, as well as from visuals. Letterforms or words may stand out by using weight for contrast. The interplay of positive and negative shape relationships will have enormous effect on establishing flow from one frame to another.

The conceptual interplay between type and visuals in screen-based applications is much the same as in print, except the bonus of motion might add potential for heightened dramatic or comedic effect. How type interfaces with visuals in screen-based media—as in print—can effectively communicate meaning, both literally and symbolically, as seen in Figure 14-9, the opening sequence for the television show *Will & Grace.*

Figure 14-9

Opening television sequence:

Will & Grace

Studio: Number 17, New York, NY

Art directors: Emily Oberman and

Bonnie Siegler

"The big type moving across the

screen represents Will and Grace

and how their lives overlap, and

the footage shows the characters'

personalities."—Number 17

Sound and Music

We've all heard advertising jingles that we can hum or that stay with us, provoking endearment to brands or nostalgic feelings. Audio provides a strong component in screen-based media, adding enthusiasm and engagement to the experience and making the piece memorable for the audience. For example, regarding Figure 14-10: "In your face graphics and imagery animating to industrial speed metal sounds gave Nitro a look and feel like no other energy drink of that time," says art director Michael Sickinger. Music influences viewers; it can greatly enhance a brand, group, or the spirit of a cause. It can identify and captivate.

Music, sound effects, voice, and other types of sound have the potential to enhance and/or create rhythm, contrast, and focal point; music and sound can also enhance emotional communication, creating suspense, urgency, and humorous elements, among many other types of communication.

Figure 14-10

Product concept: Nitro Energy Drink

Studio: Firmenich Inc., Flavors Creative Marketing Studio,

Plainsboro, NJ

Art director/graphic designer: Michael Sickinger

© *Firmenich Inc.*

"Energy drinks have been one of the fastest growing beverage categories in recent years. Nitro was developed as a concept by Firmenich to compete with the growing number of energy drinks during this boom. The idea behind Nitro was to create a better-tasting energy drink that still had the benefits and functional ingredients that are associated with energy drinks. Geared toward the extreme sports individual, Nitro's identity was loud, fast, and hardcore. This Flash movie was created to reinforce Nitro's identity both visually and acoustically. The name said it all, Nitro! A packaging design prototype was also created to complete the story."—Michael Sickinger

Practical Considerations

After or in conjunction with learning the principles of design for screen-based media, students should study the software for time-based media, production techniques—such as DVD authoring, sizing for output, video and audio capture, photo import, and animation of still images and codes—storyboarding, narrative theory, integration of screen-based media into interactive (web) media, sound, music for motion, compositing, and television commercial concepts, as well as studying historical, modern, and contemporary concepts of film, video, animation, web motion graphics, and web films.

Summary

Video, film, and digital media are utilized in screen-based visual communication. The applications of these media usually involve the passage of time and motion. The goal of visual communication motion design is to create a dynamic, multi-sensory experience for the viewer. Screen-based media can support graphics that move over a period of time. In order to create moving graphics, the designer must be well acquainted with the necessary technical issues, production techniques, and software. As always, a designer working with motion must consider concept generation, function, form, aesthetics, meaning, and, ultimately, communication.

Motion aesthetics refers to the process and consideration of how form creates impact over time in a design. Most designers, art directors, and film directors utilize a storyboard to plot out their motion design. Motion aesthetics, planning, and basic production techniques are involved in any motion project. The designer must also take into account screen-based principles and visual basics. Motion in screen-based media can include sound and music. There are numerous practical considerations for screen-based media.

EXERCISES

Exercise 14-1: Storyboarding

Part I

1. Write an essay based on one of the following themes:
The funniest thing that ever happened to me.
My first date.
If I ruled the world…

2. Outline the essay. Define the chronology.

Part II

Draw out a storyboard for your story. In ten frames, draw the key scenes in the story. Use three for the beginning, four for the middle, and three for the end of the story.

This exercise teaches storytelling and framing visuals.

Exercise 14-2: Opening titles

Design opening titles, combining typography and visuals using contrast, for either a film or a television program.

Draw a storyboard in five frames.

The skills utilized in this exercise prepare a student for dealing with motion.

Exercise 14-3: Analyze a Flash design

Find a Flash design solution on the Web and analyze it (writing or drawing, or both) in terms of motion aesthetics.

Becoming a keen observer enhances your ability to design, which is the point of this exercise.

Exercise 14-4: Flip book project from Professor Alan Robbins, Department of Design, Kean University of New Jersey

1. Take photos of the action you want to show, using classmates to act them out VERY slowly frame by frame. You need about forty images for a flip book.

2. Ideally the sequence of actions you choose should be amusing and with big action (falling down, jumping up, hopping, etc.).

3. Then, trace over the photos on tracing paper using a pencil (or trace over the digital photo in Photoshop) and convert each frame into a cartoon. (You could also change the image in a zillion other ways—colorize, collage, etc.—to get away from using just the photo itself.)

4. By tracing, you are encouraged to exaggerate, simplify, morph, cartoon, and otherwise "pump up the action."

5. Finally, make photocopies of the drawings at the right size onto card stock (otherwise it won't flip), and assemble into a booklet with any kind of binding—anything from a simple rubber band to plastic binding.

6. Voila! You have a flip book.

Part IV.

Message and Communication

Message and Communication

Message and Communication

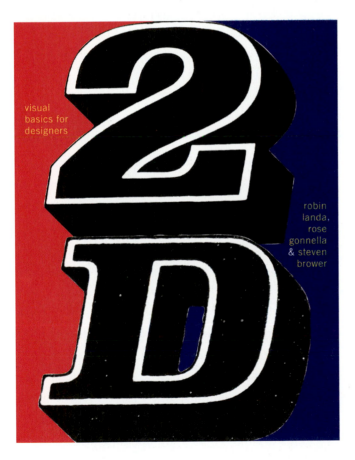

composition {

balance · type · scale
hierachy · shape · unity · rhythm

A

message · format · color · texture
motion · line · depth

Objectives

- Define the design concept
- Learn how to identify the design problem
- Identify the target audience and types of research
- Understand denotative and connotative messages
- Realize the value of design history

visual
basics for
designers

2D

robin
landa,
rose
gonnella
& steven
brower

What Is a Design Concept?

Graphic design has two main functions: it is a problem-solving activity and a means of communication. Generally the problem being solved is a given, as it is the client who comes to the designer for help in communicating what they want and need to convey. How that information is communicated, how clearly and precisely, is the responsibility of the designer. What is imparted is the **design concept**—the creative thinking underpinning the design solution; it is expressed through the integration and manipulation of visual and verbal elements. The designer becomes the interpreter of the material, deciding what should gain emphasis and articulation. The immediacy or subtlety of what is being said rests within the context of the material. Studies have shown that posters on the street are viewed on the average for three seconds, if at all. Therefore, the information needs to translate quickly, or engage the viewer longer, for it to be deciphered. A book has the benefit of demanding much more of the viewer's time. Packaging generally must communicate with the perspective buyer as they stroll down the aisle.

Stating the Design Problem
and Audience Expectations

Graphic design goes beyond mere decoration and artifice. Although many may think of design as only aesthetics and organization, there is a school of design that has a deeper resonance—that is **conceptual design**, the thought behind the design and what it is communicating. This places the designer as an active creator, editor, and author of ideas, rather than a passive participant or sales adjunct. The designer is enabled to communicate directly with the viewer, instead of simply demanding their attention.

It always begins with the audience. Who are they; what are their collective experiences; what is it you are trying to say to them? What information needs to be communicated and how quickly? It is the role of the designer to control all these factors effectively.

The power of visual design is that it breaches most boundaries. Often, you do not need to speak the language to understand. Good design translates into most languages and cultures. And the message is a gift from the designer to the viewer. One of the reasons conceptual design has flourished in Europe is because there are so many different languages spoken. Design is the universal language, and though you may not read the language figuratively or literally, you can still appreciate the design, and even the mystery of it.

At the same time, even good design doesn't transcend all cultural differences. For example, when an esteemed firm first designed an award-winning logo, it was tested in China and they found the number of petals in the image to be unlucky. They changed the number of the petals to ensure acceptance there. And since design contains language, that component certainly doesn't always translate well, even from England to America, where different words and phrases have different meanings. Even color is absolutely not universal in meaning.

We are given a visual lexicon by which to communicate. Before written language, we communicated through symbols. As children, we understood this symbolism succinctly. It is only as adults that we overcomplicate the most basic forms of communication.

An interesting class assignment is to come up with one hundred visual clichés within twenty minutes. Students in graduate classes, many of whom are professionals, struggle to complete this assignment within the time frame given. Even after a discussion of what comprises a visual cliché as opposed to an oral one, they still find it difficult to complete the task. This is surprising, since we learn to communicate through drawn symbols before achieving a sophisticated understanding of letterforms. As small children, we learned that a sun represents not only what we see in the sky, but also a happy day; happier yet would be a rainbow. Conversely, a cloud conveys the opposite, and so on.

The point of this is that we inherit visual shorthand, passed down from generation to generation. This is our own hieroglyphics, a legacy that goes back as far as the cave paintings of **Lascaux**—a way of communicating without words, yet in a concise and compelling manner.

Although new symbols can occasionally be produced (the peace symbol, designed by Gerald Holtom, was created in 1958 in London), this is a rare occurrence. It is nearly impossible to reinvent the wheel, and if you set out to do so, you most likely will become quite frustrated. A suggestion, therefore, is not to struggle to fashion new symbols, but rather to utilize the ones already in existence in a fresh manner, to make use of what is given in new and unexpected ways (Figure 15-1).

It is the audience that shares the design. What the audience already knows is important. Therefore, one must work from within the framework of what is familiar.

When Milton Glaser was asked to design a logo for an existing campaign for New York, his solution was one that had long existed in the vernacular. Carved into the bark of trees and scrawled on schoolbooks everywhere, "I ❤ you" was easily recognizable, although, as hard as it is to believe, this was its first graphic incarnation. Instantly understood and with an air of whimsy, "I love [fill in the blank]" was a graphic shot heard round the world—so much so, that it seems impossible that its origins began only twenty-five years ago (Figure 15-2).

In the logo designed for the charitable outreach program shown in Figure 15-3, a heart is combined with holding hands to convey the message that the organization cares and is there to help.

Figure 15-1
One Hundred Visual Clichés

Figure 15-2
Logo: I Love New York
Studio: Milton Glaser, Inc., New York, NY
Designer: Milton Glaser
Client: New York State

Figure 15-3
Logo: Hands On
Studio: Steven Brower Design, New York, NY
Designer: Steven Brower
Client: United Jewish Appeal

Flags as a Theme

The American flag is another case in point. A common design problem given for book jacket designers is the assignment where political theory or events are either an overt or underlying theme. What is shown here are several solutions featuring the flag in one form or another to convey the material contained within these works of nonfiction. In several, the American flag is used in various incarnations.

The book shown in Figure 15-4 was published just prior to the Oliver Stone film of the same name. The details of Kennedy's assassination, which is the subject of the book, are well known, and therefore easily conveyed. Shown is a photo-illustration of bullet holes in an American flag to represent Kennedy's assassination and its damaging effect on the country. The concept required three bullet-hole entrances for the book's back cover and three exit holes for the front cover.

The three entrance and exit wounds on the front and back covers should strike an eerie cord for anyone old enough to remember the assassination. By placing the entrance wounds on the back cover and exit on the front, it actually countered the theme of this tome, that President Kennedy's death was the result of a conspiracy and not a lone gunman. Rather than using a photo of Kennedy, shooting bullet holes through the American flag is an unexpected image. The typewriter type, which was actually set on a typewriter, further enhances the concept, as this form of typography would have been utilized on a file hidden in some darkened bureaucratic office.

Figure 15-4
Book jacket: *JFK: The CIA, Vietnam, And The Plot To Assassinate John F. Kennedy* by L. Fletcher Prouty
Studio: Steven Brower Design, New York, NY
Designer: Steven Brower
Photographer: Arnold Katz
Client: Birch Lane Press

Returning to the flag as an icon, the flag painted on wood (seen in Figure 15-5) was purchased at a flea market. It was aged, using various stains, rubbing dirt and fall leaves into it, and hitting it with a hammer. Then it was sawed apart, holes drilled, and screws and nails added. The thinking here was to visually represent the concept of the book—that our political system is in need of, and indeed can be, repaired. By showing the flag in a state of disrepair, in a form that could be fixed with some effort, it imparts the message of the need for a "kit" that contains the correct repair tools, without actually showing it.

It also is an example of how designers should not rely on the computer to create solutions for all their problems. It is possible that this image could have been created in Photoshop, but it's doubtful it would have the same realism or resonance.

Figure 15-5

Book jacket: *Great American Political Repair Manual* by Sam Smith

Studio: Steven Brower Design, New York, NY

Art director: Deborah Morton Hoyt

Designer: Steven Brower

Photographer: Arnold Katz

Client: W. W. Norton

Unlike the first two examples, the flag shown in Figure 15-6 simply represents America, without a deeper political meaning. It was a simple but effective device to turn a piano into the stars and stripes to illustrate the title and content of this book by John Rockwell.

In Figure 15-7, echoing a campaign poster, the illustration works well with the typography to produce a 1930s period feel. Selecting an unexpected tone of blue, the red, white, and blue of the cover is not too obvious. The cover benefits here from a short and self-contained title, requiring no author's name. In a different take on the same theme, Seymour Chwast uses the very image of FDR as an icon, utilizing his easily recognizable form in place of the "D" (Figure 15-8).

Figure 15-6
Book cover and thumbnail sketch: *All American Music* by John Rockwell
Art director: Ruth Jenson
Designer: Steven Brower
Client: Da Capo Press

Figure 15-7
Book cover: *The Wisdom of FDR*
Studio: Steven Brower Design, New York, NY
Designer/Illustrator: Steven Brower
Client: Citadel Press

Figure 15-8
Book cover: *FDR: Architect of an Era* by Rexford G. Tugwell
Studio: Push Pin Studios, New York, NY
Designer: Seymour Chwast
Client: Macmillan

Understanding the Target Audience

Who is your target audience? In what segment of society do they reside, and how would you know? Often this information is given in the client's brief, a summation of the graphic problem that requires solving. Another approach if this information is not available is to think of the problem and audience as differing "genres"—a book for children differs greatly from one for adults. An alternative music magazine should have a different look, feel, and size of body text from one for the American Association of Retired Persons. Is the design product meant to appeal to the widest possible audience—known as mass market—or a specific targeted segment of the whole? As a designer, it is your job to find this out.

The great Russian art director/designer Alexi Brodovitch used to tell his students to "astonish me." Words to live by, the designer should always strive to astonish the target audience. It is the designer's task at hand to create memorable and inventive, lasting images that the audience will respond to in a meaningful way.

Most magazines today, including design magazines, are completely overlaid in "cover lines," which are essentially the table of contents on the cover. Add to that the photograph of a head or torso and you have the majority of the covers produced every month, despite the subject. The logotype for the magazine still appears in the top quadrant, so that it can be easily read as the magazines sit in stepped shelves on the rack.

While not a complete break with convention (the logo appears in traditional placement), everything on the cover of the magazine shown in Figure 15-9 is completely rendered in henna on a model's back—including the cover lines. Rather than scream at you for attention, a more subtle, inviting approach makes for a memorable image.

Figure 15-9

Magazine cover: *Print*, May/June 2000
Studio: Steven Brower Design, New York, NY
Art director/Designer: Steven Brower
Henna artist: Makiko Yoshimura
Photographer: Barnaby Hall
Client: RC Publications

Types of Research

A recent addition to the design process is marketing research. These surveys give the designer clues into what the audience's taste levels and expectations are. Much money is spent in the hope of understanding the target audience. Still, this is not always an advantage, and can even be counter to the creative process. Even the most expensive and concise research can often lead to a mundane, homogenized product; the lowest common denominator is often the case. It is the role of the graphic designer to surprise, reveal, elevate, and deliver the unexpected, thereby capturing the imagination of the audience, rather than simply giving them what they expected in the first place.

In many areas of design there is no such research, as it is a costly practice. For example, in book publishing there is virtually none. Each book is a single effort and the publisher takes their best shot every time. This is not to say there aren't sales and marketing departments at publishing houses, simply that they do not have the budget to research each and every effort.

Denotation and Connotation

Denotation is the literal meaning of an image or word; for example, a sun = a sun, and a cloud = a cloud. However, how you create the visual will give the image a deeper connotation, so that a sun = a ray of hope, and a cloud = a sense of woe. This **connotation** is the secondary, suggested or implied meaning, owing to the manner in which the visual is drawn, manipulated, or characterized. However, in the hands of a designer, connotation becomes the primary meaning, and denotation the secondary meaning. This is also true for typography: the literal meaning or denotation is the actual letters and words, while the underlying meaning (connotation) is communicated by the font or lettering.

The poster in Figure 15-10 was part of an experiment by five participants to create posters with social and political significance. It was the first in a series to be hung around Manhattan. As such, what is shown is on the face of the poster, and what is actually being said beneath the surface requires deeper analysis. The racist words on the bottle are not to be taken literally. On their own, they are intentionally repugnant. The image of the bottle puts these words in an unexpected context. It is only when you read the rather small "warning" label ("Prolonged exposure is dangerous to the health of children") that you begin to understand the connotation of the piece: the concept that we force-feed racism to our children.

Denotation and connotation work on two levels here within the image of the baby bottle. In addition to the primary intent, the bottle also represented a birth of the design group, one that didn't survive much past this initial outing.

Figure 15-10

Poster: (Untitled)

Designers: Post No Bills: Steven Brower, John Gall, Leah Lococo, Morris Taub, James Victore, and Susan Welsh

Ambiguity

Not all concepts have to be readily interpreted. It is possible, once you have engaged the viewer, to slow down the process of interpretation. In the baby bottle poster, the intent is understood only with closer examination. The payoff is greater, because the viewer becomes more involved in the process. **Ambiguity**—designing in a manner where the designer's intent is not immediately recognized—can lead to intrigue and involvement, resulting in an engaging design, but it can also lead to confusion, if in the end the concept does not reveal itself.

Metaphor

Metaphor is the act of using the given lexicon of symbols to represent something other than what is shown. It is the implied meaning, as opposed to the literal one. Often dreamlike, stirring in us a resonance that goes beyond the surface of the piece, metaphors tap into our unconscious. By combining two symbols, designers can convey meaning of great power.

In her native Bulgaria, Luba Lukova created the theater poster shown in Figure 15-11. By replacing the tuning keys of the guitar with daggers, these two innocuous images that would have little strength separately, together become forceful and provocative. Commented Lukova: "This is a theatre poster I did for the company where I worked as a full-time designer. It promotes a theatre performance based on Federico Garcia Lorca's poetry. The name of the poster is *There Is No Death for the Songs*. The idea for the image came from Lorca's poems where there is always drama, love, death, music, daggers. So, the guitar bleeds like a human being. It is strange that when the poster was posted on the streets, people saw a political meaning in it, but I did not intend that when I was working on it. I guess the times were like that, and they always suspected that I would do something to tease the censors."

Figure 15-11

Poster: *There Is No Death for the Songs*

Design studio: Luba Lukova Studio, Long Island City, NY

Designer: Luba Lukova

Client: Drama Theatre Blagoevgrad

For this eclectic publication (Figure 15-12) featuring various areas of interest and specialization unified by the single topic "Fringe," science that stands outside the scientific community is discussed. In the same fashion that writer Lee Smolin builds to a logical conclusion, so does the layout, echoing scientific and mathematical equations.

Figure 15-12

Magazine: *Oxymoron* Vol. 2

Studio: Pushpin Group, New York, NY

Art directors: Steven Brower and Seymour Chwast

Designer: Steven Brower

Client: *Oxymoron*

Borrowing from History

A common but misunderstood practice is to borrow from design history. Indeed the history of graphic design is one of revival. Styles return decades later, in new, invigorated forms. The use of Art Nouveau forms in the 1960s did not look exactly like its original occurrence in the 1800s—it is clearly of a new era. Streamlined and Art Deco typography of the 1930s and 1940s returned in a slightly different manner and context in the 1970s. And even 1950s **"kitsch"**—design that purposefully uses popular culture artifacts and icons, mass-produced objects, and "low-art" for imagery—has been with us ever since. Designing in the manner of borrowing from the past is called **retro,** for the **retrospective style** that is being revived. Still, the use of historical forms is a tightrope walk: when is it homage, parody, or uninspired pilfering? In the hands of a good designer, the intent is clear; in lesser hands, less so.

In Figure 15-13, we see a perfect example of using historical reference to great advantage. Herbert Matter was a Swiss graphic designer working in the 1930s and 1940s. Among his best-known works are his series of posters used to promote travel in his native country. These posters appear regularly in graphic design history anthologies. In 1985, Paula Scher—then of Koppel and Scher, and now with Pentagram—began working on a campaign for the newly formed Swiss Swatch Watch Company. Her lively, playful design sensibility and the brightly colored inexpensive plastic watches were a perfect match. For her second outing with Swatch, she decided to create a parody of one of Matter's posters, which hung in the office of the marketing director for the company. Her poster works on several levels. For someone unfamiliar with Matter's poster, it stands on its own merits—light hearted and animated. For those in the know, it's a humorous take on a design icon (Figure 15-14).

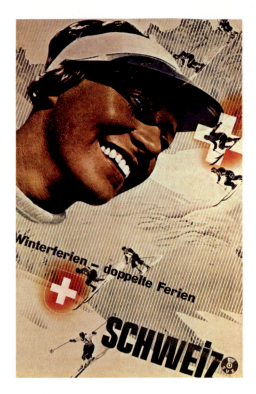

Figure 15-13
Poster: *Suise*
Designer: Herbert Matter
The Herbert Matter Collection. Department of Special Collections, Stanford University Library.

Figure 15-14
Poster: *Swatch*
Design firm: Pentagram
Designer: Paula Scher
Client: Swatch

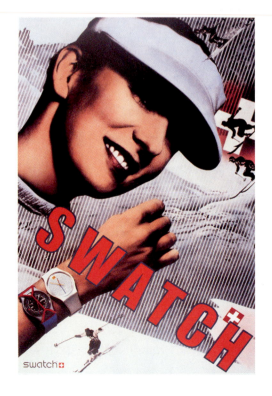

Luba Lukova's spin on Robert Indiana's much parodied and copied *Love* painting (Figure 15-15) is refreshing. Reproducing the order of the universally known letterforms, she adds her own personal twist, with her representation of various kinds of love (Figure 15-16).

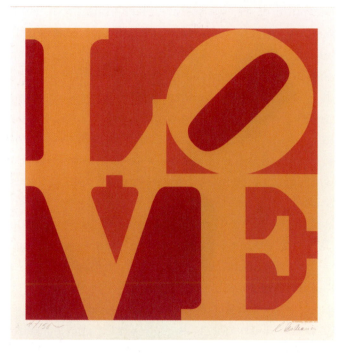

Figure 15-15
Painting: *Love*
Artist: Robert Indiana
©2006 Morgan Art Foundation Ltd./
Artists Rights Society (ARS), New York.

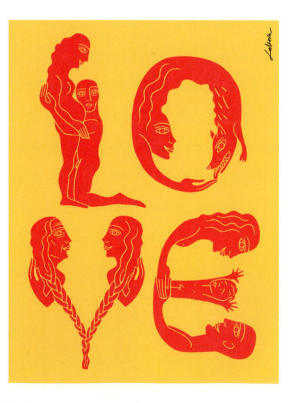

Figure 15-16
Poster: *Love*
Design studio: Luba Lukova Studio, Long Island City, NY
Designer: Luba Lukova

The title of the book shown in Figure 15-17 lends itself readily to a 1960s-style illustration, and a literal translation of the title, using Milton Glaser's iconographic Dylan poster for inspiration. The wall of type behind the figure lists the myriad of authors contained within this edition and also references the look of trade paperbacks of the period. By combining the two, the result does not look like a cover from the 1960s, but rather the early 1990s, when it was produced.

For the nonfiction exposé cover shown in Figure 15-18, the use of the iconographic logo for 20th Century Fox was obvious. Still, it makes for a powerful cover. When referencing trademarks or logotypes, always be careful not to infringe upon copyrighted forms.

Figure 15-17
Book cover: *The Psychedelic Reader,* edited by Timothy Leary, Ralph Metzner, and Gunther M. Weil
Designer/Illustrator: Steven Brower
Client: Citadel Press

Figure 15-18
Book cover: *The Fox That Got Away* by Stephen M. Silverman
Studio: Steven Brower Design, New York, NY
Art director/Designer: Steven Brower
Photographer: Dennis Potokar
Client: Birch Lane Press

For the special advertising-themed issue of *Print*, archival photography is used to make the point of a historical context (Figure 15-19). Applying different type styles for each article to create a broadside effect for the advertising sandwich board, this cover quotes both the handbills of the nineteenth century and the depression era images of the early twentieth century—two comments on the world of economics and commerce contained within one image.

Howard Fast was a well-known author of fiction and screenplays, who was blacklisted during the McCarthy era of the early 1950s. Forced to publish under a pseudonym, his novel Sylvia achieved some success, but was never reprinted. This new 1992 edition bears Fast's name for the first time (Figure 15-20).

Ironically, the plot of this mystery novel echoed some of the circumstances of its publishing history. The title character is a woman of mystery, herself using a pseudonym to hide something in her past. The illustration serves as a visual double entendre, illustrating the mysterious nature of the title character and the blacklisting of the author in the 1950s. It is based on both a cinematic still photograph from the 1940s and Mexican billboard paintings of the same era. A sense of mystery is immediately tangible, along with a strong graphic impact.

Figure 15-19
Magazine cover: *Print*, Nov/Dec. 2000,
"Advertising Design & the New Economy"
Studio: Steven Brower Design, New York, NY
Art director/Designer: Steven Brower
Photography: Wide World Photos
Client: RC Publications

Figure 15-20
Book cover: *Sylvia* by Howard Fast
Studio: Steven Brower Design, New York, NY
Designer/Illustrator: Steven Brower
Client: Birch Lane Press

Establish an Emotional Tone

It is important to establish an emotional tone in designs, and humor works as the great equalizer. It's a way of disarming an audience. Greater political statements can be made through humor than with more strident articulations. As true as is the difference between a comedian joking about a political event versus a politician making a speech regarding one, the same is true for the designer and the audience. You can sway more people with a smile than a frown.

Often humor in design is based on expectations. We are presented with something that we anticipate will appear a certain way, yet there is a twist (Figure 15-21). Rather than create the expected, a mundane all-type cover suitable to the subject matter (Figure 15-22), this cover reflects a discomfort with public speaking. Literally translating the title, the speaker is either passed out or expired behind the podium. The title type echoes the figure and reinforces the concept with the "D" in "Die" resting on its side.

Figure 15-21

Book cover and thumbnail sketch: *Memoirs of a Mangy Lover* by Groucho Marx

Studio: Steven Brower Design, New York, NY

Art director: Ruth Jenson

Designer: Steven Brower

Client: Da Capo Press

By graphically interpreting the title, this cover captures the essence of Groucho's irreverent humor. Itself a play on Dylan Thomas's book *Portrait of the Artist as a Young Dog*, the title comes to life—Groucho as mangy mutt! The original thumbnail sketch shows the concept in its purest form.

Figure 15-22

Book cover: *I'd Rather Die Than Give A Speech* by Michael M. Klepper with Robert Gunther

Studio: Steven Brower Design, New York, NY

Art director/Designer: Steven Brower

Photographer: Richie Fahey

Client: Citadel Press

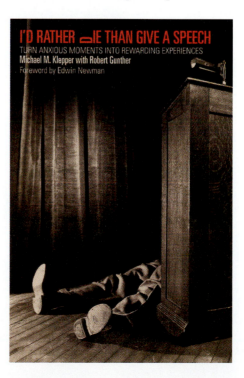

Darkest England is a novel about an African tribesman who is sent to England to try to meet with Queen Elizabeth, who is recognized as the head of their tribe as the result of a recently discovered ancient decree. The juxtaposition of images of the two cultures is at once provocative and humorous, belying the nature of the book. By placing an African ceremonial mask on the face of Queen Elizabeth, the image captures the main theme of this novel. The hand-lettered, distressed title type represents a mock version of an official document (Figure 15-23). And in Figure 15-24, the cover benefits from a terrific title. Through the use of models, the hall of fame becomes a reality, creating an unexpected visual. The use of hand scrawl adds to the total cockroach effect.

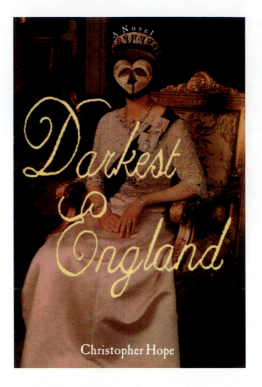

Figure 15-23
Book cover: *Darkest England* by Christopher Hope
Studio: Steven Brower Design, New York, NY
Art director: Deborah Morton Hoyt
Designer: Steven Brower
Client: W. W. Norton

Figure 15-24
Book cover: *The Cockroach Hall of Fame* by Sandra Gurvis
Studio: Steven Brower Design, New York, NY
Art director/Designer: Steven Brower
Photographer/model maker: Arnold Katz
Client: Citadel Press

For someone who has only a passing acquaintance with Disney's biography, it might seem hard to believe that there would be an exposé of Walt Disney, but indeed this was a critical biography. The goal was to convey that message within a Disneyesque oeuvre.

The smiling publicity photo of "Uncle Walt" represents his public persona. In contrast, the background illustration hints at his darker side, done in mock Disney style. This cover is a visual representation of the book's contents. It is also a colorful, attention-getting graphic (Figure 15-25).

Graphic design is overall a very neutral medium. It is difficult to express emotion through purely visual means. Music and film lend themselves to greater emotional weight, moving across space and time. Design is essentially static, even as you turn the pages of a book or magazine. Attempts to be emotive sometimes come off as melodramatic. Still, there has been a move of late to convey emotion through the use of rough-hewn line and expressive content, with some success.

It is the role of the designer to surprise (Figure 15-26). "Morla Design was commissioned to create a cover for *The New York Times Magazine*," says Jennifer Morla. "The feature article, 'The Shock of the Familiar,' examined how design is inherent in all objects, yet is not clearly understood by the general public. We responded conceptually by objectifying the magazine itself. By placing the masthead upside down, one has to reexamine how to open this very familiar object. The cover is literally the object that shocks us."

Figure 15-25
Book cover: *Walt Disney: Hollywood's Dark Prince* by Marc Eliot
Studio: Steven Brower Design, New York, NY
Designer: Steven Brower
Client: Birch Lane Press

Figure 15-26
Magazine cover: *The New York Times Magazine*
Design firm: Morla Design, Inc., San Francisco, CA
Art directors: Janet Froelich and Jennifer Morla
Designers: Jennifer Morla and John Underwood
Client: *The New York Times*

Photography

Today photographs have become an integral part of graphic design, to the neglect of illustration. In fact, the photograph was invented by Joseph Niépce, a French printer working in 1822. His son, Isadore, was an artist and would provide illustrations for the books they produced. When he was drafted into the army, his father lacked the same facility to draw. He thereby created a light-sensitive material that could be adhered directly onto a pewter plate. He would then expose light through an oiled, transparent illustration, creating the world's first photographic image transfer. This technology in time led to the advent of capturing reflected light through a lens onto metal plates and eventually film.

This struggle between illustration and photography has continued throughout the history of graphic design, but in a yin/yang-like balance until the advent of the World Wide Web. It was not simply technology that provoked the shift toward stock photography, but economy as well.

To hire a photographer or illustrator to create an original work of art (depending on the size and usage) would on the average cost $1,500 and up. You can purchase stock photography these days within the $10 to $100 range. The down side is that creativity is lost and an entire stratum of creatives have lost work. The result is often a lackluster homogenization of photographic imagery.

Still, it is the world we live in. Overall, our relation to photography has changed as well. There was a time when we believed that "pictures don't lie." Today that is no longer true. With digital programs such as Photoshop, the ease of photo-manipulation has increased exponentially. Altering the reality of what we see even occurs regularly on live television. Only home viewers see the logos and advertisements that appear on the field and around the stadium during football games.

Designer John Gall's cover for *A General Theory of Love* is the perfect example of how to use photography (Figure 15-27). There is no way a stock photograph would match the concept as exactly or as cleanly.

Figure 15-27
Book cover: *A General Theory of Love* by Thomas Lewis, MD, Fari Amini, MD, and Richard Lannon, MD
Art director/Designer/Photographer: John Gall
Photographer: Boris Schmacenberger
Publisher: Vintage Books

Designing with Meaning

Design has a rich history of using social responsibility as a means to an end. From protest posters to leaflets and publications on social issues, and both print and television advertisements for public service advertising (**PSAs**), the designer as citizen has participated in trying to improve the world in which we live.

Seymour Chwast's iconographic anti-war poster, shown in Figure 15-28, is a perfect example of one designer's contribution; about it he said: "This poster (1968) was a reaction to American forces bombing Hanoi during the Vietnam conflict, which I was against. It was produced by a marketer of posters to be sold in poster shops, popular in the sixties. The art in blue was printed from a woodcut proof. The red, green, and blue colors were added. The advertising slogan, 'End Bad Breath,' focuses on the message of the poster."

Although created for a commercial magazine (Figure 15-29), George Lois's emblematic covers for *Esquire* in the 1960s and 1970s raised the bar for personal statement and political dialog—at the time when Lt. Calley was on trial for his responsibility for the My Lai massacre in Vietnam. Comments George Lois: "Those who think he is innocent will say that proves it. Those who think he is not innocent will think that proves it."

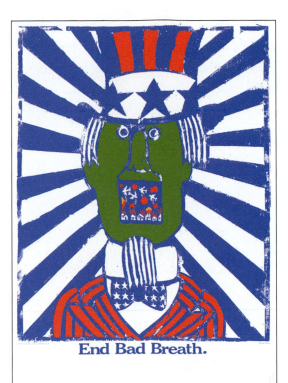

Figure 15-28
Poster: *End Bad Breath*
Studio: Push Pin Studios, New York, NY
Illustrator/Designer: Seymour Chwast

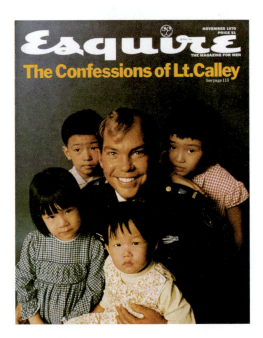

Figure 15-29
Magazine cover: *Esquire,* November 1970
Art director: George Lois
Client: *Esquire*

Logotypes are the most basic form of communication. They need to be recognizable and make their statement clearly. "We wanted to use the whole country as the symbol for this left-leaning radio station," stated Number 17 about their logotype design for Air America (Figure 15-30).

Figure 15-30
Logotype
Studio: Number 17, New York, NY
Art directors: Emily Oberman and Bonnie Siegler
Client: Air America

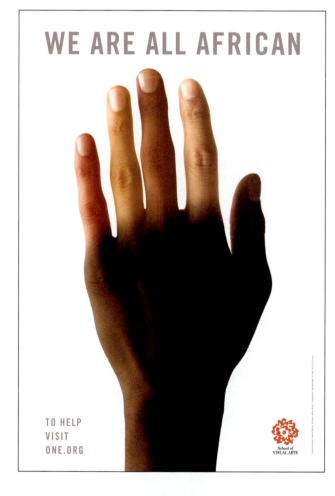

Figure 15-31
Poster: *We Are All African*
Studio: Milton Glaser, Inc., New York, NY
Designer: Milton Glaser
Client: one.org/School of Visual Arts

Milton Glaser's *We Are All African* poster (Figure 15-31) is a call to arms for all designers to do work that matters. In a talk that he gave at the AIGA National Design Conference in Boston in 2005, he stated ". . . speaking subjectively, the world seems more fragile and imperiled that it did in the mid-eighties. Perhaps the world always seems at risk. . . . My personal response to this condition has lead me to become more active in civic life. As designers, we've been concerned about our role in society for a very long time. It's important to remember that even modernism had social reform as its basic principle, but the need to act seems more imperative than ever. . . . We can reject the passivity and narcissism that leads to despair, and choose to participate in the life of our times."

Summary

Conceptual design is about thought as opposed to mere decoration. It is a means to an end, a way of getting to the heart of the design problem and communicating directly with the audience. Rather than simply create "a pretty picture," the designer creates "a picture worth a thousand words." The designer should be in total control of what is being communicated and how clearly it is understood. Given the context, the designer's solution should always speak directly to the target audience in a visual language they understand.

EXERCISES

Assignments are generally given over a two-week period, with the first week consisting of sketches and the second week a finished **comp** or **comprehensive**—a detailed representation of a design. Extensive feedback should be given the first week during the critique and very often the students will completely change their design for the finish. Surprisingly, there is just as much to discuss the second week as well.

The assignments are conceived for their conceptual resonance, with the aim to challenge each student's preconceived notions about design in specific, and hopefully life in general. Still, much time is also given over to aesthetics. Choice of typography and imagery are investigated, and the intended audience is taken into consideration.

Of paramount importance is whether each piece is communicating what each student intends it to. Request that the author of the piece remain quiet while the class interprets their work. When all discussion is exhausted, the student can then explain what his or her intentions were and whether or not they missed the mark.

Exercise 15-1: Design a paper airplane (in-class assignment)

Here the intent is simple. Perhaps this might seem counter to conceptual thinking, but in the end **form follows function**—the shape, material, or appearance

that something takes is in direct response to what is being communicated. The only question is: does it fly? Over-decoration and design will tend to weigh it down, but this is the approach most take. They believe because this is a design problem, they have to "design," when a streamlined, less is more approach is what is required.

Exercise 15-2: Design a 6 x 9-inch book cover for your autobiography

Traditional elements are title, subtitle, author's name, and image, but these are optional. The cover should communicate what you want to tell your audience (the class) about yourself (one-week assignment).

The purpose of this assignment is communication. No research is needed, as the students know their subject matter and are aware of how they want to be presented to the world. Yet, there are a surprising number of miscues sent out to the viewer, aside from the normal uncertainty of the average college student. As always, the questions they should ask themselves are: Are you comunicating exactly what you intend to? Are you in control of the tools used to communicate?

The critique is essential here, for this is where the students receive feedback on how their pieces are being perceived. This assignment also offers the opportunity to discuss, on a more personal level, how the students are approaching their careers.

Exercise 15-3: Design a 6 x 9-inch cover for the biography of an "icon," someone so famous that they are instantly recognizable (two-week assignment)

This book cover assignment differs from the autobiography in that it requires research. The instructions are to select a personality who is so famous that they can be reduced to iconography. Is this a person who is recognizable in symbols? In a photograph without a name attached? In abstraction? If so, how much information do you really need on the cover? This affords the opportunity to utilize the "less is more"

philosophy. How reductive can it be? One approach is to remove each piece of information a step at a time, until the piece no longer works. Then put back the last piece removed.

Exercise 15-4: Design a street handout that a hardened New Yorker would readily take from a stranger; budget and form are open (one-week assignment)

This assignment should be given early in the semester, as it lays the groundwork for the rest of the school year as to how to approach design conceptually. Here the premise is simple. Design a handout that any hardened New Yorker would willingly take from a stranger. Any visitor to the city has surely witnessed the surplus of this activity and the general lack of success most of these hawkers of ephemera have. What would make someone take what it is you have to offer?

In class, you will find the most successful pieces are ones that have some intrinsic value, that get your attention and capture your imagination. Most would not take flyers, as the expectation is that they are being handed something that is valueless, attempting to sell them something or proselytize them in some way.

Often, context is important. Most would take food if the person handing it out wore an official uniform and stood in front of a restaurant or officially decorated stand; otherwise, they would not.

There are a number of reasons why some handouts do succeed.
- It is a gift.
- It has intrinsic value.
- It has a sense of play or whimsy.
- It is "something for nothing."
- It is utilitarian and/or practical.
- It is unique.
- The context is important.

These are indeed all the qualities that comprise a successful design solution, the gift being the presentation of the design from the author to the viewer, the value being the exchange of information, and so on. This serves as a good foundation assignment to stimulate an understanding of what design should and can be about.

Exercise 15-5: Design five postcards that are to be mailed to a household that contains a parent(s) or guardian and a teen; topics are open (two-week assignment)

This is a difficult assignment, because there are two distinct audiences here. The objective of these postcards is to get the adults to communicate with the teen and visa versa. The assumption is that their aesthetic taste levels are disparate, and in general, teens are not generally open to unguarded communication with their parents. Of course, this is a great simplification and overstatement, but it works for the purpose of the assignment. The key word here is "communication," which can be misinterpreted to denote "to talk." Often solutions are "to go shopping" between mothers and daughters and "to sporting events" between fathers and sons. However, this has nothing to do with communication, and simply bringing the two parties together is not the same thing as communicating.

The reason there are an odd number of cards is to make the task more difficult. The cards cannot be evenly distributed between the two audiences.

One solution would be to try to find a common theme between parent and child. Some attempt to remind parents that they were young once and inform the teens that their parents may understand what they are going through better than they think. The most successful solutions have been ones that utilize the cards as puzzle pieces. They raise curiosity on the part of both audiences, and each must deliver the pieces to one or the other to solve the puzzle. By placing them in the same room, one would hope that they would then communicate.

Conclusion

by Steven Brower

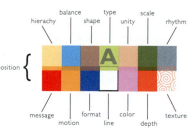

On becoming a graphic designer . . .

> There are three essential commandments:
> 1) Respect the elders
> 2) Embrace the new
> 3) Encourage the impractical and improbable
> without bias
>
> —*David Fricke**

Students entering a four-year university or art school directly from high school have one expectation: that things will somehow be different. Generally they find this to be true. Random class schedules and increased personal responsibilities are the earmark of adult education.

Still, for the art student, there is a foundation year that may smack of the familiar: required classes that may or may not directly relate to your discipline or interest. Drawing, painting, and two-dimensional design are the backbone of a good arts education that dates back to the days of the Renaissance. I remember my puzzlement in 2D as a young fine-arts student (I switched my major later on), wondering how all these squares and color wheels will one day pay off in my work, and I would imagine that for a graphic design student, it may be even more confusing.

Now, I am not advocating any radical change in the way first-year art students are taught. I firmly believe that the basics are the way toward a bedrock understanding of the underlying themes of composition, harmony, and color that will carry through for a lifetime. It simply seems there is a chasm that needs to be breached. For after that foundation year, things move quickly—especially for graphic design students—and by the time they begin Basic Graphic Design and

Type 1, the fundamentals are expected to be applied accordingly. Quite a bit is being asked of students to make the leap from those squares and triangles to a mastery of type and image.

What appears to be missing is a basic two-dimensional design education through graphic design examples. The benefit of this is two-fold: the students learn by example, and they actually experience the work of others in the field. If there is one overarching failure I find in design education today—or perhaps to put it squarely on their own shoulders—it is that students aren't looking hard enough. A commonly heard refrain is "I don't remember names, I just remember the work." Another, better yet, in answer to "What typeface did you use?" is the chorus that could be sung in unison "I don't know, it was on my computer." Students today need to push their chairs back from their computers to better explore the world beyond.

It also seems to me that we have lost our need for heroes and heroines—that nothing is more intriguing than ourself, and anything that happened before our own birth is of little significance. Eventually we will become the snake eating its tail, doomed to repeat the same exercises over and over, in smaller concentric circles, until nothing at all is left. And what a wide, beautiful history we will all be missing.

* These words, spoken by *Rolling Stone* editor David Fricke at the beginning of a music festival in the 1980s, open Vin Scelsa's "Idiots Delight" weekly radio show on WFUV in New York City. Used with permission.

Design isn't easy. We have to work at it. It is not enough to simply make a pretty picture. Many graphic design students think that creating something that is aesthetically pleasing is the end, rather than simply one of the means. It also needs to solve the problem, address the audience, and communicate the ideas and information contained within for it to be successful. Beauty is in the eyes of the beholder, but a good idea speaks to everyone and lasts forever.

Many of today's students believe the way to begin to solve a problem is to turn on their computer, "Google" an image search, download a photo (often low resolution), and begin to manipulate it. Somehow, the end result is "presto change-o" theirs; however, there are problems with this approach.

- There is nothing original at the starting point, and it will never exactly fit what you want it to, no matter how you may manipulate it.
- The same image can appear simultaneously on a magazine or book cover or another student's solution for the same assignment.
- Usage rights have not been obtained, and you can be sued if your work is published.

Trust me: A stick figure with a terrific idea behind it is a much greater solution than a Photoshop collage with none. If creating a particular image you have in mind is beyond your abilities, then find an illustration or photography student and ask for help. The end result may be a portfolio piece that benefits both. I highly recommend that this practice of working with illustrators and photographers should continue throughout your career—this may finally turn around the dearth of originality in today's marketplace. There was a time when magazine covers consisted of more than a photograph of the head or torso of a beautiful smiling model or celebrity.

Another option is to buy a digital camera, which have dropped greatly in price, and start photographing everything yourself. Or continue drawing throughout your lifetime. Nothing helps push concepts better than hand-to-mind coordination.

Another concern of the design student is style, and students aren't sure how to achieve this. What I would offer is to be less concerned about style and more about sensibility. Therein lies true originality, as none of us think exactly alike. We are all individuals, through nurture and nature, and your sensibility is the true stamp on all your work, at least until cloning is permitted and perfected.

Lastly, I would advise all students and designers to remain hungry, work hard, and remember that your best solution is your next one. Be a sponge; soak up all the information around you. Read everything. Learn everything. Experience everything (within reason or local laws). Be open to new possibilities. And as Winnie the Pooh says: "think, think, think."

abstracted shape: a simple or complex exaggeration or distortion of an object, used for stylistic distinction and/or communication purposes.

achromatic: without hue, containing only black, white, or gray.

actual texture: see **tactile texture.**

additive colors: colors that we see on screen-based media, which is light energy itself; see also **subtractive colors, digital color,** and **reflected light.**

alignment: the positioning of visual elements relative to one another so that their edges or axes line up.

ambiguity: designing in a manner where the designer's intent is not immediately recognized.

analogous: any three hues adjacent to each other on the pigment color wheel.

Art Deco: a stylistic period (1920–1939) of design and fine art that is characterized by bold geometric shapes that reflect an interest in the built environment and industry of what is also known as the Machine Age.

Art Nouveau: a stylistic period (1880–1910) of design and fine art that is characterized by highly interwoven, organic shapes that reflect an interest in the natural environment.

asymmetry: the equal distribution of visual weights without a central axis.

atmospheric perspective: an atmospheric spatial effect that can be represented on a flat surface if the designer takes into account the effect the atmosphere has on color, shape, form, texture, and detail from a distance; also called aerial perspective.

background: the part of a picture or pattern that appears to be in the distance or behind the most important part.

balance: stability or equilibrium created by an even distribution of visual weight on each side of a central axis or among all the elements of a composition; see also **visual weight.**

body copy: text used in the body of text; also called **text type.**

broadside style: mixing many type styles on a single, large sheet of paper, typically printed on one side.

brush scripts: a style of thicker, bolder typefaces that imitate sign lettering.

caps or capitals: the larger set of letters, also called uppercase.

character: a letterform, number, punctuation mark, or any single unit in a font.

chiaroscuro: an Italian word that means "clear and dim," and defines a style that utilizes light and shadow to create the illusion of depth and space.

chroma: the saturation of a color.

chronology: the order of events.

classical: serif type, also referred to as roman.

closed composition: the limits of a composition are defined by the objects or marks within the format.

close-up shot: a shot that is zoomed in on.

CMYK: the four basic process colors (ink pigment) from which all colors are optically layered and mixed during the offset-lithographic printing process: cyan, magenta, yellow, and black.

collage: the cutting and adhering of different bits of materials onto a two-dimensional surface.

color: a property or description of light energy.

color palette: a group of colors selected for use in a design or image.

color schemes: purposely related groups of colors, which are thoughtfully selected for use in a design or image; see also **color palette**.

color temperature: refers to whether a color *looks* hot or cold, but can't actually be felt; the **warm colors** are the reds, oranges, and yellows, while the **cool colors** are the blues, greens, and violets.

color wheel: a circular chart of color harmonies that organizes and displays the interrelationship of the visible spectrum of colors.

comp or comprehensive: a detailed representation of a design.

complementary: any two hues that are directly opposite one another on the pigment color wheel.

conceptual design: the thought behind the design and what it is communicating.

condensed typeface: a typeface that is taller than it is wide.

connotation: the secondary, suggested or implied meaning.

context: where and how a format will be seen or used.

continuity: the handling of design elements, such as line, shape, texture, and color, to create similarities of form, and also called similarity; it is used to create family resemblance.

continuous-tone: in regard to the printing process, images (photographs or illustrations) that contain smooth modulations (tones) of color.

contour: a linear drawing of the edges of an object (both the outer and inner edges).

contrast: the difference in visual properties that makes a shape, form, or image distinguishable from other shapes, forms, or images and from the background.

cool colors: those hues perceived to be cold or cool in temperature: blues, greens, and violets.

correspondence: an agreement among the visual elements in a composition, or when style is utilized as a method of connecting visual elements, for example, a linear style.

critique: an assessment or evaluation of work; also called **crit**.

cropping: cutting an element so the entire element is not seen.

crosshatching: a drawing technique where two series of parallel lines cross over or intersect.

debossing: the process of producing shapes or images that are pressed into the substrate (paper, for instance), making the shapes impressed below the surface.

deck: in magazines, the descriptive copy that follows the headline, used to interest the reader in the article.

denotation: the literal meaning of an image or words.

design concept: the creative thinking underpinning the design solution; the concept is expressed through the integration and manipulation of visual and verbal elements.

digital color: color perceived on screen-based media such as computer monitors and TVs.

display type: type most often as headings, over 14 points in size.

dithering: the condition that occurs when a browser tries to approximate a color by combining adjacent pixels of color; this can lead to poor readability.

dot: the smallest unit of a line, usually recognized as being circular.

drop caps: large first letters of a paragraph, also called initial caps.

drop-out type: white type that is actually the white of the page that drops out from the printed color; also known as knocked-out or reversed-out type.

edge: the meeting point or boundary (line) between shapes and tones.

embossing: a mechanical process of producing shapes or images (on various materials) that are raised above the surface of the material.

emphasis: arranging the hierarchy of the design and setting an element at the top position to give stress or importance to it, in order to influence what the viewer sees first.

engraving: a mechanical process of incising an image or design into a hard, flat metal surface. Ink is pushed into the incised areas and transferred to paper through pressure using a press.

equivocal space: deliberately created ambiguity in determining the positive/figure and negative/ground shapes of a design.

extended typeface: a typeface that is wider than it is tall.

eye level: the designer's line of vision in relation to the subject (things seen and being depicted), manifested as an imaginary line running through a two-dimensional composition and indicating the position of the overall viewpoint.

figure or positive shape (or positive space): in regard to two-dimensional design, the shape (or space) of a composition that is immediately recognizable.

flow: the arrangement of elements (deliberate or intuitive) in a design so that the viewer's visual action is led from one element to another through the design; also called movement. Flow is connected to the principle of rhythm.

flush left: body copy that is set justified on the left side, but ragged on the right (**rag right**).

focal point: the part of a design that is most emphasized.

forced perspective: the representation of forms on a two-dimensional surface by distorting the length that is projecting toward or receding away from the viewer; also called **foreshortening**.

foreground: the part of a picture or scene that appears nearest the viewer.

foreshortening: the representation of forms on a two-dimensional surface by distorting the length that is projecting toward the viewer or receding away from the viewer; also called **forced perspective.**

form: in two-dimensional design, a shape that has the illusion of existing in three-dimensional space. A form can be filled with modulated color or tones to give it the illusion of having weight, mass, or solidity.

form follows function: the shape, material, or appearance that something takes is in direct response to what is being communicated.

format: the defined perimeter and the area it encloses, where a designer begins composing a design with his or her first mark on a physical surface, such as a piece of paper, or on a screen.

frame: fundamental to screen-based media, it is a single, static image, one of many composed together to create motion graphics.

geometric shape: a shape created with straight edges, precise curves, and measurable angles, and mechanical rather than natural in appearance and style.

gesture drawing: a free-form linear drawing that focuses on emotion and action, rather than exacting representation.

golden ratio: a ratio of length to width; also referred to as the golden mean, golden number, or divine proportion.

golden section: a ratio; the mathematical formula is: $a : b = b : (a + b)$.

graphic design: a problem-solving activity and a means of communication.

grid: an underlying guide—a modular, compositional structure made up of verticals and horizontals that divide a format into columns and margins, which may be used for single-page or multiple-page formats.

grotesques: the first sans-serif typefaces, created by simply cutting the serifs off existing typefaces.

ground or negative shape (or negative space): the interstices or area between and around positive shapes.

grouping: entails ensuring that visual elements that are near one another have an express visual relationship to one another. Grouping is an important principle related to rhythm.

hanging punctuation: when punctuation marks are set slightly outside a justified type block to create an even column appearance.

harmony: agreement within a composition, where elements are constructed, arranged, and function in relation to one another to an agreeable effect.

hatching: a drawing technique that is used to create value or the illusion of atmosphere, where lines are drawn in close proximity, usually parallel; when two series of parallel lines cross over or intersect, it is called **crosshatching.**

head: the headline or title of a page of copy.

hieratic scaling: scale that is used to aid in establishing a visual hierarchy in a composition.

home page: the primary entrance to a web site that contains the central navigation system.

horizontal extension: a format shape commonly used for the expression of time and conveying continuous movement.

hue: the name given to colors, such as red or green, blue or yellow; is used synonymously with the word color.

illusion of spatial depth: the illusion of three-dimensional space, which can be shallow or deep, recessive or projected.

imaginary texture: texture that is purposefully depicted in abnormal or unnatural ways in order to expand the meaning and message of an image or design.

impasto: the surface and technique of applying paint thickly, creating a highly tactile, textural quality.

implied line: a line "broken" into parts or fragmented in some way rather than being continuous.

initial caps: large first letters that begin a paragraph, also known as **drop caps.**

interstice: the space between visual elements.

interval colors: mixtures of the pigment primary and secondary colors: red (primary) + orange (secondary) = red-orange (interval).

justified: body text that is set flush right and flush left.

kerning: the adjustment of the space between pairs of characters (**letterspacing**).

kitsch: a style of design (said to have originated in the 1950s) that purposefully uses popular culture artifacts and icons, mass-produced objects, and "low-art" for imagery.

knock-out: a design and production term derived from the printing industry to designate a shape or area of a composition that is defined by the area surrounding it and the color of the paper on which the design is printed.

ladder effect: when too many hyphenated lines appear one after the other, which creates the impression of a ladder or steps.

Lascaux: caves in France where paintings by primitive man (a way of communicating without words) were discovered.

laser-cutting: paper is cut (burned through with a laser beam) with precision that can yield fine tactile results.

layout: the arrangement of type and visuals on a printed or digital page.

leading: the distance between two lines of type (line spacing).

"less is more": statement by Mies van der Rohe, originally applied to architecture, states that you can achieve more by removing visual clutter and simplifying the design.

letterpress: a printing process that involves a design (primarily of letters) created on a raised surface. Ink is rolled over the raised area and transferred to paper by means of a press.

letterspacing: the space between letters.

line: an elongated dot or defined area created on a substrate with a visualizing tool; an element of design.

line art: in regard to printing processes, line art refers to non-tonal graphics.

line direction: guides the viewer from a starting dot on a page or screen to the line's terminus.

line of vision: the movement of a viewer's eye as it scans a composition; it may also be called a line of movement, a directional line, or a psychic line.

line spacing or leading: the distance between two lines of type.

linear: a predominant use of lines in drawing an object or within a composition.

linear perspective: a schematic way of translating three-dimensional space onto a two-dimensional surface—of creating the appearance of spatial recession. This is based on the idea that diagonals moving toward a **vanishing point** or points will imitate the recession of space into the distance and create the illusion of spatial depth.

local texture: a texture that is depicted naturally or in a normal context, such as fur on a cat; it is local to the object on which it is naturally found.

long shot: a shot seen from far away.

mark: a truncated, free-form fragment of a line.

mass (weight): refers to density or solidity of a form.

medium shot: a shot seen from a medium distance.

metaphor: the act of using the given lexicon of symbols to represent something other than what is shown; it is the implied meaning, as opposed to the literal one.

middle ground (midground): an intermediate position between the foreground and the background.

modern type: the sleek, streamlined sans-serif type that was refined during the era (of the same name) in design that began in the early twentieth century.

monochromatic: a design or image limited to only a single hue, but which may contain variations in brightness and darkness.

motion aesthetics: the process and consideration of how composition creates impact over time in a design.

negative or ground shape (or space): the interstices or area between and around positive shapes.

nonobjective shape: a shape that does not represent any specific object from the environment, meant to symbolize an idea, rather than refer to a thing or object.

open composition: the compositional space appears or "seems" to stretch on beyond the limits of the format.

organic shape: a shape that seems to have a naturalistic, curvilinear, or biomorphic feel and stylistic appearance.

outline: a linear drawing of the outer edges of an object.

pattern: a consistent repetition of a single visual unit or elements within a given area.

picture plane: the flat, two-dimensional (planar) surface, such as a printed page or screen-based page, on which a designer organizes a composition. Some call it an imaginary transparent plane that coincides with the face of the page or substrate on which a composition is built; others call it a "transparent front wall" between the viewer and the objects that are seen. In some cases, it acts as a transparent plane of reference, onto which a designer places elements to establish the illusion of three-dimensional forms in space.

pixel: the smallest unit of light (with or without hue) of a screen-based image or design, that is square rather than circular, like a dot.

point: a position on a format not defined with color.

point of view: determined by our position and the angle of our vision in relation to the thing being seen.

point size: the vertical size, or height, of letters and line.

polychromatic: an image or design having many hues.

positive or figure shape (or space): in regard to two-dimensional design, the shape (or space) of a composition that is immediately recognizable.

primary colors: the three basic pigment (subtractive) colors from which all other colors are physically mixed: red, yellow, blue.

prism: used by Newton to split light into the **visible spectrum** of color **wavelengths** when it passes through; is used to demonstrate that light is composed of colors.

process colors: the four basic colors from which all colors are optically mixed during the offset-lithographic printing process: cyan, magenta, yellow, and black (**CMYK**).

proportion: the comparative size relationships of parts to one another and to the whole, where elements or parts are compared to the whole in terms of measure and/or quantity; it is also an aesthetic arrangement, a harmonious or agreeable relationship of parts or elements within a whole.

PSAs: public service advertising, either in print or on television.

radial (or all-over) **balance:** a combination of horizontally and vertically oriented symmetry where the elements radiate out from a point in the center of the composition, or an extensive repetition of an element or elements.

rag right: body copy that is set justified on the left (**flush left**), but ragged on the right.

ramped color: a smooth gradation between two hues or two values or intensities of one hue.

reflected light: the colors we see on the surfaces or objects in our environment.

repetition: *like elements* in a single composition, across multiple pages and throughout a web site, that build a sense of place—of correlation for the viewer—and create coherence in the visual work.

representational shape: a shape that depicts a recognizable object or thing from a known environment and can be depicted in a highly realistic way or abstracted for expressive purposes.

retro, for the retrospective style: a style that borrows and revives design from the past.

RGB: the three basic light (**additive**) colors from which all other colors are mixed: red, green, and

blue (RGB); these RGB primaries are used in computer painting, drawing, and photographic editing software programs.

rhythm: a pattern that is created by repeating or varying elements.

rhythmic relationships: formed in screen-based media by using the different types of shots, by the duration of each shot, and—the same way as in print—by the interaction of visuals, with contrast and variation.

roman typeface: serif typeface, also referred to as **classical** type.

rule: in the nomenclature of typography, a line is called a rule; they are straight, horizontal, or vertical lines that separate and hierarchically organize bodies of type, and can also act as a border or become an enclosing box.

runaround: type that is contoured to follow the edge of a visual element, such as a silhouetted photograph.

sans serif: type without serifs.

saturation: the brightness or dullness of a color or hue; a hue at its highest level of intensity is said to be purely saturated, and has reached its maximum **chroma.**

scale: in a design, the size of an element seen in relation to other elements within the format, and based on proportional relationships between and among elements.

screening back: to print an image, color, or typography at less than 100 percent.

script: a letterform design that most resembles handwriting.

secondary colors: direct mixtures of the pigment primary colors resulting in green, orange, and violet (the light secondaries are yellow, cyan, and magenta).

self-contained composition: the format is the outer limits of the application, not the outer edges of a page or screen.

serif: the shape at the end of character stokes, also refers to a type with serifs.

shade: a hue that has black mixed into it, to make it darker.

shape: a configured or delineated area on a format, created either partially or entirely by lines (outlines, contours) or by color.

spatial relationships: the distance between the thing being seen in relation to the viewer, such as how far or how close, and the shifts between near and far.

split complementary: a three-hue relationship on the pigment color wheel: one hue, plus the two colors adjacent to its complement.

spread: two facing pages in a magazine or book.

stamping: a mechanical process that uses heat and pressure to adhere film to a variety of materials.

storyboard: used to visually explain an idea, it is a series of drawings, sketches, or photographs of the key shots in a planned television commercial, film, video, or any motion graphic, which are also accompanied by text.

stripes: the tightly grouped repetition of lines within a whole design or a given area of a design.

subtractive colors: colors containing physical pigments; see also **additive colors**, **digital color**, and **reflected light.**

symmetry: the equal distribution of visual weights on both sides of a central axis.

tactile (or actual) textures: textures that have *actual* tactile quality and can be physically touched and felt.

template: a designed, underlying compositional structure used as a guide for arranging visual elements, which is utilized throughout an ad campaign, multiple-page design, or web site.

temporal relationship: the relationship or interplay between two separate events or images that exists in screen-based media and involves **chronology.**

tessellation: a pattern of figure/ground (positive/negative) shape reversals, such as a checkerboard.

tetradic: four colors in two sets of complementary pairs (double complements).

text block: column or mass of type of the page that forms the overall shape.

text type: type used in the body of text, also called **body copy.**

texture: the actual tactile quality of a surface, or the simulation or representation of such a surface quality.

thumbnail sketches: preliminary, small, quick, unrefined drawings of your ideas, in black and white or color.

tint: a hue that has white mixed into it, to make it lighter.

TOC: the table of contents in a magazine or book.

tondo: a circular format.

tone: a color that is mixed with gray or a reduction of the fully saturated hue.

tracking: the adjustment of space between words.

triadic: three colors equally distant from each other on the pigment color wheel.

trompe l'oeil: literally "to fool the eye"; a visual effect drawn or painted on a two-dimensional surface where the viewer is in doubt as to whether the object (or texture) depicted is real or a representation.

two-dimensional design: the conscious and thoughtful arrangement of graphic elements on a flat surface.

type alignment: the style or arrangement of setting text type; for example, flush left/ragged right.

type family: a complete selection of style variations, such as bold, italics, and small caps, based upon a single typeface design.

typeface: a single set of letterforms, numerals, and signs unified by consistent visual properties.

unity: where the elements in a design look as though they belong together and visually hold together in an integrated structure.

value: refers to the relative level of luminosity—lightness or darkness—of a color, for instance, dark blue or light green.

value contrast: the relationship of one element (part or detail) to another, in respect to lightness and darkness.

vanishing point: the point at which parallel lines seem to converge and then disappear from the viewer's sight along a horizon line.

varied repetition: where certain standard visual elements and measurements repeat, while the treatment of one or two visual elements varies.

variety: a diversity of visual elements, that is, different types or kinds of visual elements, which can exist and still allow for continuity.

vernacular: a style of typography that imitates other sources, such as street signs.

vertical extension: a format shape commonly used to express movement up and down and divisions of landscape.

visible spectrum: the wavelengths of light visible to the human eye.

visual composition: a whole, unified arrangement of visual elements on a page, screen, or window that moves over a period of time.

visual contrast: when visual elements are put in opposition in order to illustrate or emphasize differences.

visual hierarchy: arranging elements according to emphasis.

visual textures: those created and seen in photographs, screen-based imagery, and illustrations, or rendered within shapes (figure or ground), lines, or type—on any part of a design.

visual weight: the relative amount of visual attraction or importance or emphasis the element carries in the composition.

volume: the illusion of space within a shape.

volumetric form: a shape containing the illusion of volume, and having the illusion of existing in three-dimensional space.

warm colors: those hues perceived to have hot to warm temperature: reds, oranges, and yellows.

wavelength: a scientific term for a specific kind of progressive, radiating energy.

wood type: typefaces carved in wood, beginning in the nineteenth century.

word spacing: the space between words.

Selected Bibliography

Arnheim, Rudolf. *Art and Visual Perception.* Berkeley, CA: University of California Press, 1974.

———. *The Power of the Center: A Study of Composition in the Visual Arts.* Berkeley, CA: University of California Press, 1984.

Behrens, Roy R. *Design in the Visual Arts.* Englewood Cliffs, NJ: Prentice Hall, 1984.

Chown, Marcus. "The golden rule." *The Guardian,* Thursday, 16 January, 2003. *www.guardian.co.uk/ online/science/story/0,12450,875198,00.html.*

Gage, John. *Color and Culture Practice and Meaning from Antiquity to Abstraction.* Berkeley and Los Angeles, CA: University of California Press, 1999.

———. *Color and Meaning, Art, Science, and Symbolism.* Berkeley and Los Angeles, CA: University of California Press, 1999.

Kessel, John Keith. "A Short History of the Grid." *www.santarosa.edu/~jwatrous/art3/Grid-history.html.*

Landa, Robin. *Advertising by Design™.* Hoboken, NJ: John Wiley & Sons, Inc., 2004.

———. *Graphic Design Solutions.* 3rd ed. Clifton Park, NY: Thomson Delmar Learning, 2005.

———. *Introduction to Design.* Englewood Cliffs, New Jersey: Prentice Hall, 1983.

Landa, Robin, and Rose Gonnella. *Visual Workout: Creativity Workbook.* Albany: OnWord Press, Thomson Learning, 2000.

Lauer, David, and Stephen Pentak. *Design Basics.* 5th ed. Columbus, OH: Ohio State University, 2004.

Lupton, Ellen. *Thinking With Type.* New York: Princeton Architectural Press, 2004.

Meggs, Philip B. *A History of Graphic Design.* 3rd ed. Hoboken, NJ: John Wiley & Sons, Inc., 1998.

Nelson, Roy Paul. *Publication Design.* Dubuque, IA: Wm. C. Brown Company Publishers, 1972.

Vest, Jeremy; William Crowson; and Shannon Pochran. *Exploring Web Design.* Clifton Park, NY: Thomson Delmar Learning, 2005.

Williams, Robin. *The Non-Designers Design Book.* 2nd ed. New York: Peachpit Press, 2004.

Wong, Wucius. *Principles of Form and Design.* 2nd ed. Hoboken, NJ: John Wiley & Sons, Inc., 1996.

Zelanski, Paul, and Mary Pat Fisher. *Design, Principles and Problems.* New York: Holt-Rinehart Winston, 1984.

Zeldman, Jeffrey. *Designing with Web Standards.* Berkeley, CA: New Riders, 2003.

———. *Taking Your Talent To The Web.* Indianapolis, IN: New Riders, 2001.

Subject Index

Agencies, Clients, Creative Professionals, and Studios Index